"Art, like morality, consists of drawing the line somewhere." G.K. CHESTERTON

American Illustration 12

The 12th annual of American editorial, book, advertising, posters/maps, graphics, unpublished work and video.

Edited by Edward Booth-Clibborn
Designed by Frankfurt Balkind Partners

editor)

Edward Booth-Clibborn

publisher)

Kenneth Fadner

designers)

Kent Hunter and Ruth Diener, Frankfurt Balkind Partners

cover and divider illustrations)

Johan Vipper, Frankfurt Balkind Partners

production manager)

Tina Moskin, Frankfurt Balkind Partners

production coordinators)

Mark Heflin and Jay Heflin

printed by)

Dai Nippon, Hong Kong

special thanks to)

Parsons School of Design for providing the space and equipment for the American Illustration 12 competition.

The artwork and the caption infor-

mation in this book have been supplied by the entrants. While every effort has been made to ensure accuracy, American Illustration does not under any circumstances accept any responsibility for errors or omissions.

If you are a practicing illustrator, artist, or student, and would like to **submit** work to the next annual competition, write to)

American Illustration

5 East 16th Street, 11th floor New York, NY 10003 212.647.0874

distributor to the USA Trade)

Rizzoli International Publications 300 Park Avenue South New York, NY 10010-3599

distributor to United Kingdom and World Direct Mail)

Internos Books
12 Percy Street
London W1P 9FB U.K.

book trade for the rest of the world)

Hearst Books International 1350 Avenue of the Americas New York, NY 10019

No part of this publication may be reproduced, stored in a retrieval system, or transmitted in any form or by any means—electronic, mechanical, photocopying, recording, or otherwise—without prior permission of the copyright owner.

Copyright @ 1993, Amilus, Inc.

Contents

Introduction

Edward Booth-Clibborn of American Illustration and this year's jury:

Gail Anderson, Richard Baker, Jessica Helfand, Kent Hunter, Mirko Ilić, Mark Koudys, Kandy Littrell.

ĥ

EditOrial

Illustrations for newspapers and their suppliments, and consumer, trade, and technical magazines and periodicals.

14

Books

Cover and interior illustrations for all types of fiction and non-fiction books.

112

Advertising

Illustrations used for advertising in consumer, trade and professional magazines.

144

Posters/Maps

Poster illustrations used for consumer products, institutions and special events/
Maps for magazines and promotional use.

154

Graphics

Illustrations for brochures, record albums, self-promotion.

1611

Unpublished Work

Comissioned **but unpublished** illustrations, and personal work produced by professionals and students.

174

Video

Video for television commercials, corporate and self-promotion.

200

Index

Names and addresses of contributing artists; names of art directors, designers, publications, publishers, design groups, advertising agencies, writers and clients who were involved in the creation and use of these images.

Introduction

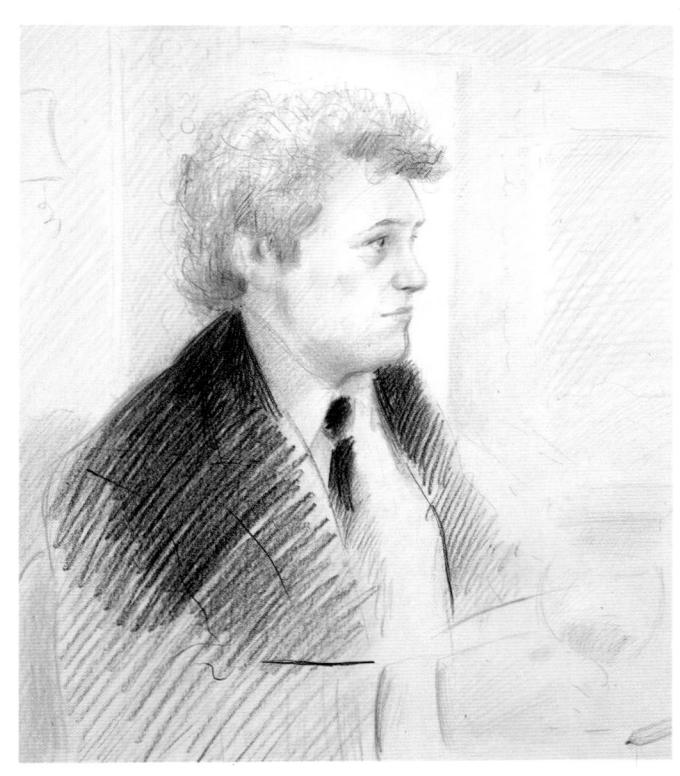

The judging for this edition of "American Illustration" took place in March of 1993 with a jury of seven people, all of whom I would like to thank for their time, enthusiasm, wit and wisdom. X With the publication of this twelfth annual we have reached a point where a definite style of American illustration has emerged. This is especially true of the work from the younger people whose submissions we have accepted over the last few years; people who have since become very successful as American illustrators. X But there is a disturbing trend behind this success. X Put simply, too many people are copying other people's work. X This year, for example, the jury rejected quite a number of items produced by people who, to put it bluntly, can only be described as rip-off artists. X Tragically, the artists who suffer most are the people like Edward Sorel, Guy Billout, Bob Blechman and Brad Holland whose highly original work is so often plagiarized. **Who** is to blame for this? X I fear that it begins in art schools, where students are pressured into producing portfolios designed to get them work, rather than to show off the individual talents. X It is also a sad reflection of the visual communications business in general, where people are increasingly prepared to pay less for a copyist than they would for the original thinker. X It seems to me that there is only one way to stamp this out, and that is that copyists' work should not be recognized. X Our jury has done their part, particularly by dismissing every copyist's submission and including the exceptionally imaginative work for the windows of Bloomingdales by Jessie Hartland and Josh Gosfield's fine work for Barneys' windows. I believe it takes real talent to be able to see the broad applications open to illustration and then have the vision to carry fresh ideas through to the end. It is work like this-and much else beside-which shows that, after twelve years, "American Illustration" is very much here to stay as the benchmark of excellence in a highly competitive world.

Jessica Helfand

Jessica Helfand has been design director at the "Philadelphia Inquirer Sunday Magazine" since July, 1990. During this time, the magazine has won over 60 awards in graphic design and photography from the Society of Newspaper Designers and the American Institute of Graphic Arts, among others. ∞ Prior to this, she was a designer with Roger Black Studio in New York, where she worked on the redesigns of numerous American and European publications Including "Mother Earth News," "McCalls" and "Grazia." ∞ She has lectured at the University of Pennsylvania, and has been guest critic at Yale University, Temple University's School of Journalism, University of the Arts and Tyler School of Art In Philadelphia. Helfand judged this year's Illustrator's Club of Washington show, and last year's competition sponsored by the Philadelphia chapter of the American Society of Magazine Photographers. Her work has appeared in numerous publications including the Print Regional Design Annual and the Communication Arts annuals in both photography and illustration. She holds a B.A. and a M.E.A. in graphic design from Yale University.

favorite deadly sin: lust

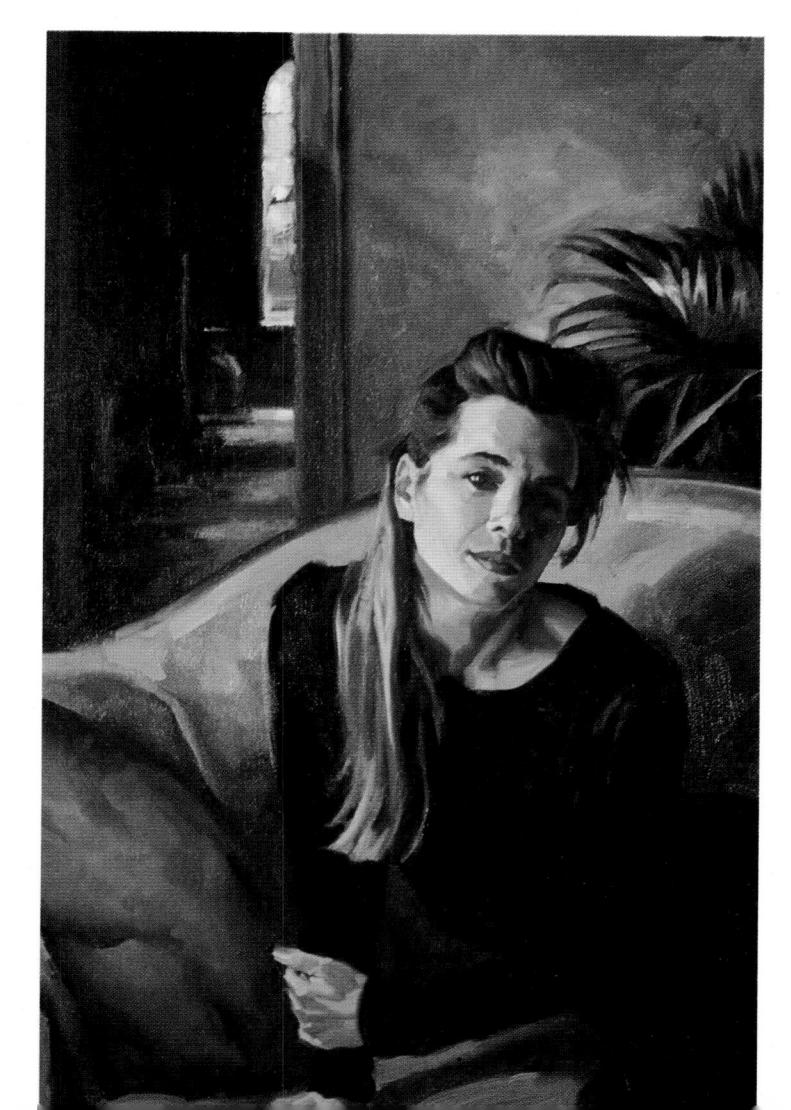

portrait by Gregory Manchess

Kandy Littrell

Kandy Littrell is senior art director for covers at "Newsweek." In addition to her past freelance work with Random House and Houghton Mifflin, she has held various posts at "The New York Times Magazine," "New England Monthly," and "Rolling Stone." ∞ As an illustrator, Kandy's work has appeared in such publications as "Ms. Magazine," "National Lampoon," "Psychology Today," and "Savvy." Throughout her career, her efforts have been awarded by The Art Directors Club of New York, Communication Arts, and SPD, to name a few.

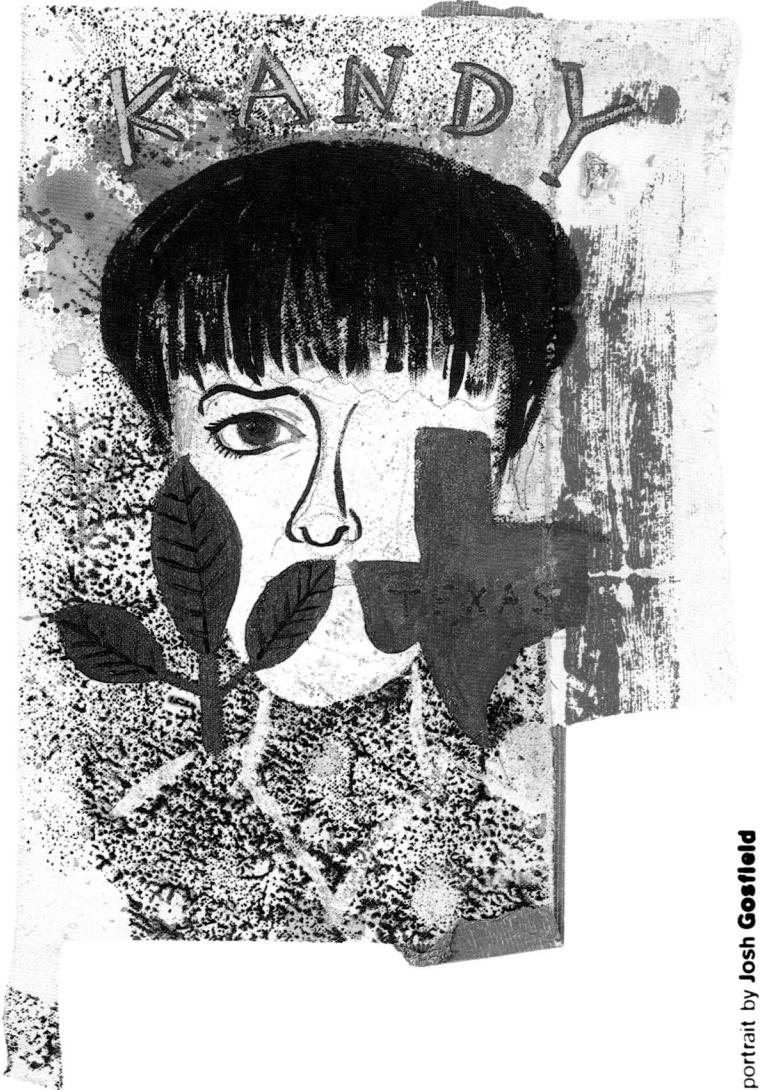

favorite deadly sin: sloth

Kent Hunter is Executive Design Director and a principal of Frankfurt Balkind Partners, an integrated communications agency based in New York and Los Angeles and San Francisco. Known for its innovative approach to annual reports, the firm is increasingly working in video and multi-media, utilizing their expertise in advertising and entertainment marketing. The firm's work for Time Warner, MTV, The Limited, MCI, and others has won every major design award. ∞ Kent is a past vice-president of the New York chapter of the American Institute of Graphic Arts, has judged numerous design shows and gives lectures around the country. He passionately collects folk art.

Gail Anderson

Gail Anderson has worked at "Rolling Stone" with Fred Woodward since 1987, the past three years as deputy art director. She served as the assistant designer at "The Boston Globe Magazine" from 1985-87 and as a designer at Vintage Books prior to that. Her work has received awards from the Society of Publication Designers, the Type Directors Club, AIGA, The Art Directors Club, and Communication Arts Magazine. She is co-author with Steven Heller of "Graphic Wit: The Art Of Humor in Design," and "The Savage Mirror: The Art of Contemporary Caricature." They are currently working together on "American Typography," a survey of modern type. A School of Visual Arts graduate, Gail now teaches design in SVA's Continuing Education program. Her work is represented in the permanent collection of the Cooper-Hewitt Design Resource and she serves on the Executive Committee of AIGA's New York chapter.

favorite deadly sin: sloth

portrait by Robert Risko

favorite deadly sin: sloth

portrait by Terry Allen

Richard Baker was born in Kingston, Jamaica where he learned to Rub-A-Dub Style all night long to the tunes of Big Youth. Faced with the career choices of working for the Royal Postal Service or selling kali weed, he headed no'th to The Big Apple. ∞ After graduating from the School of Visual Arts, he moved to Boston to work as a designer and art director for The Boston Globe. He then went to work for The Washington Post Magazine as its art director for three years. He is currently back in New York working as art director at Vibe Magazine. ∞ He sometimes still thinks about a career in sales and postal service.

Mark Koudys

Mark Koudys is Canadian, and therefore an extremely nice and polite person. He grew up in an octagonal house just outside Niagara Falls, which may or may not account for the many facets to his work and character today, but must certainly explains his fear and loathing of tourism and honeymoons. Currently he is a principal of Atlanta Art and Design in Toronto, which specializes in editorial design and corporate communications programs. His work has been recognized by The American Institute for Graphic Arts, Society of Publication Designers, Communication Arts, Graphis and the Toronto Art Directors Club. His surname comes from Dutch parents, it's pronounced "cowt-ice," and it means "cold-ice," which raises the question of what other kind of ice they have in Holland...but perhaps it is not a question which need concern us any further here...

favorite deadly sin: lust

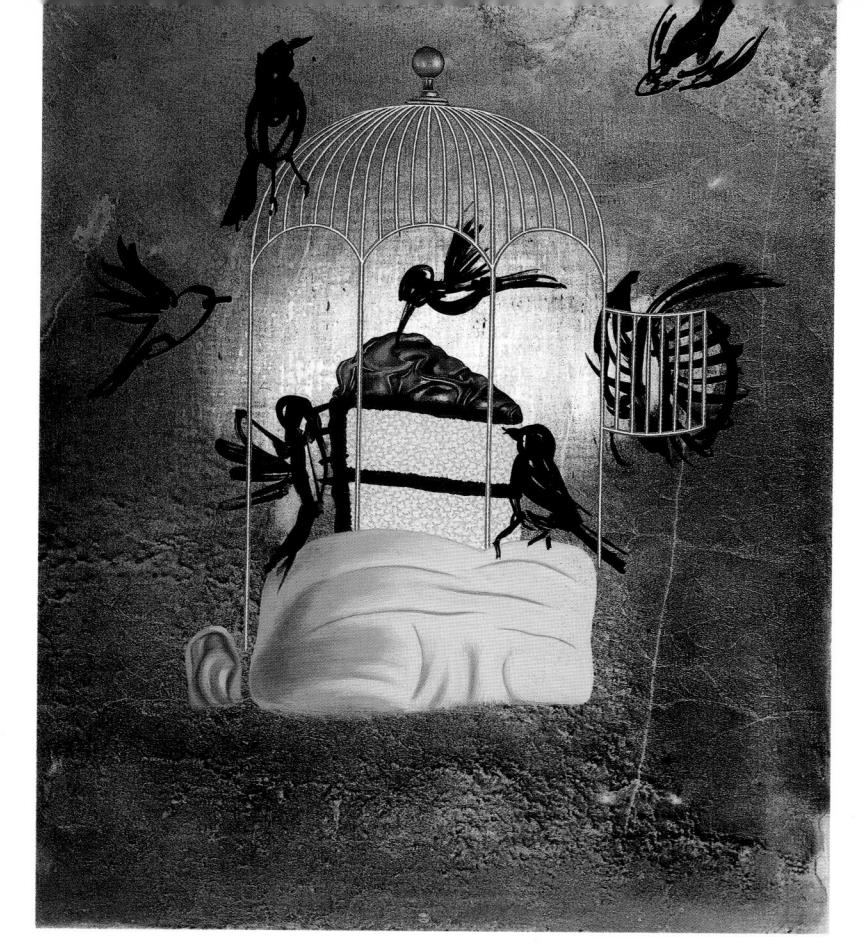

favorite deadly sin: anger

Mirko Ilić was born in Bosnia in 1956. He started to publish his work at the age of seventeen. His work ranged from comics and illustrations to art direction for film, theater posters, album covers and book covers. In 1986 he emigrated to the U.S. where he continued to work for a wide range of clients, primarily as an illustrator. He has art directed "Time International" and is currently art directing the Op-Ed page of "The New York Times." Mirko has been awarded a gold medal by the Society of Illustrators and by the Society of Publication Designers.

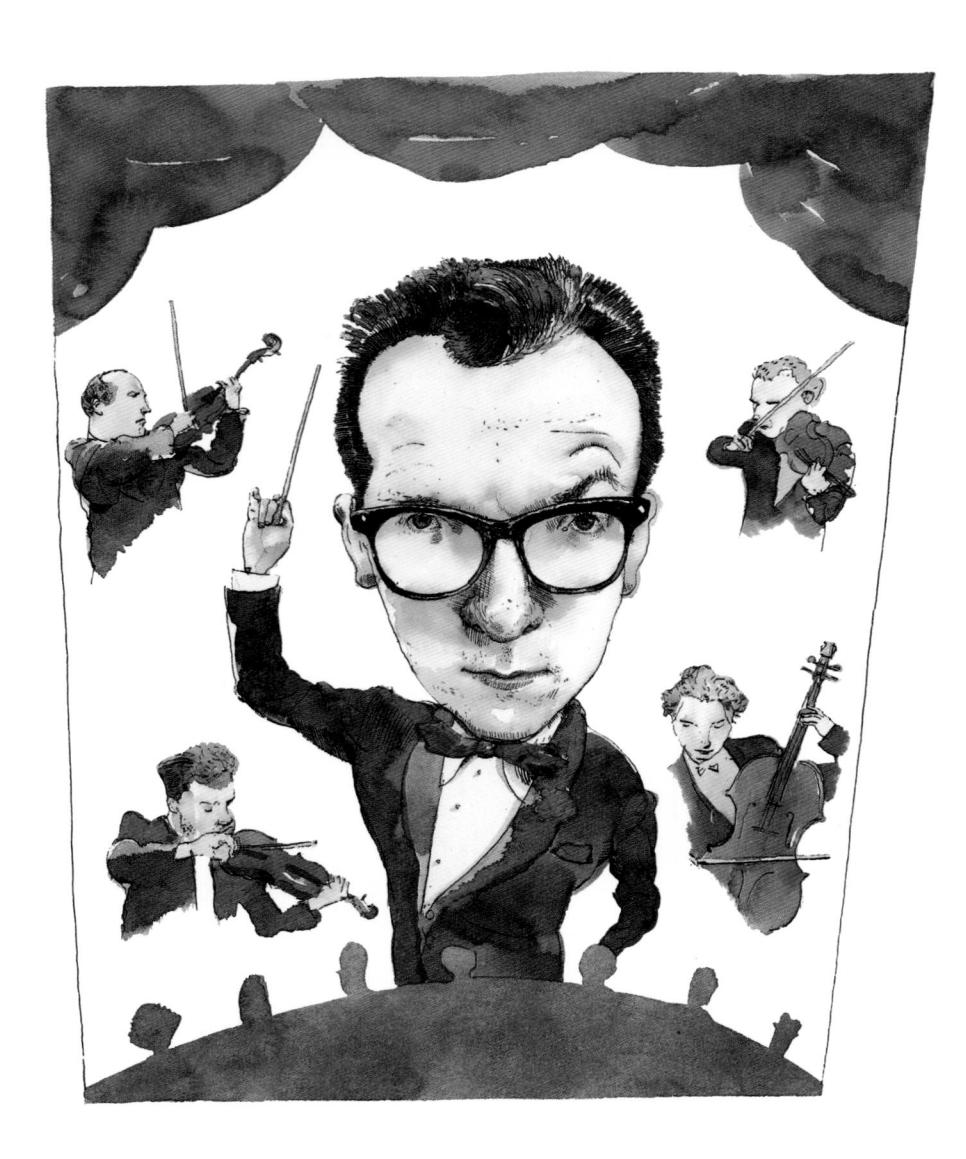

Barry Blitt

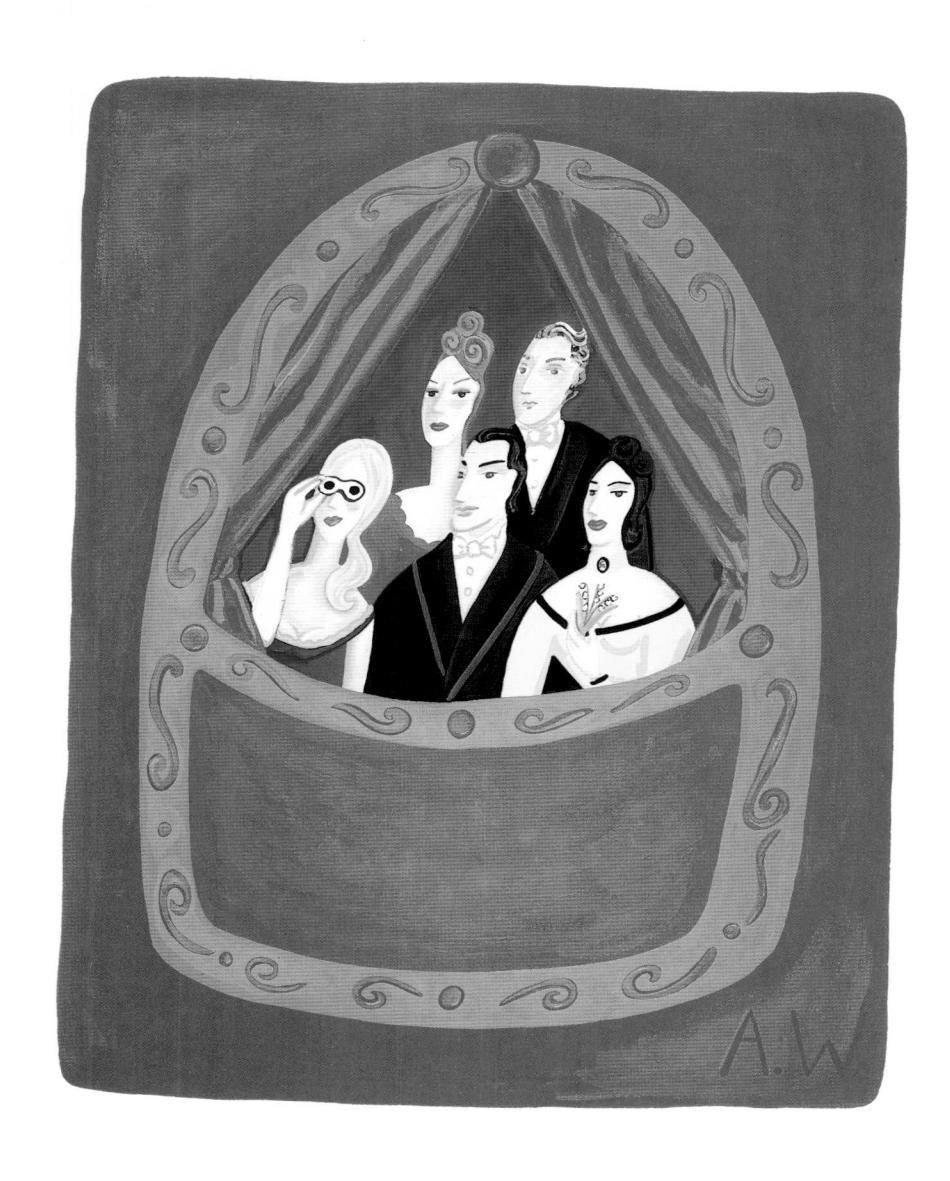

Alexandra Weems

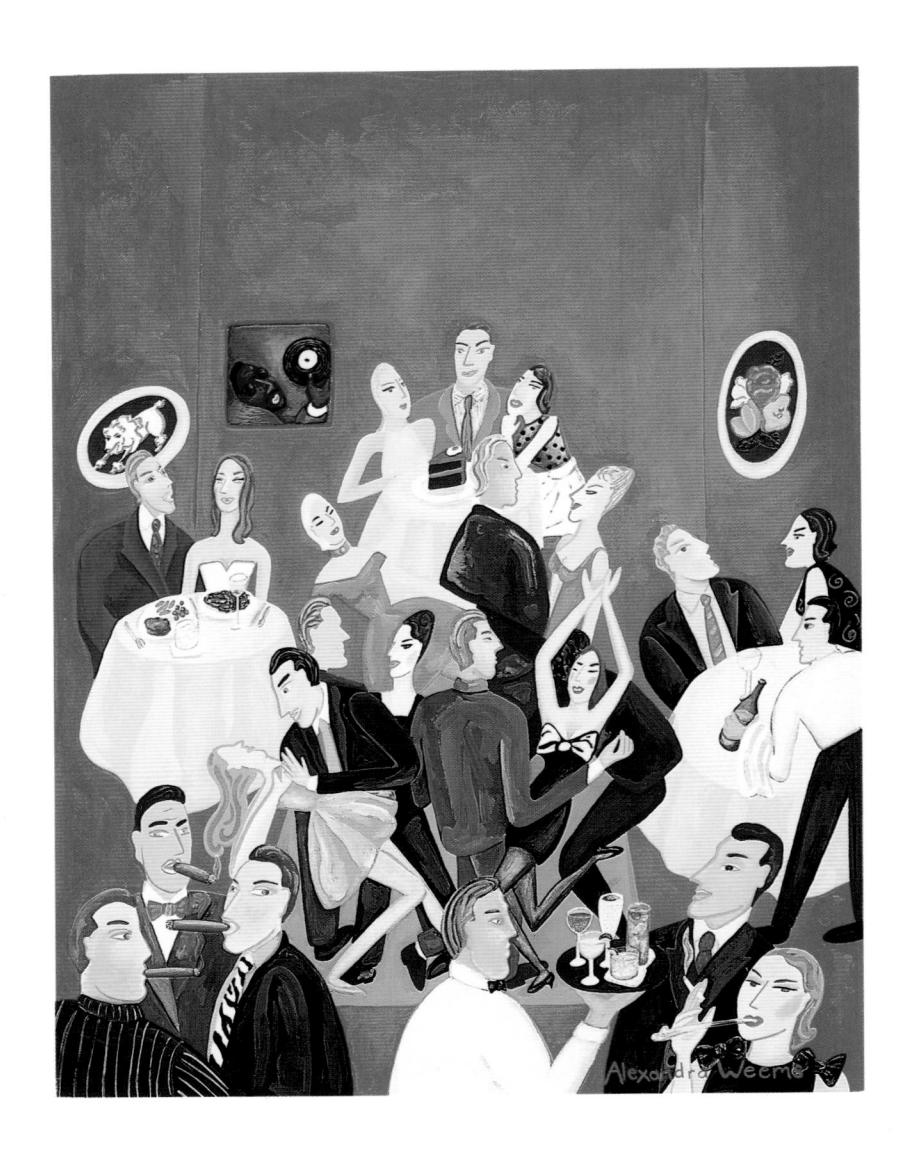

Alexandra Weems

Art Director) Chris Curry
Medium) Gouache on BFK Rives

The second of two lilustrations commissioned for The New Yorker's "Night Life" section (above).

00

Art Director) Pamela Berry
Medium) Gouache on paper

Writer) Michael Kaplan

Publication) US Magazine

Date) August 1992

Publisher) Straight Arrow Publishers, Inc.

Cable sex shows were the subject of the article "You Get What You Pay For" featuring this illustration (right).

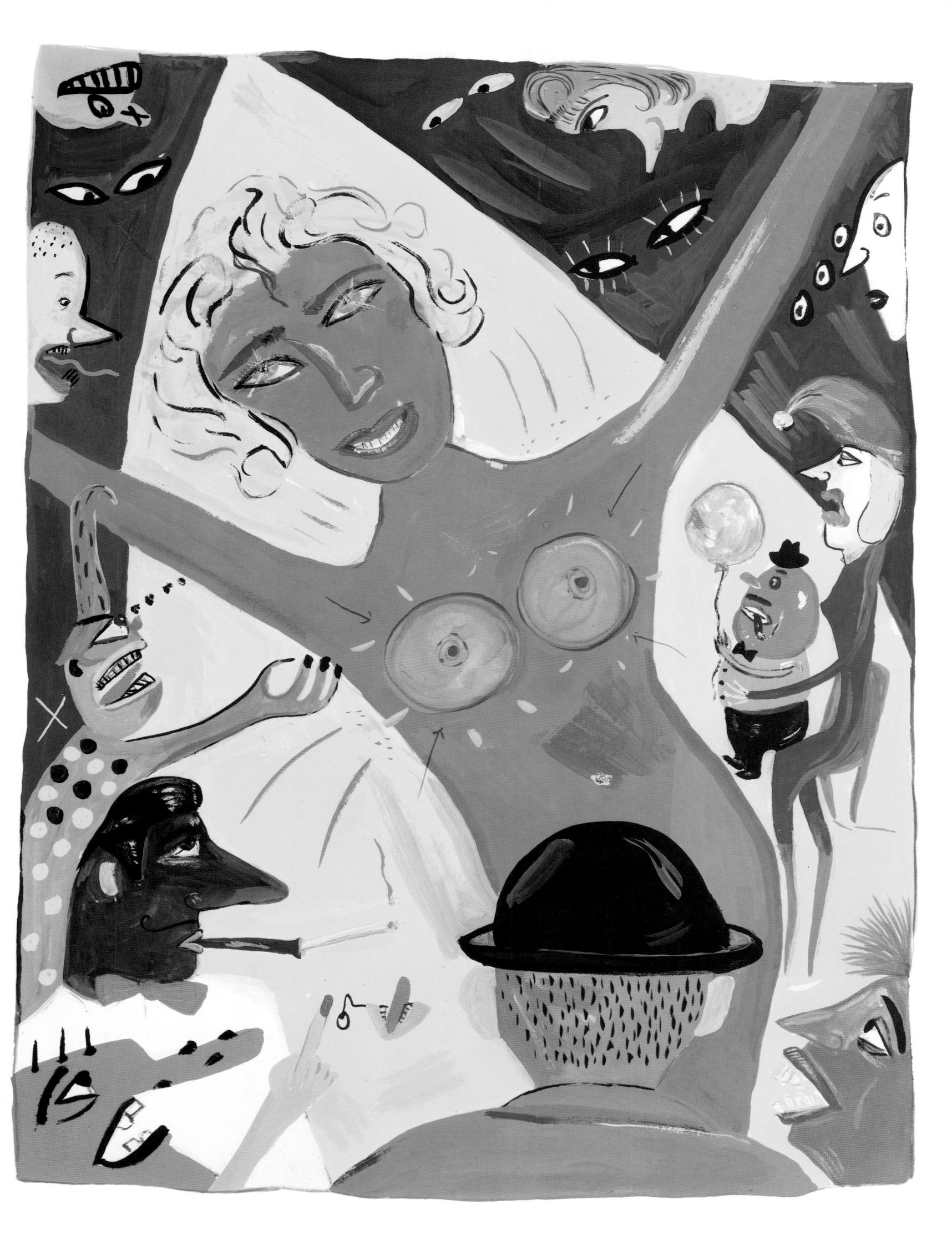

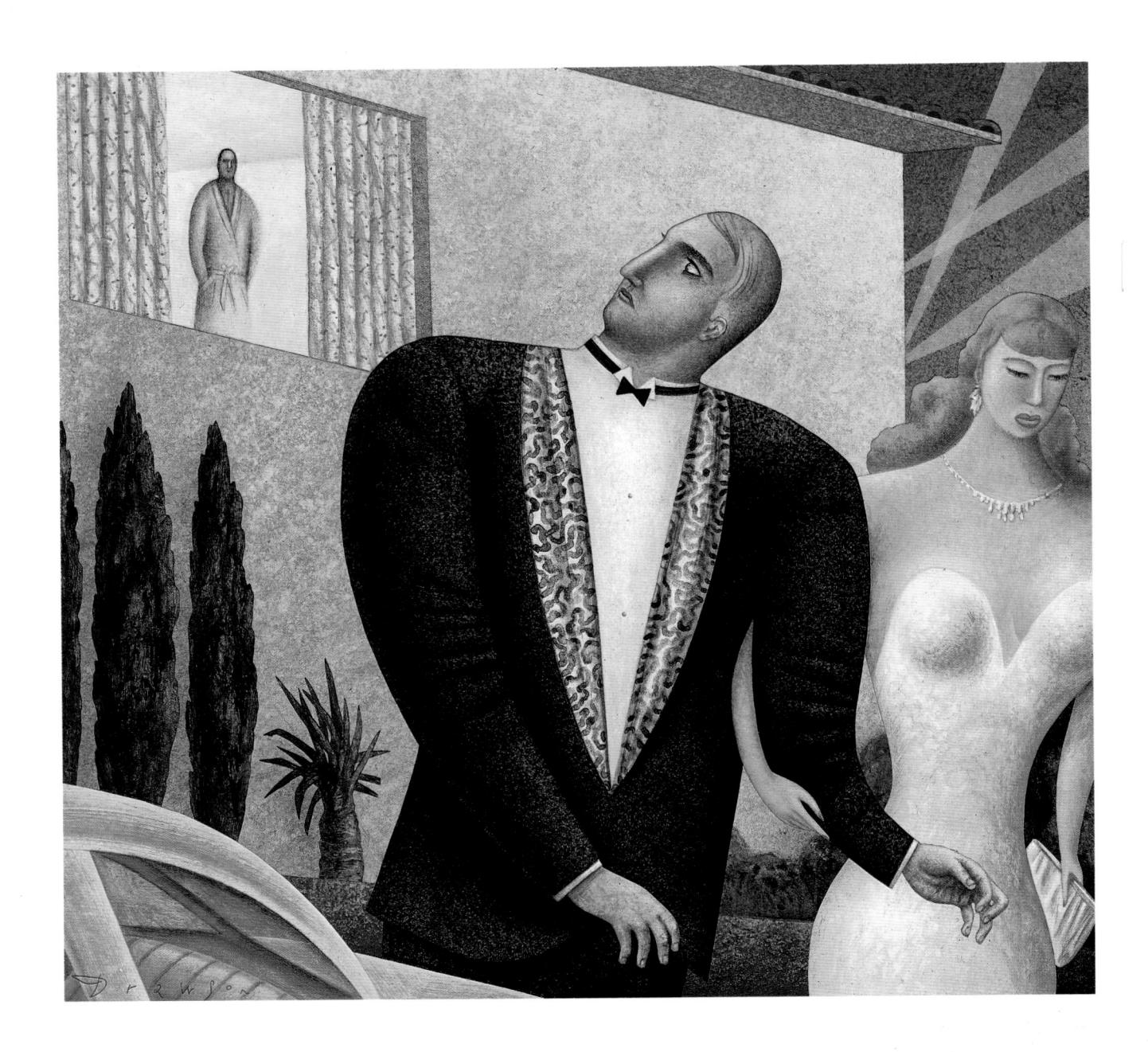

20

Blair Drawson

Maurice Vellekoop

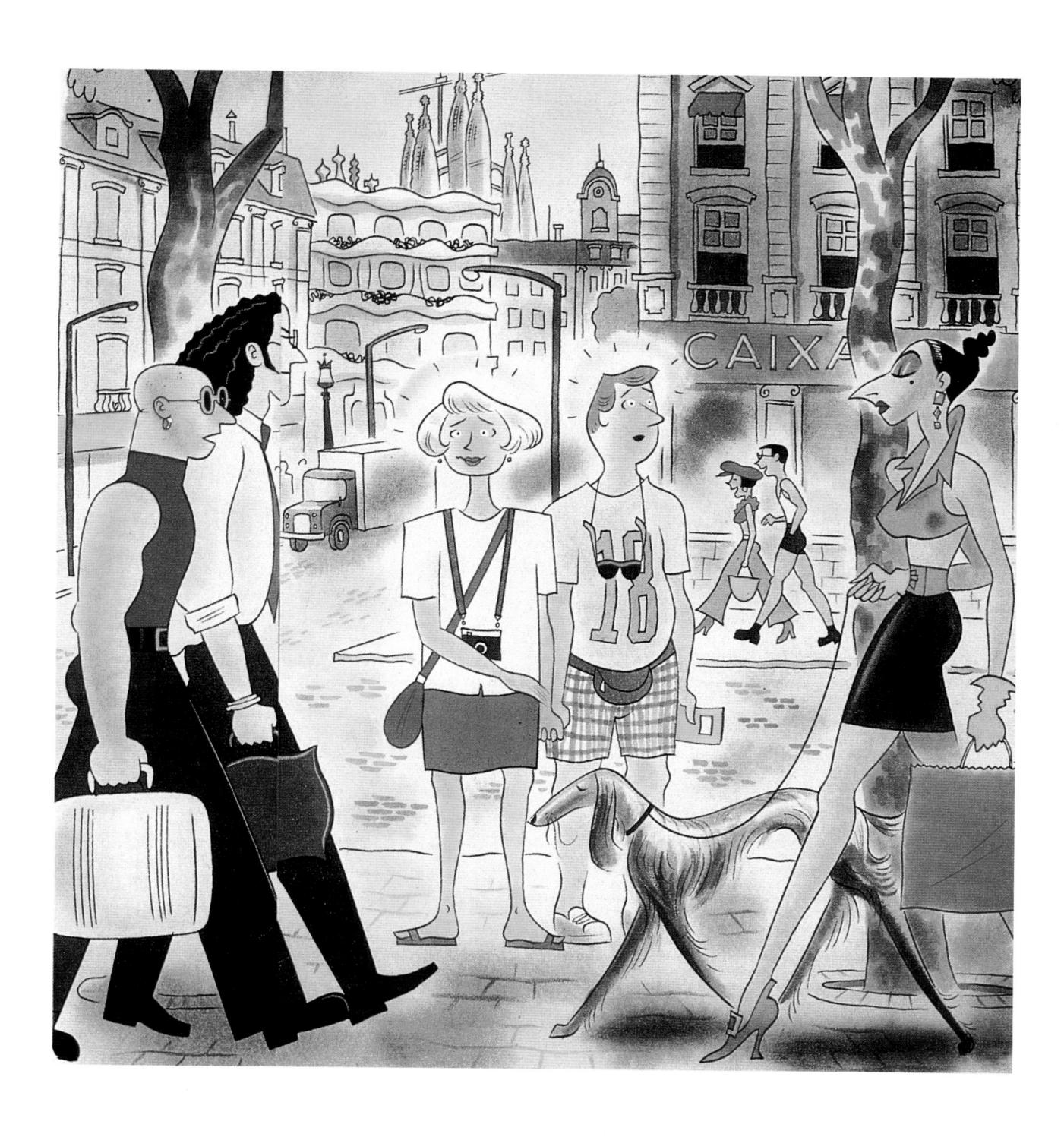

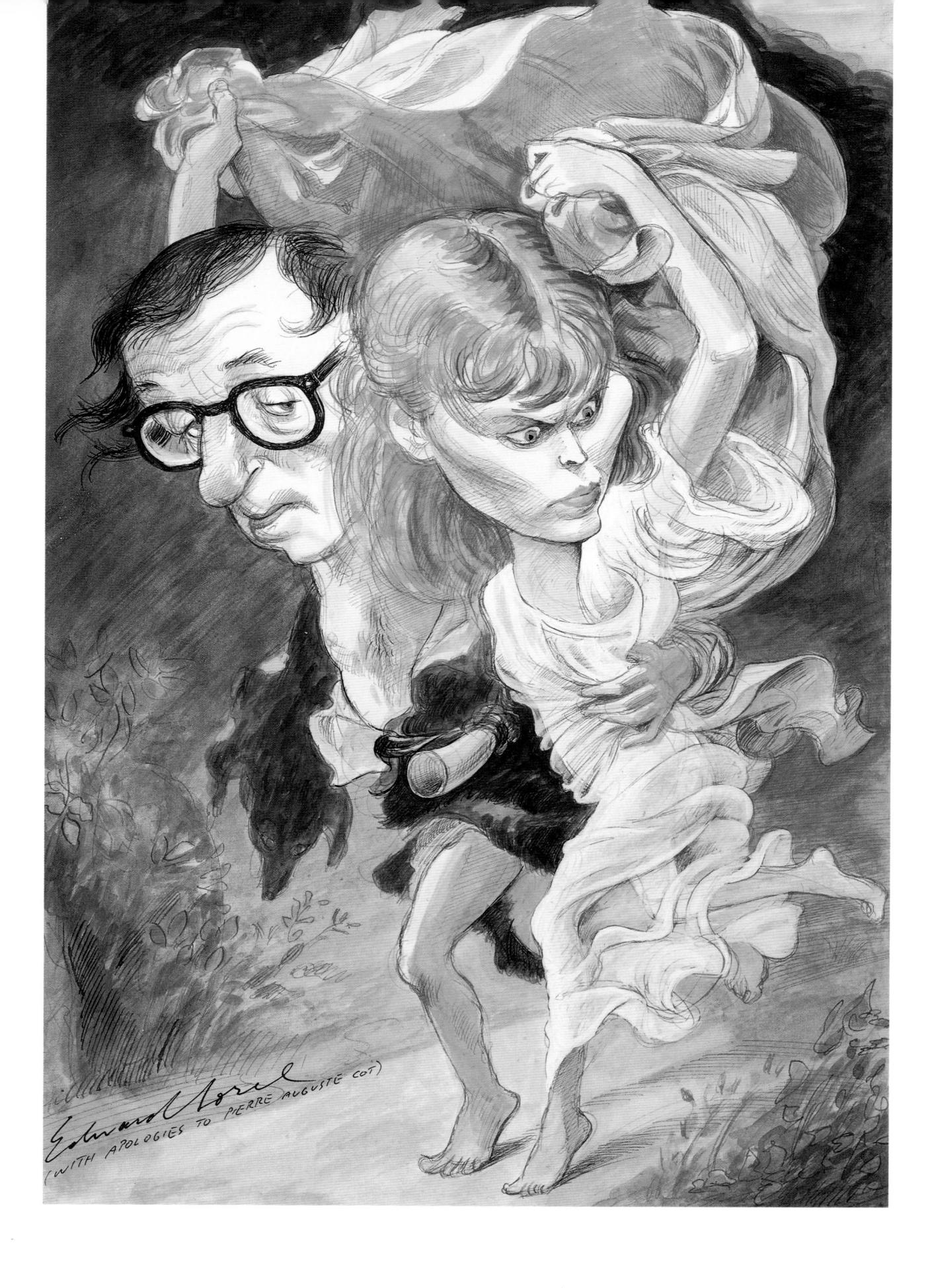

Edward Sorel

Sandra Hendler

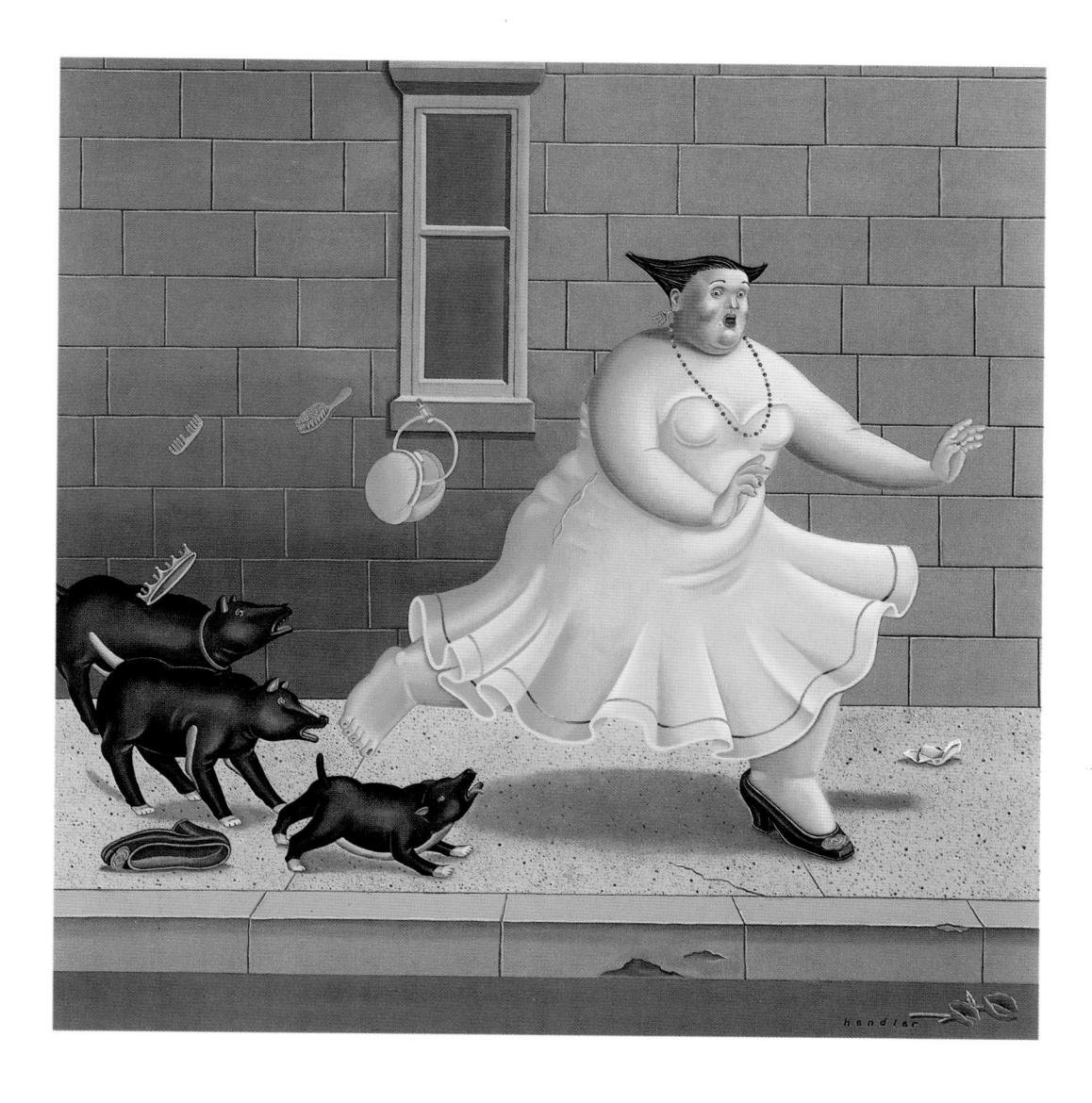

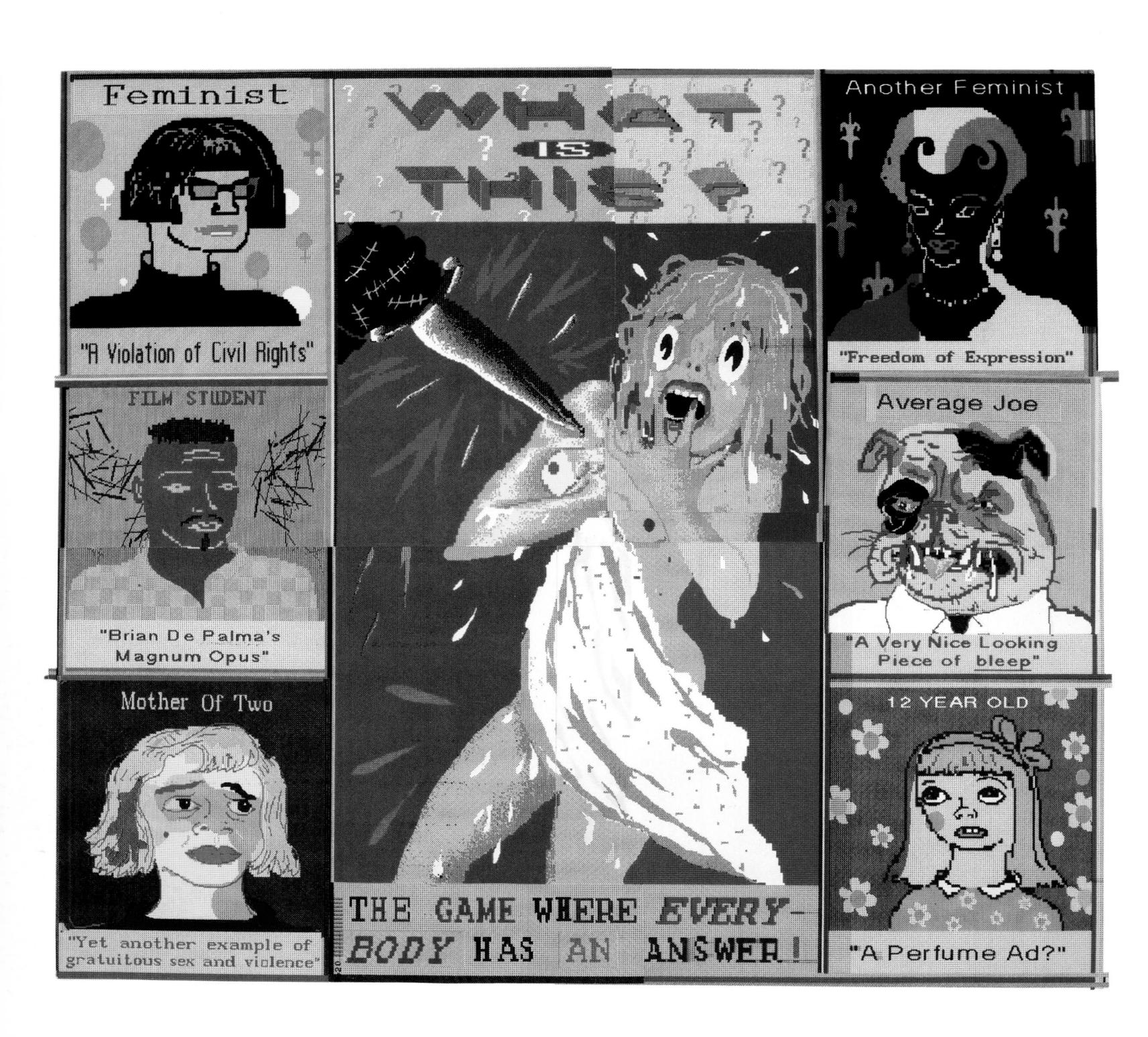

Georganne Deen

Art Directors) Rudolph C. Hoglund and Jane Frey Editor) Johanna McGeary Writer) John Kohan
Publication) Russia Special Issue of Time Magazine Date) December 7, 1992. Publisher) The Time Inc. Magazine Company
Medium) Paint and collage This collage accompanied the article "Can Russia Escape Its Past?"

Janet Woolley

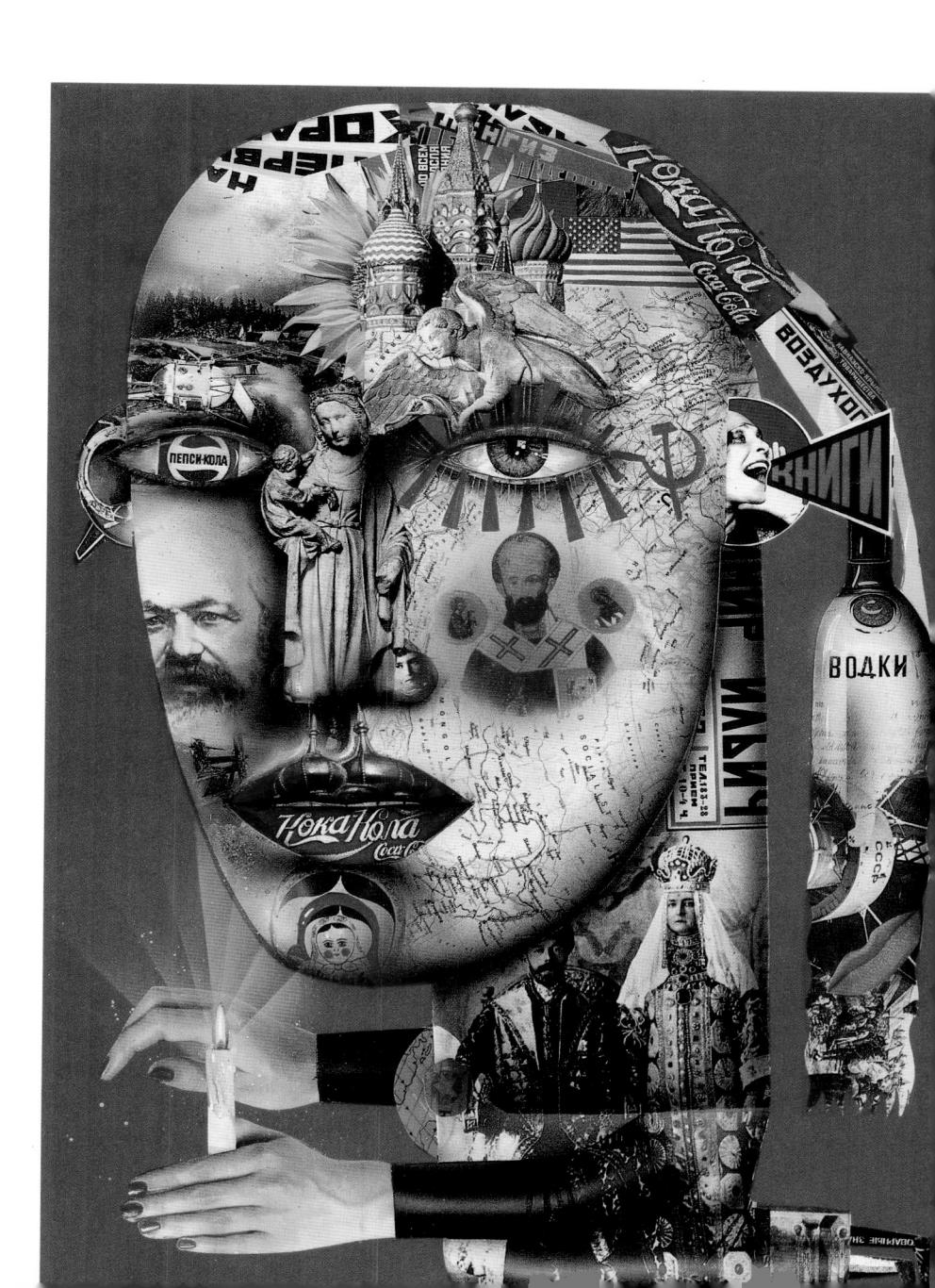

Brad Holland

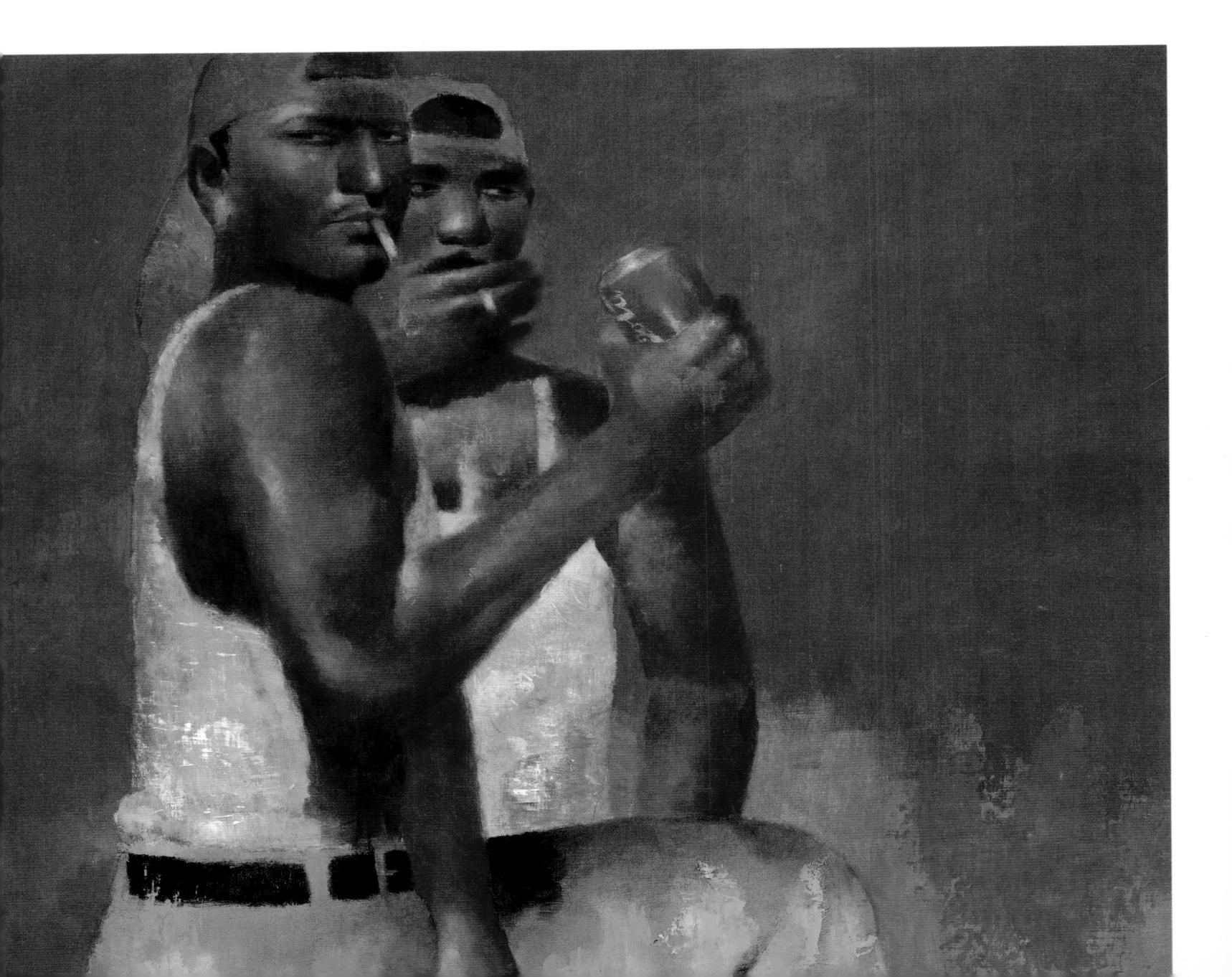

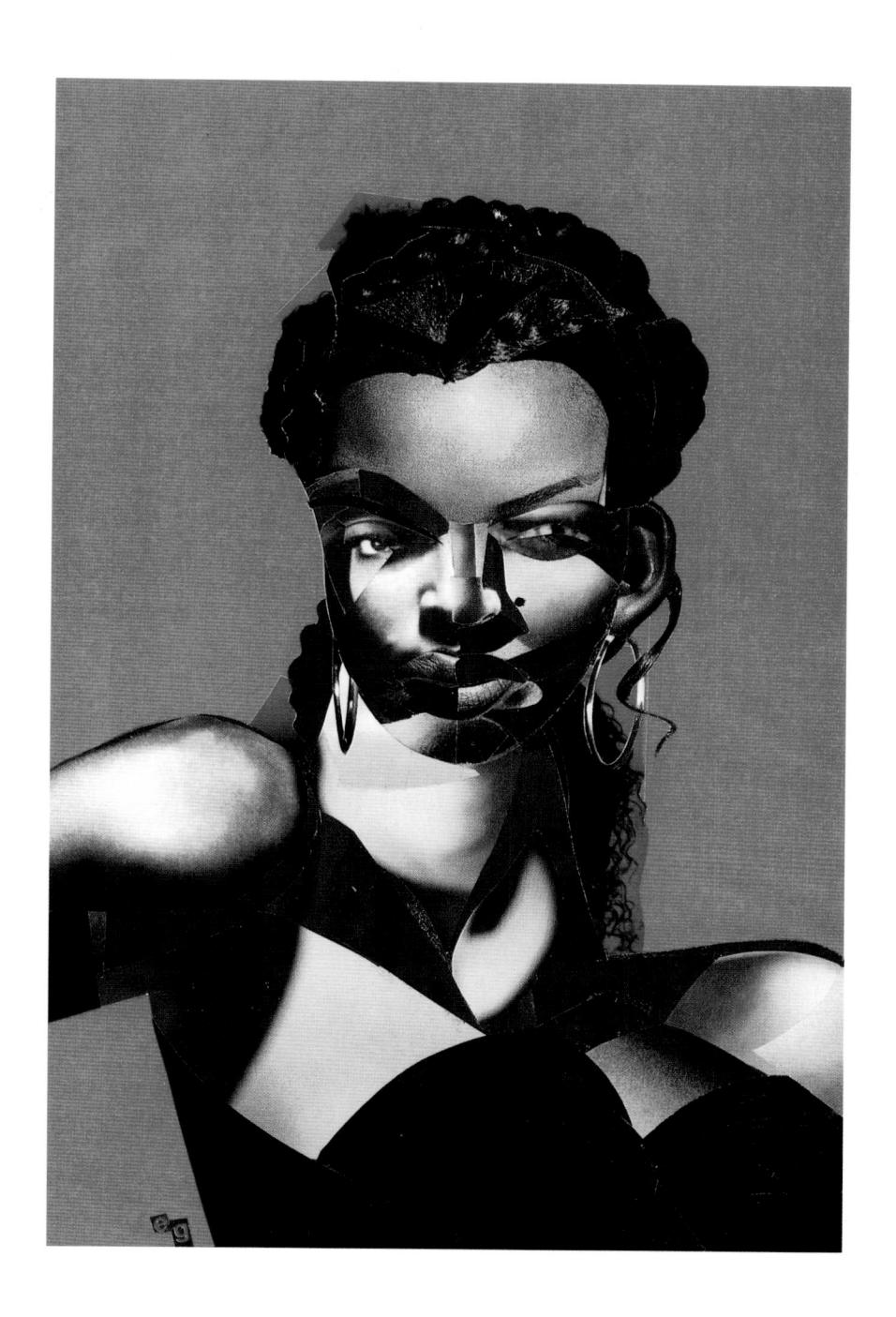

Ed**mund G**uy

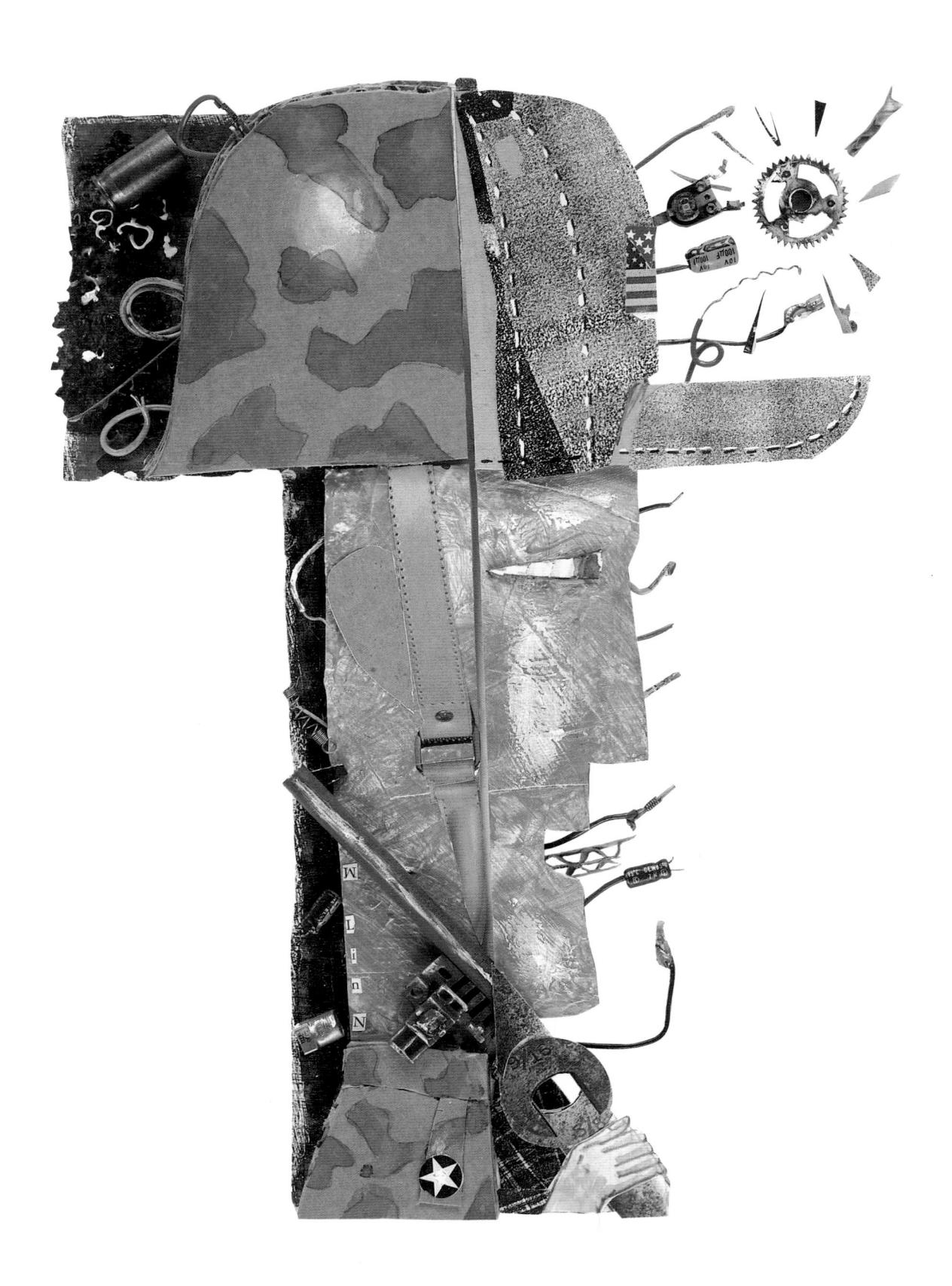

Warren Linn

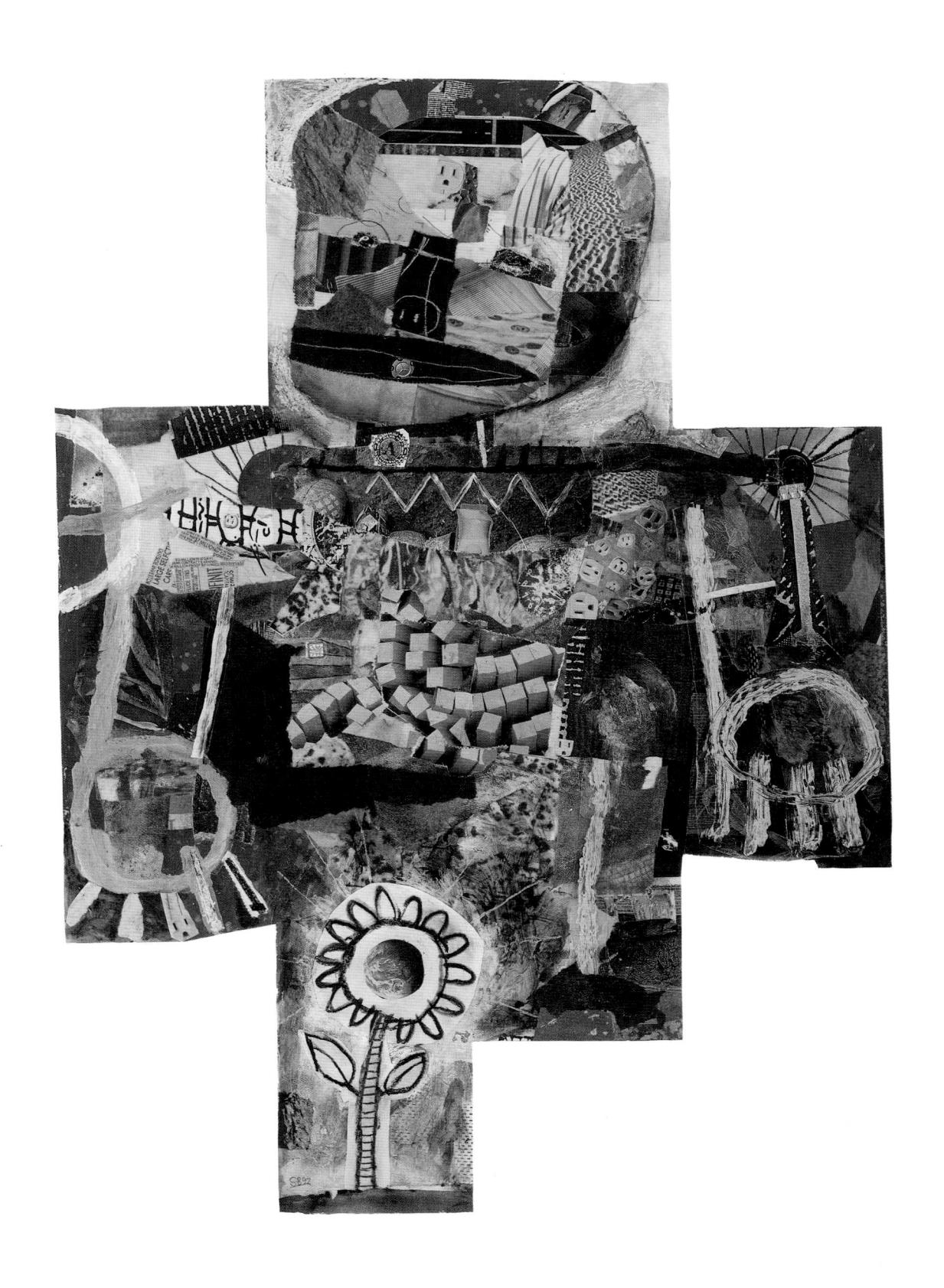

Stephen Byram

Art Director) Mirko Ilić Editor) David Shipley Writer) T. Rosack Publication) The New York Times

Date) June 1992 Publisher) New York Times Company Medium) Mixed media This illustration accompanied an essay on environmental and commerce issues for the Times Op-Ed page.

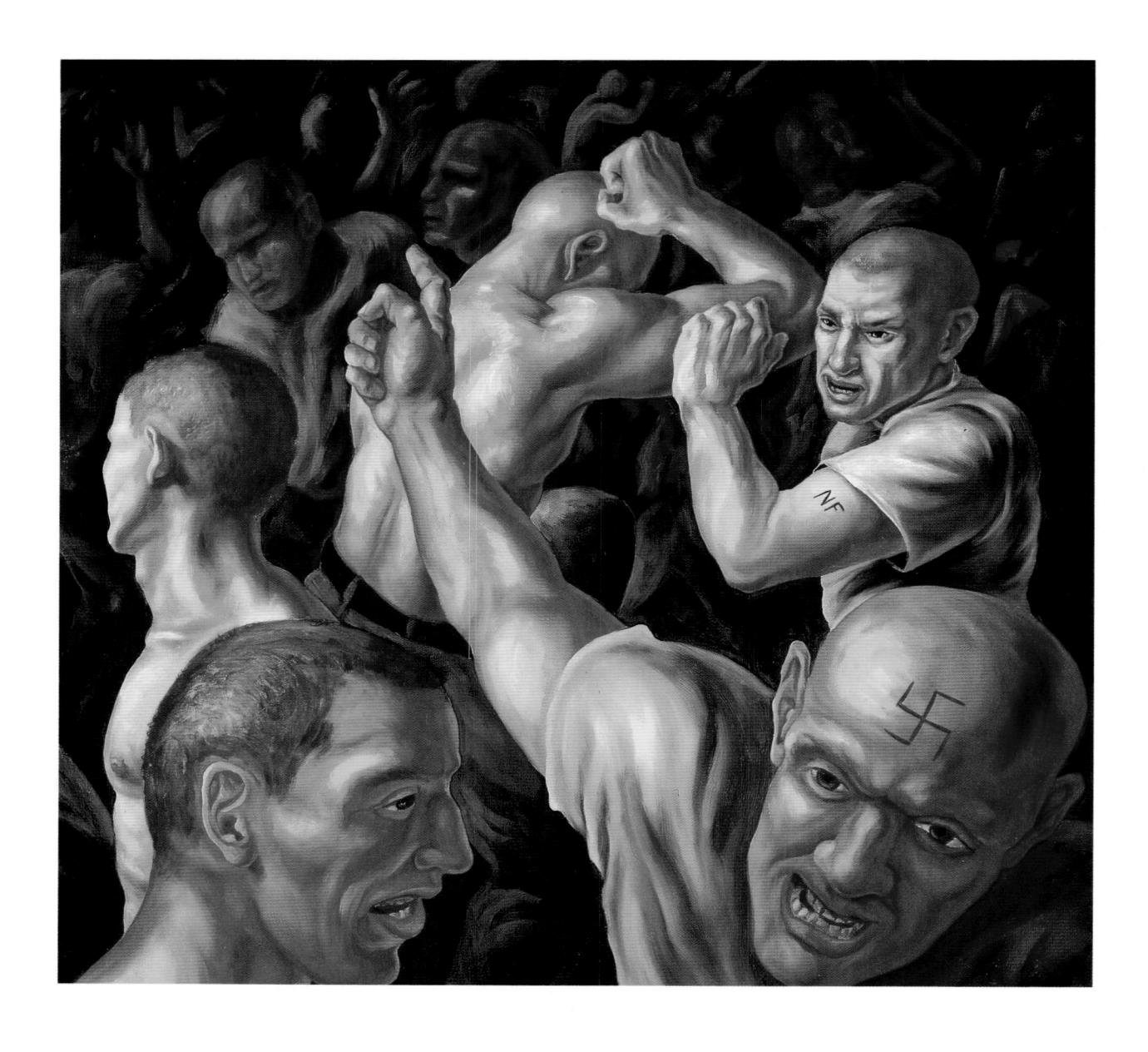

Owen Smith

Art Director) Fred Woodward

Publisher) Straight Arrow Publishers, Inc.

this illustration ran with

Publication) Rolling Stone Date) September 17, 1992

Medium) Graphite and gouache Appearing on the Contents page, the illustration ran with the heading "The Bush Years, Supreme Cruelty."

Sue Coe

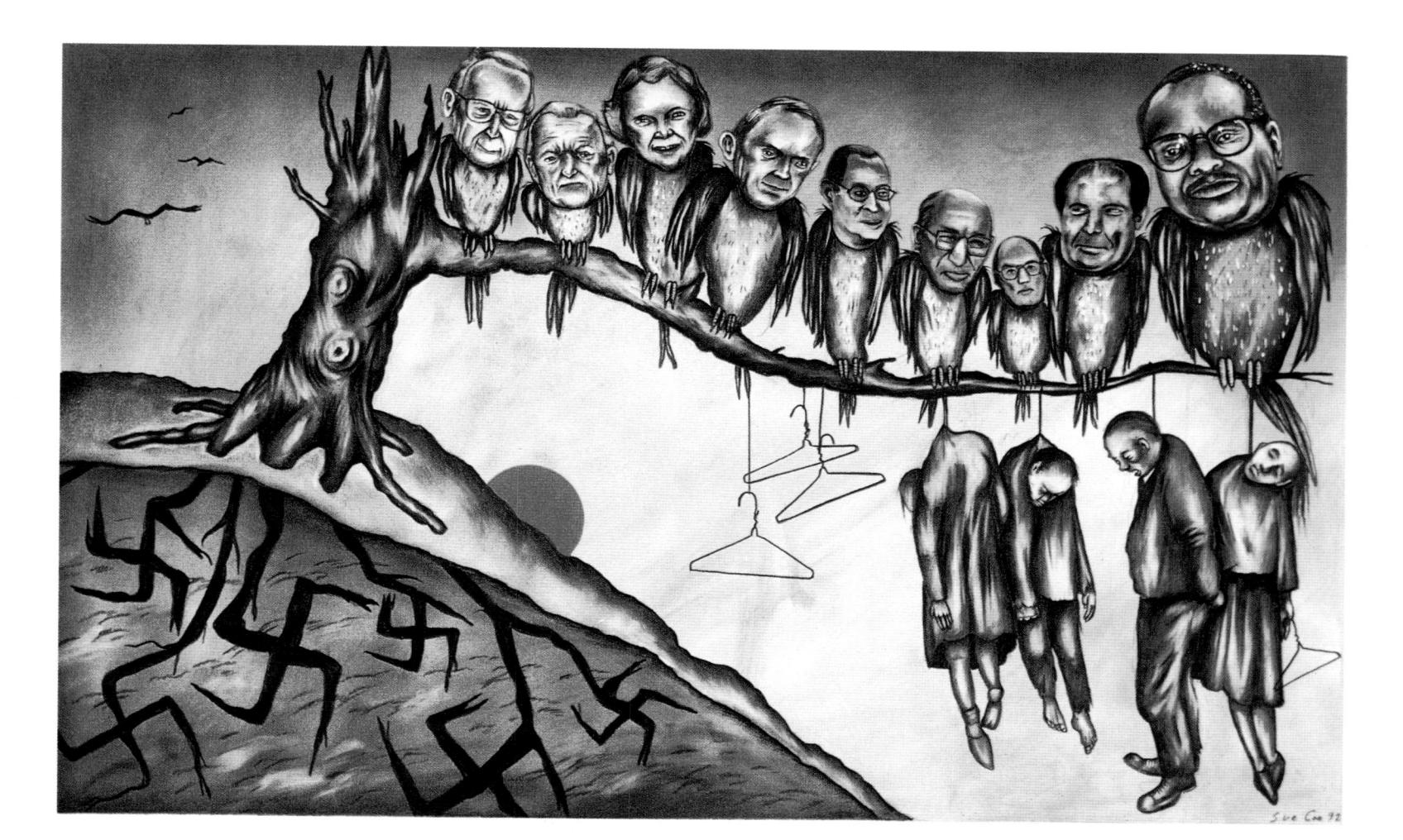

Art Director) Fred Woodward Publication) Rolling Stone Date) September 3, 1992

Publisher) Straight Arrow Publishers, Inc. Medium) Graphite and gouache "The Bush Years, The Environmental President" was the heading for this illustration, appearing on the Contents page.

Sue Coe

32

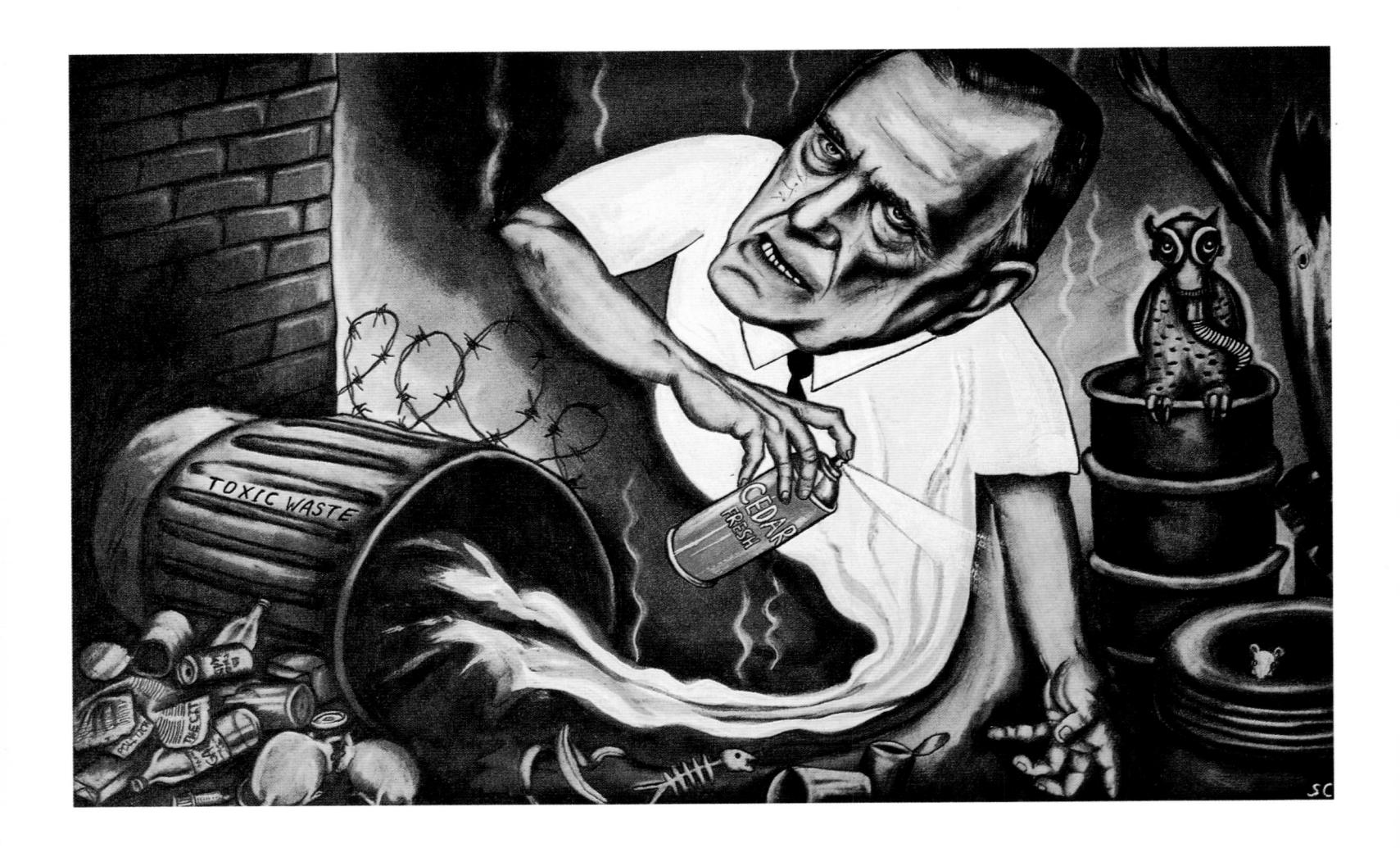

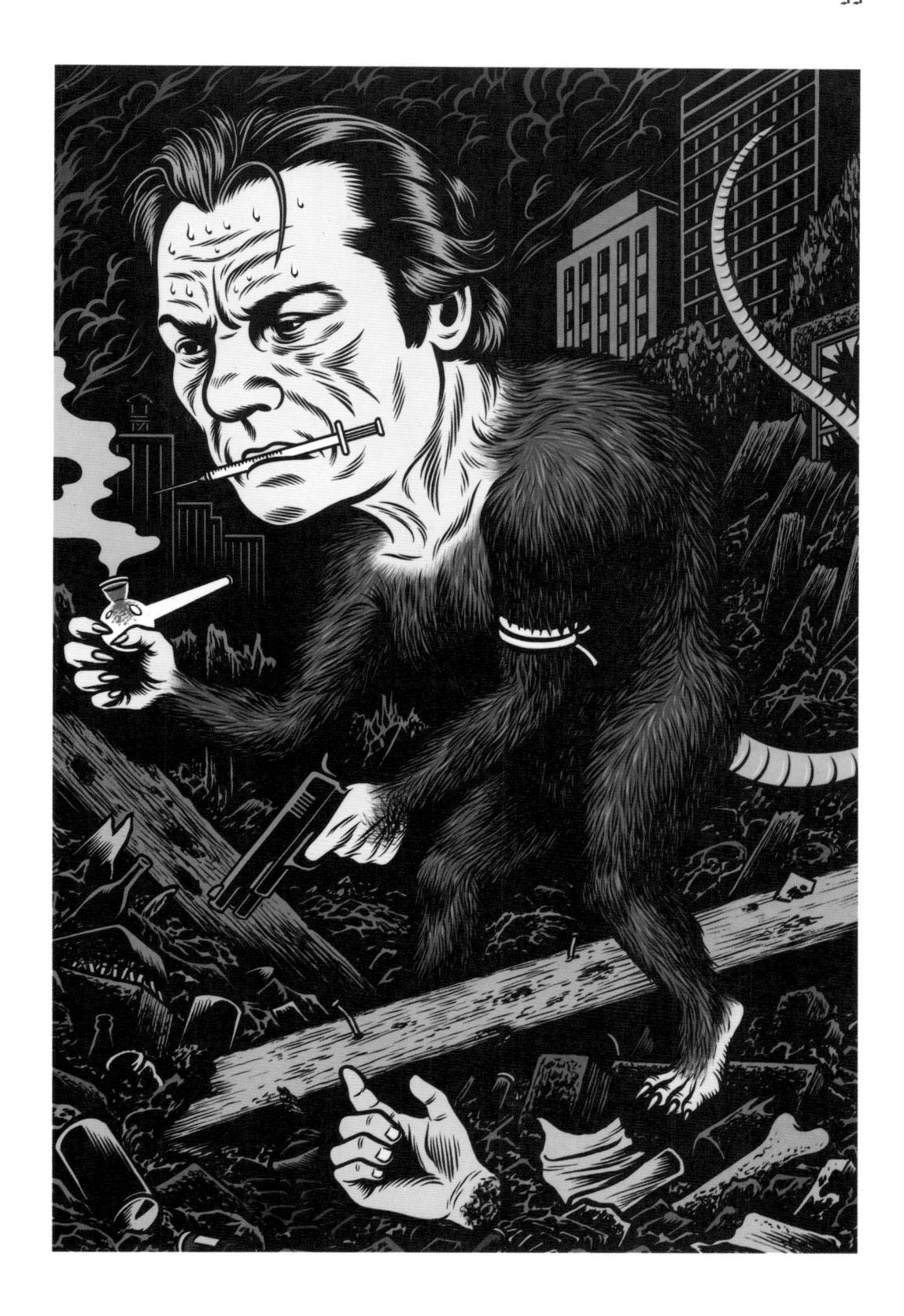

Charles Burns

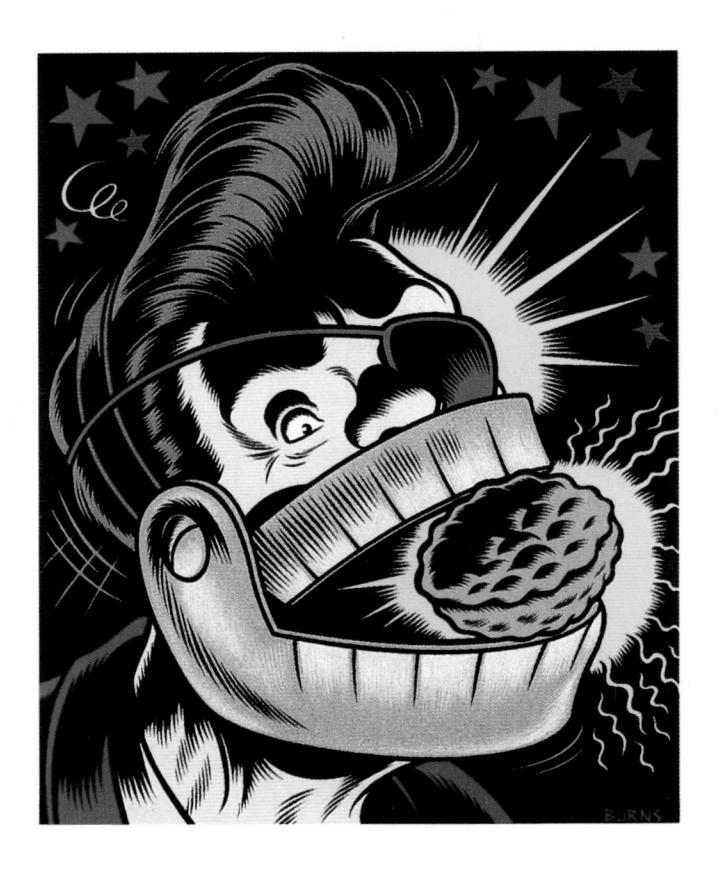

Charles Burns

Art Director) Chris Curry Editor) Tina Brown Publication) The New Yorker

Date) December 14, 1992 Publisher) Condé Nast Publications, Inc. Medium) Pantone paper and ink

This illustration was found in the "Night Life" section of The New Yorker (above).
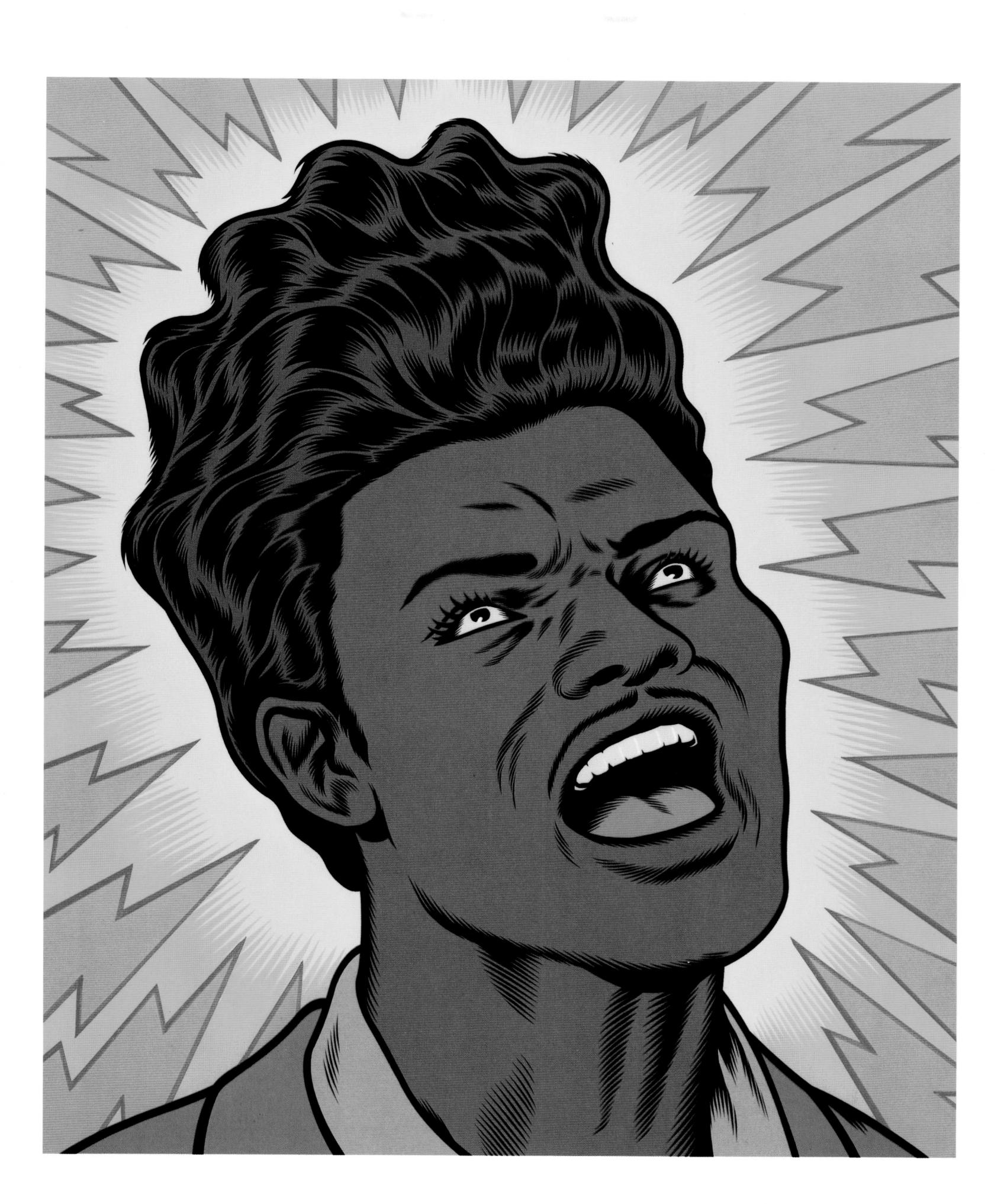

Charles Burns

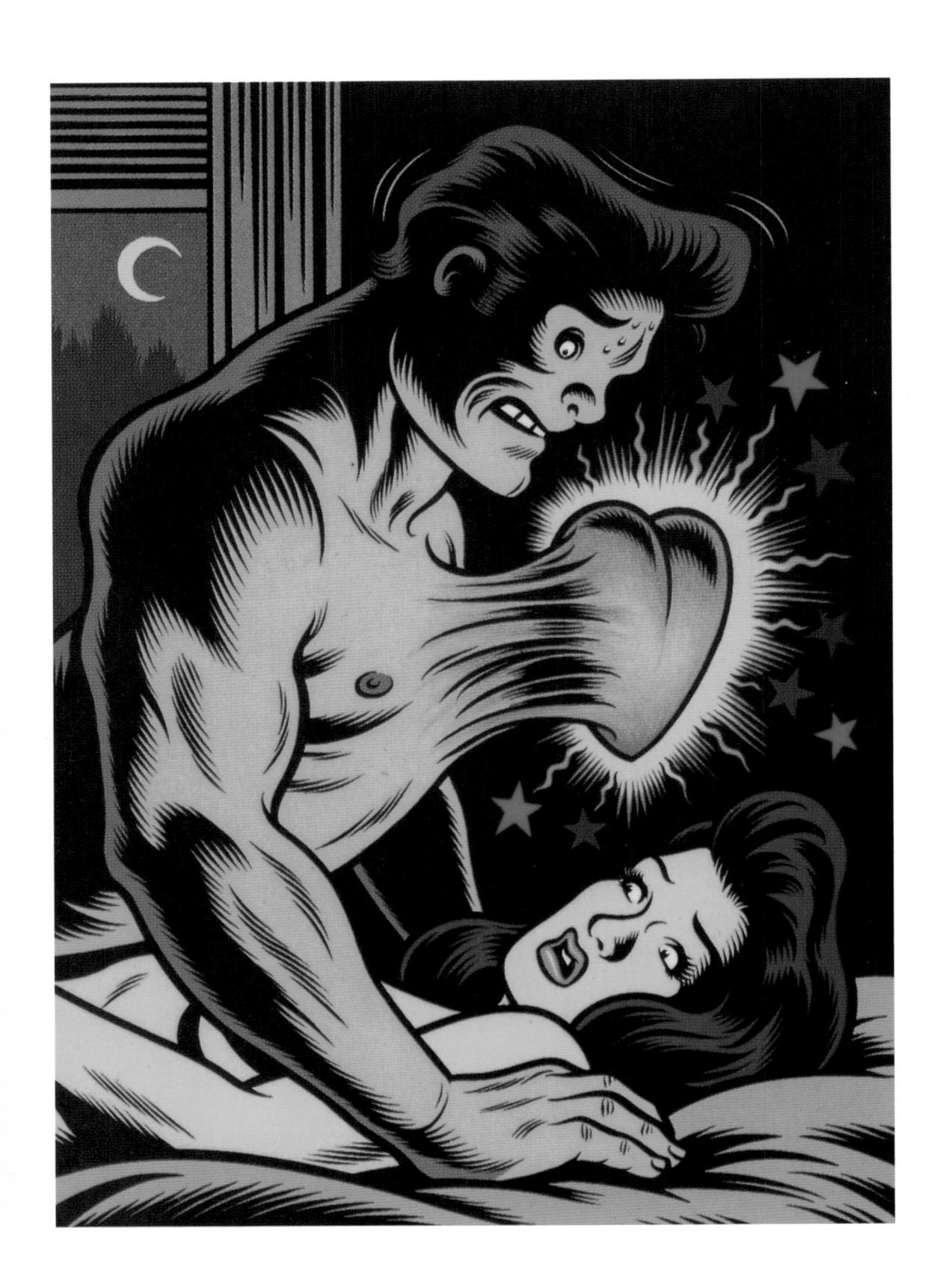

37

Gary Baseman

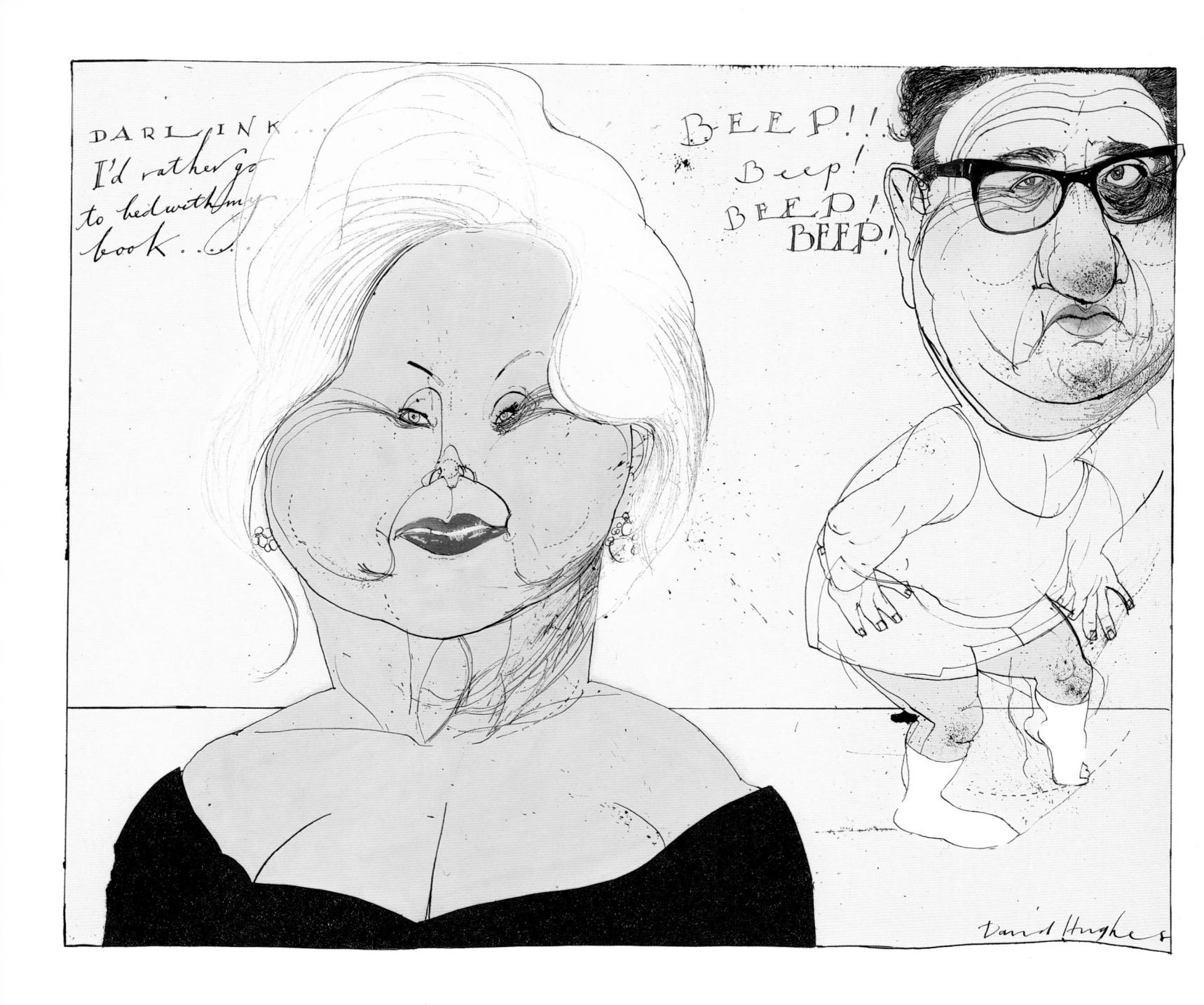

38

David Hughes

Robert Risko

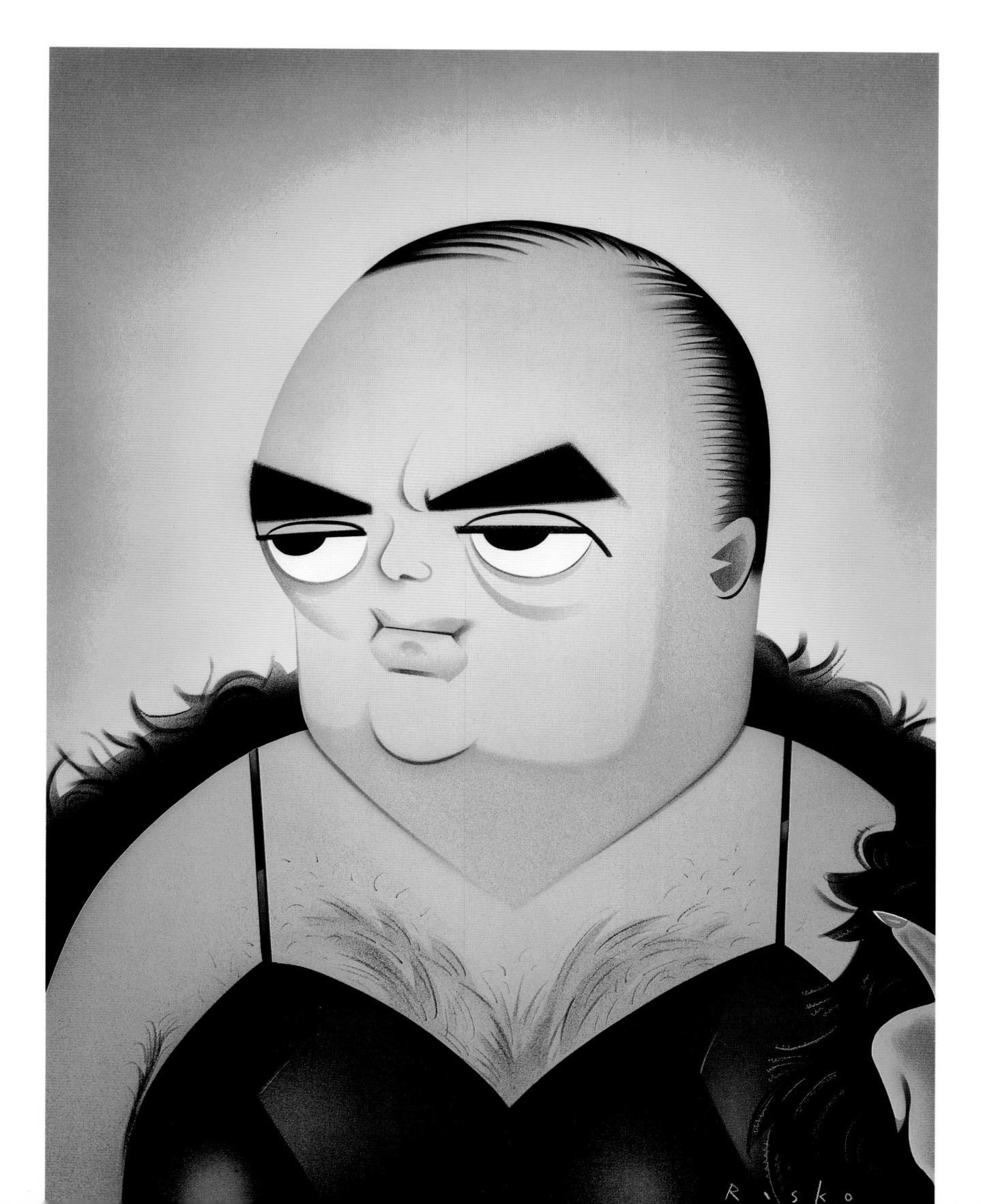

39

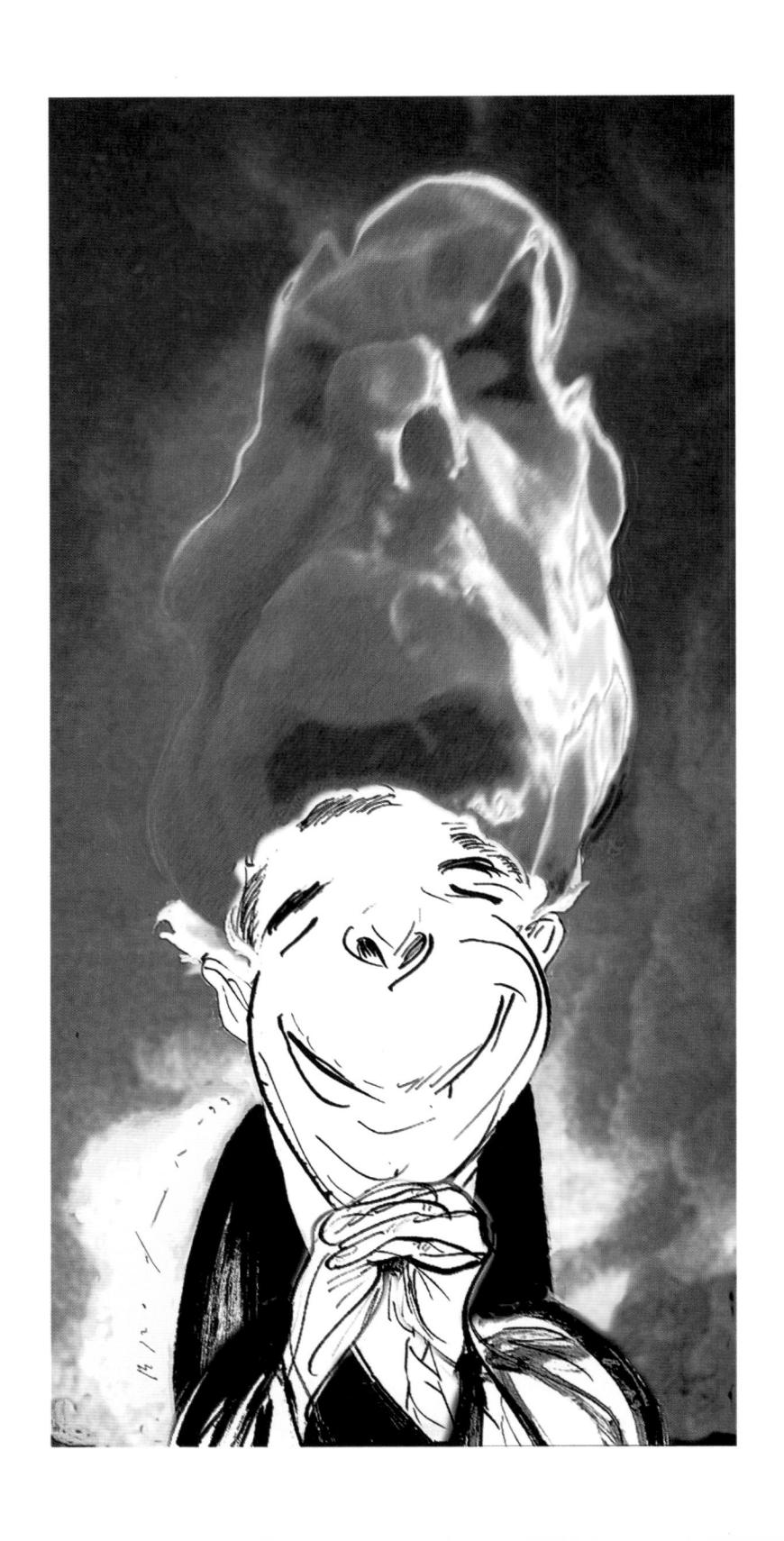

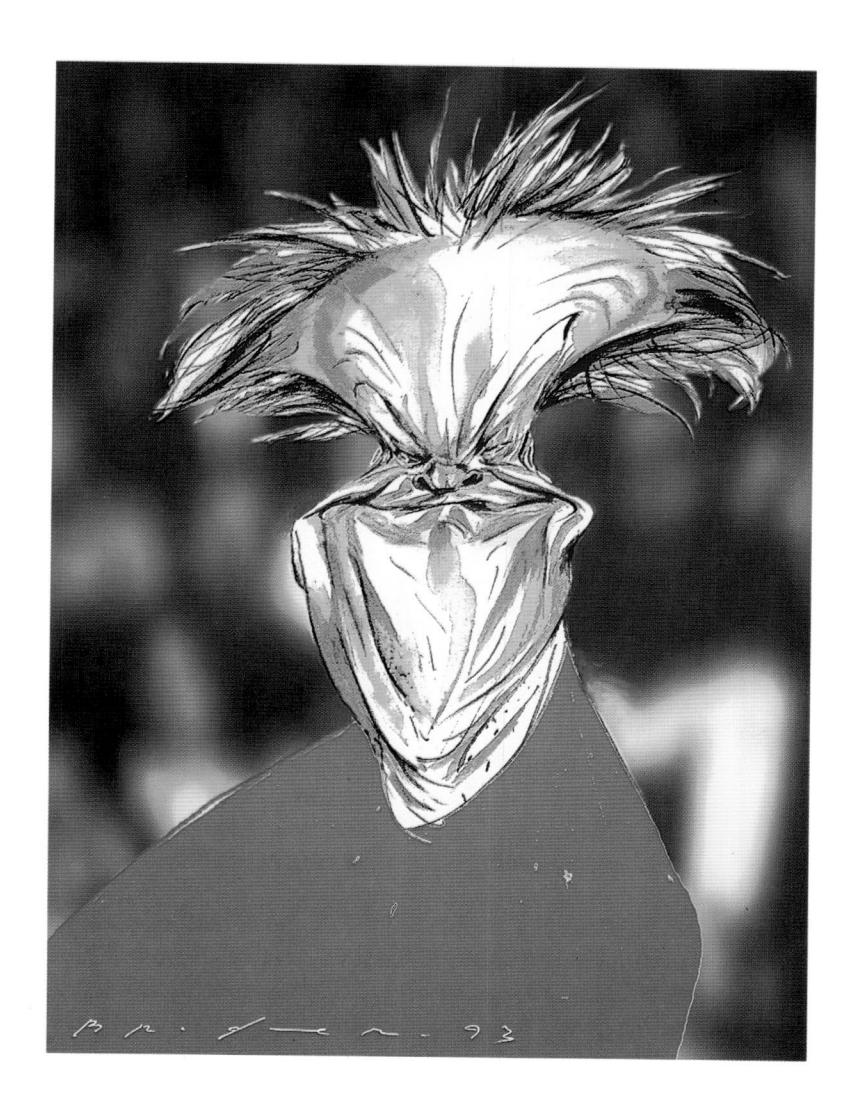

Steve Brodner

Art Director) Pamela Berry Publication) US Magazine Date) March 1993 Publisher) Straight Arrow Publishers, Inc. Medium) Mixed media using computer The caricature of Jack Nicholson highlights the actor's features (above).

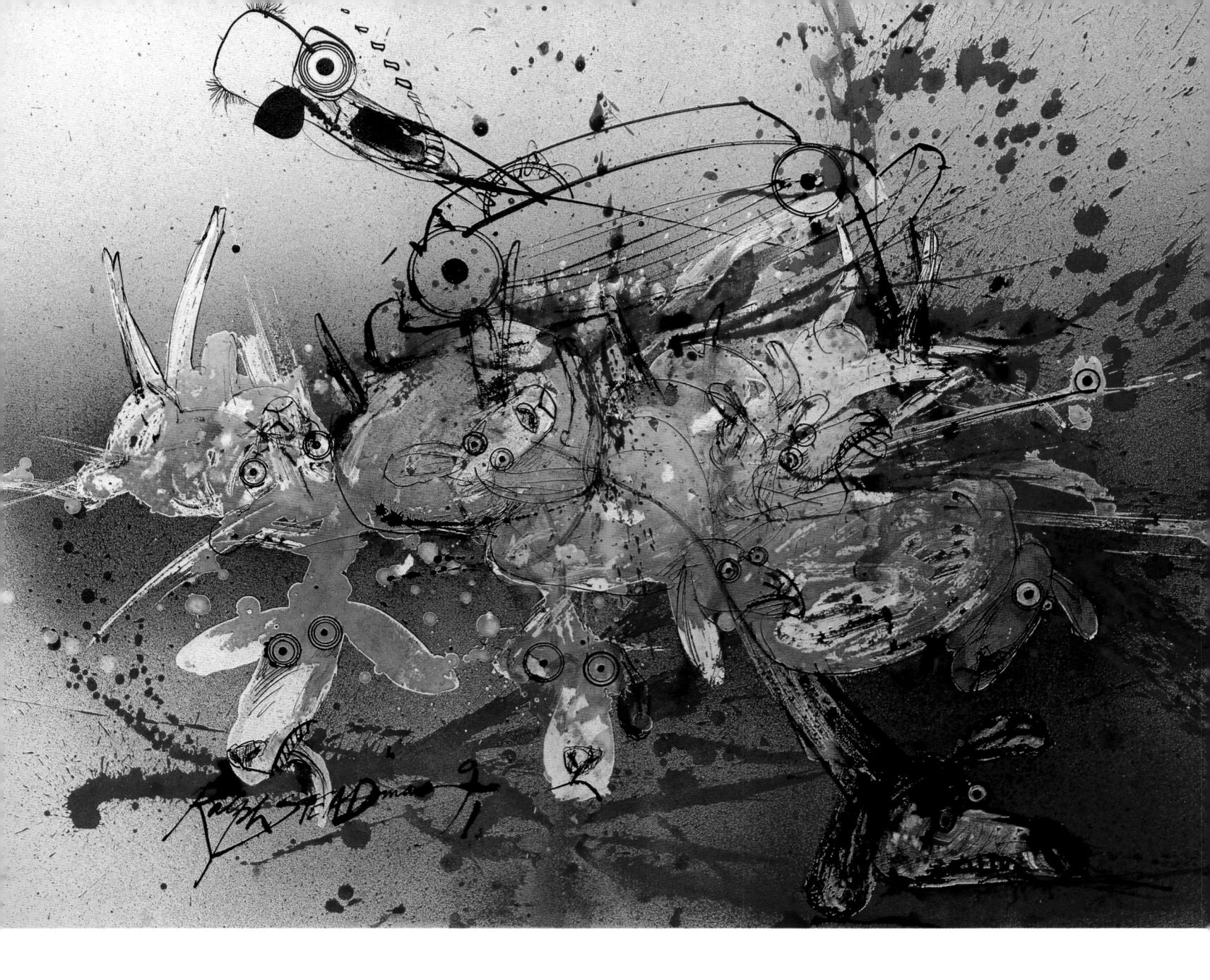

42

Ralph Steadman

Art Director) Lisa Powers Editor) Kenneth Auchincloss Writers) Steven Strasser, Bill Powell, Peter McKillop,
Frank Gibney Jr., George Wehrfritz Publication) Newsweek International Date) December 21, 1992 Publisher) The Washington Post Company
Medium) Linoleum cut The quest for democracy in Asia is represented in this illustration for the article "People Power."

Frances Jetter

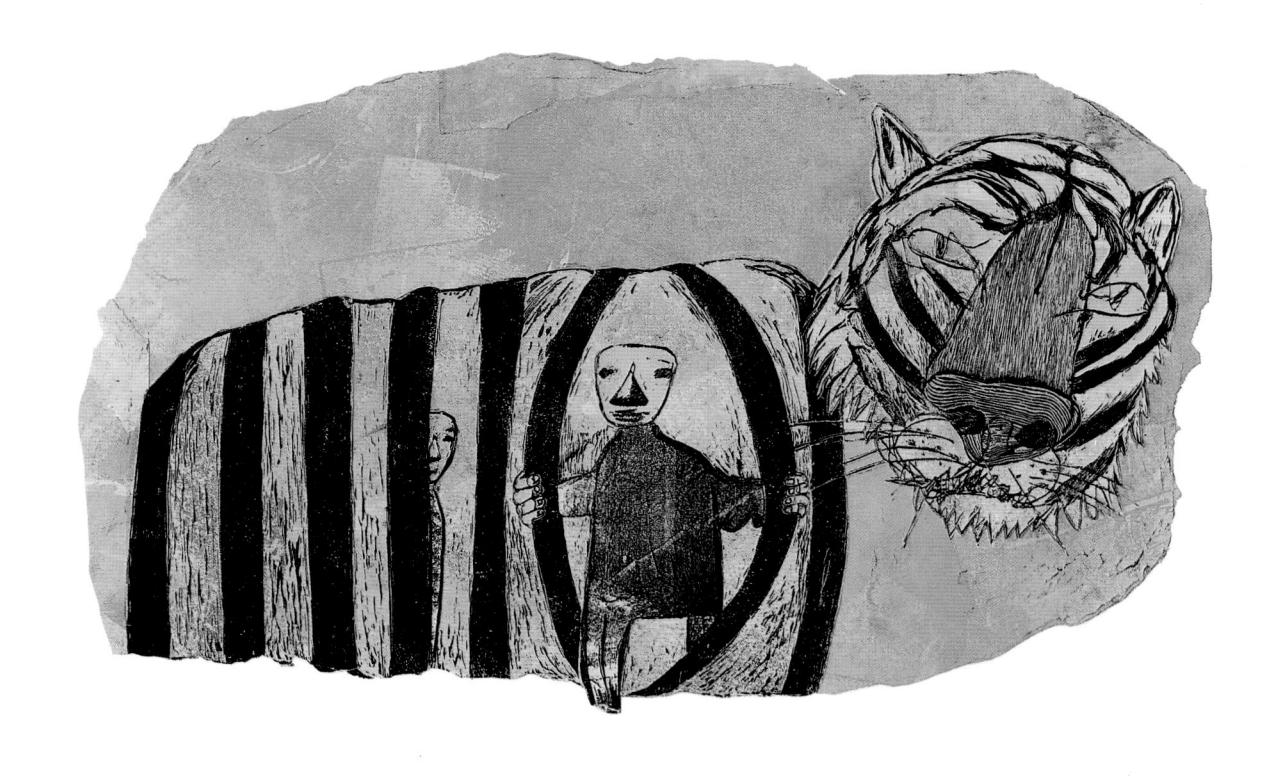

Blair Drawson

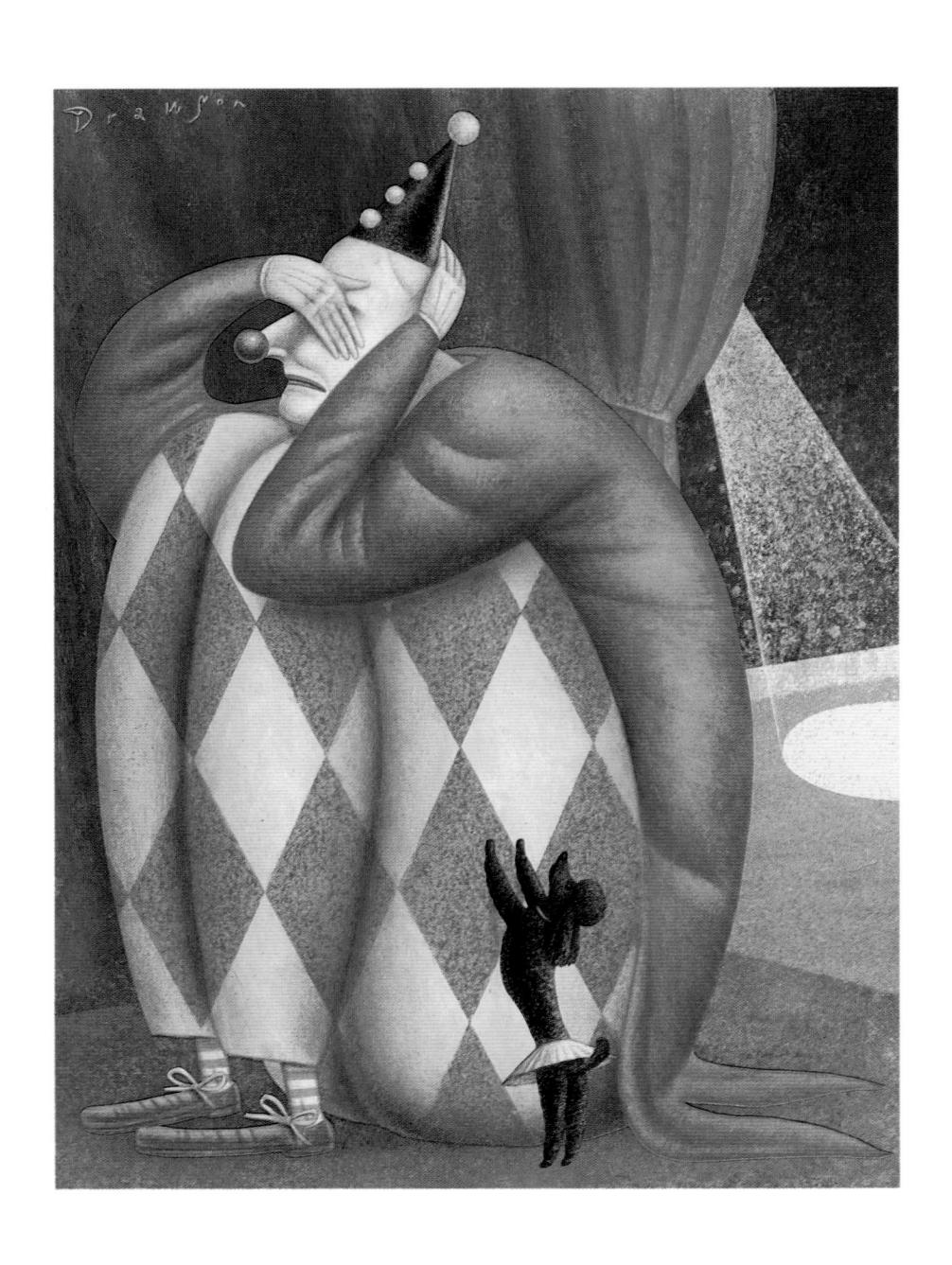

Wiktor Sadowski

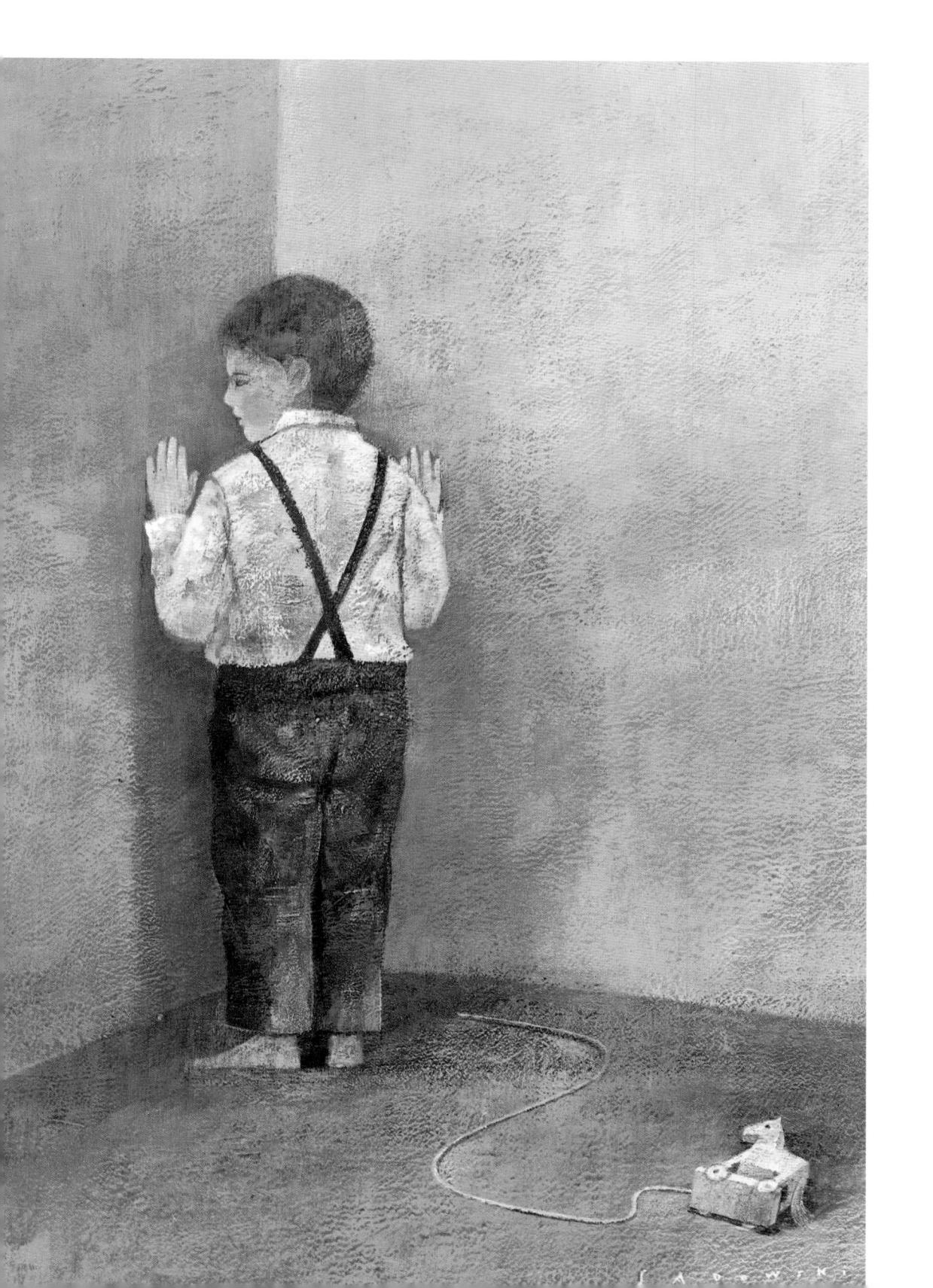

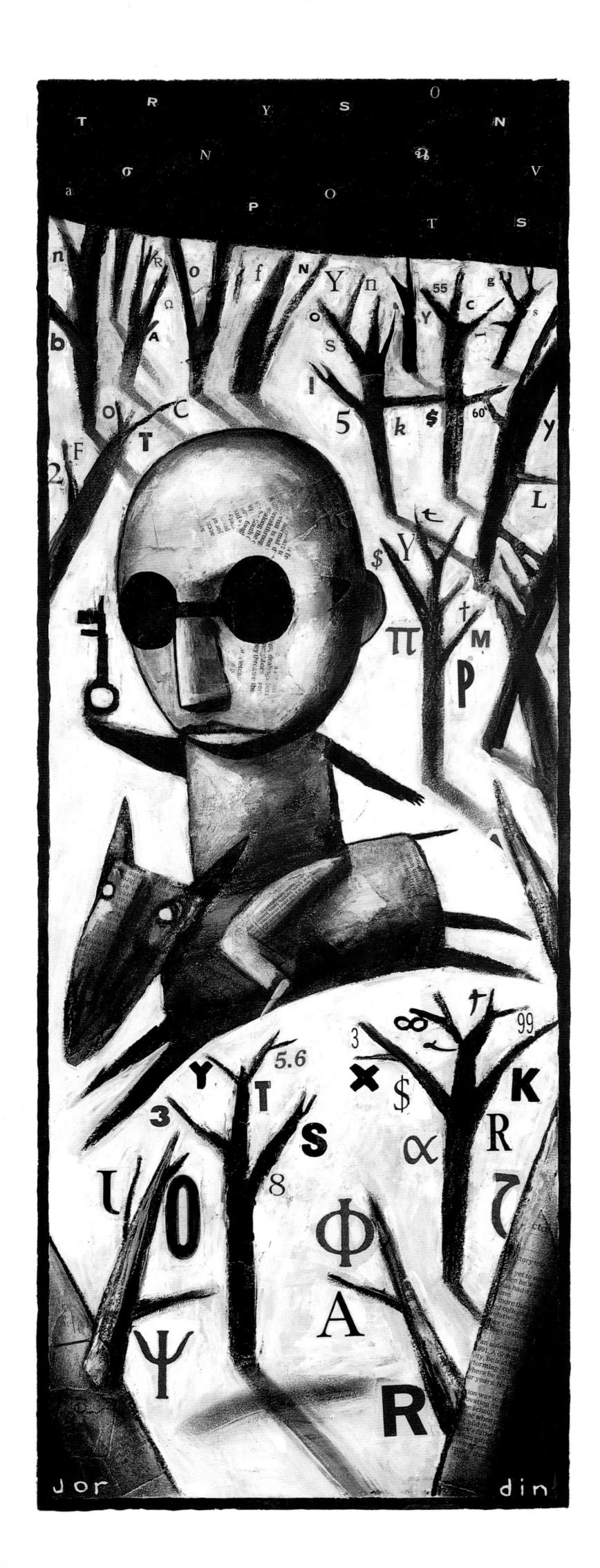

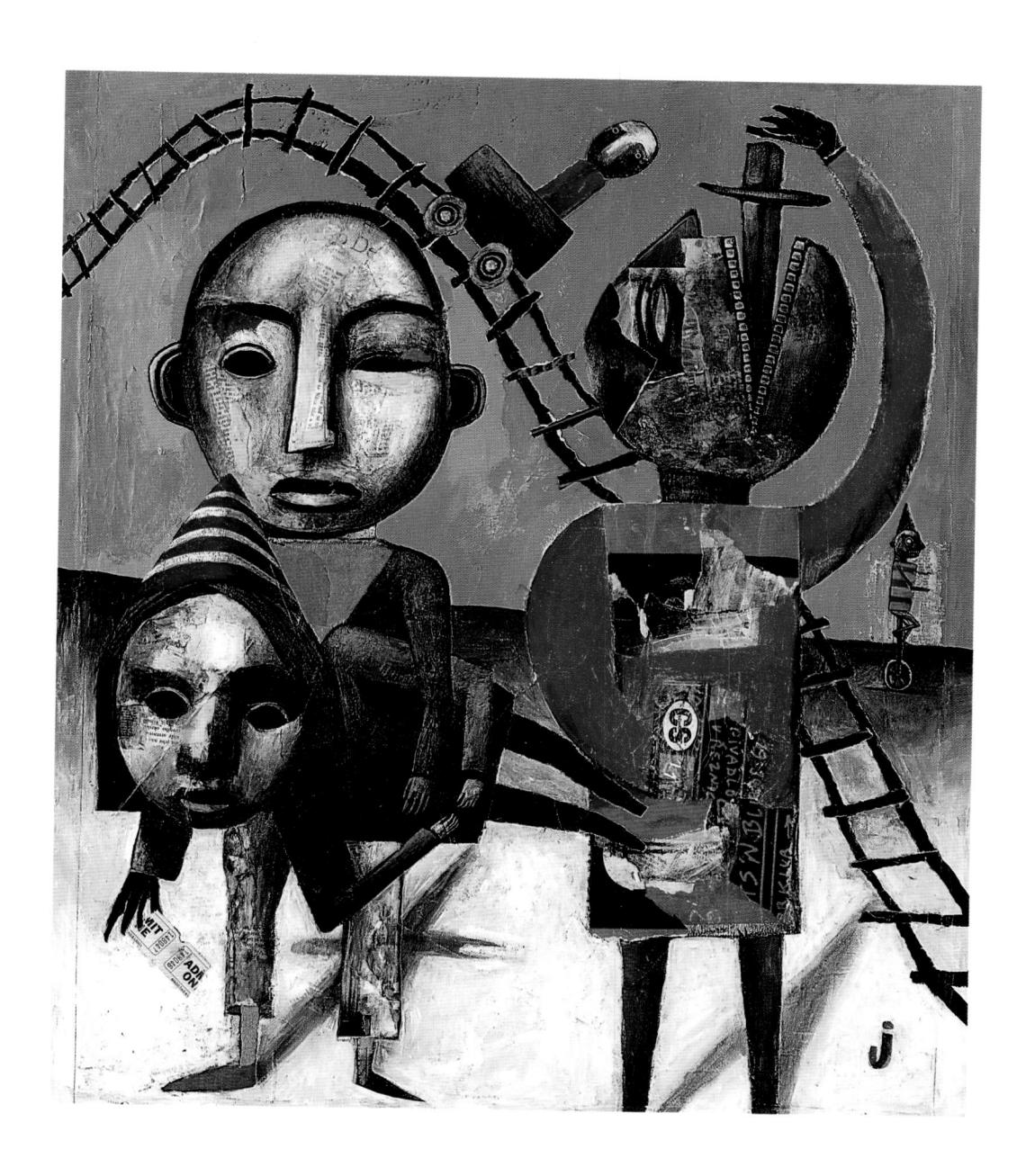

Jordin Isip

Art Director) David Carson Editor) Marvin Scott Jarrett Publication) Ray Gun Date) April 1993 Publisher) Ray Gun Publishing, Inc. Medium) Mixed media An interpretation of the song "Breadcrumb Trail" by the Slint band for the feature "Sound in Print" (above).

Art Director) Laura N. Frank Editor) Earl W. Foell Writer) Zbigniew Brzezinski

Publication) World Monitor Magazine Date) March 1993 Publisher) The Christian Science Publishing Society

Medium) Mixed media This illustration accompanied the article entitled "Power and Morality."

Jordin Isip

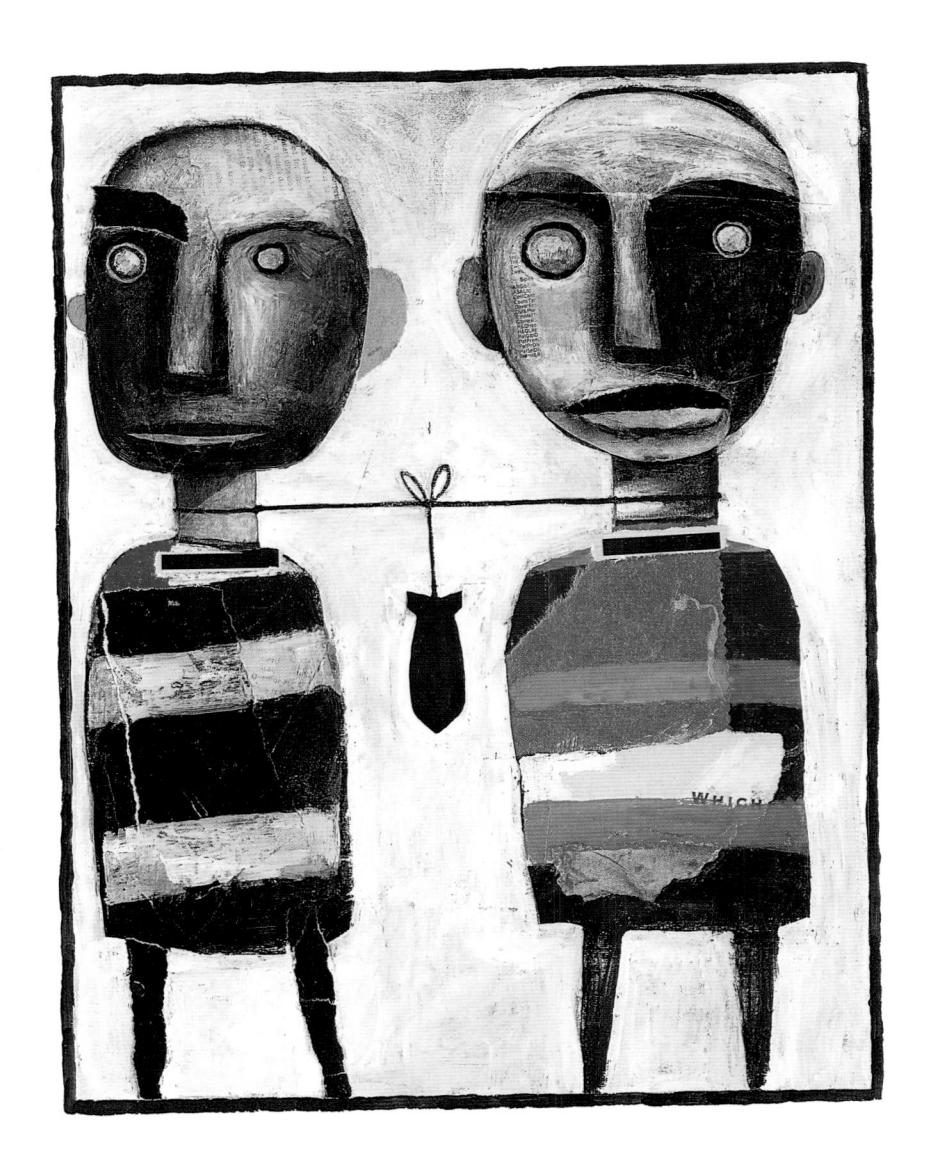

48/49

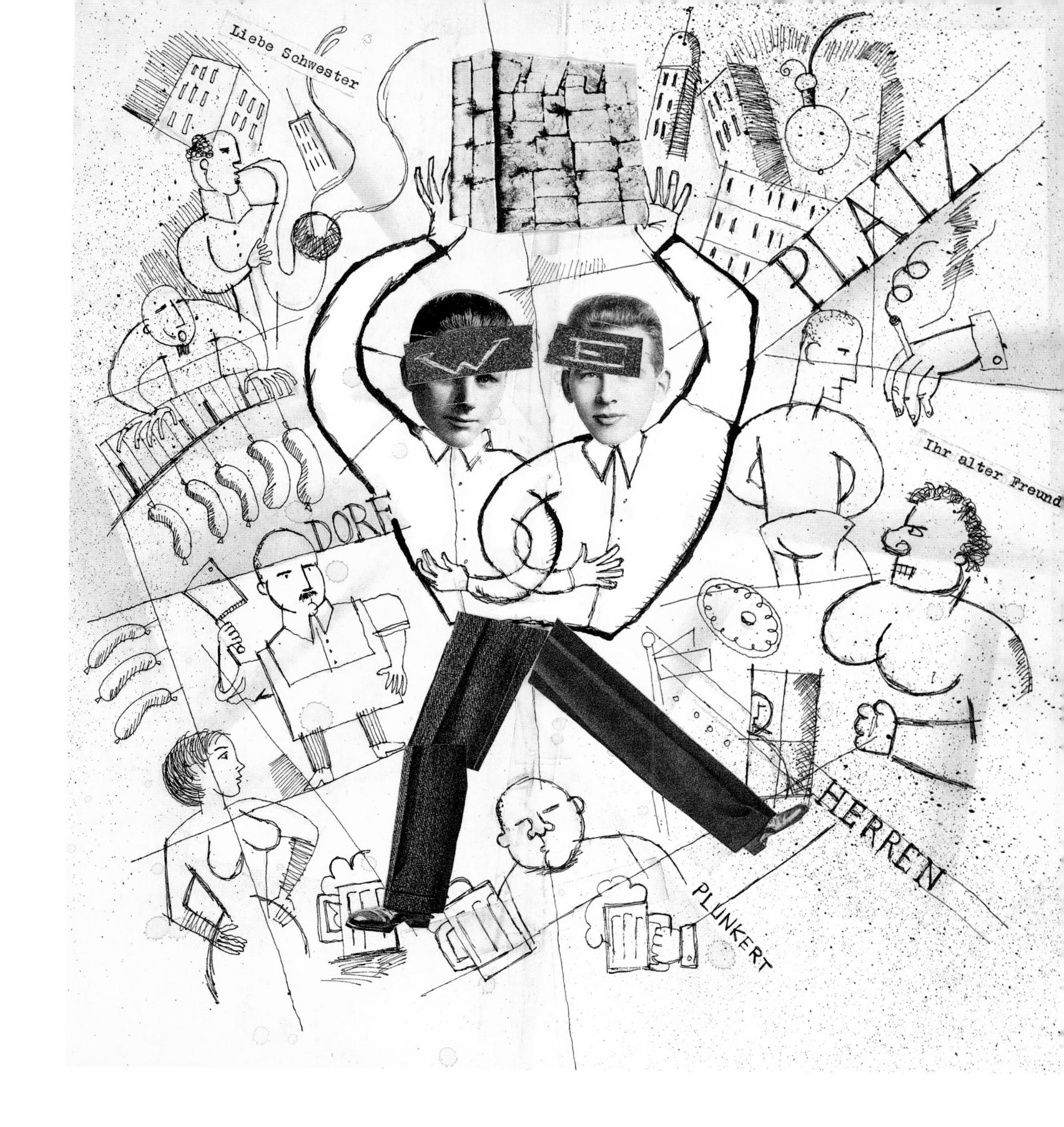

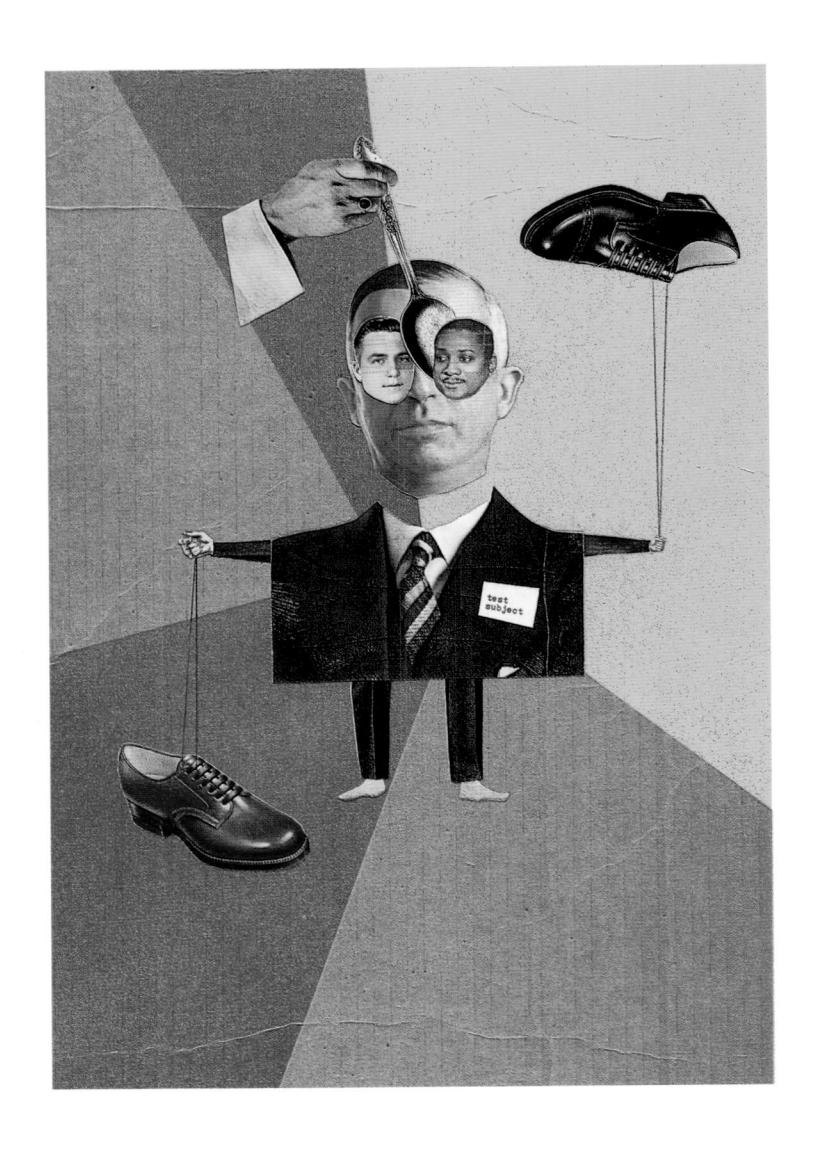

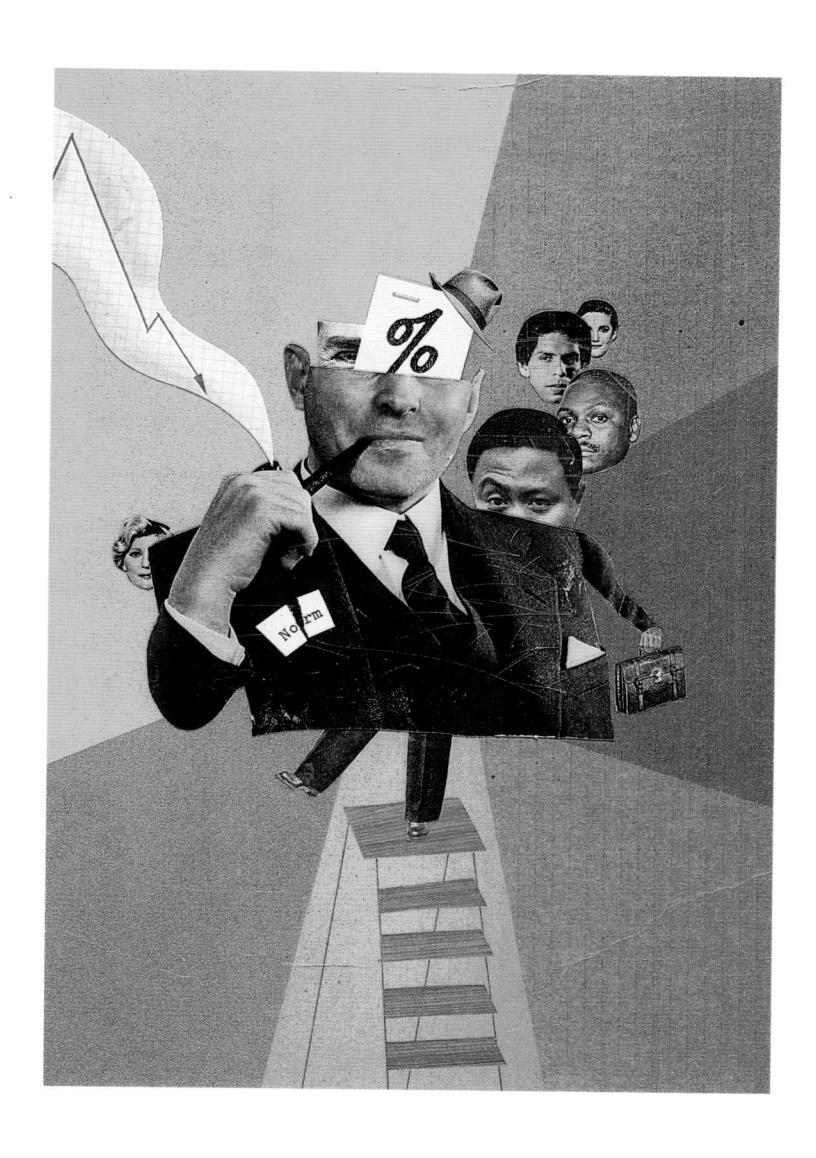

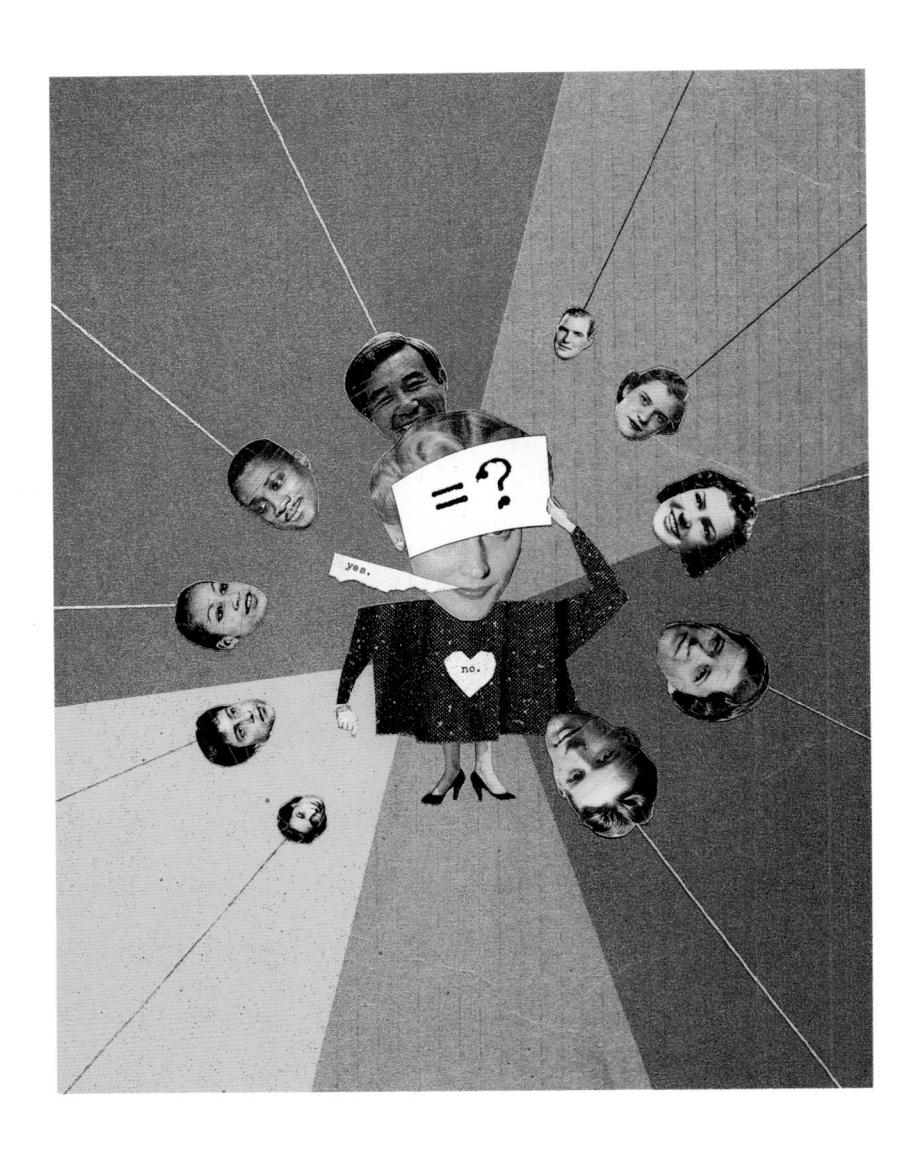

Josh Gosfield and Nola Lopez

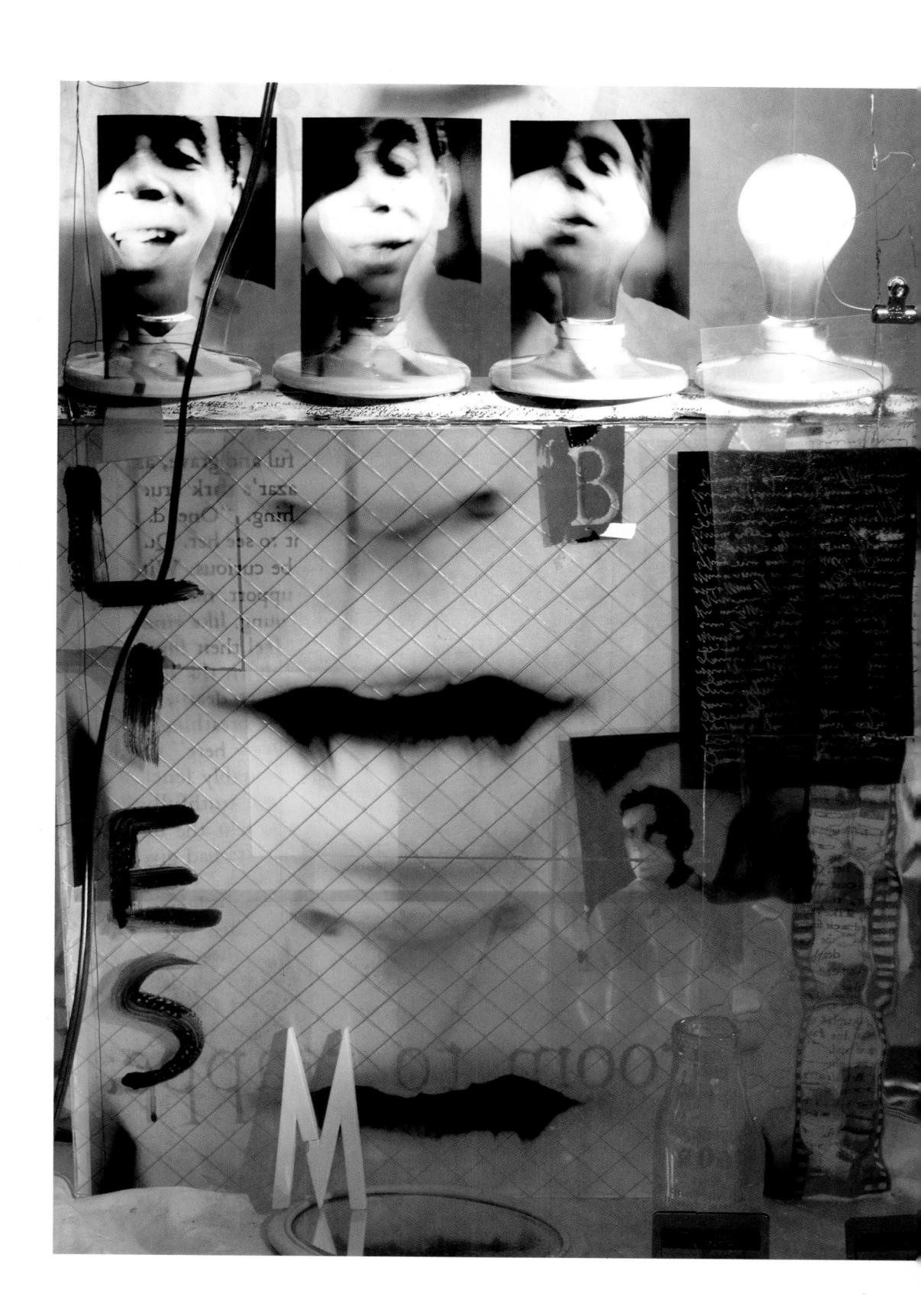

Christian Northeast

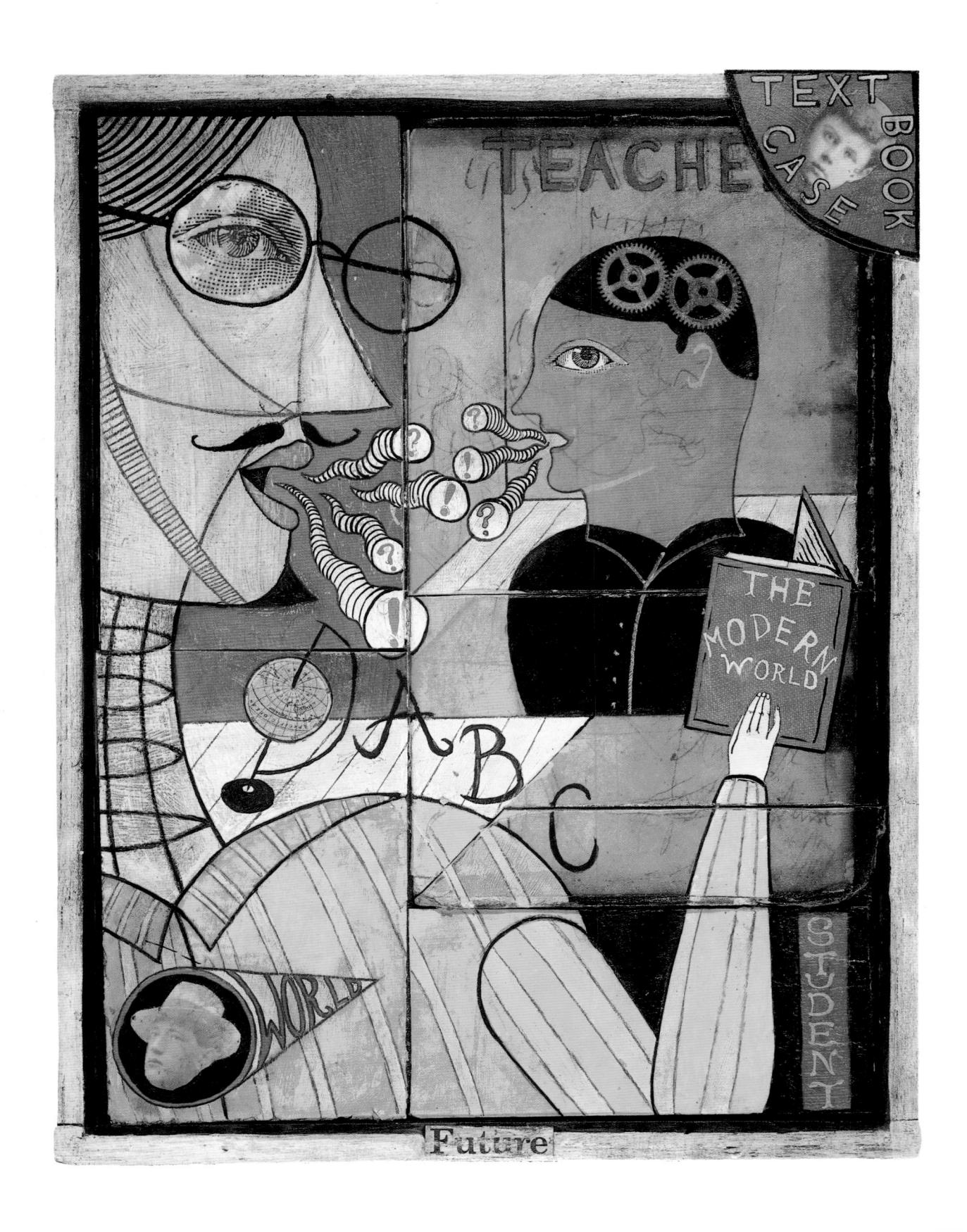

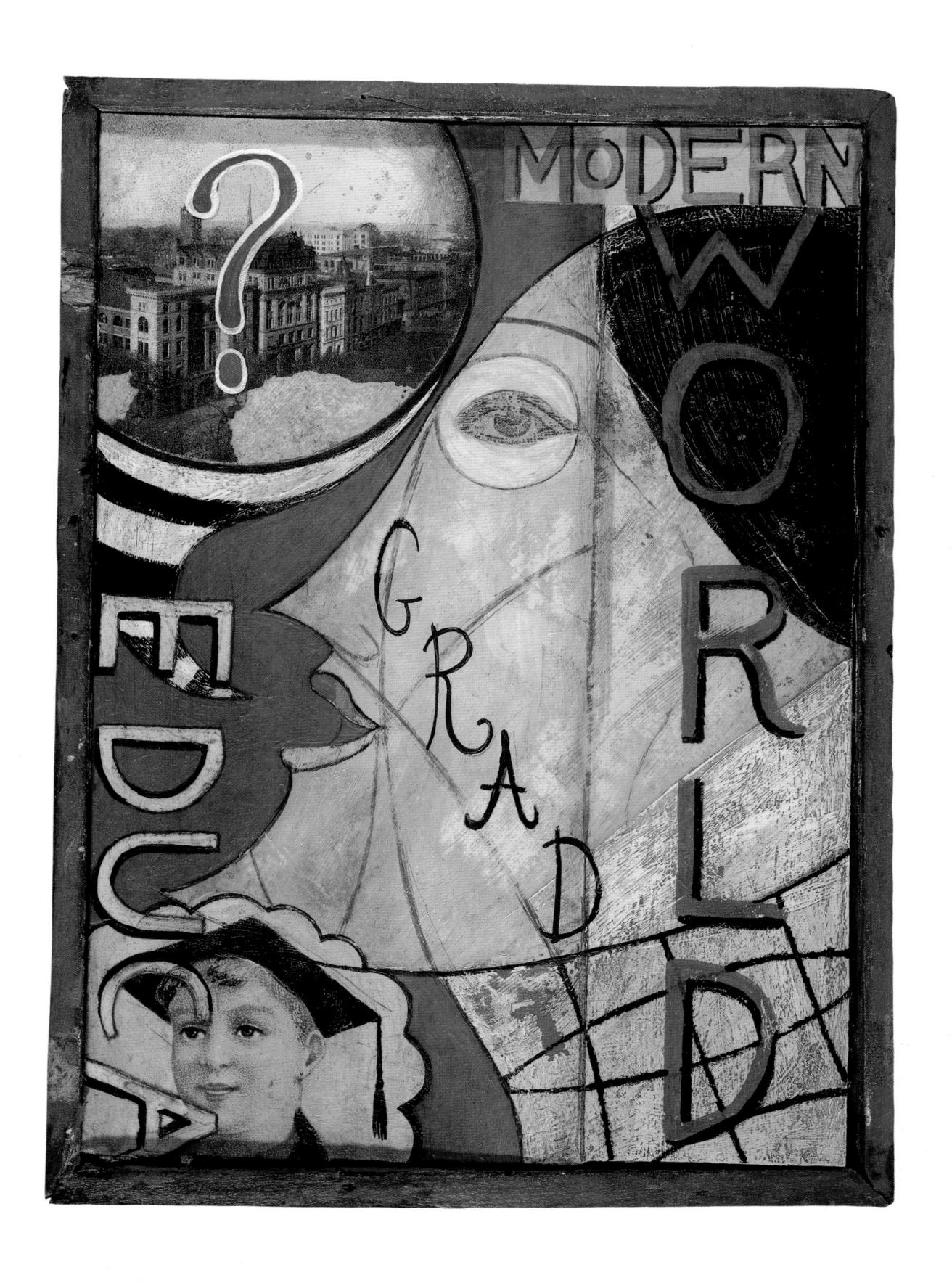

Christian Northeast

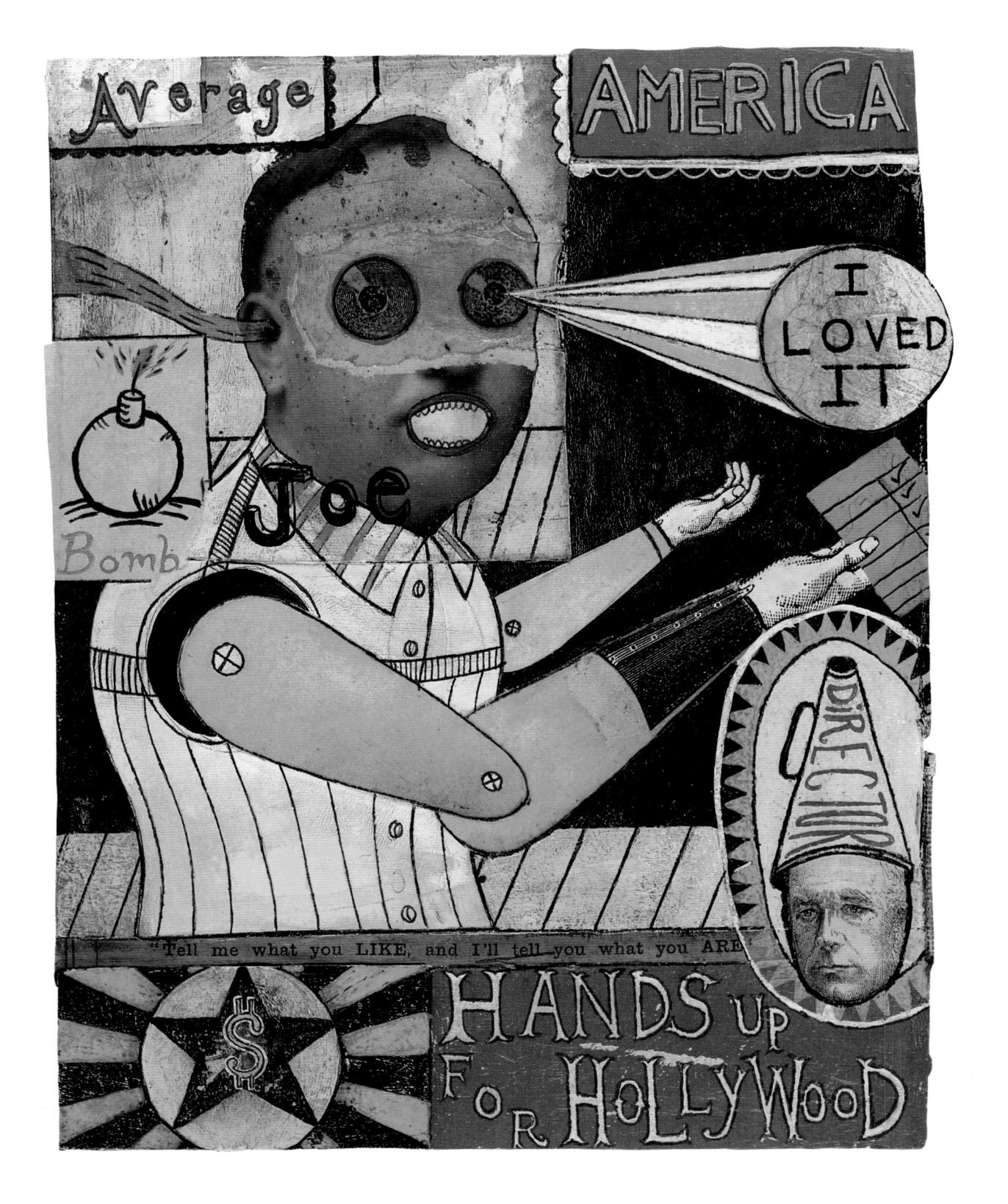

56

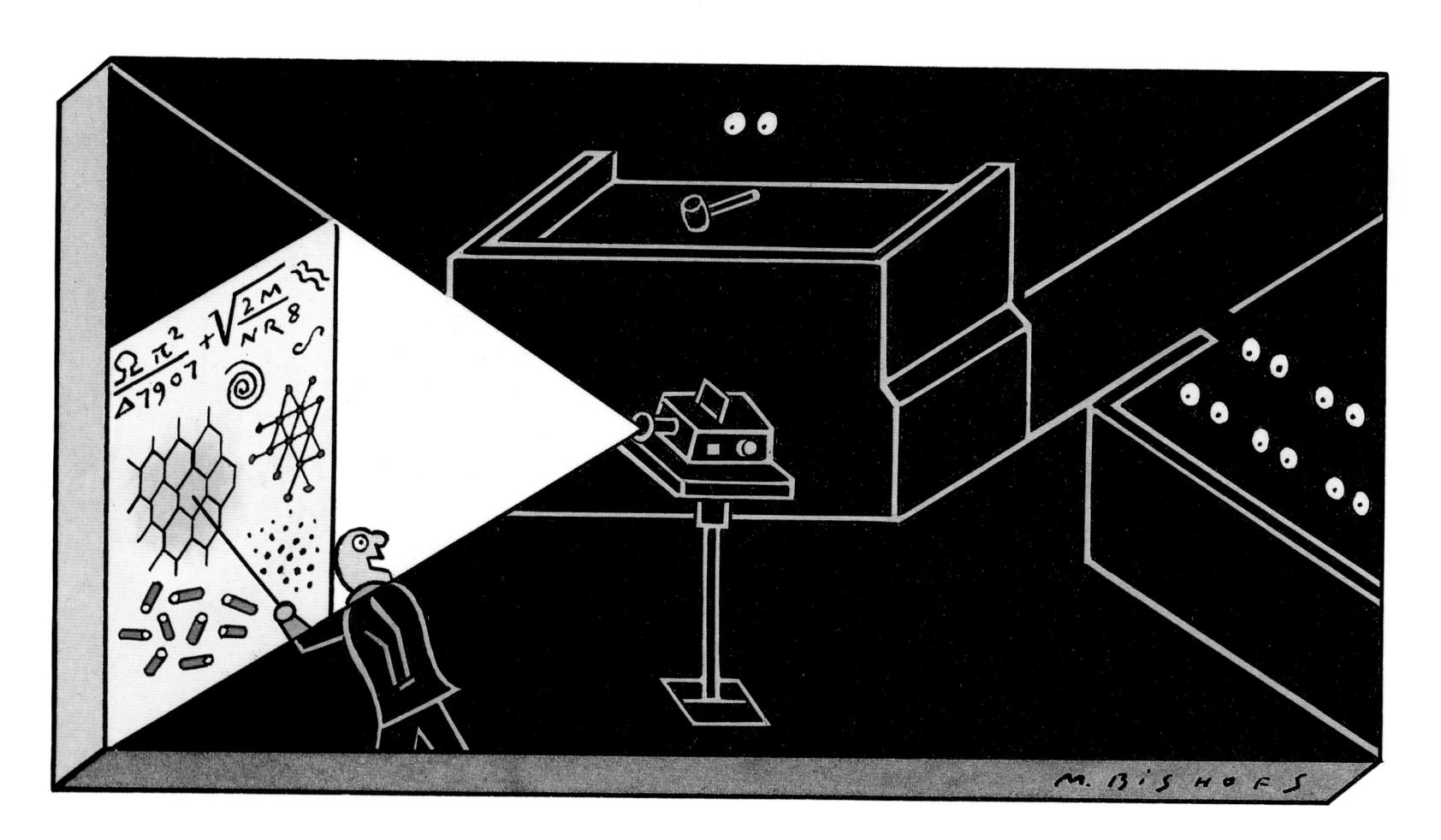

Maris Bishofs

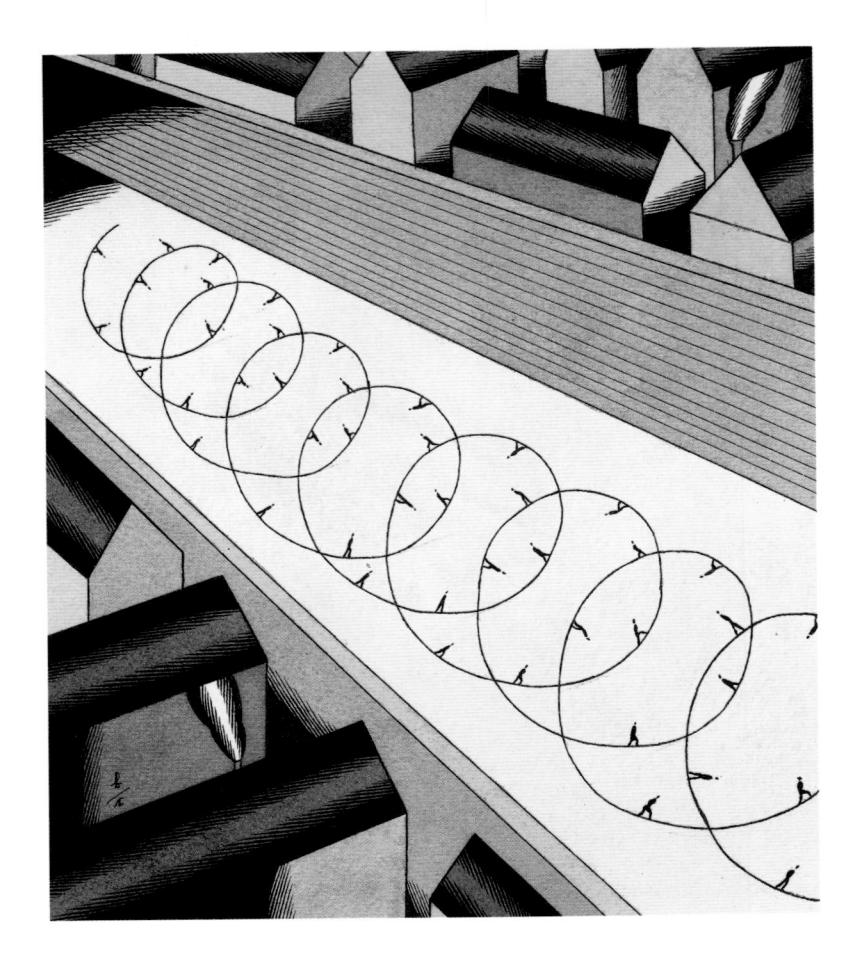

Brian Cronin

Jeffrey Fisher

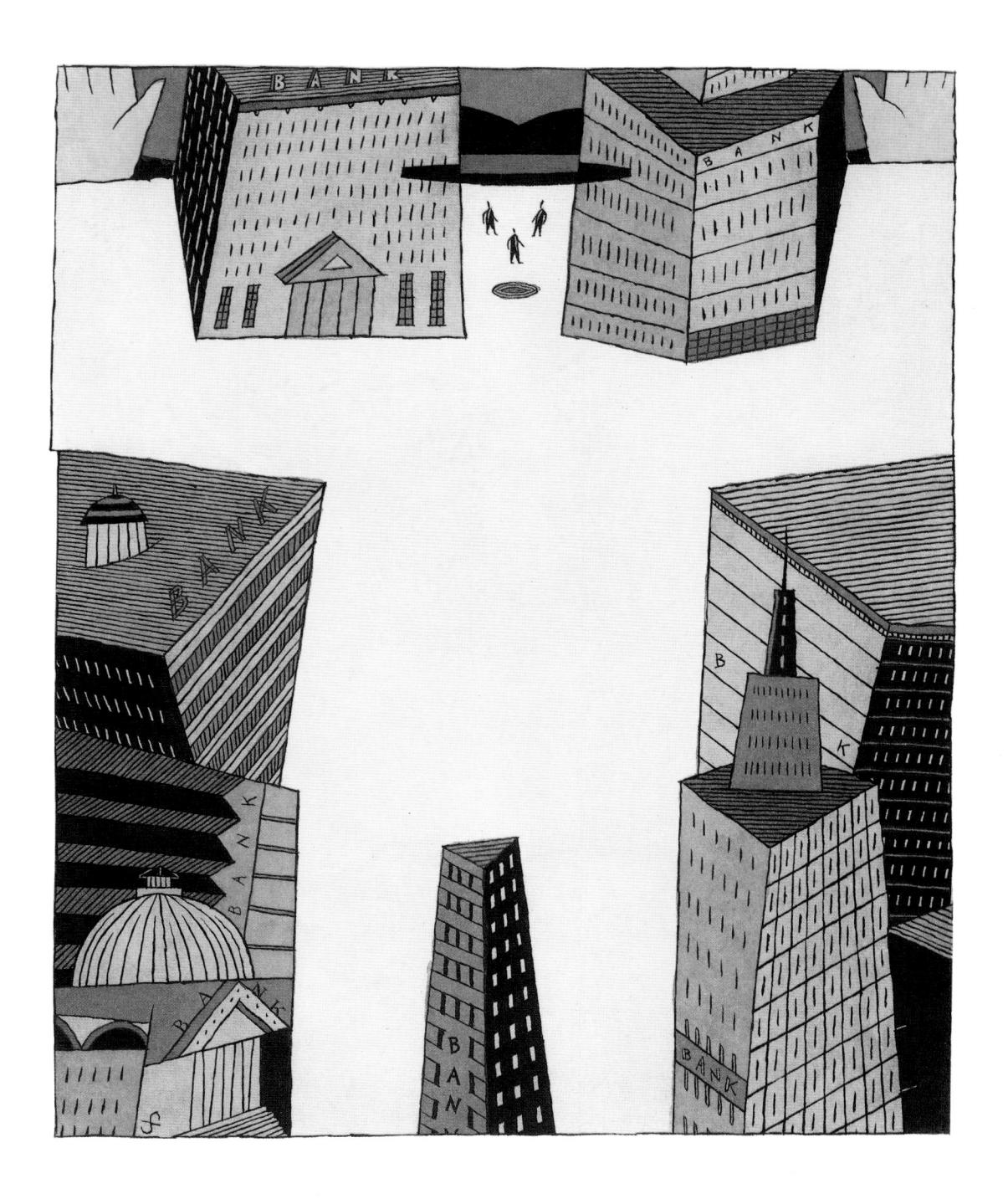

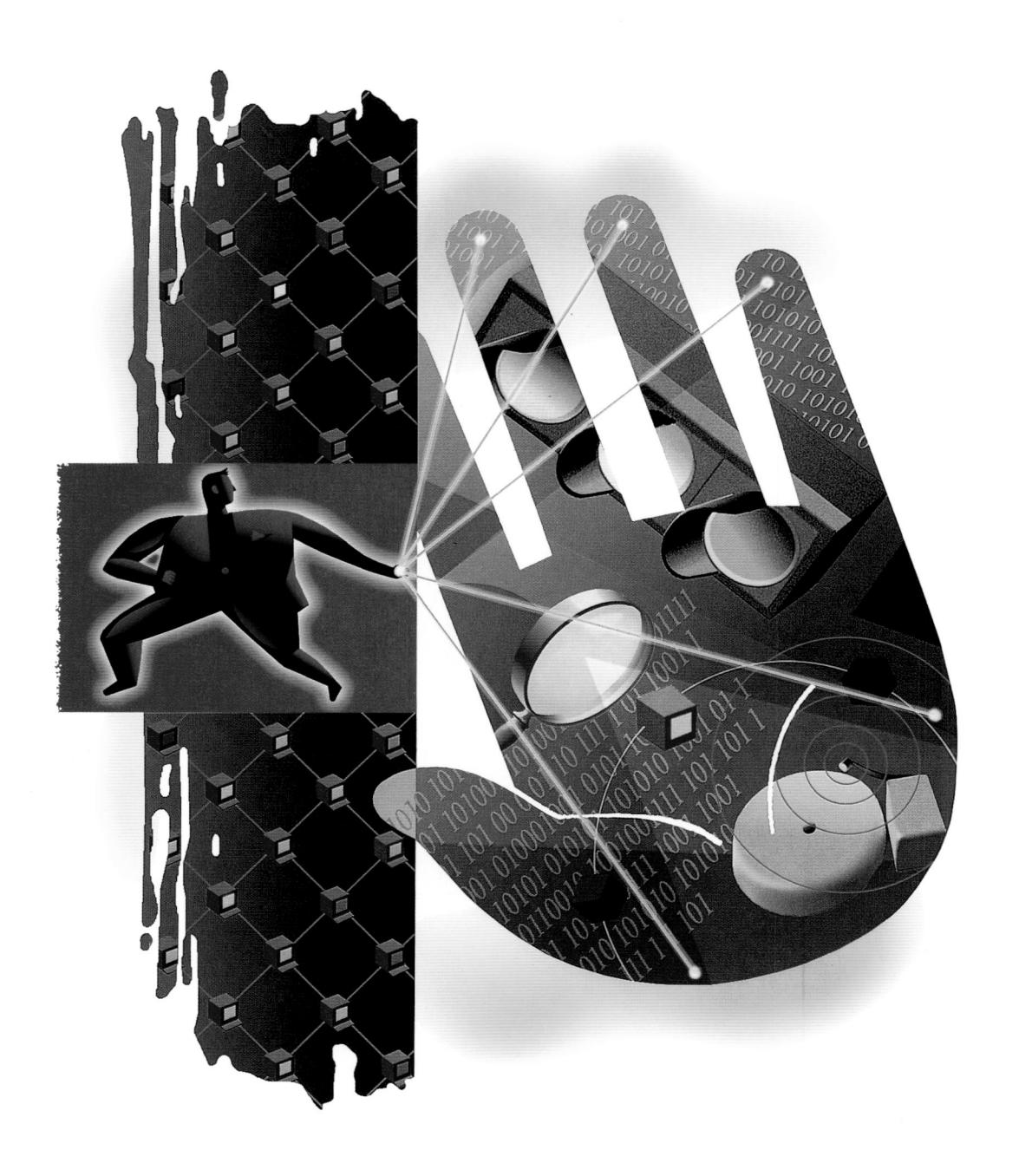

Mick Wiggins

Terry Allen

61

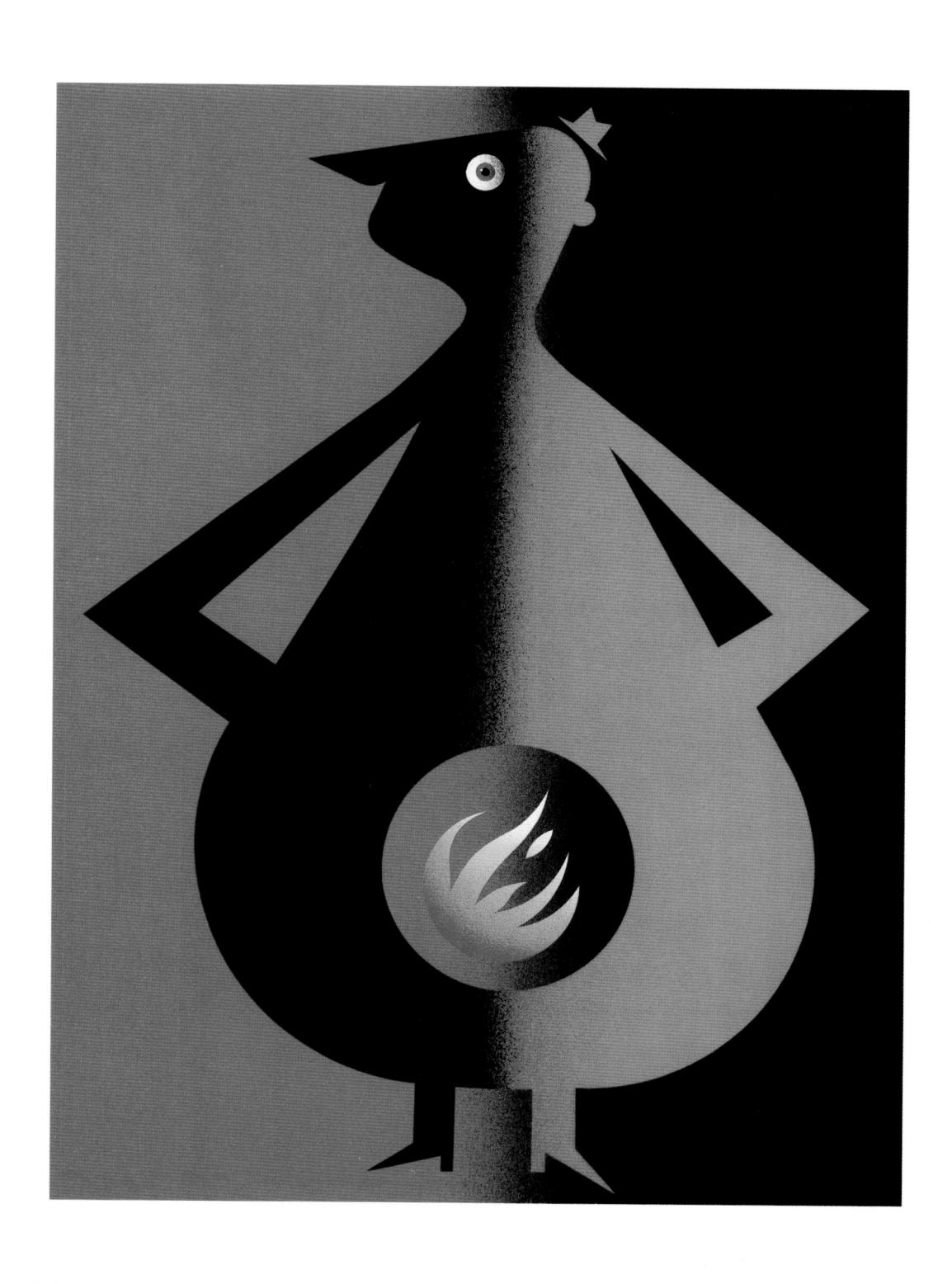

Hanoch Piven

Art Director) Chris Curry Editor) Tina Brown Publication) The New Yorker Date) March 29, 1993 Publisher) Condé Nast Publications, Inc. Medium) Gouache and sandpaper This caricature of pop singer Prince was included in the feature "Goings on About Town" (below).

00

Art Directors) Fred Woodward and Gall Anderson Writer) Peter Travers Publication) Rolling Stone
Date) February 4, 1993 Publisher) Straight Arrow Publishers, Inc. Medium) Collage
"Madonna's Come-On," a review of her movie "Body of Evidence," included this caricature (right).

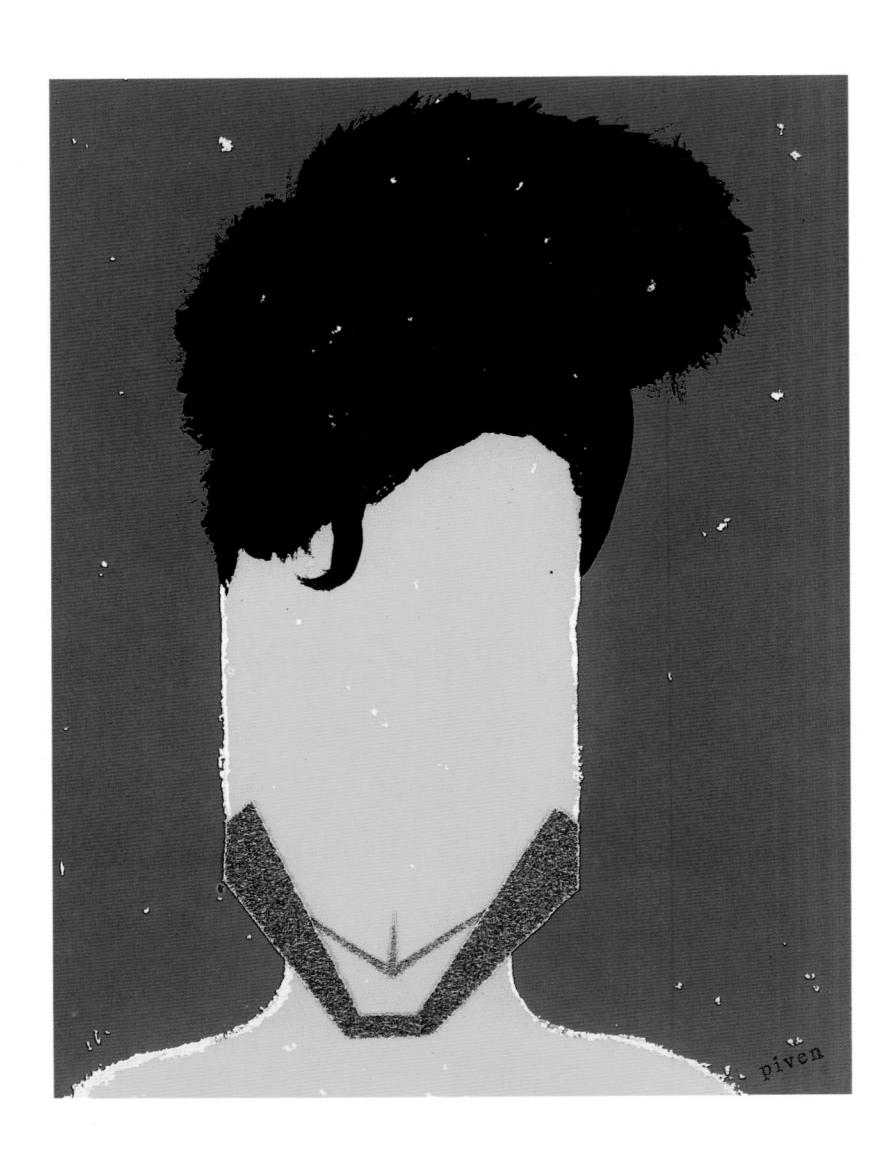

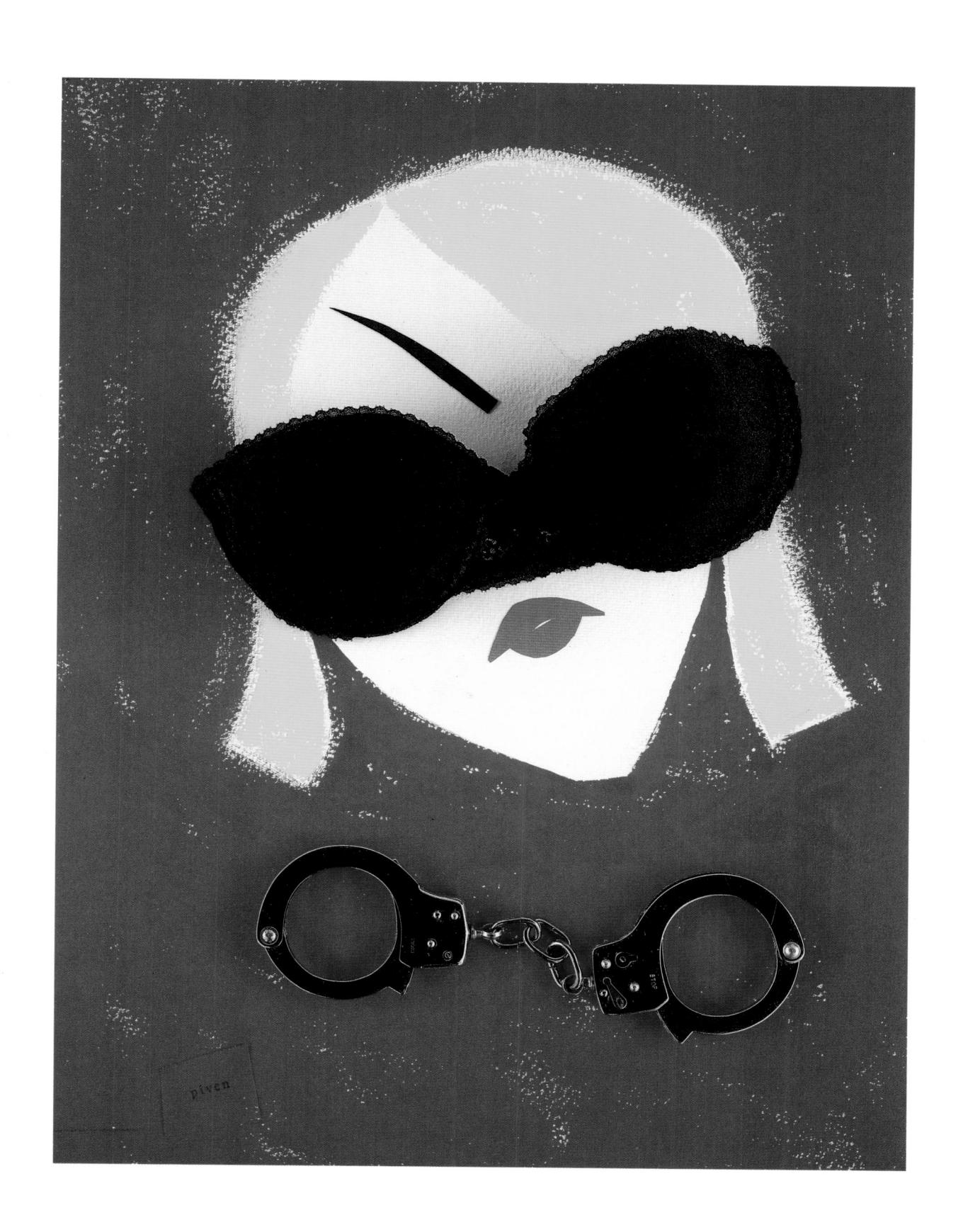

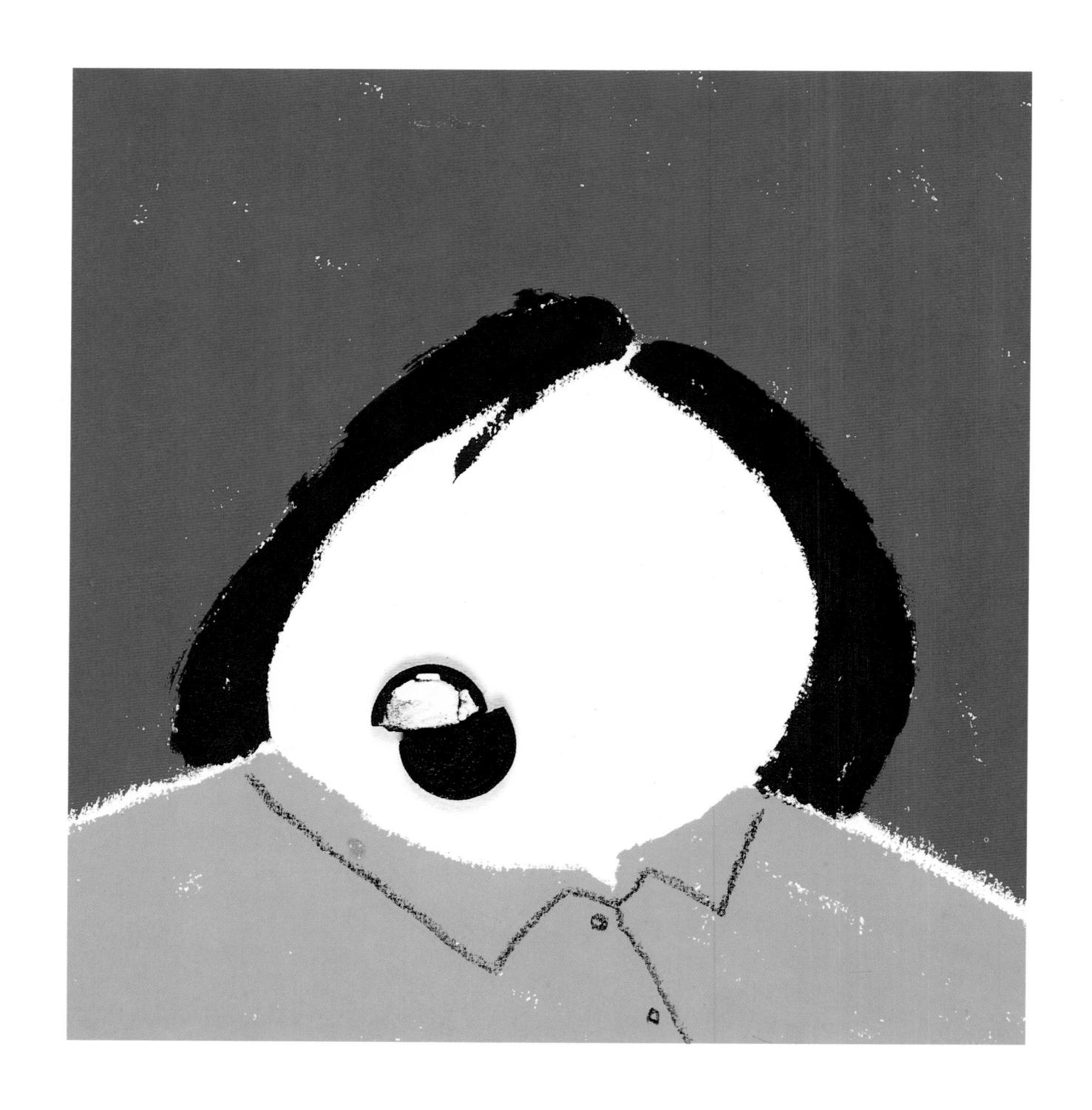

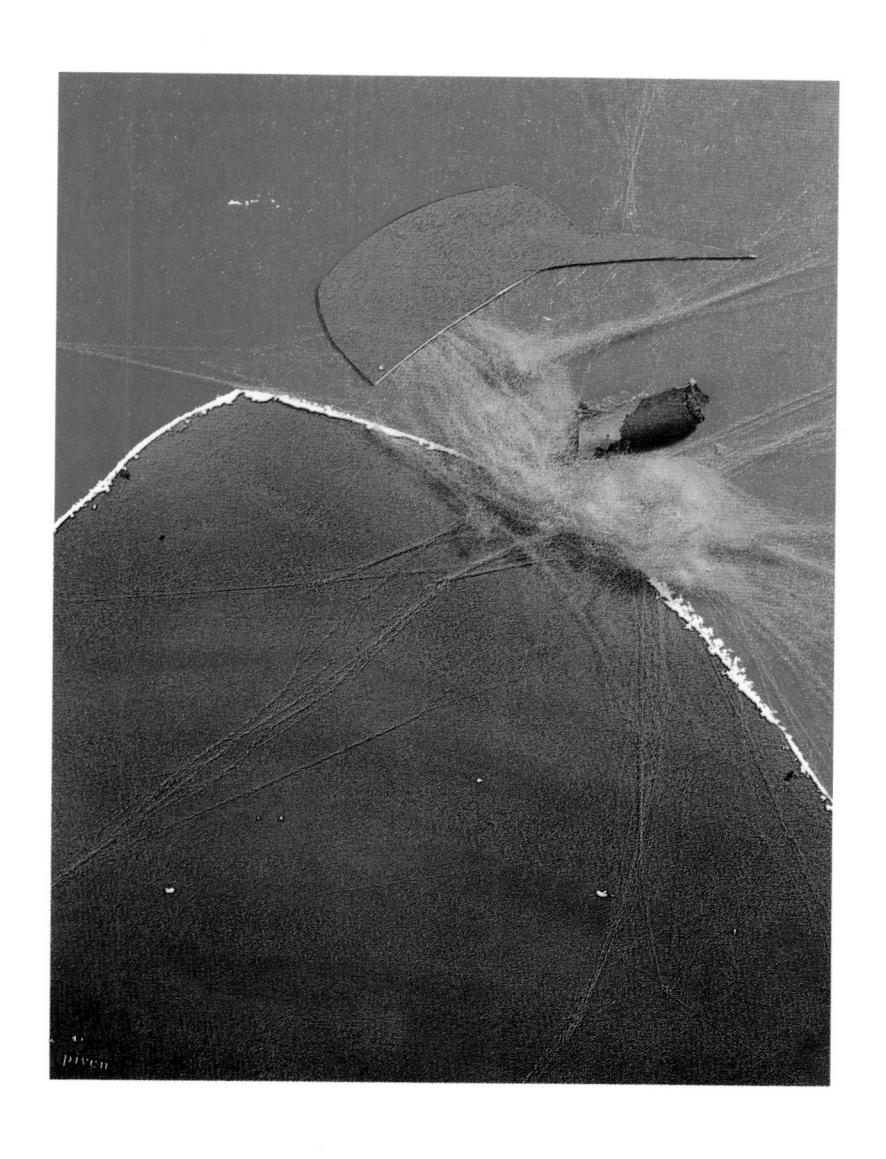

Hanoch Piven

Medium) Collage This caricature of Fidel Castro previously unpublished (above).

Brian Krueger

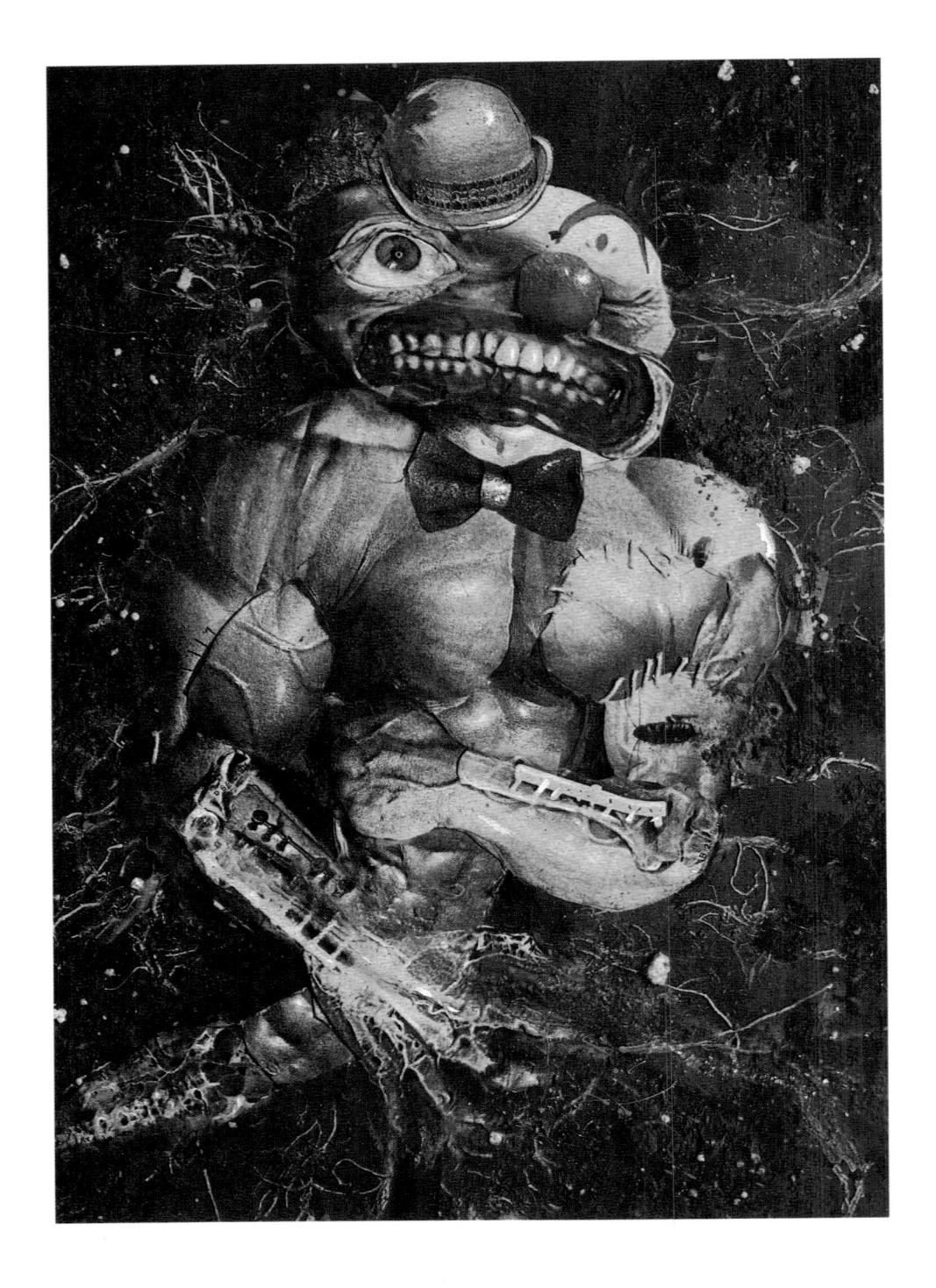

66

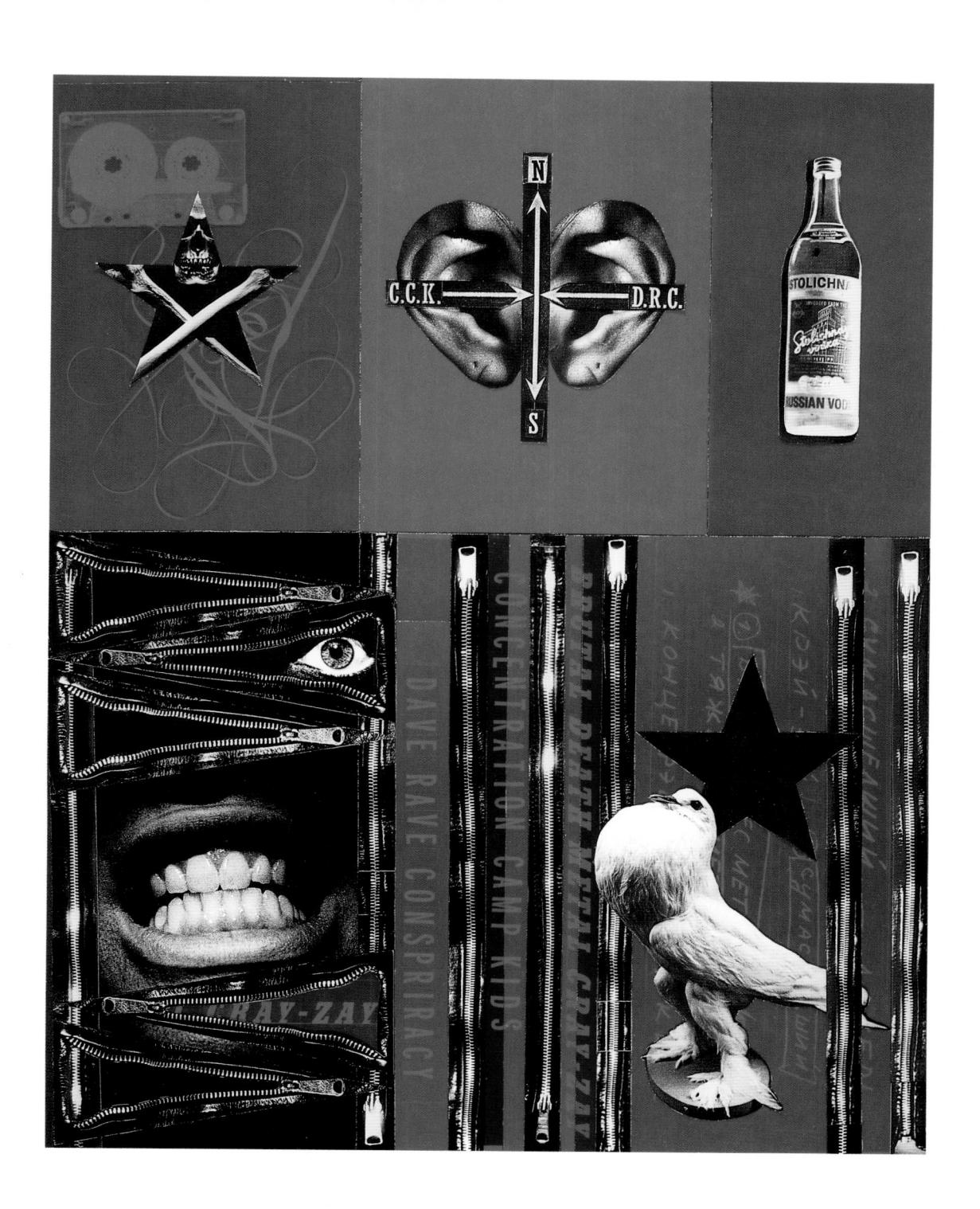

Amy Guip

Amy Guip

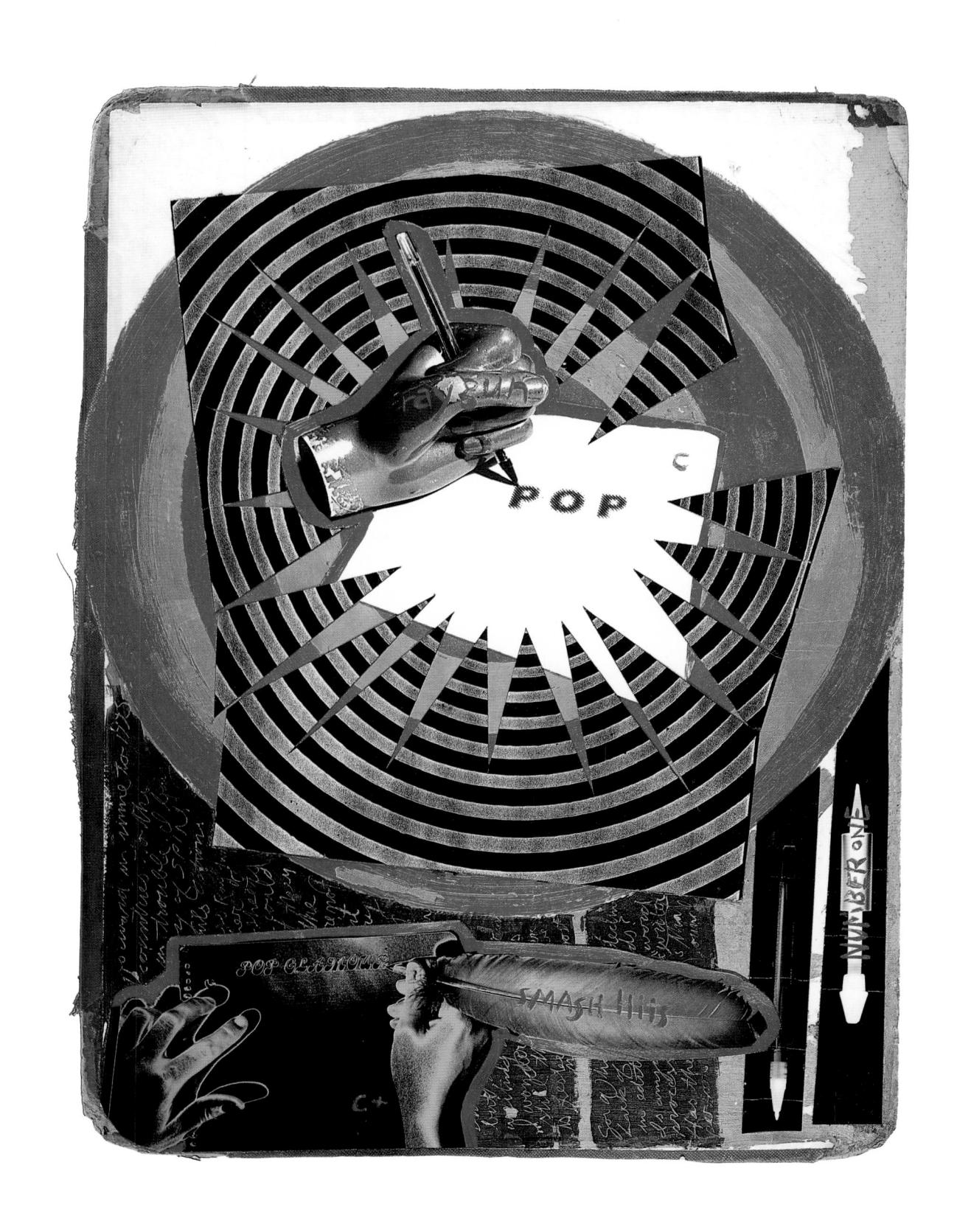

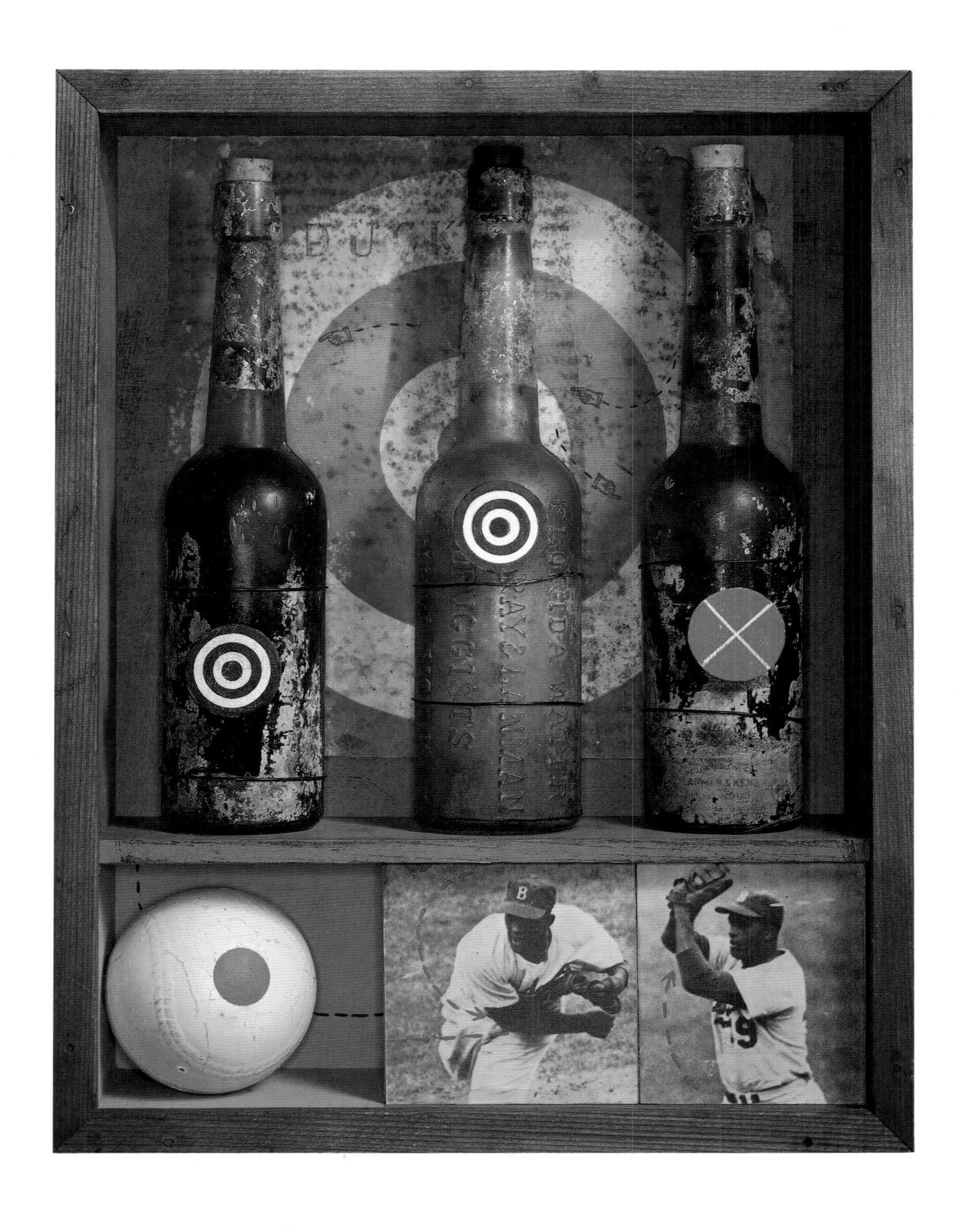
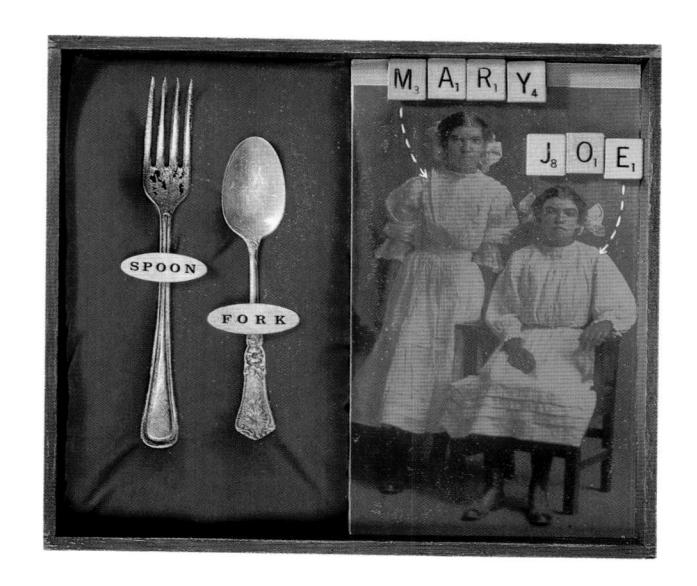

Gary Tanhauser

Art Director) Jane Palecek Editor) Eric Schrier Writer) Bonnie Wach Publication) Health

Date) September 1992 Publisher) Hippocrates Partners Medium) Mixed media The task of choosing a unique name for your child was the subject of "What's in a Name," featuring this illustration (above).

00

David Plunkert

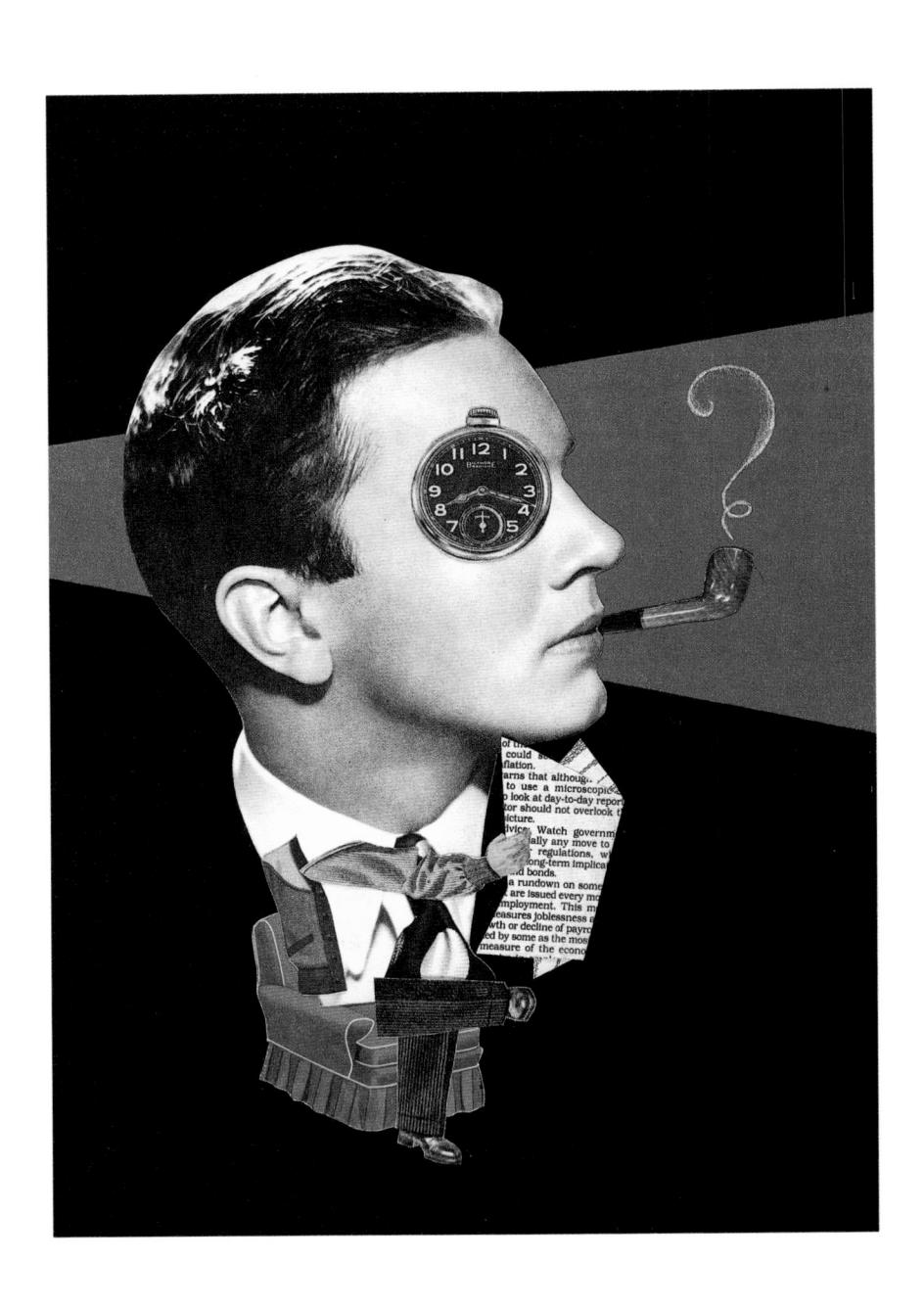

Benoît

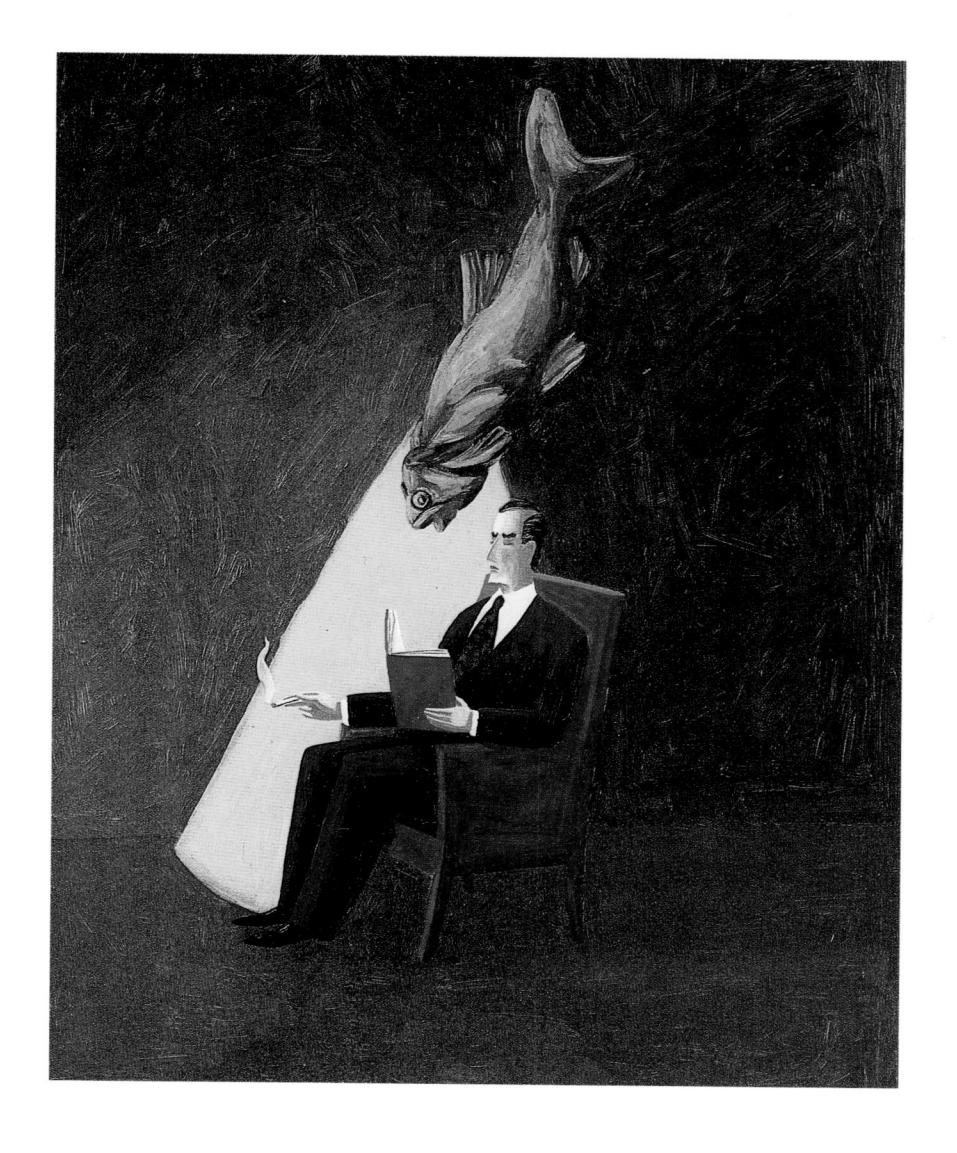

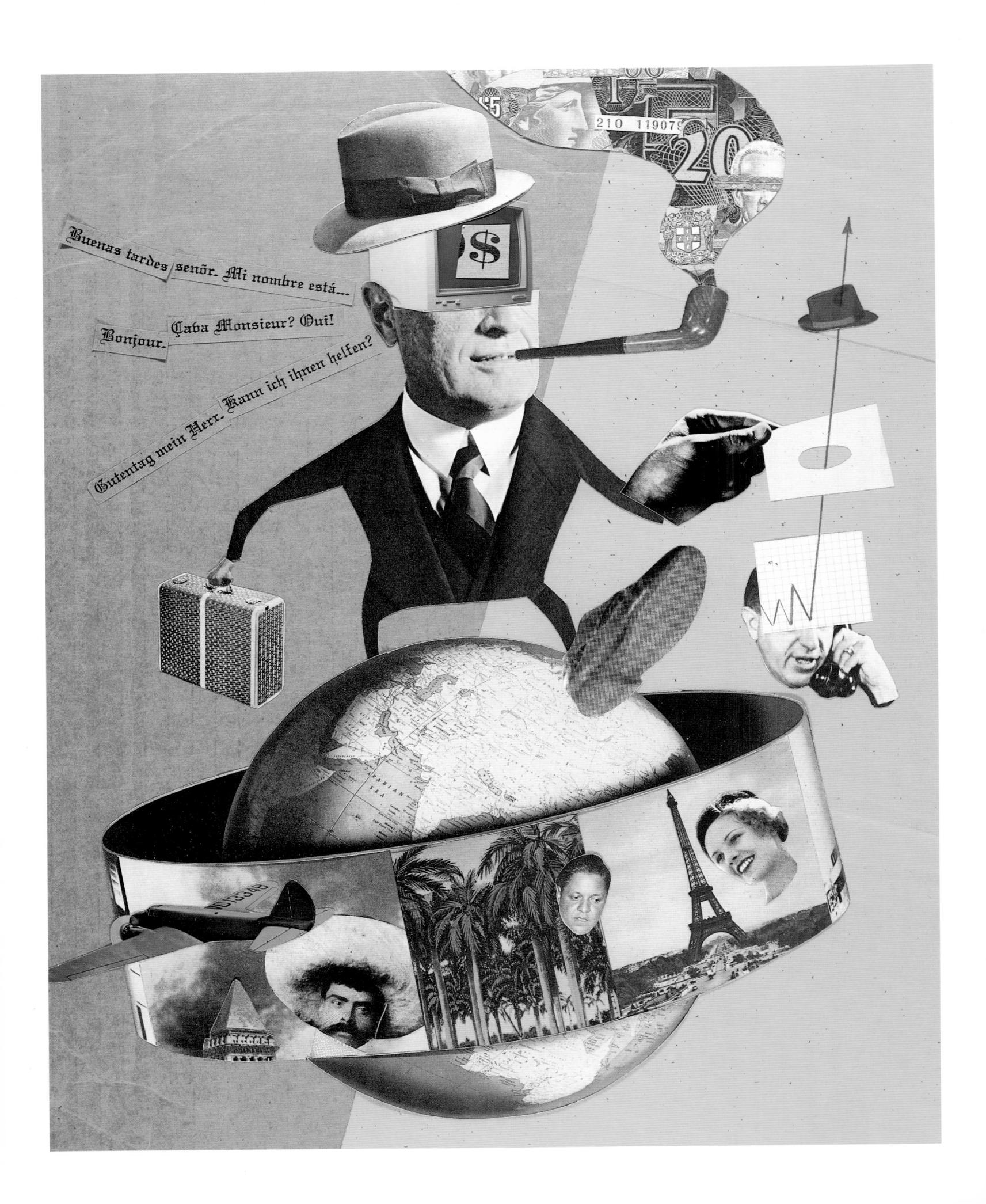

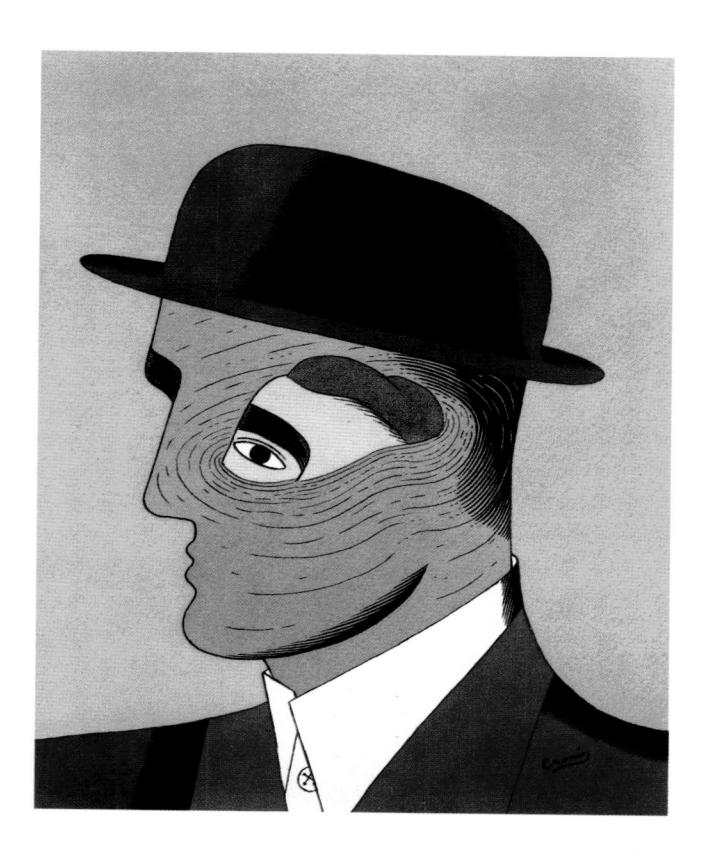

Brian Cronin

Art Director) Lucy Bartholomay

Date) March 14, 1993

Publisher) Affillated Publications, Inc. Medium) Pen and ink and watercolor

The cover illustration for the feature "What's the Matter with Men?" (above).

~

Art Director) David Loewy Editor) Florence Lazar Publication) Varbusiness Date) February 1993 Publisher) CMP Publications Medium) Collage This interpretation of the global salesman was used for the article "Sales Around the World" (left).

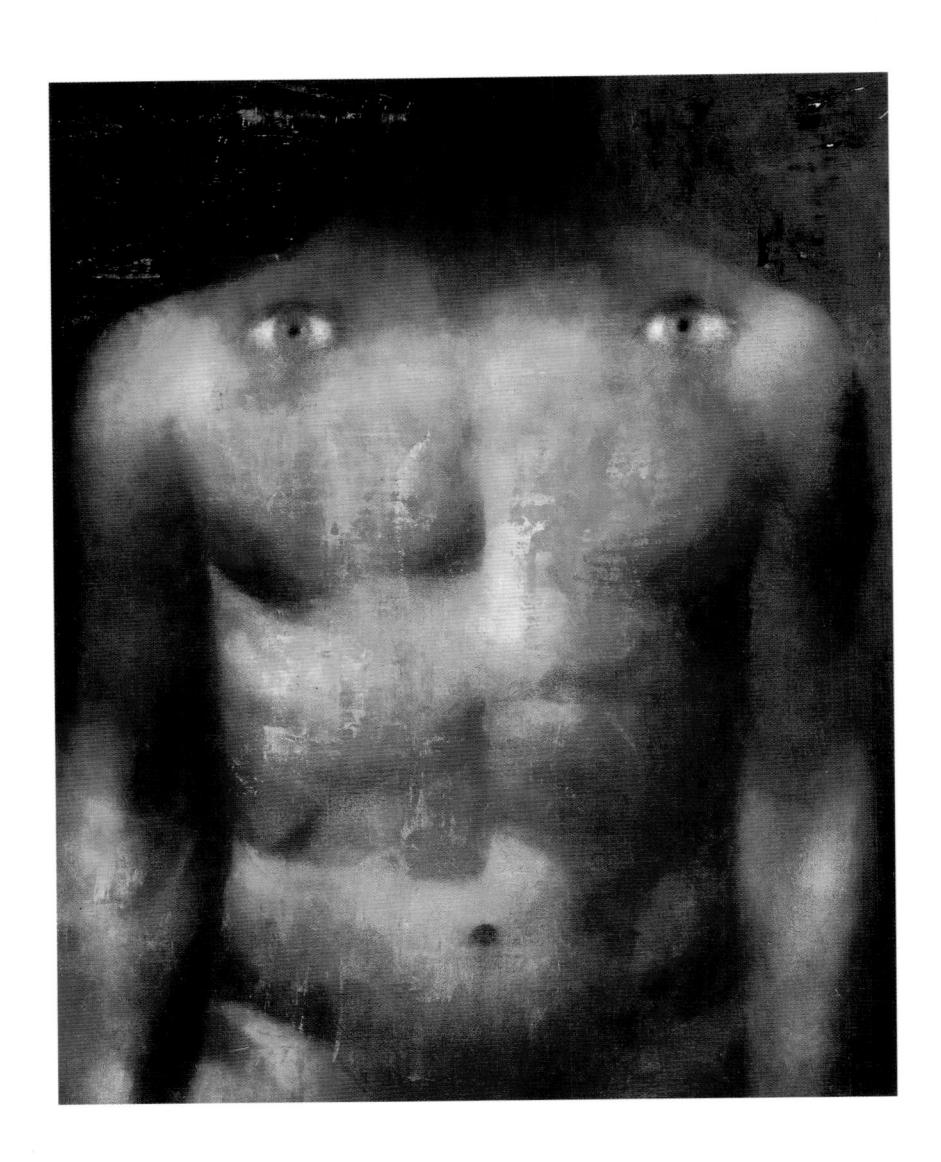

Brad Holland

Malcolm Tarlofsky

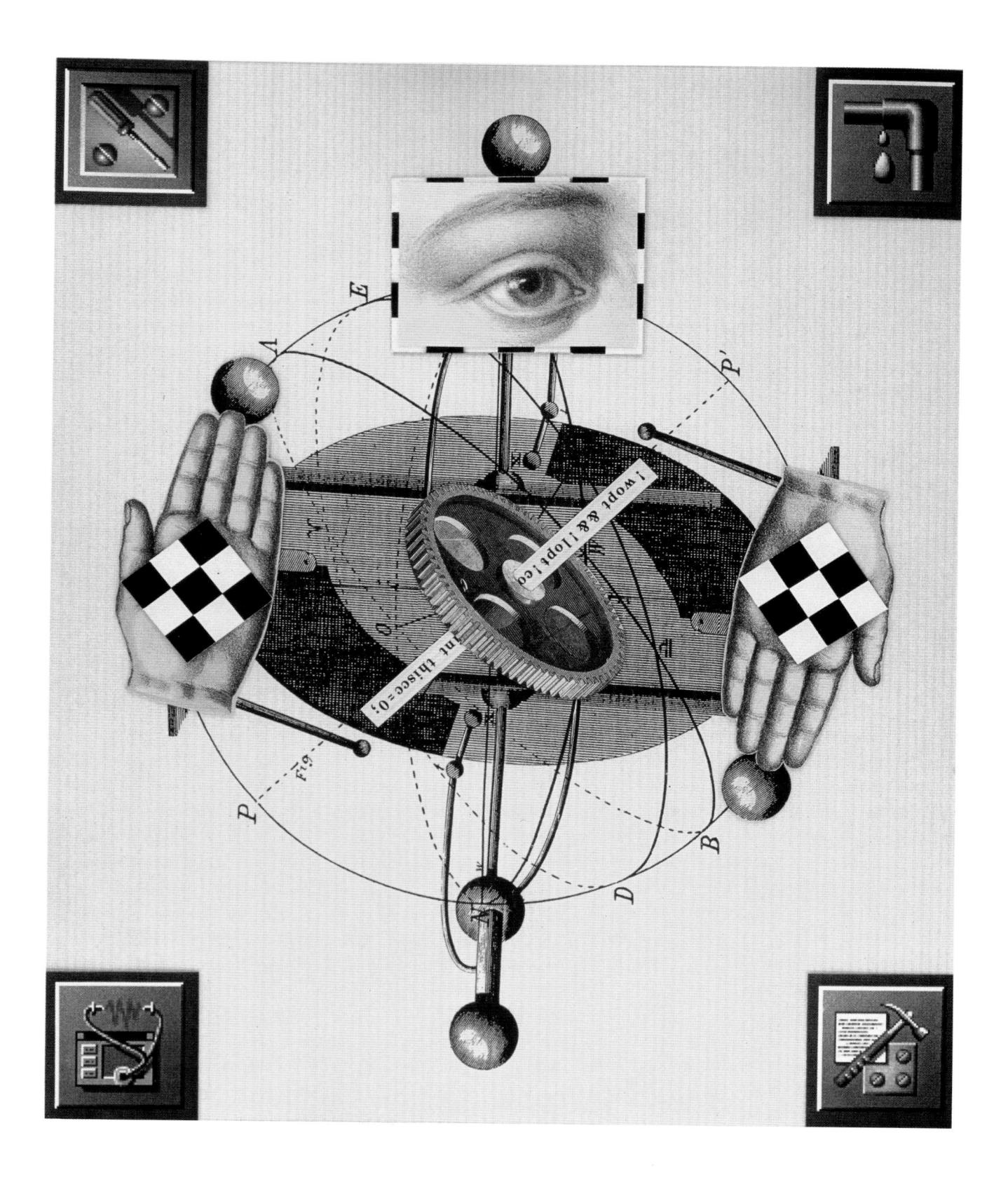

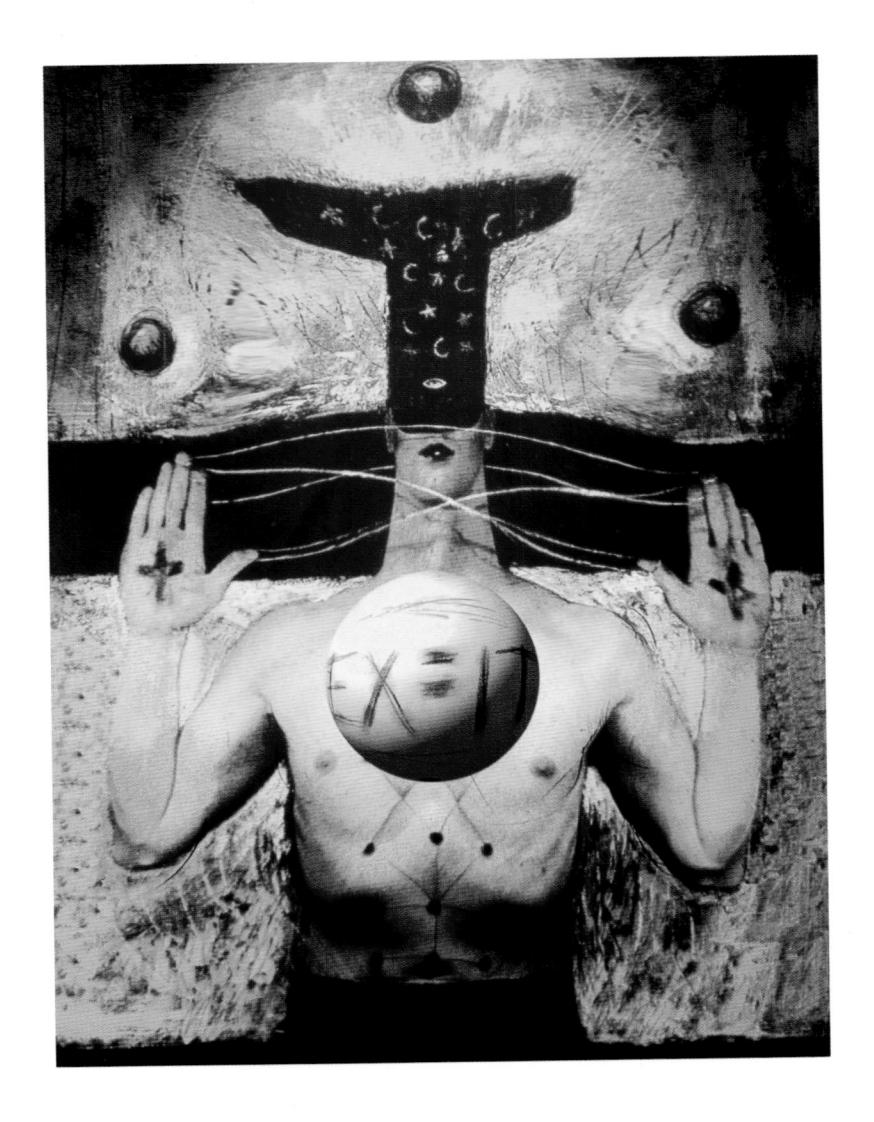

Eric **Di**nyer

Matt Mahurin

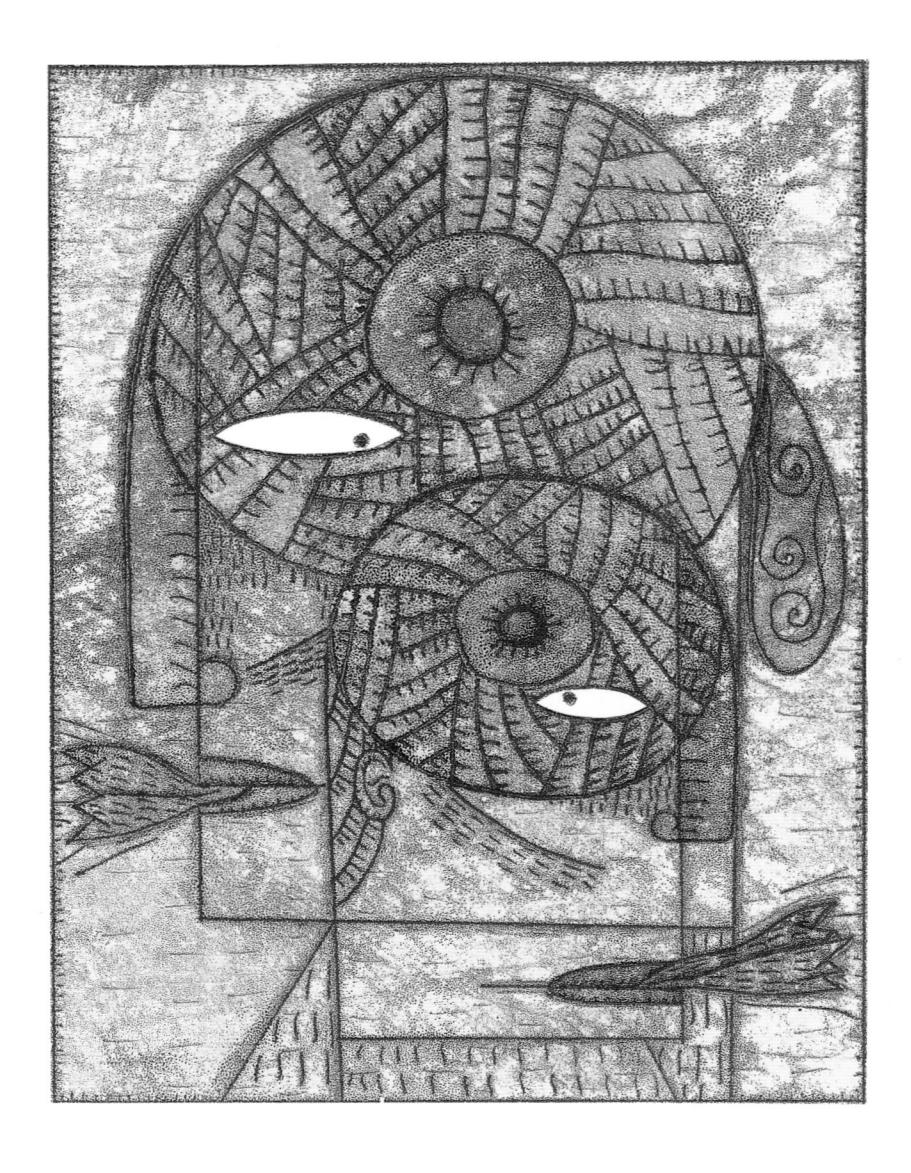

Richard Downs

José Ortega

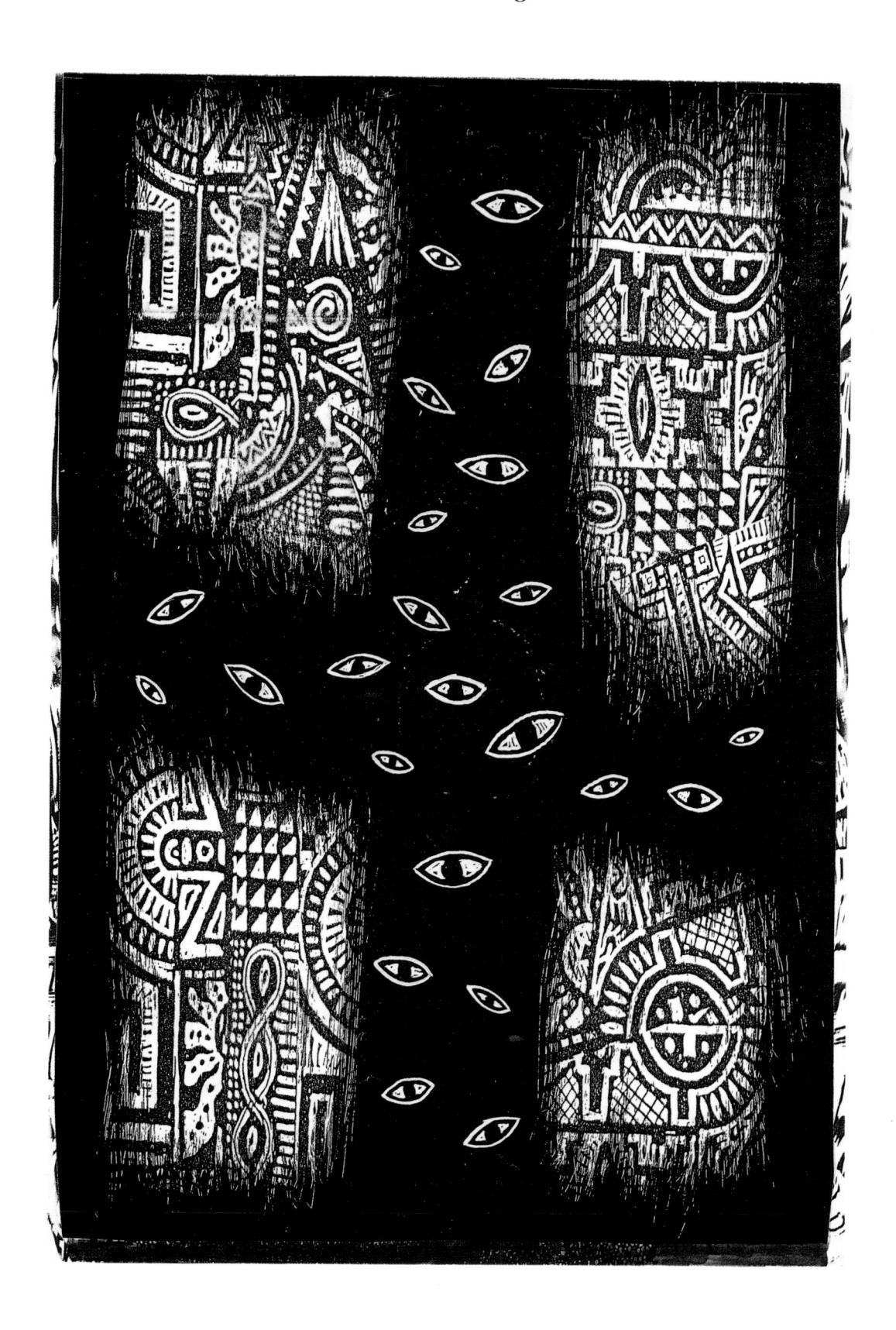

81

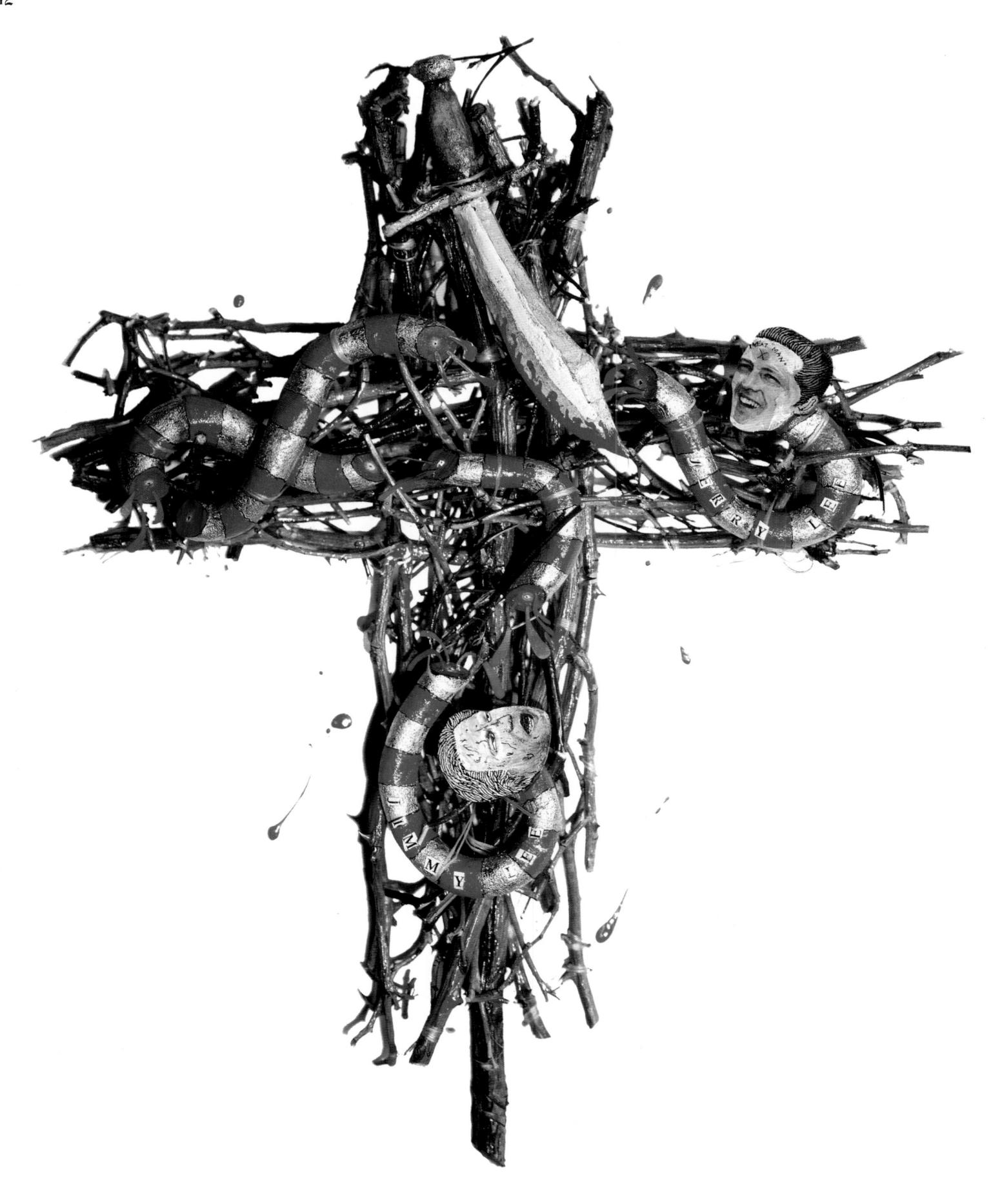

Henrik Drescher

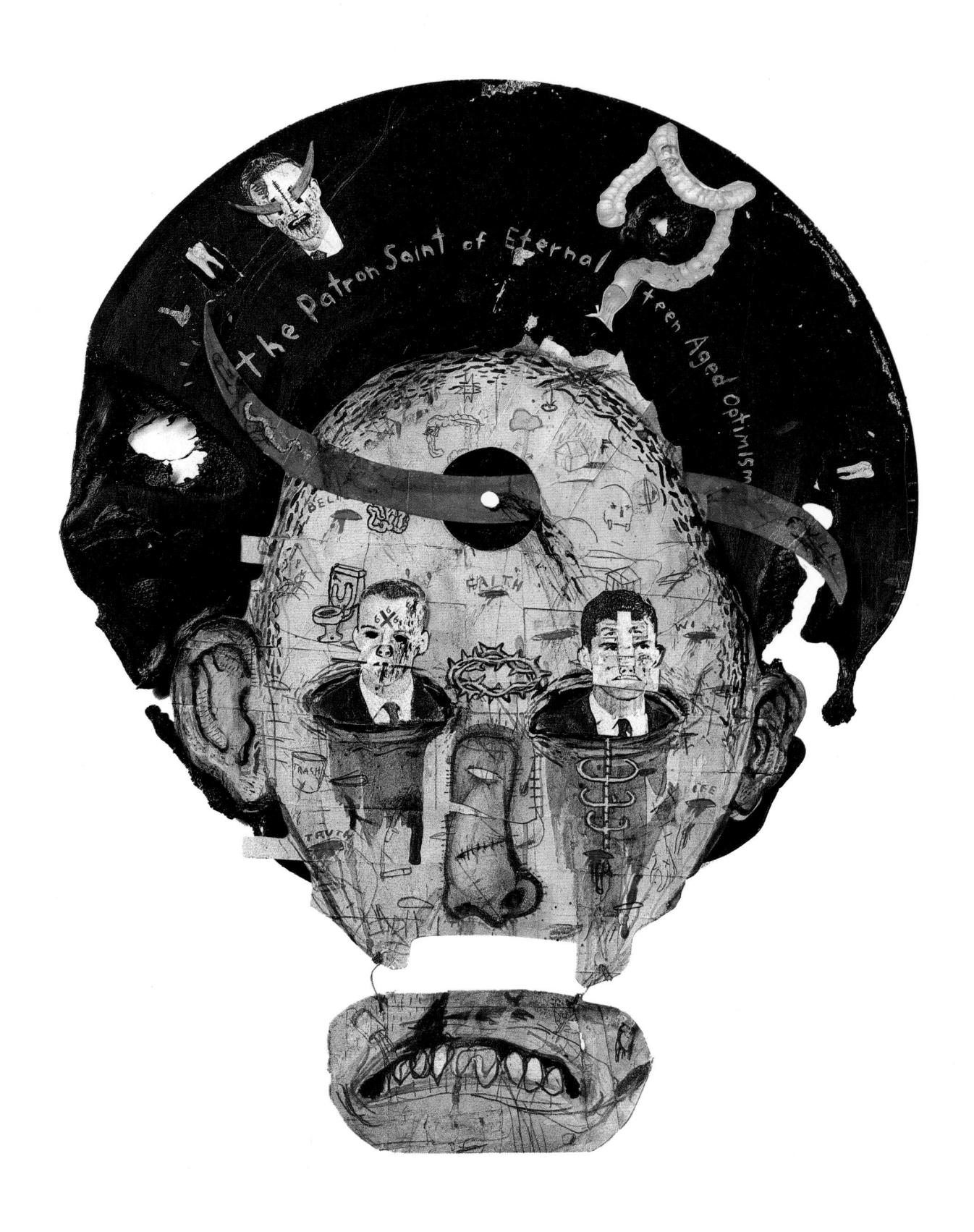

Jason Holley

Art Director) Tom Fillebrown Editor) Marc Weidenbaum

Date) October 1992 Publisher) MTS Inc. Medium) Mixed media

Death Metal, but Were Afraid to Ask," was the title of the article featuring this illustration.

Writer) Mike Gitter Publication) Pulse!

Everything You Ever Wanted to Know About the article featuring this illustration.

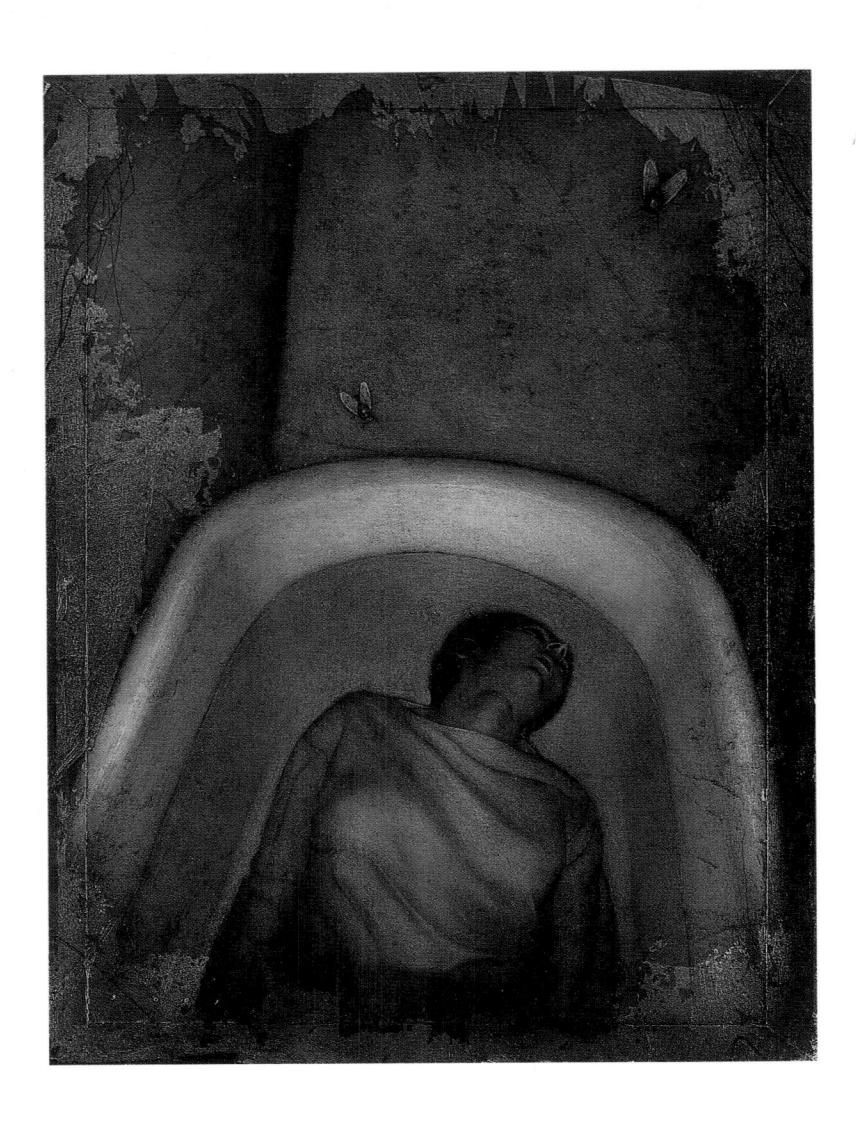

Joel Peter Johnson

Brad Holland

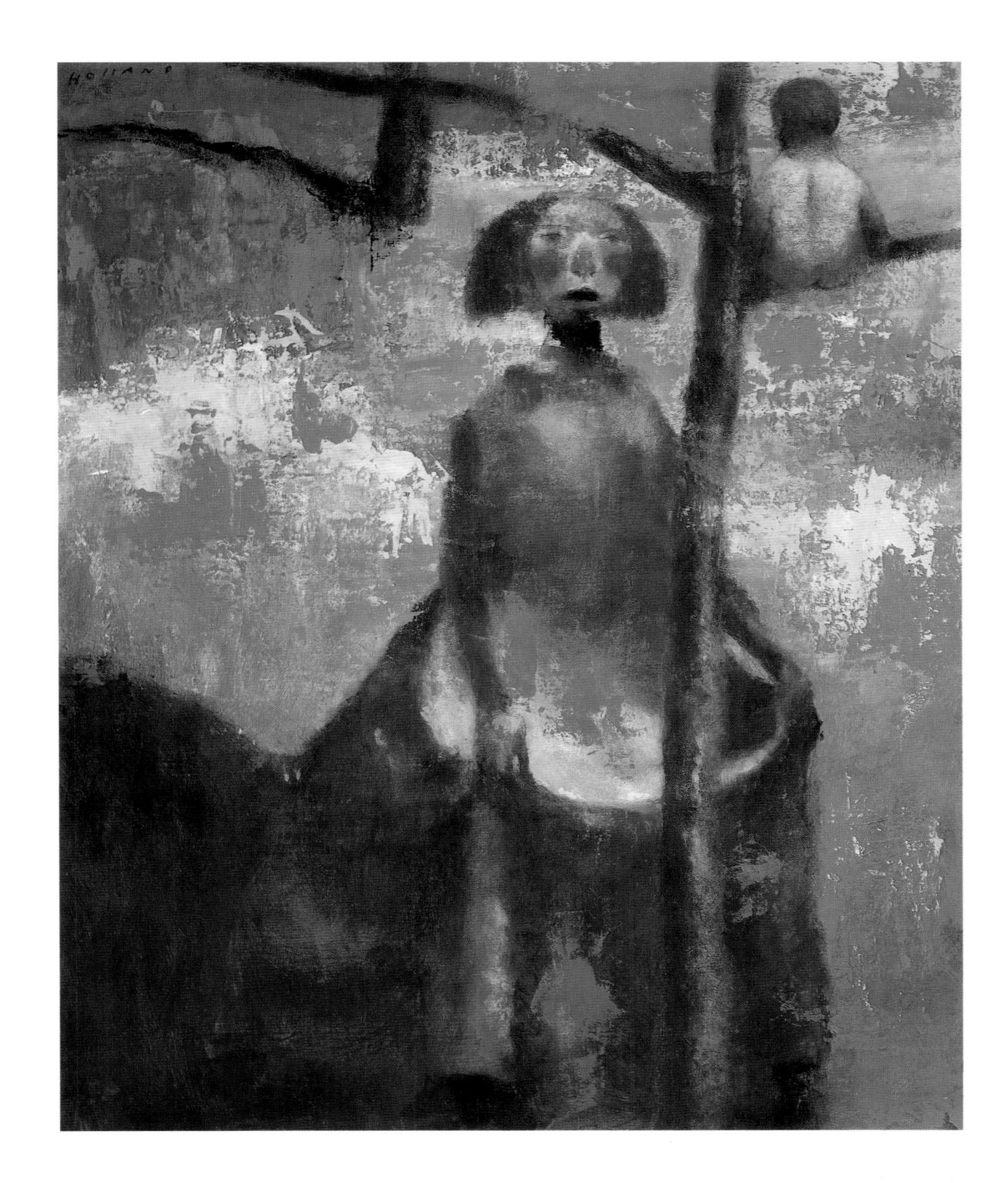

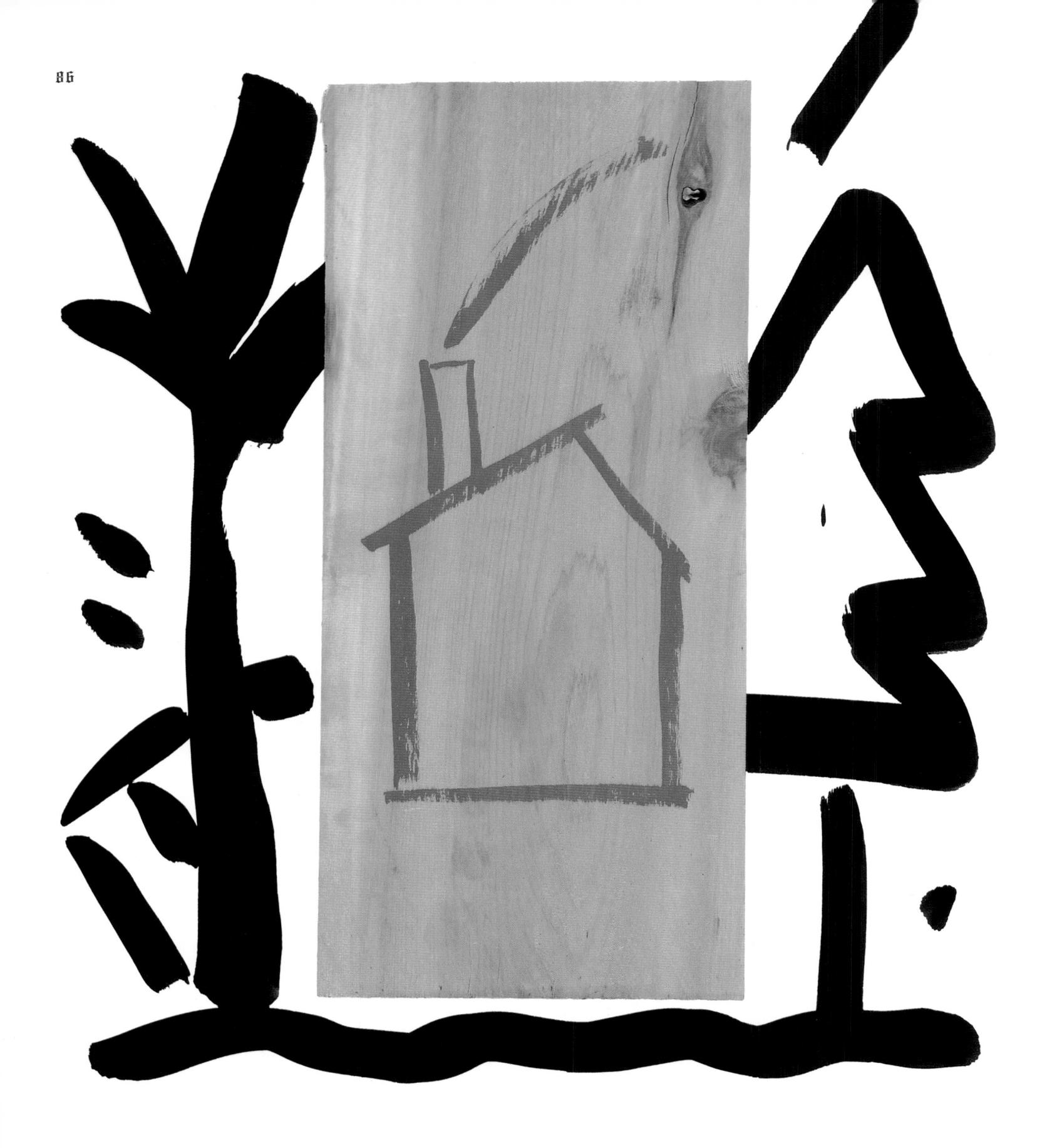

Patrick Blackwell

Jeffrey Fisher

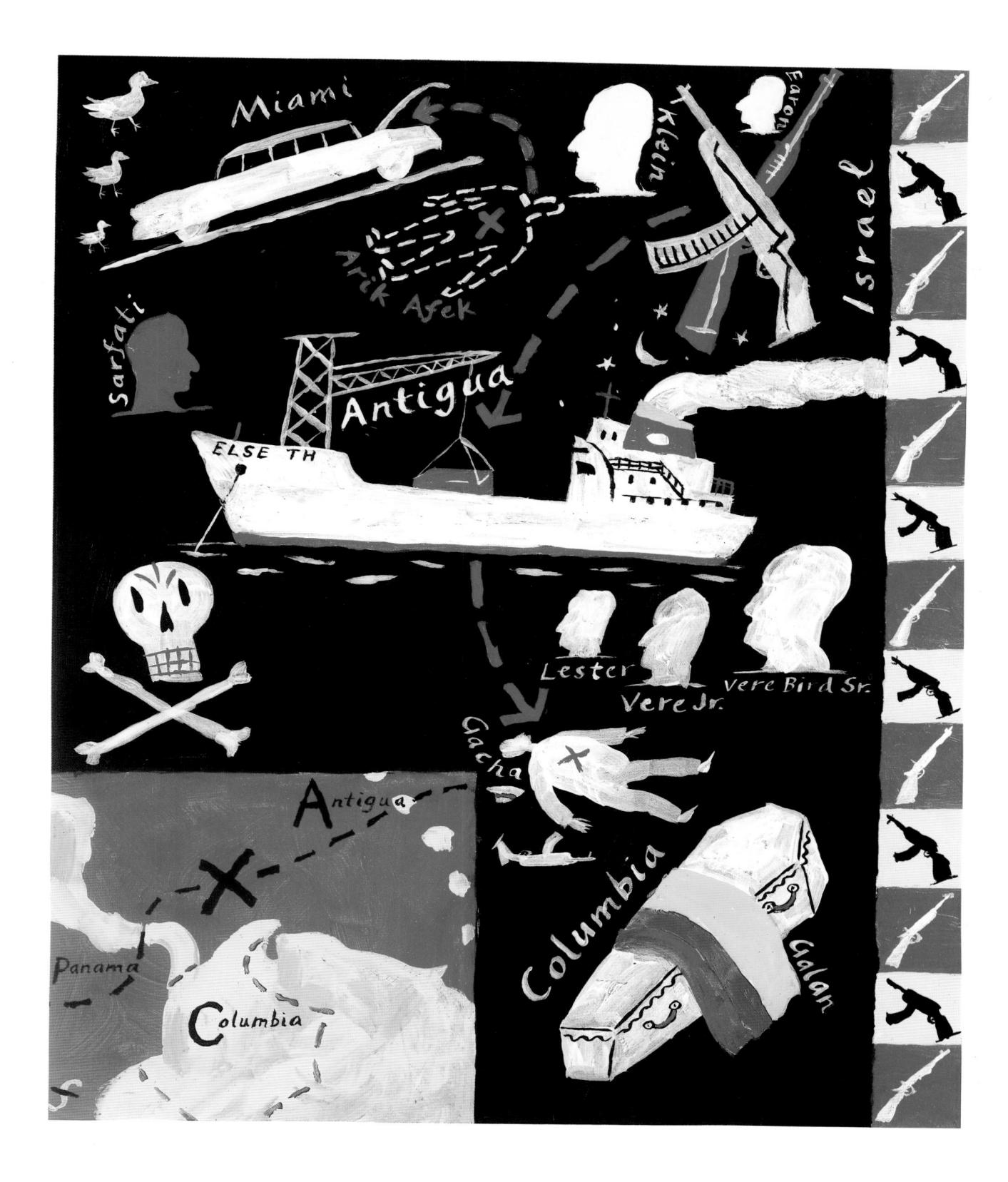

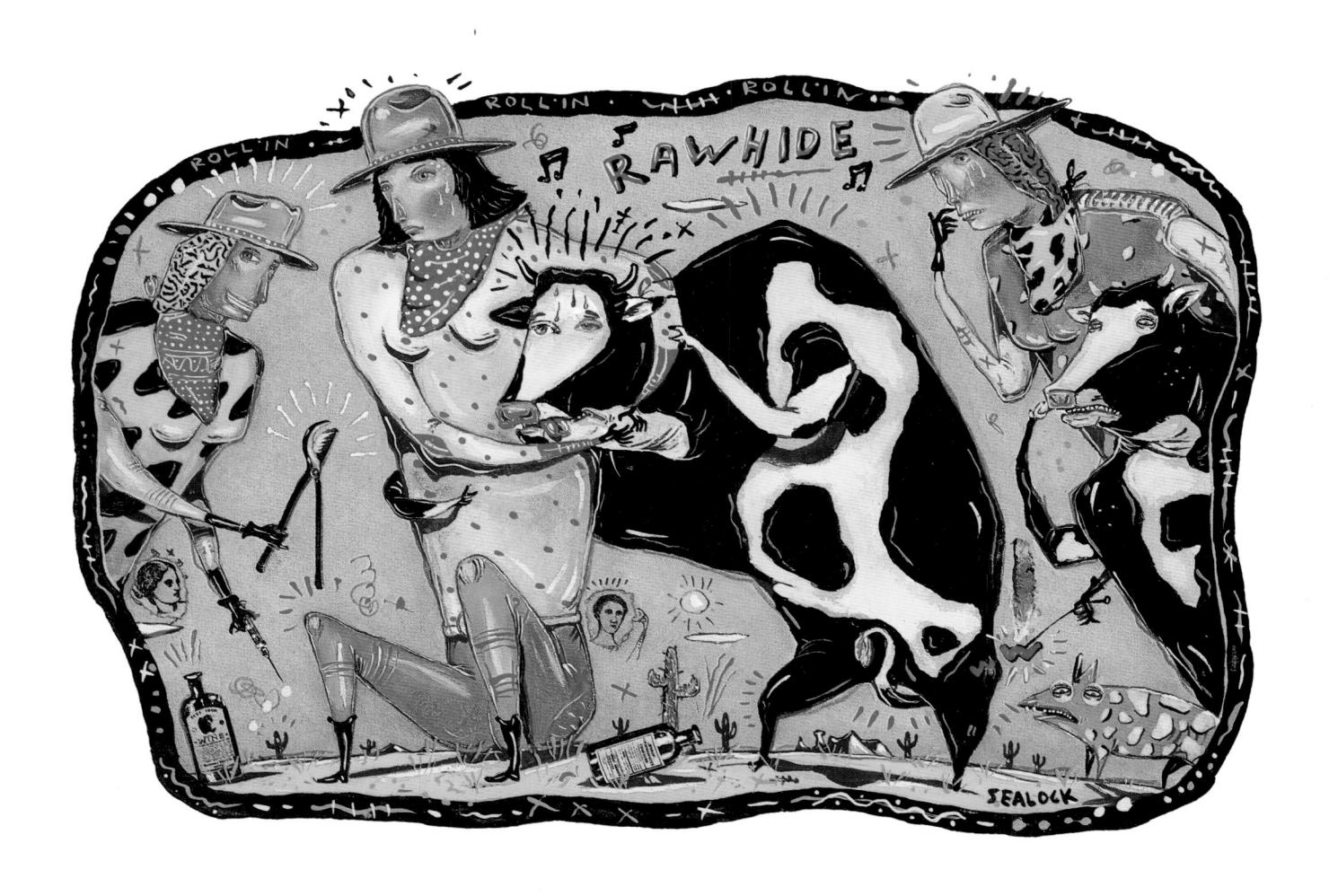

Rick Sealock

Christian Clayton

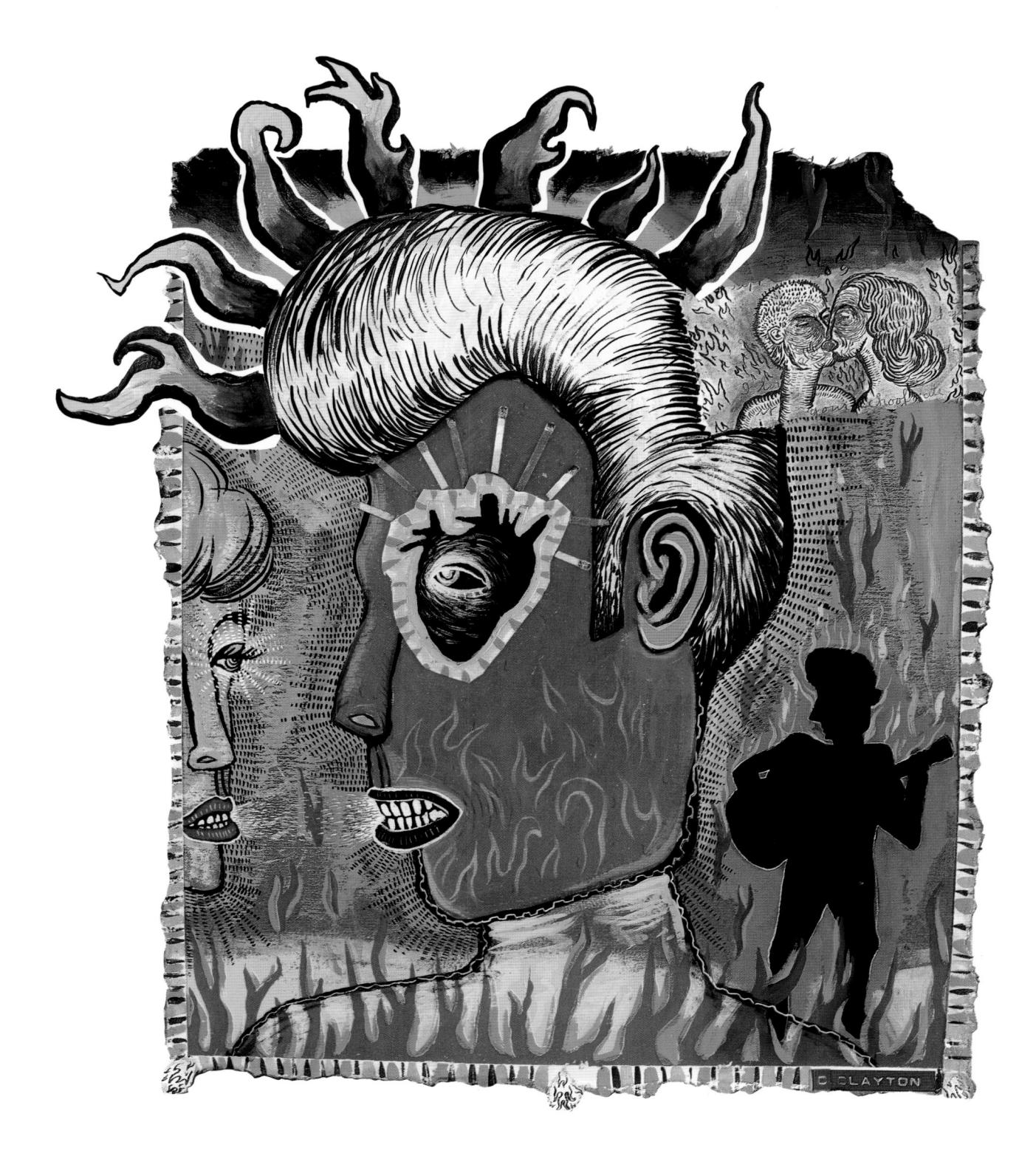

89

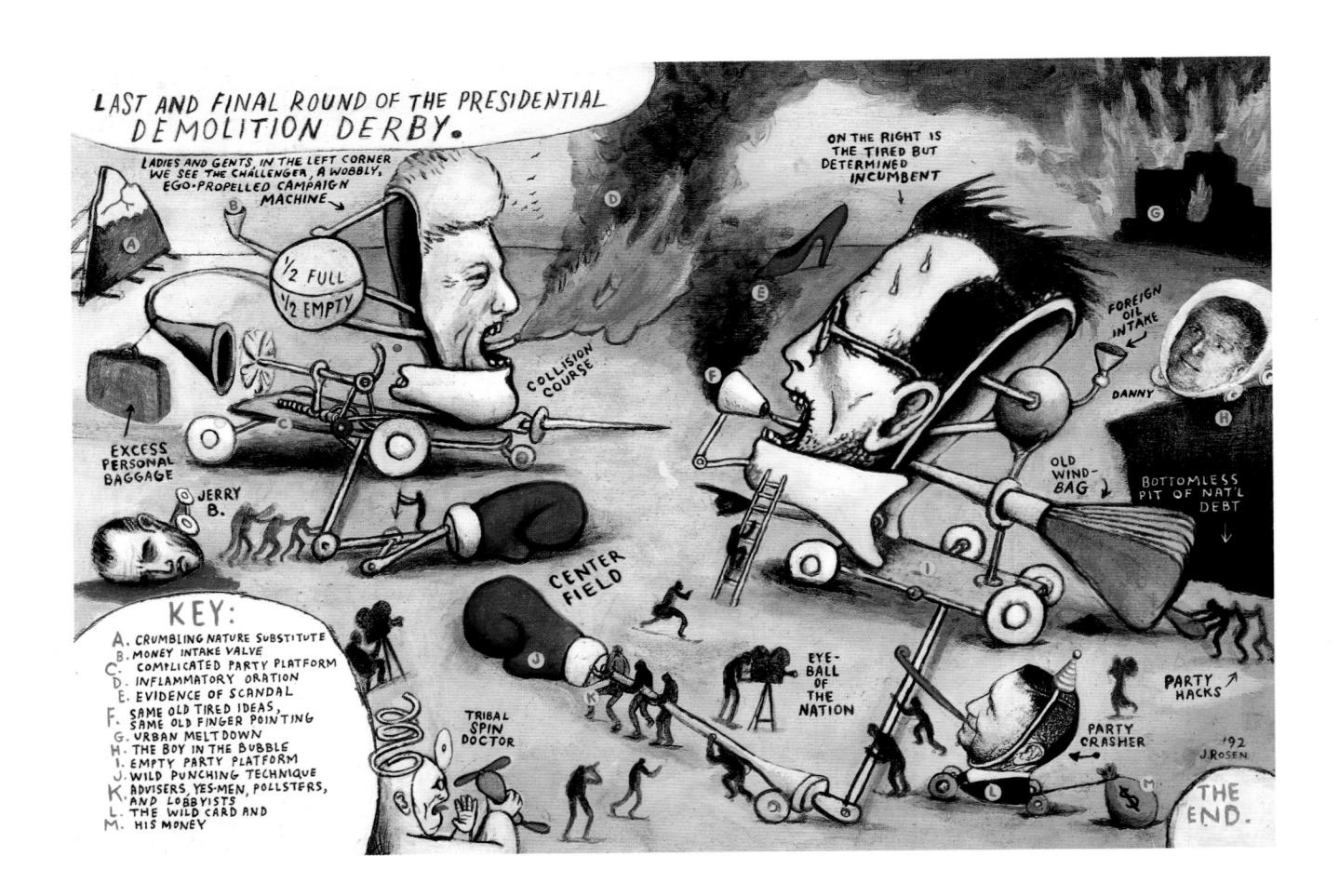

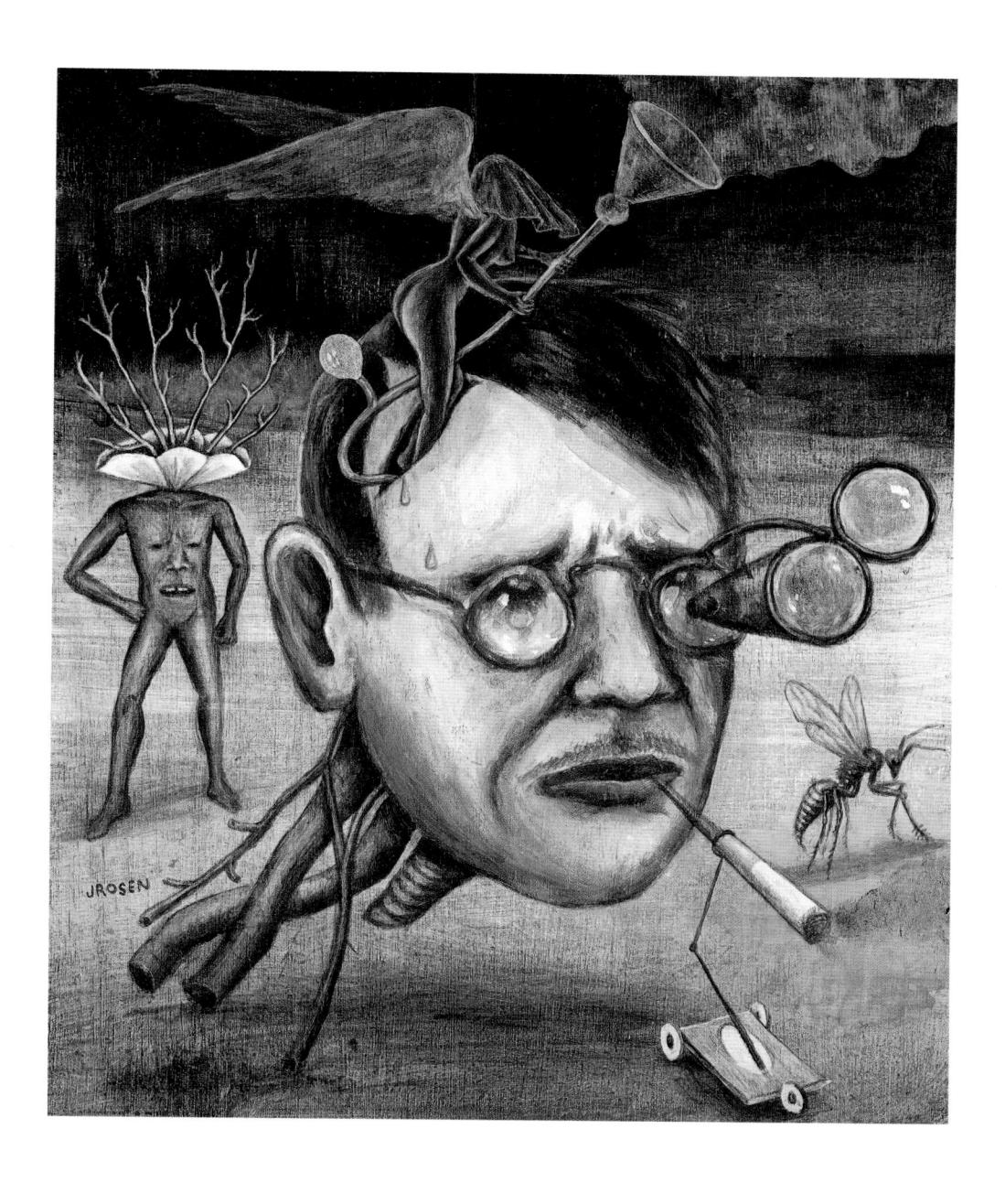

Jonathon Rosen

Art Director) David Carson Editor) Marvin Scott Jarrett Publication) Ray Gun Date) Fall 1992 Publisher) Ray Gun Publishing, Inc. Medium) Acrylic An interpretation of the song "Love's Secret Domain" by the group Coil (above).

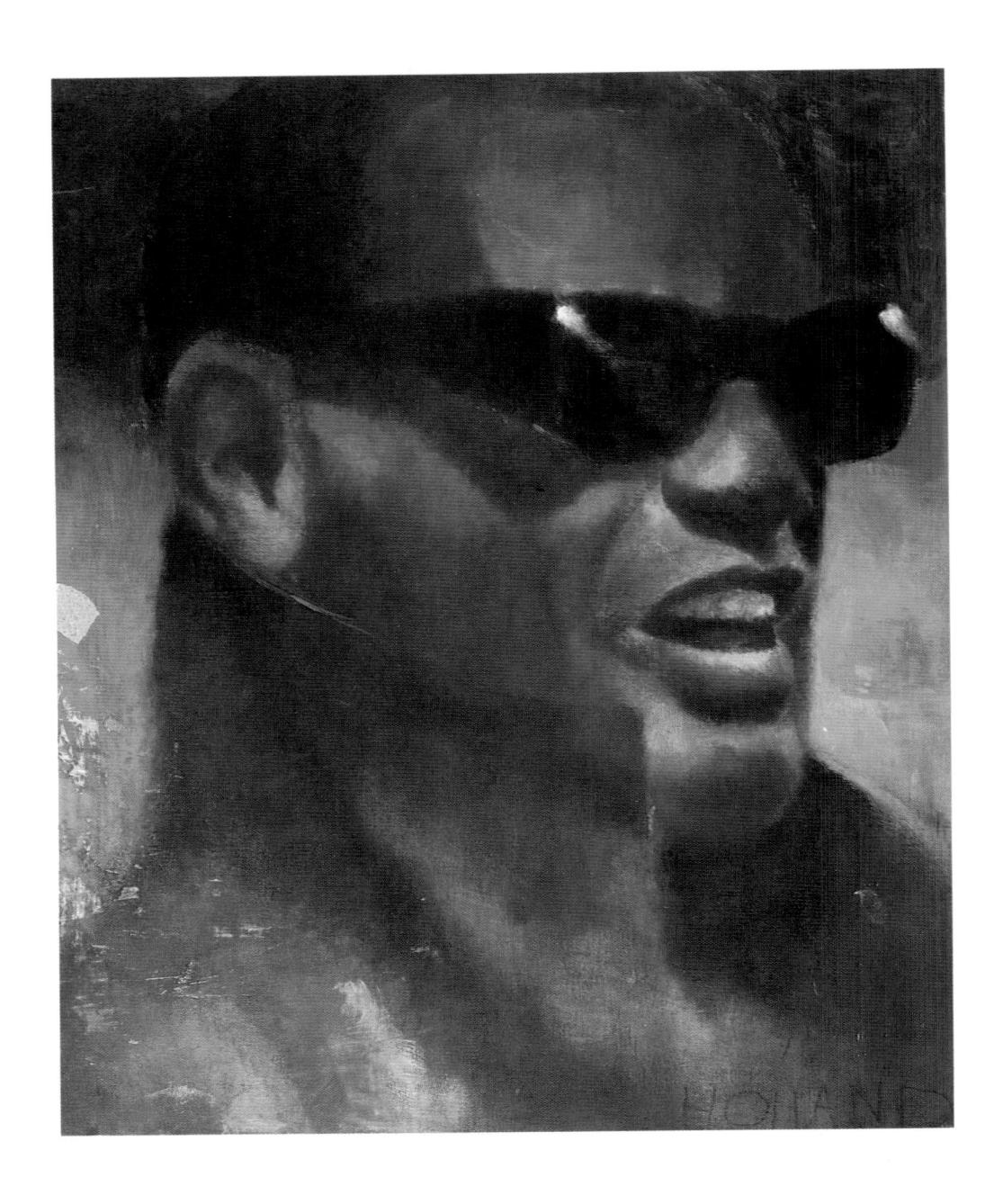

Brad Holland

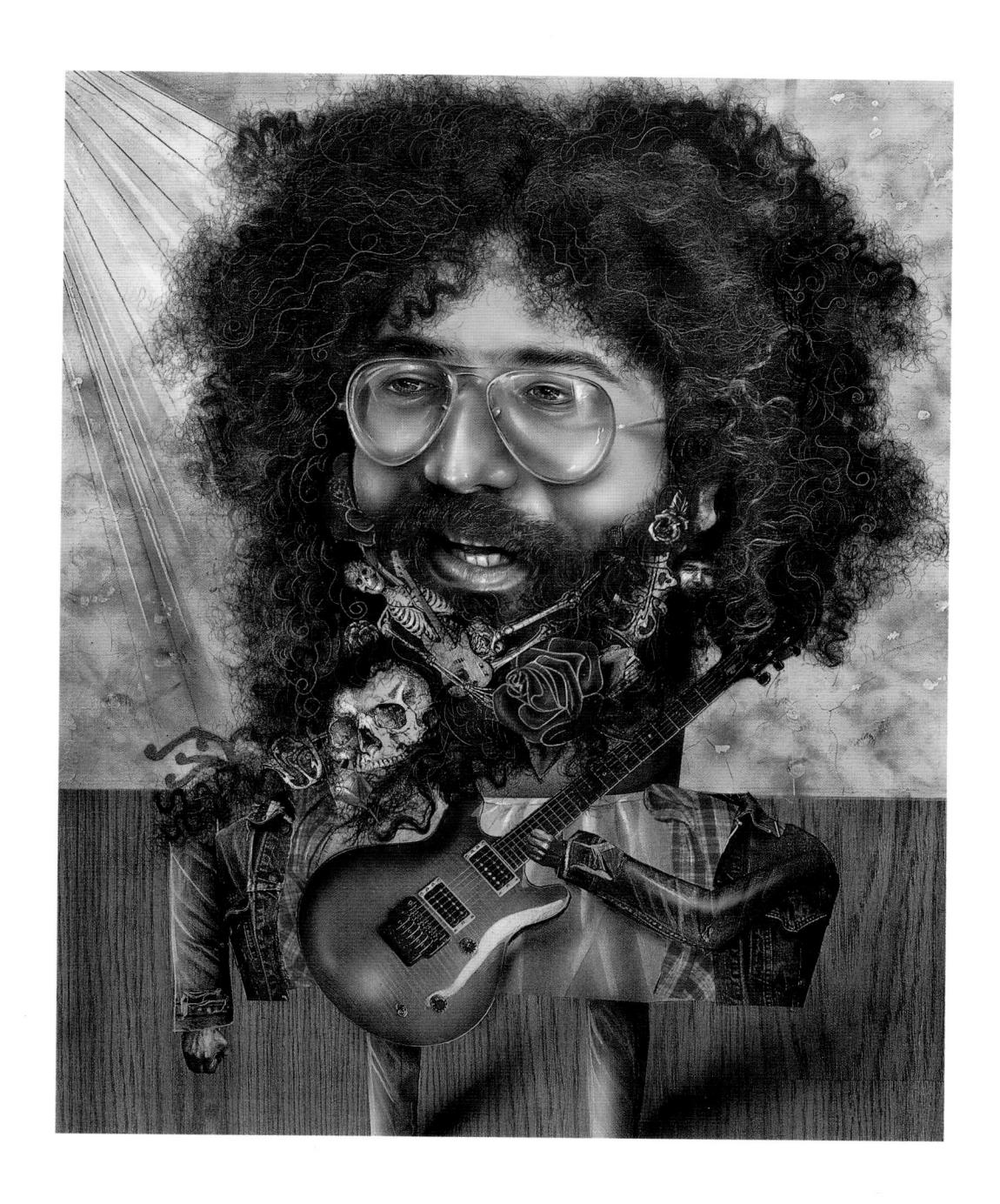

Janet Woolley

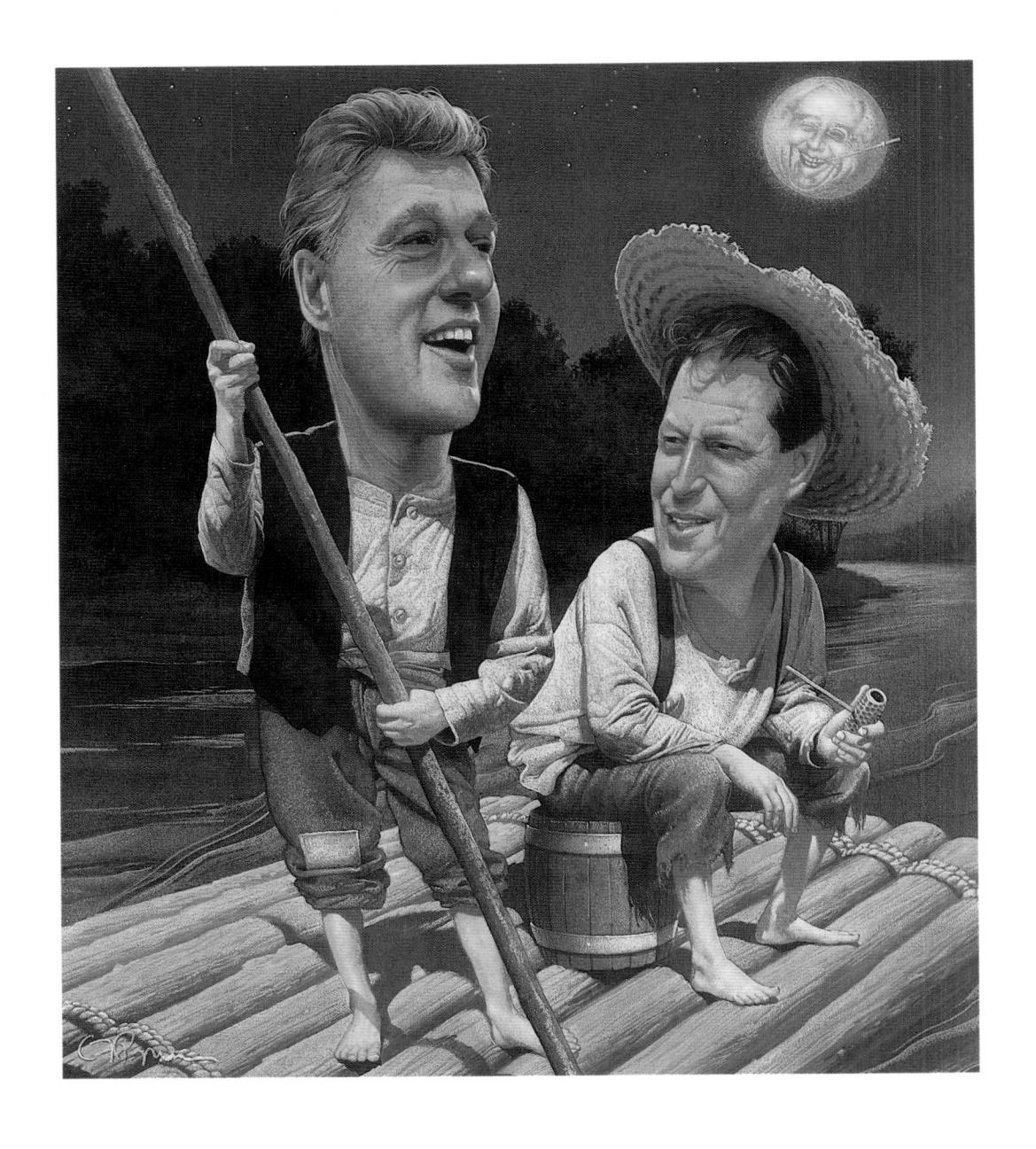

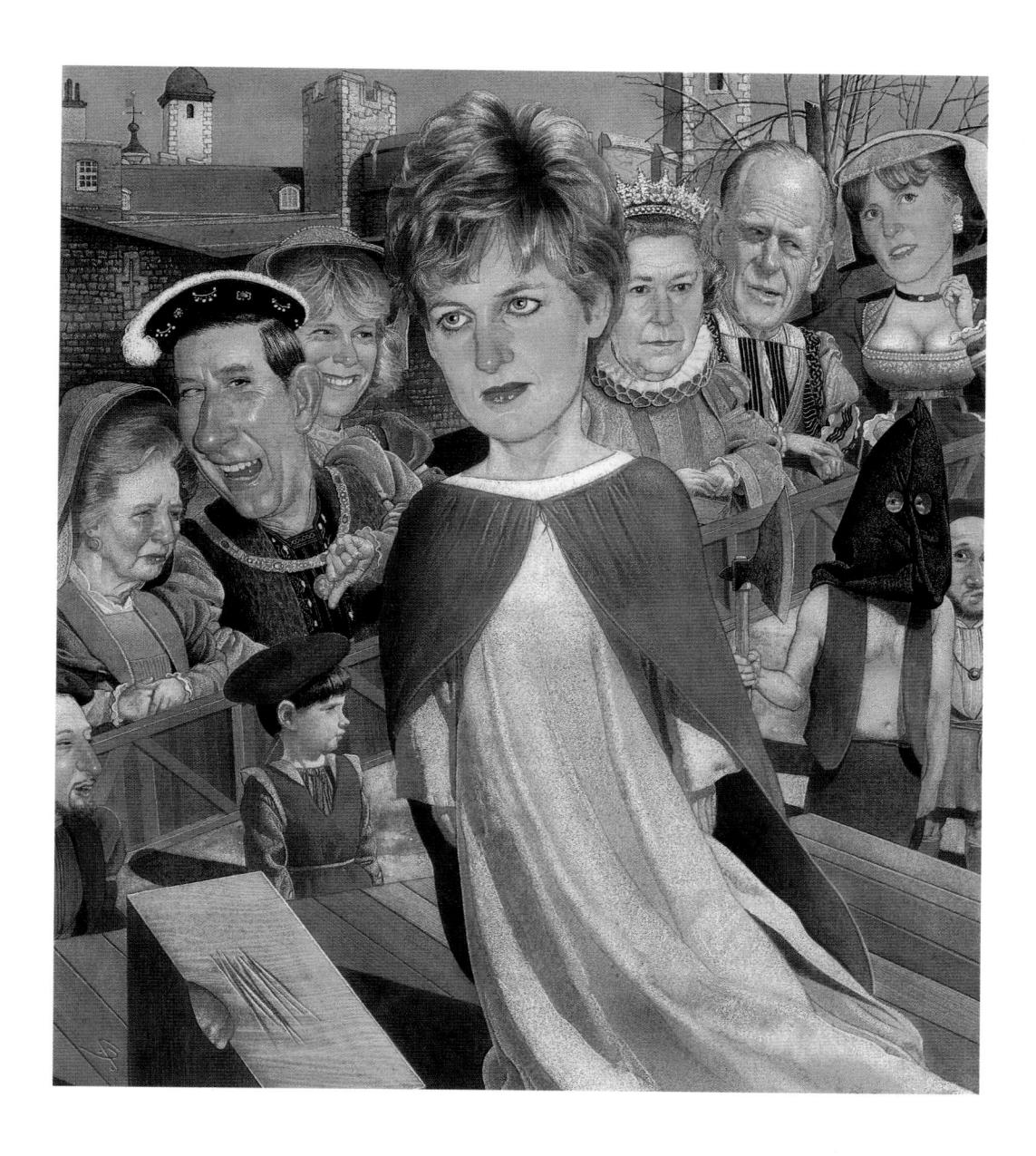

C.F. Payne

Art Director) Robert Priest Writer) John Mortimer Publication) GQ Magazine Date) April 1993 Publisher) Condé Nast Publications, Inc. Medium) Mixed media The perplexities of being Princess DI were dicussed in the article "Noblesse Besieged" (above).

Warren Linn

Art Directors) Victoria Maddocks and Jalme Ferrand Editor) Katherine Arthaud Writer) Stan Gibilisco

Publication) South Beach Magazine Date) February 1993 Publisher) South Beach Magazine, Inc. Medium) Collage and acrylic on wood A family at home with a polluted ocean was created for the article "Earthwatch: Seawise" (below).

00

Art Director) Nancy Duckworth Editor) Bret Israel Publication) The Los Angeles Times Magazine

Date) April 18, 1993 Publisher) Times Mirror Medium) Oil and acrylic A portrait of African American

men and women was created for the article "Shades of Black" (right).

Calef Brown

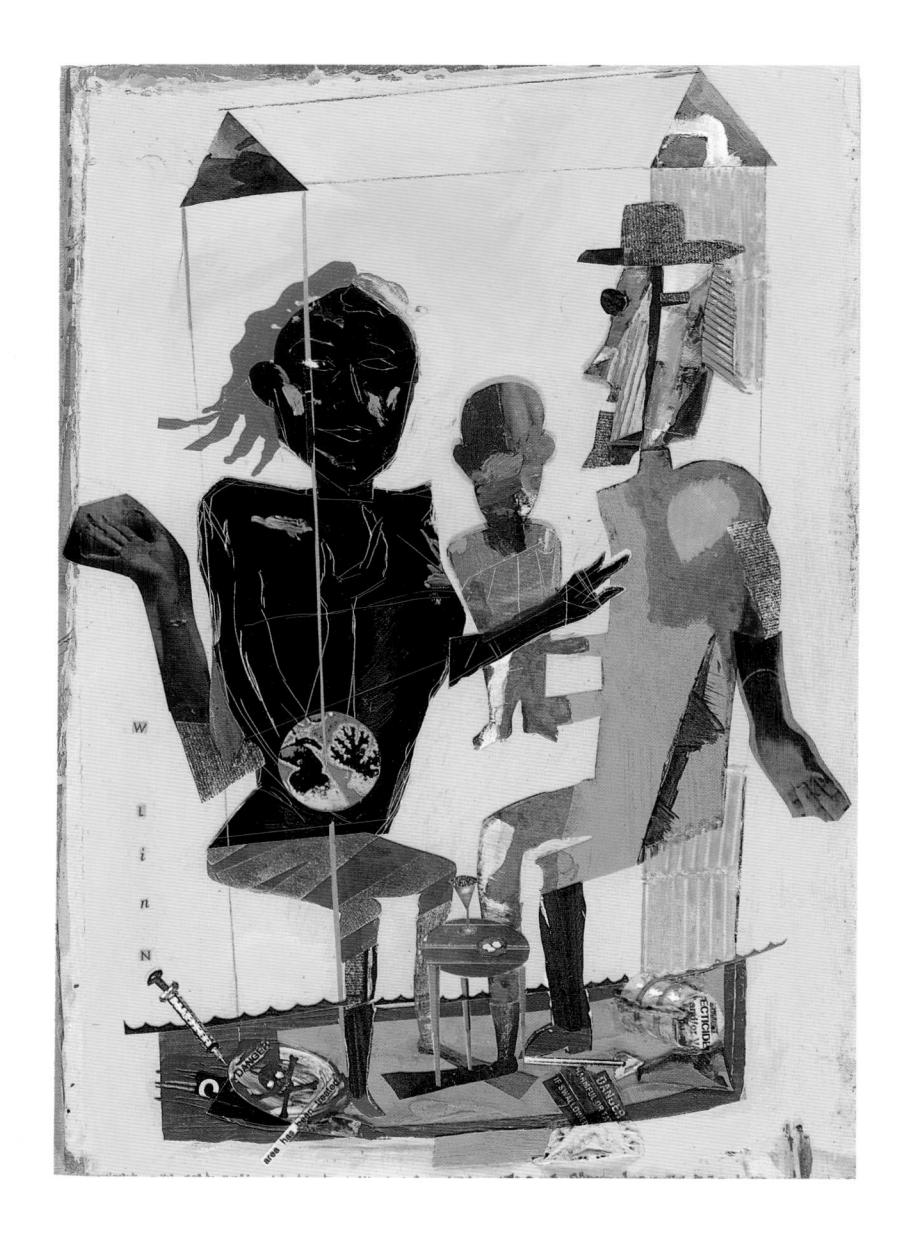

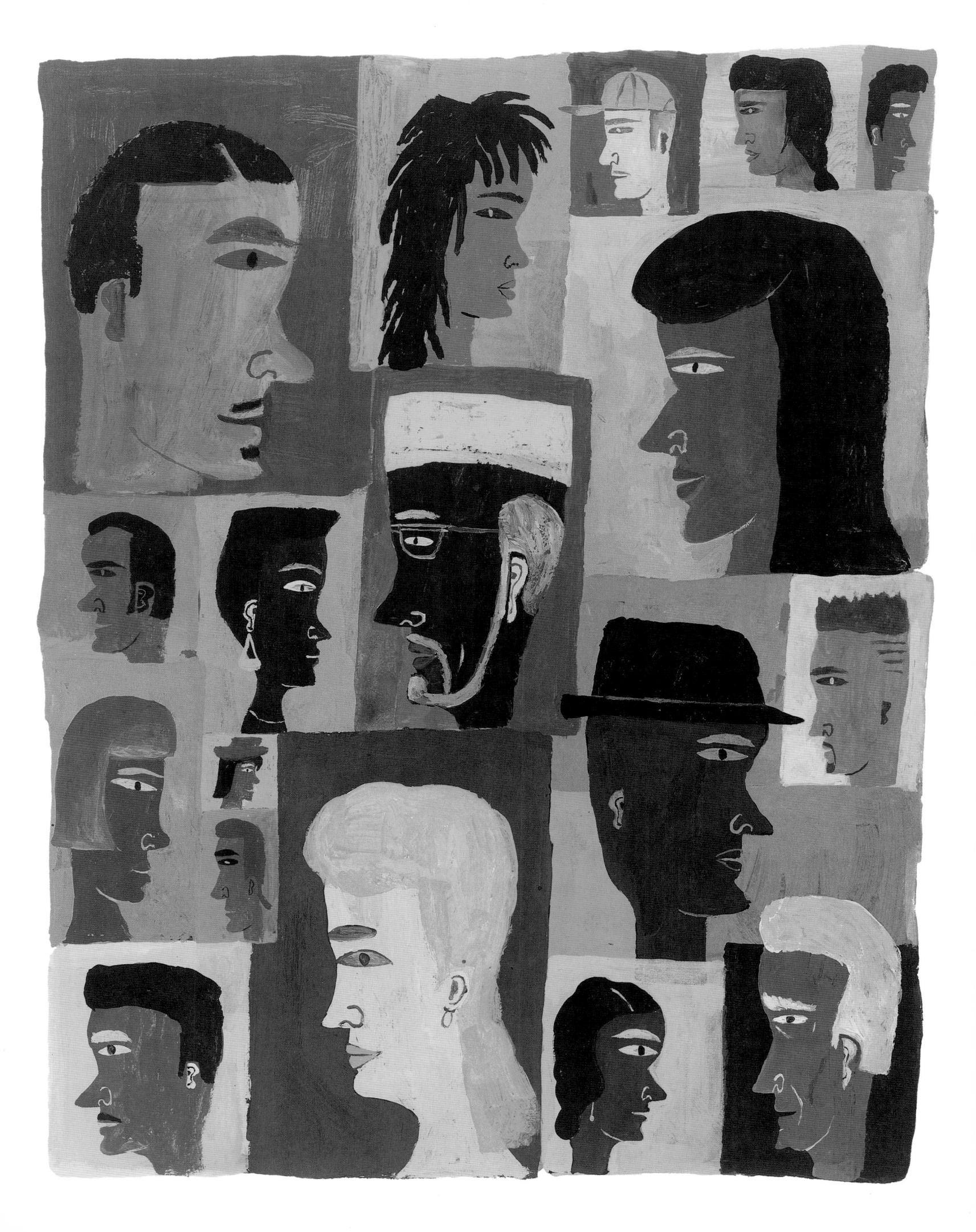

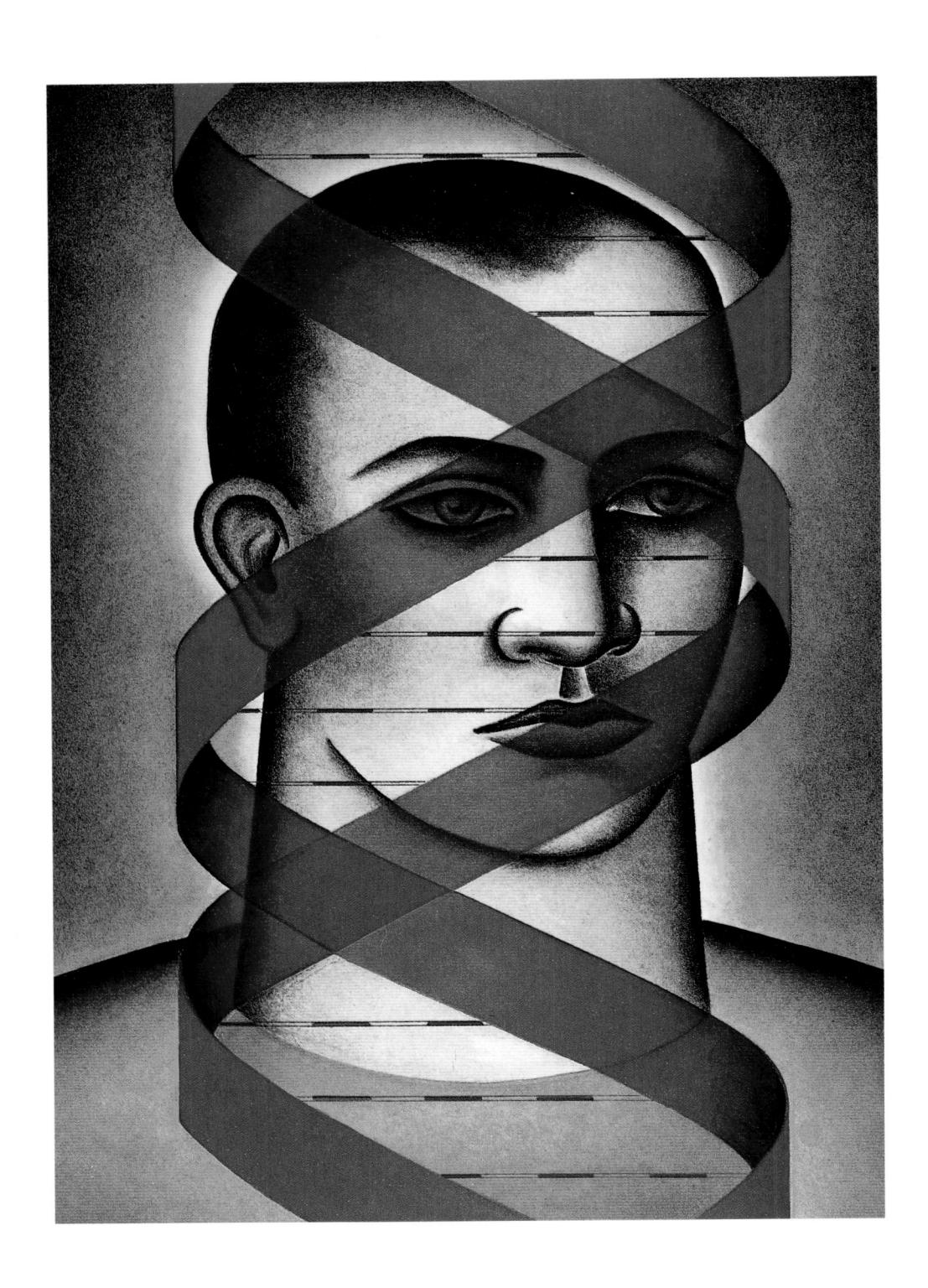

Sandra Dionisi

Art Director) Tom Suzuki Designer) Tim Cook Writers) William E. Winter and Mark A. Atkinson Publication) Diabetes Forecast Date) May 1992 Publisher) American Diabetes Association, Inc. Medium) Acrylic This illustration depicts the connection between diabetes and DNA.

Stefano Vitale

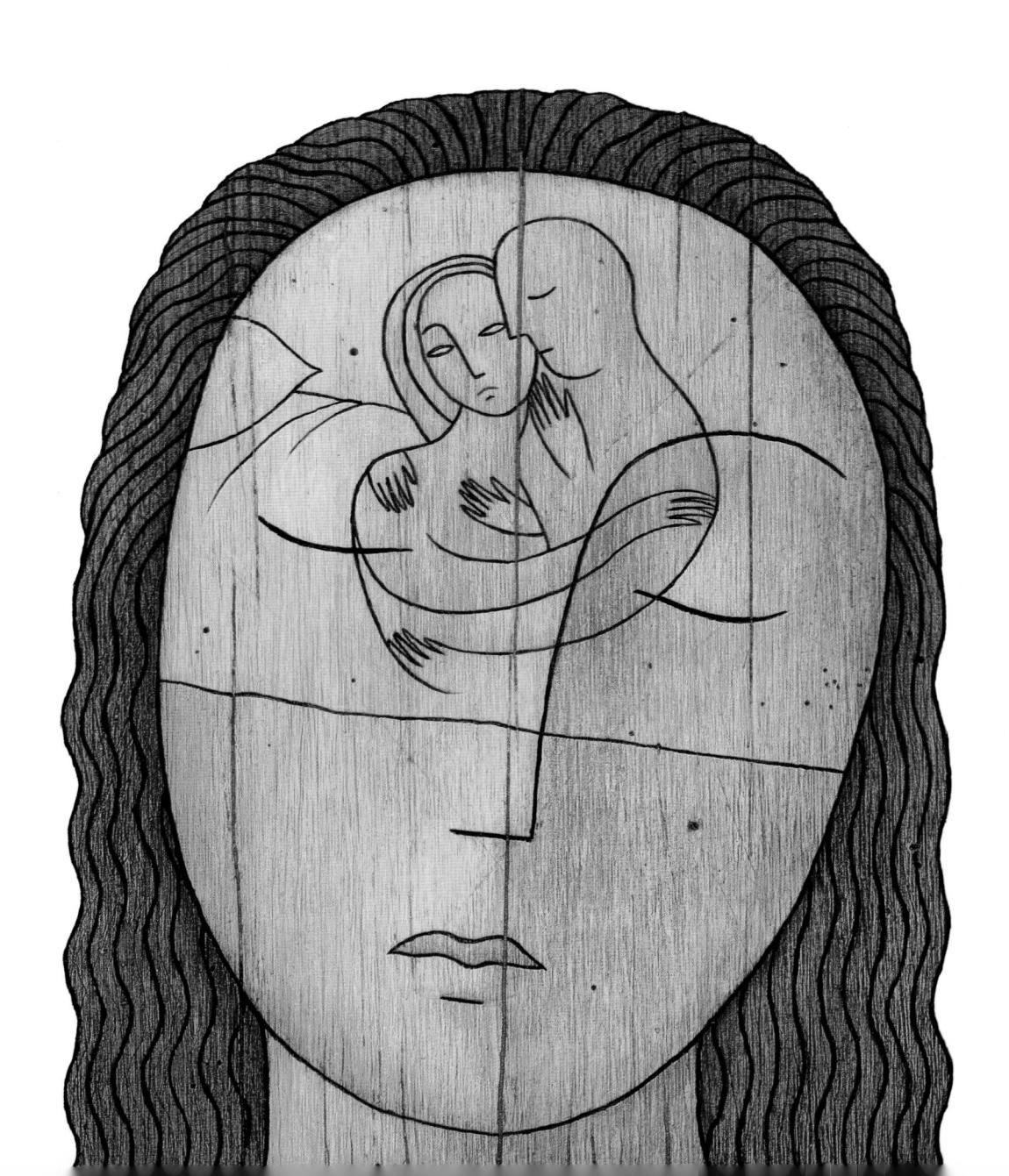

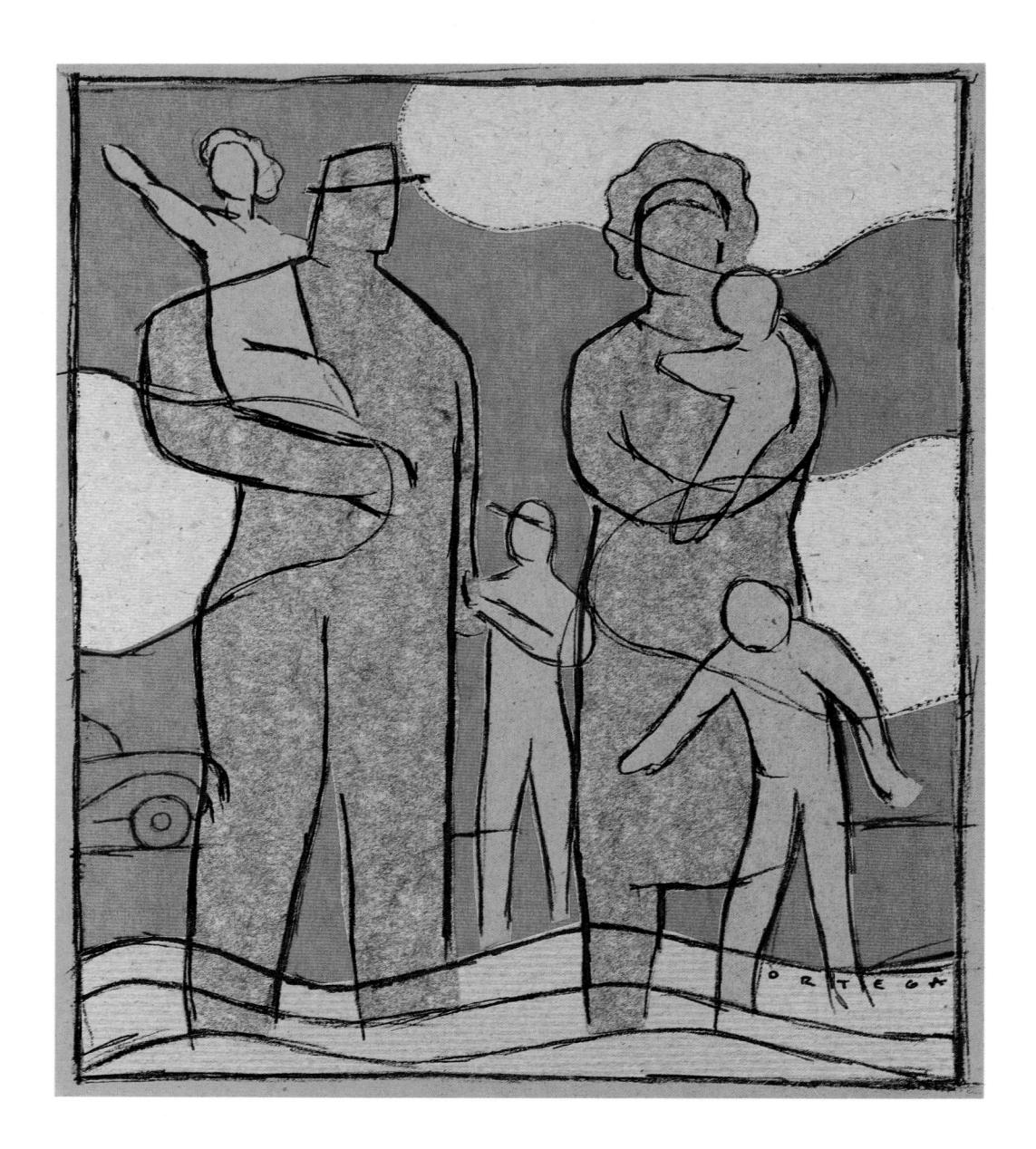

José Ortega

Art Director) Sarah Stearns Editor) William Inman Writer) Douglas C. McGill Publication) Bloomberg Magazine
Date) November 1992 Publisher) Michael Bloomberg Publishing Medium) Ink and watercolor
"Japan's Newest Invention" was the title of an article featuring this image.

Philippe Lardy

101

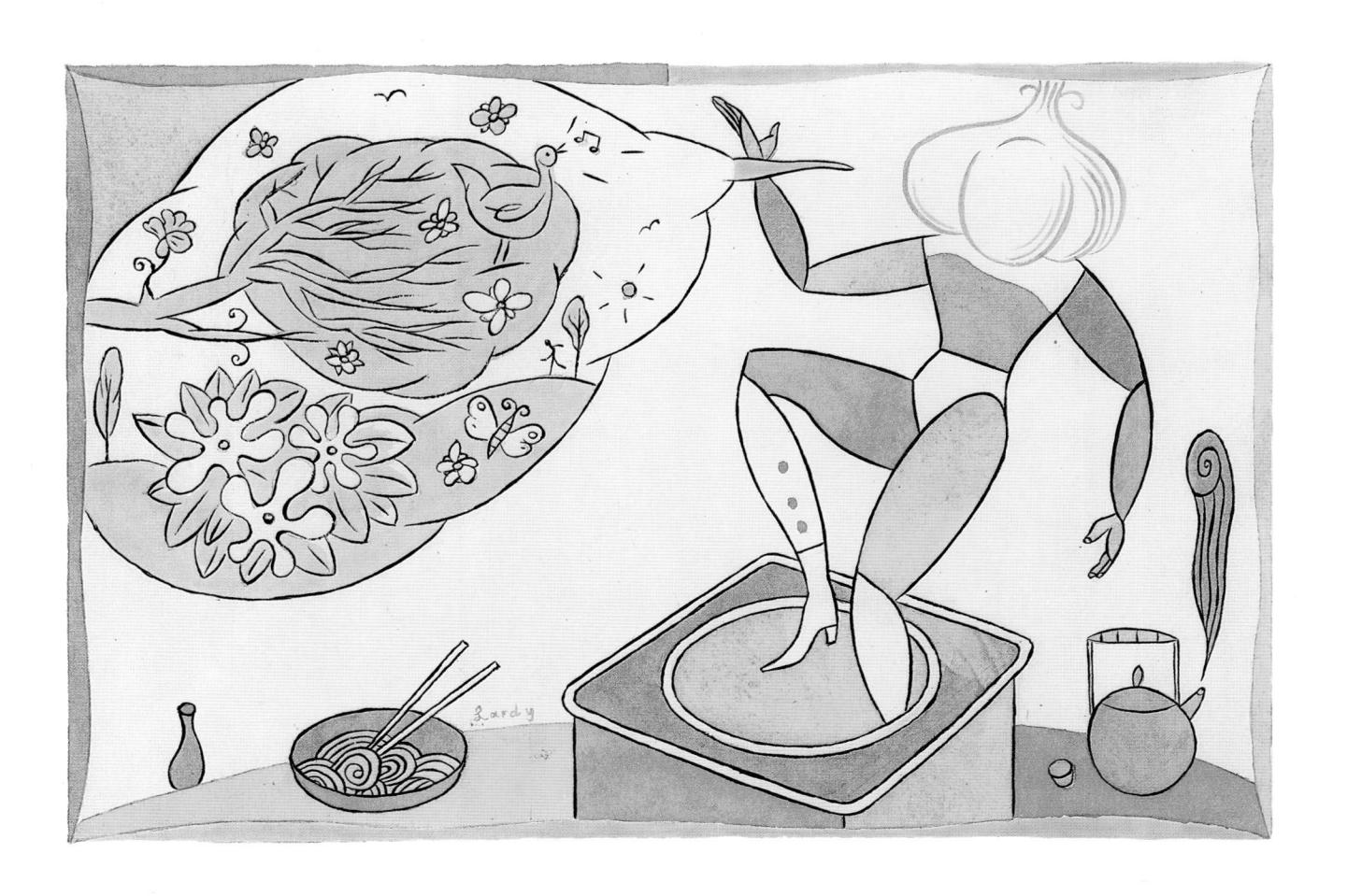

Art Director) Mark Koudys Editor) Betty Ewing-Pearse Publication) Digital News Date) Spring 1993
Publisher) Digital Equipment of Canada, Ltd. Medium) Pen and ink, watercolor, and collage
This illustration charts the evolution of the business enterprise, from supplier to business partner.

Barry Blitt

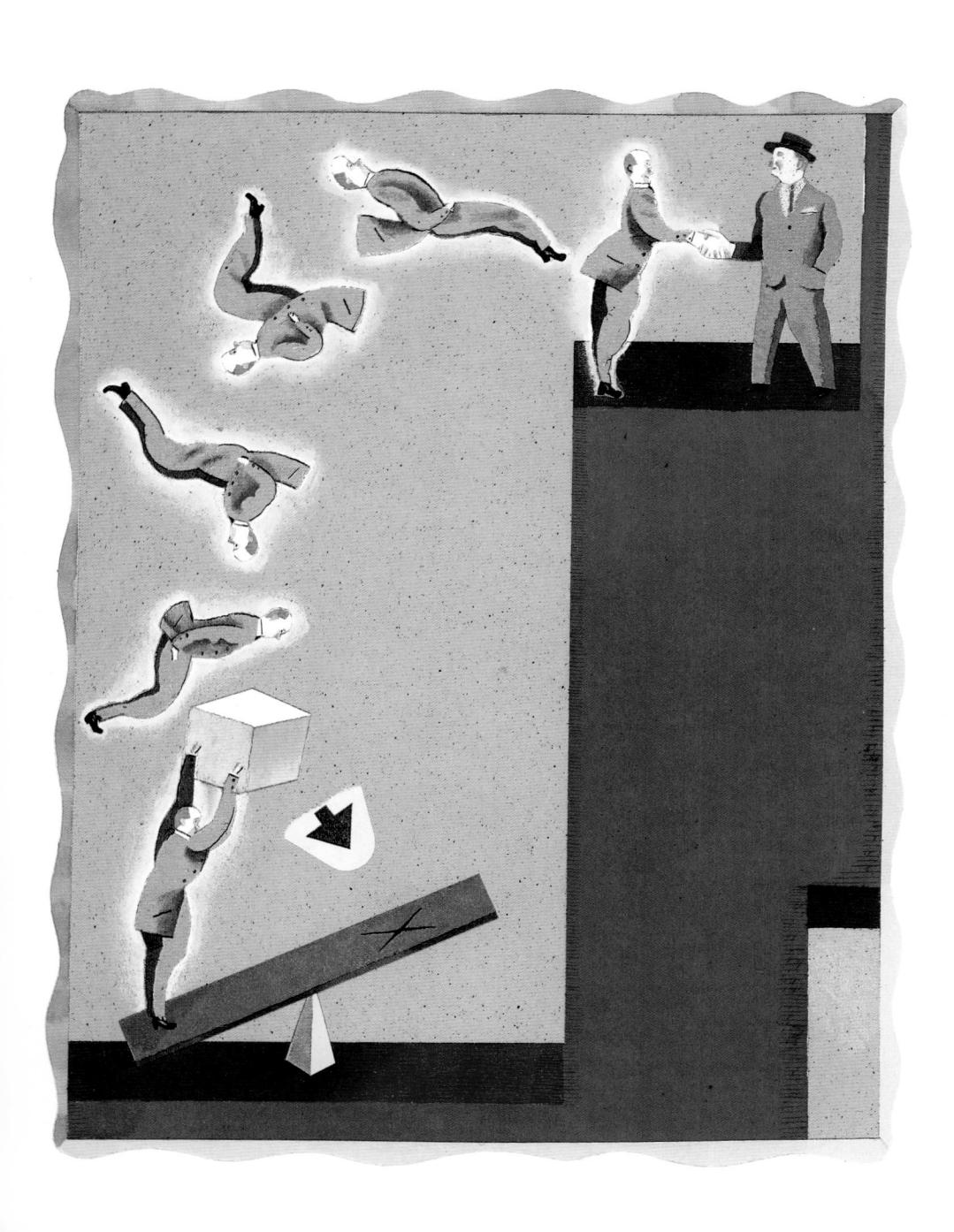

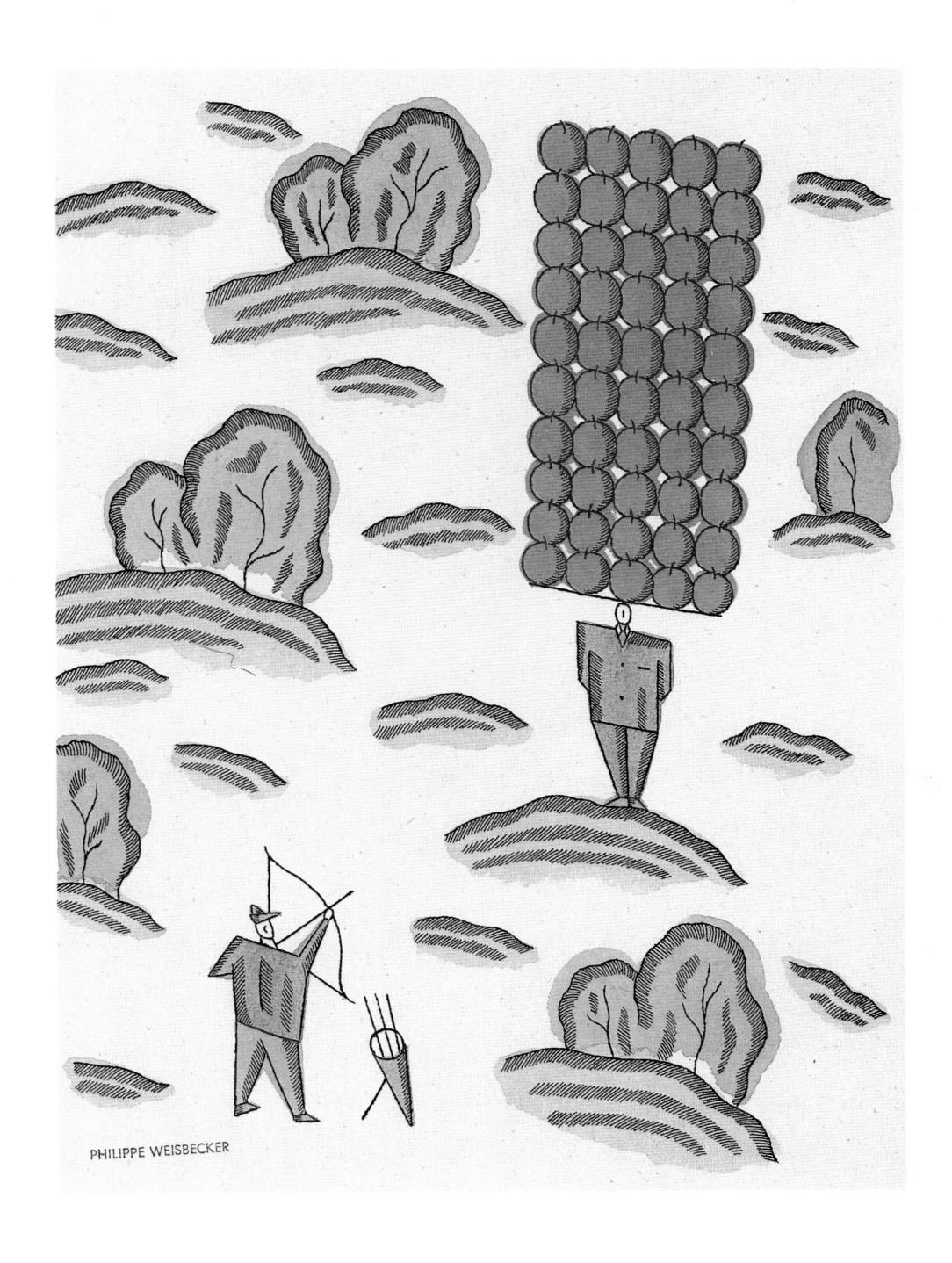

Philippe Welsbecker

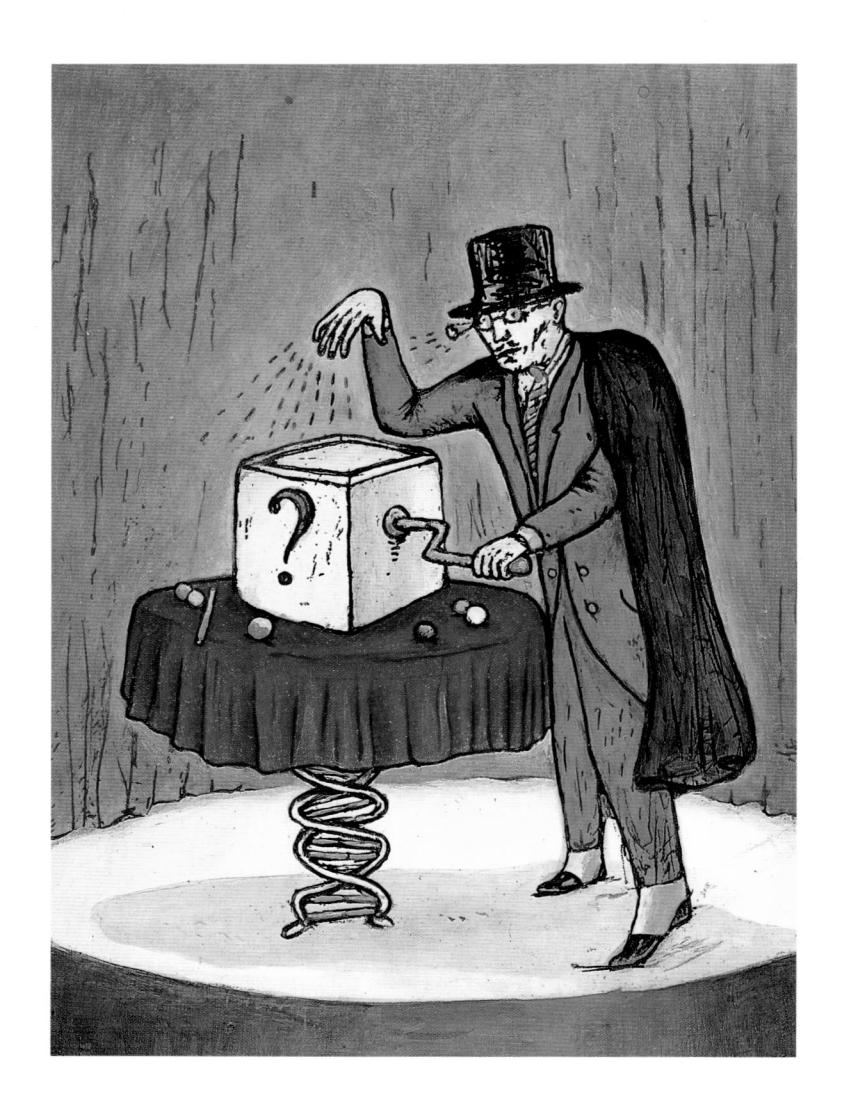

Jonathon Rosen

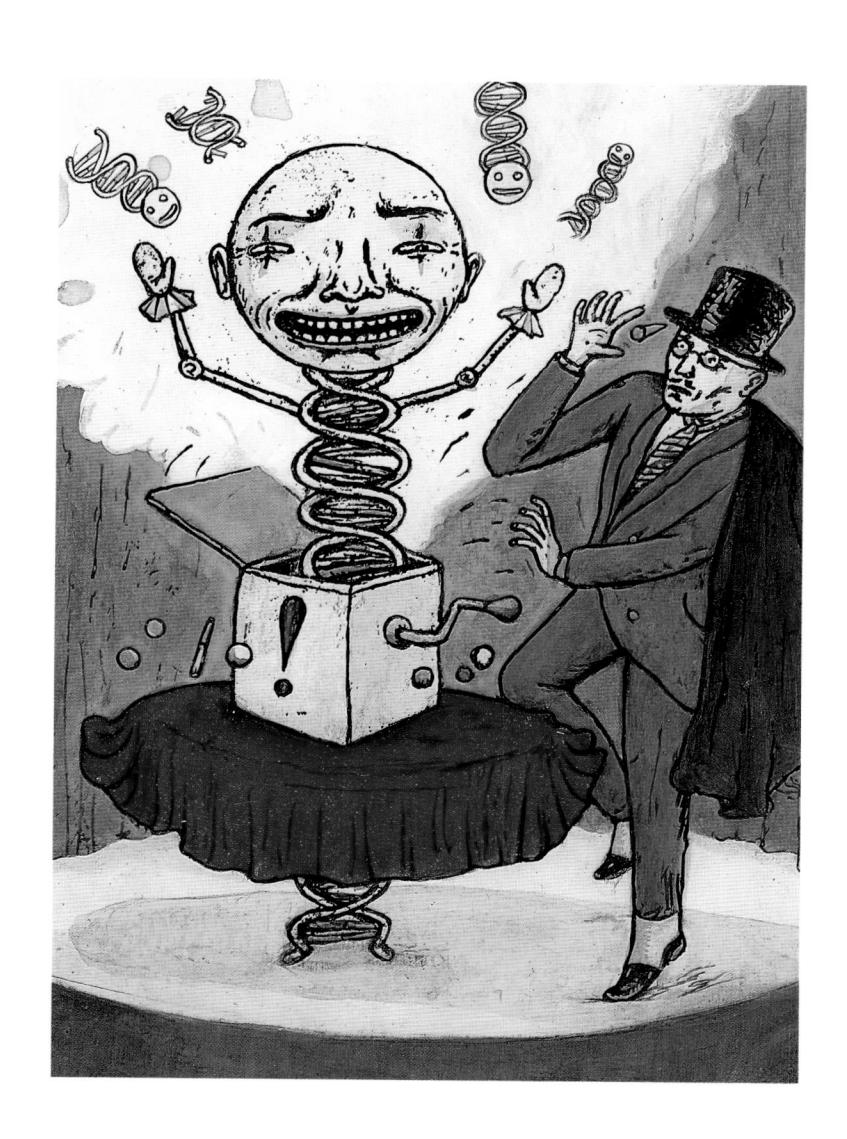

Michael Bartalos
Art Director) Cindy Hoffman Editor) Gall Ravglala Writer) Ellen Steinbaum Publication) The Boston Globe
Date) April 25, 1993 Publisher) Affiliated Publications, Inc. Medium) Mixed media "The Resilient Ones," an article examining the factors that allow children to survive dysfunctional upbringings, was accompanied by this illustration.

Steven Guarnaccia

107

gli occhiali di Le Corbusier

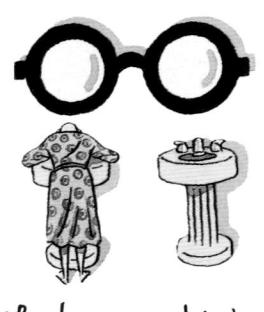

il bagno di Le Corbusier

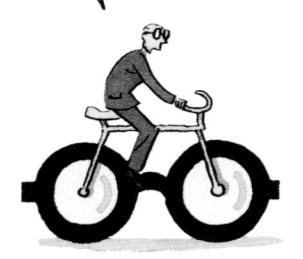

la bicicletta di Le Corbusier

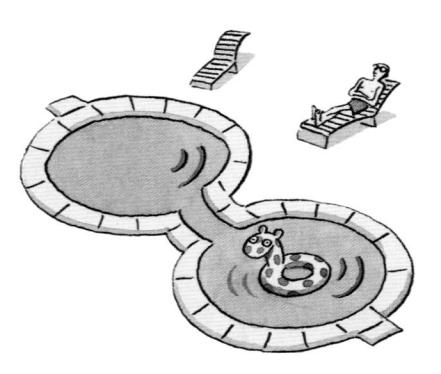

La piscina di Le Corbusier

L'orologio di Le Corbusier

La musica di Le Corbusier il biliardo di Le Corbusier

Steven Guarnaccia

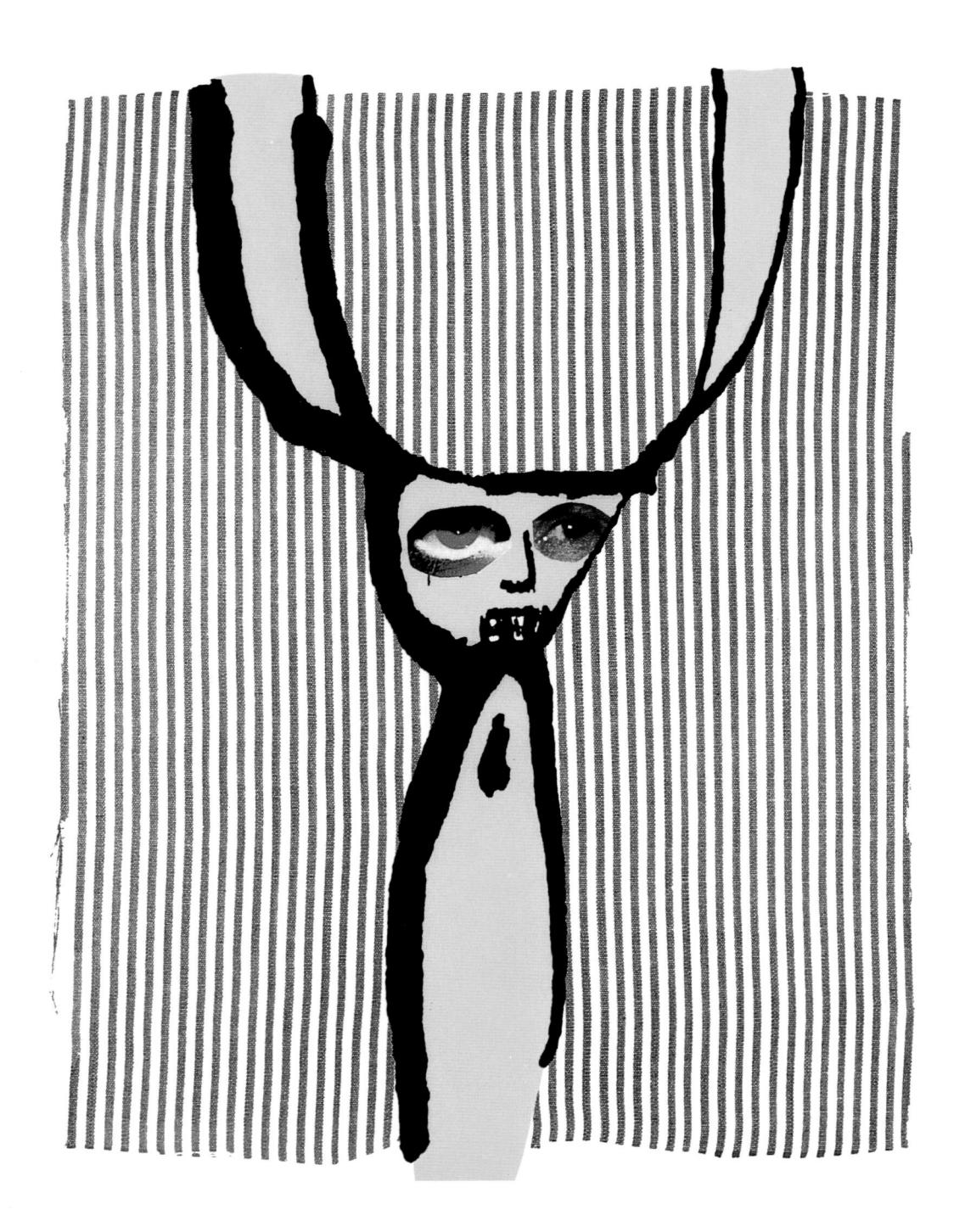

109

Scott Menchin

Scott Menchin

110

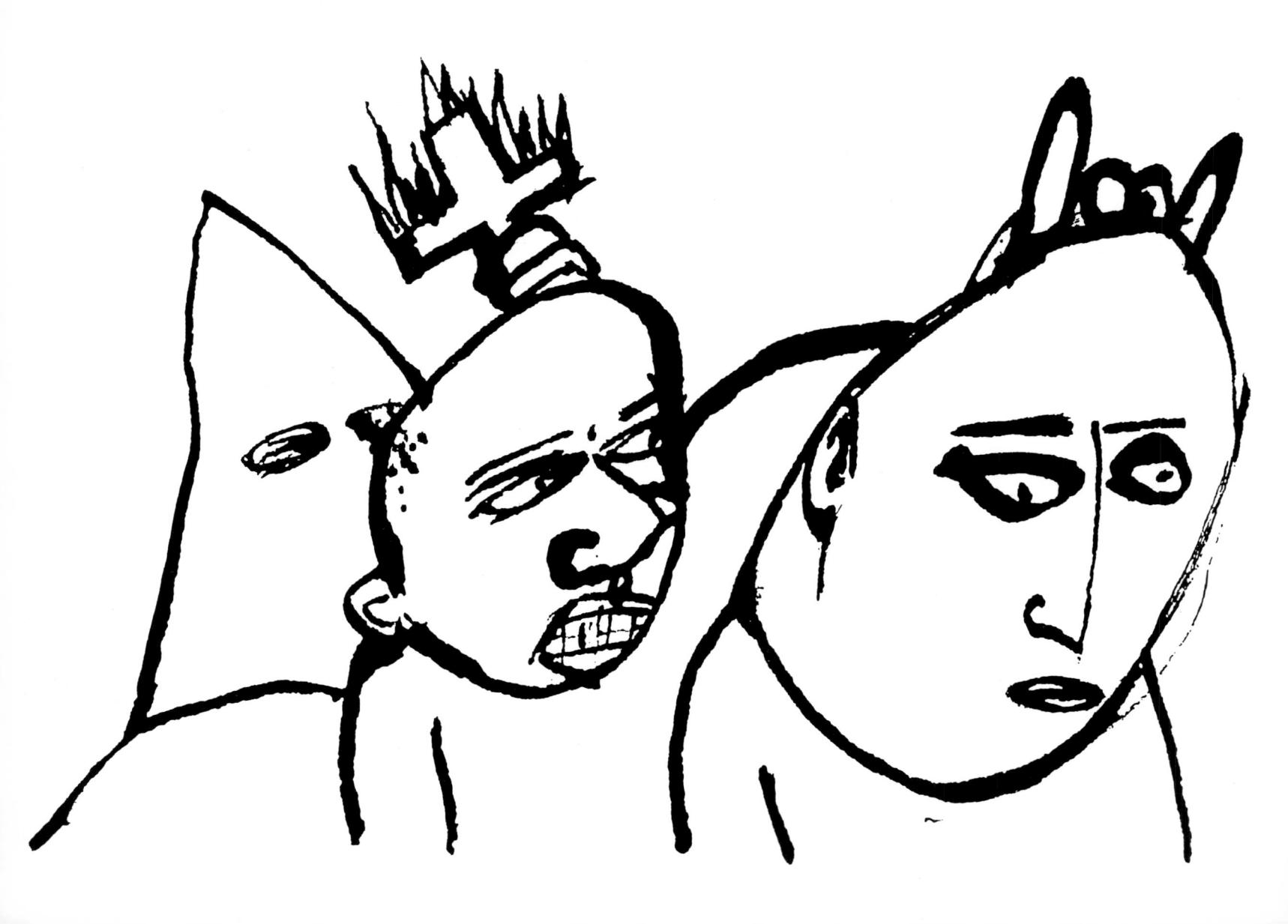

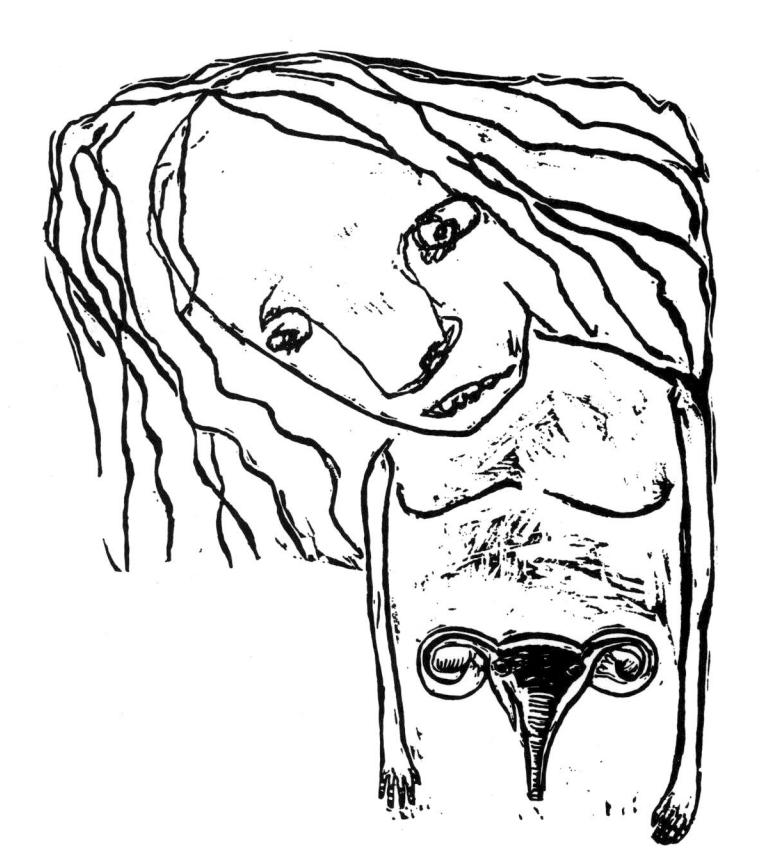

Frances Jetter

PR DE

David Diaz

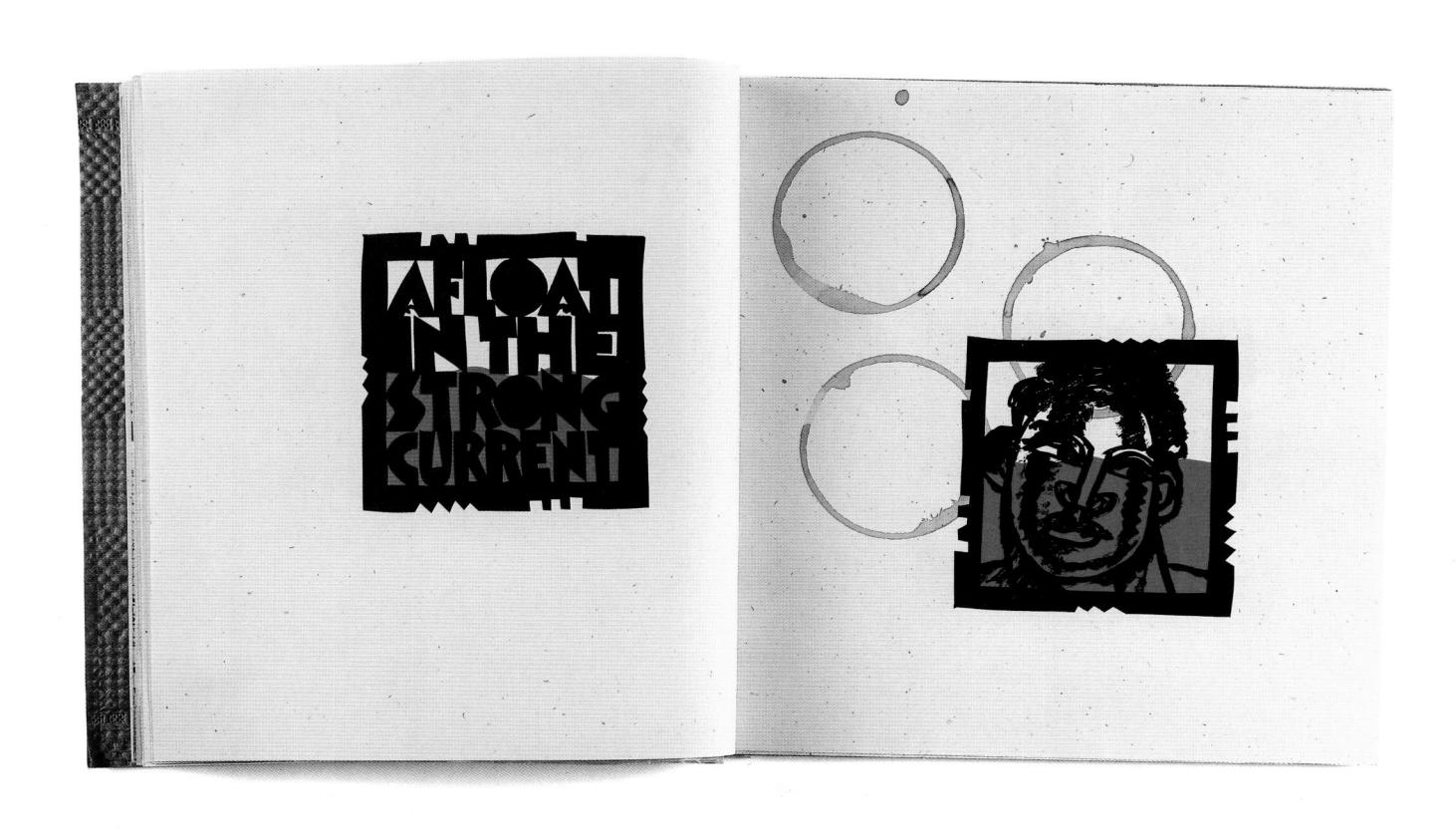

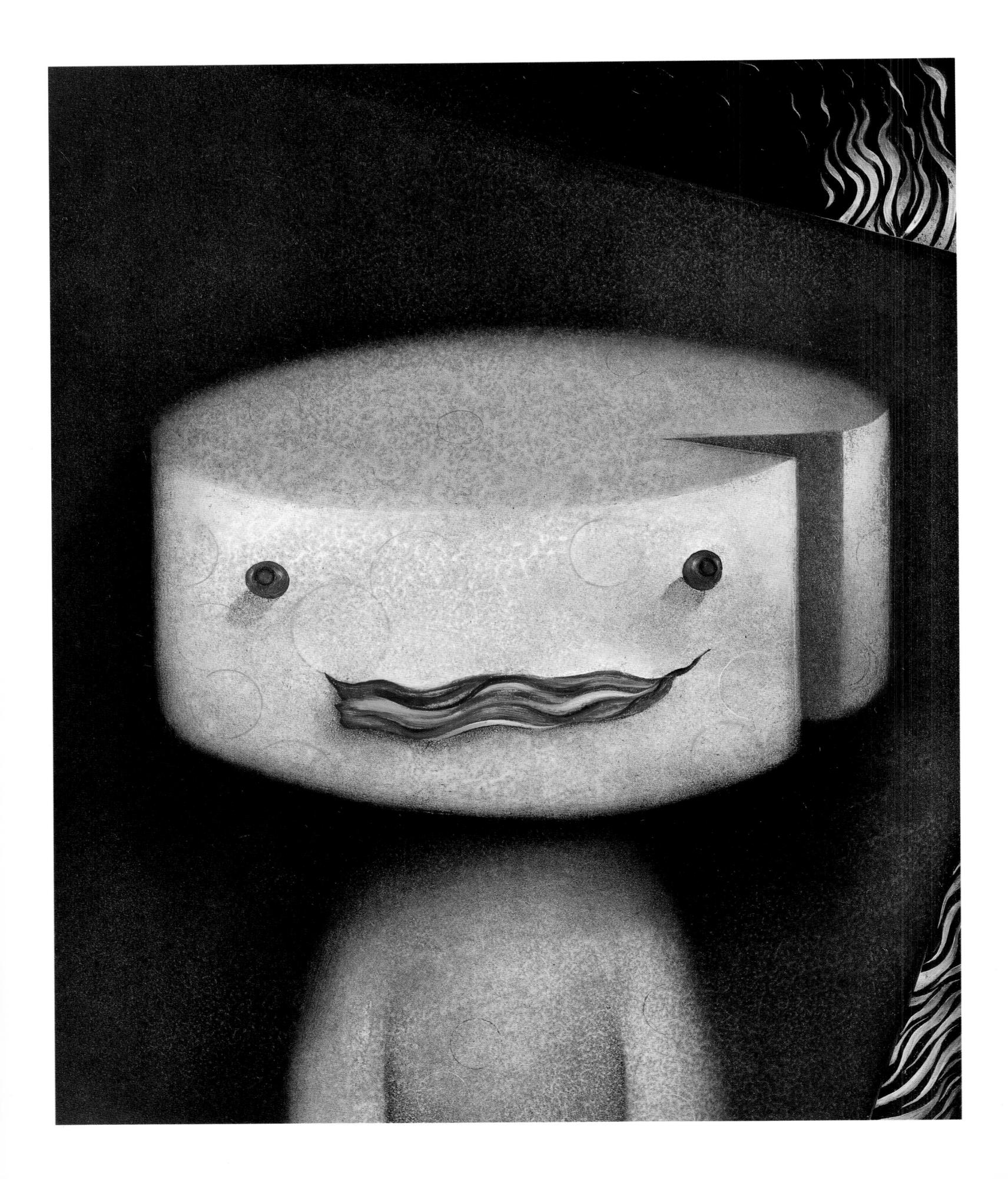

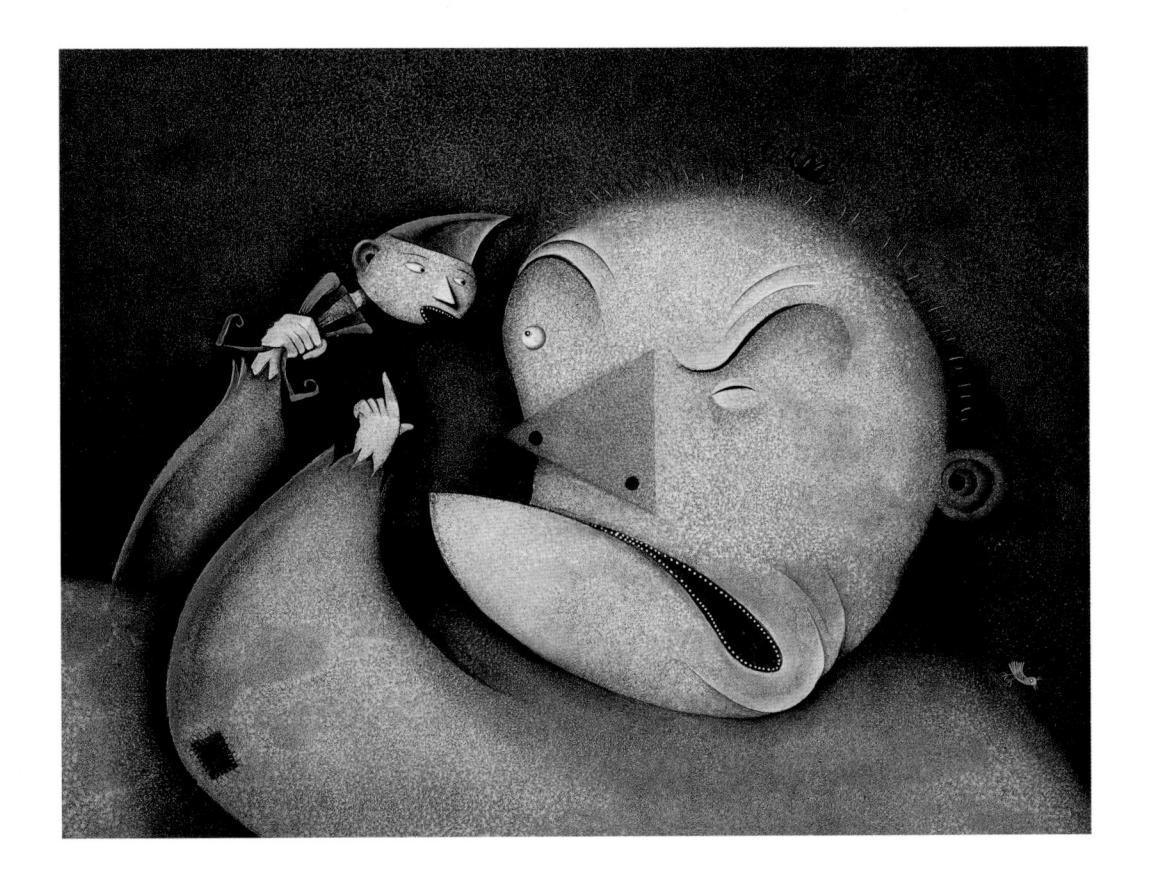

Lane Smith

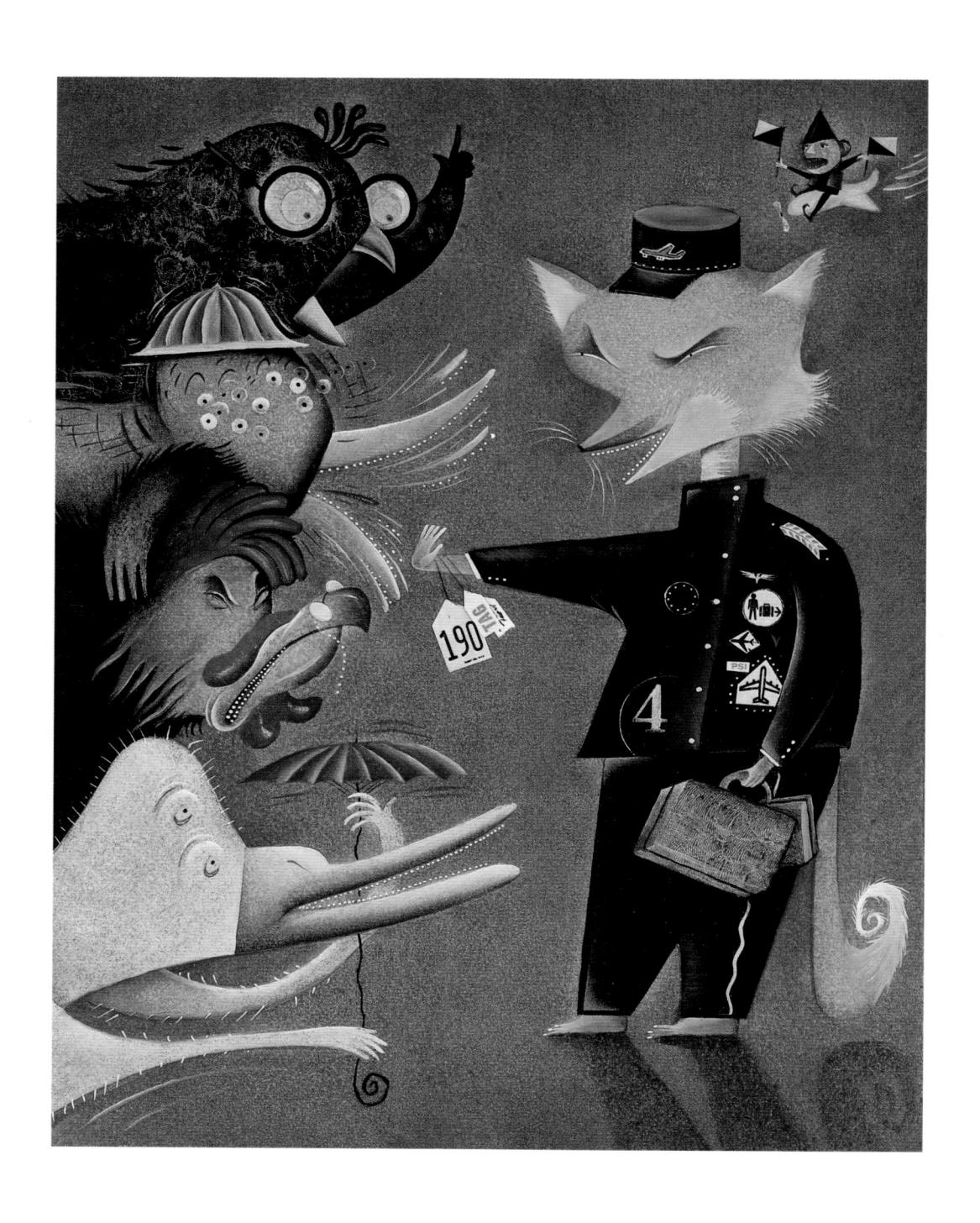

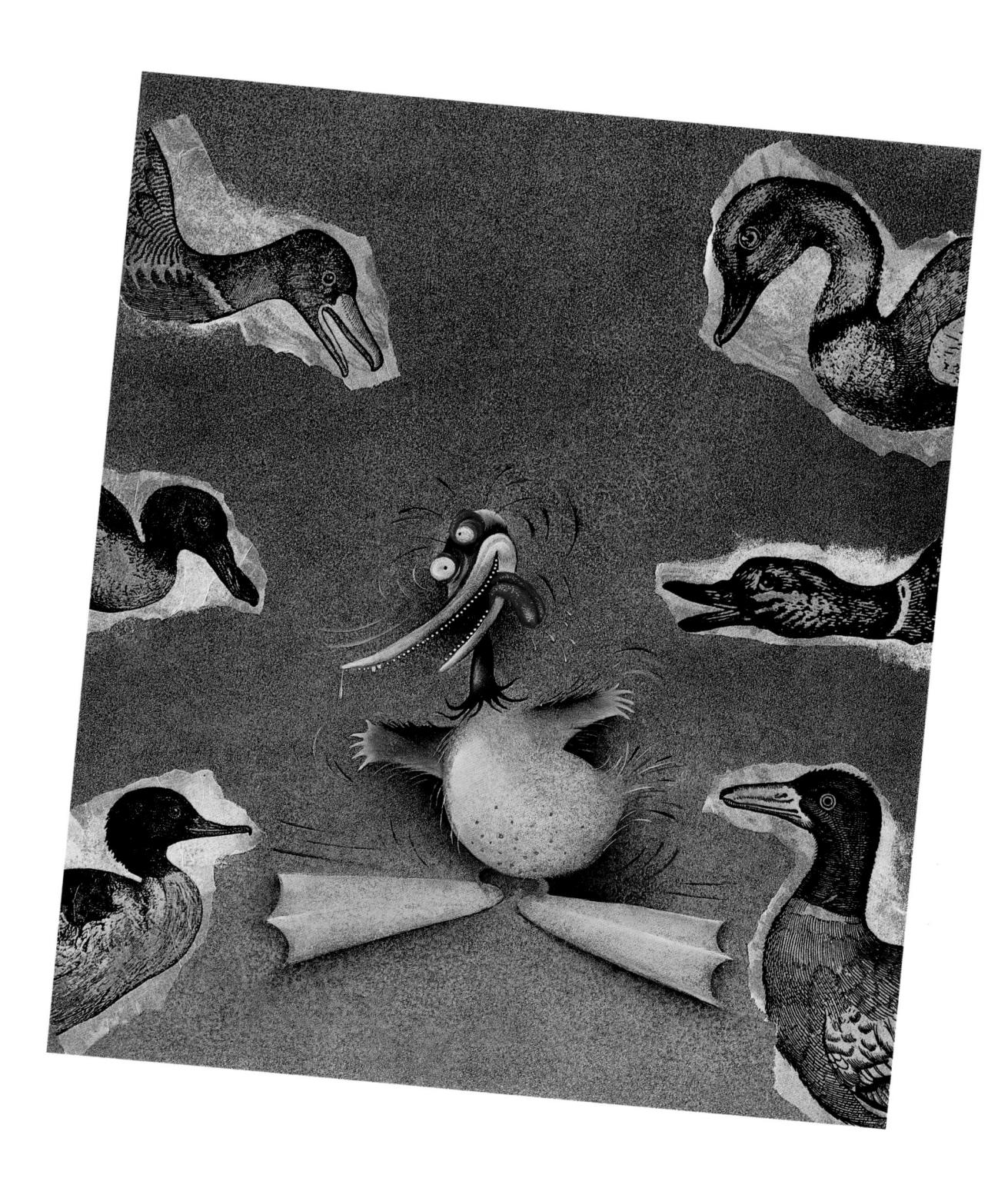

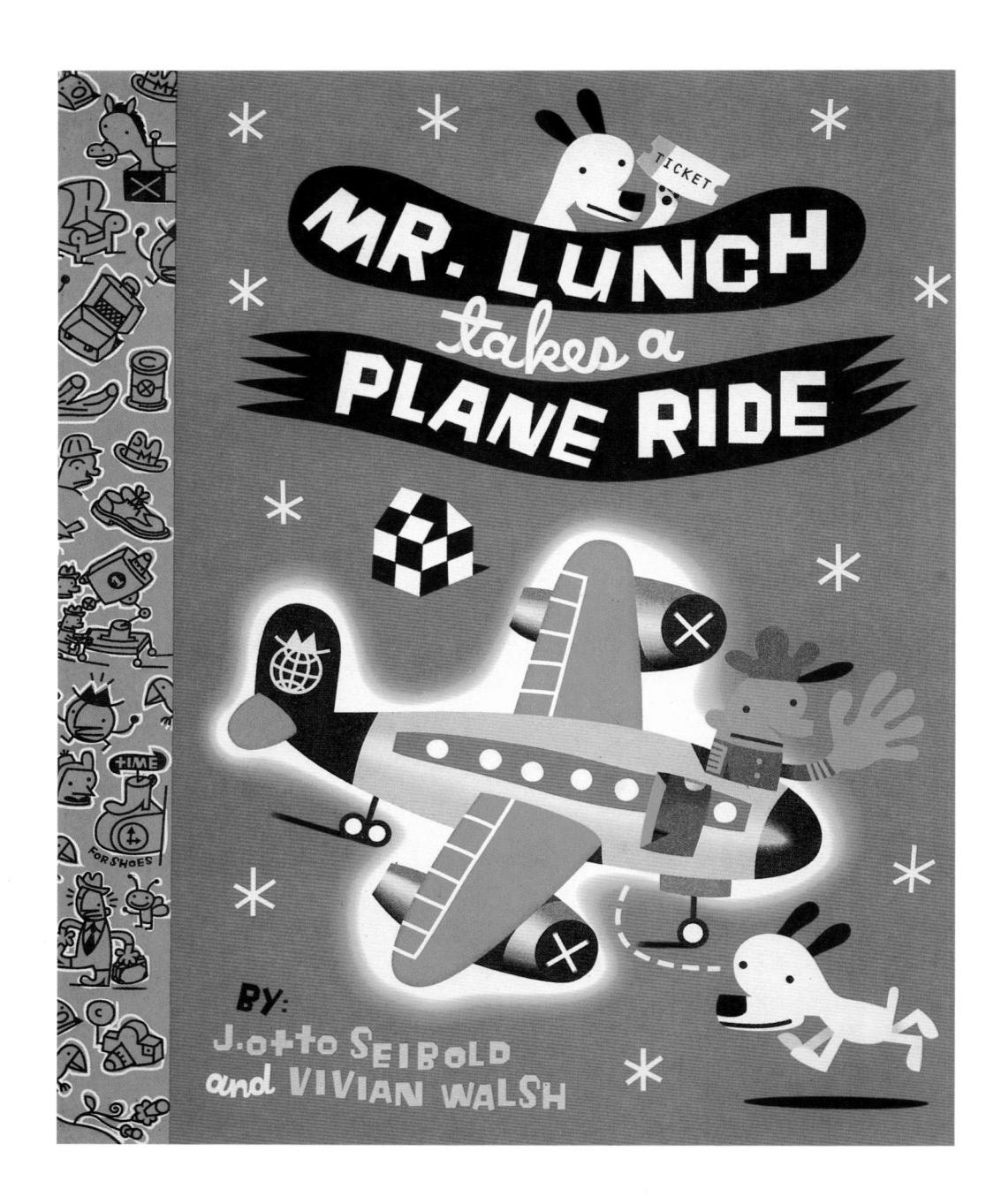

J. Otto Seibold

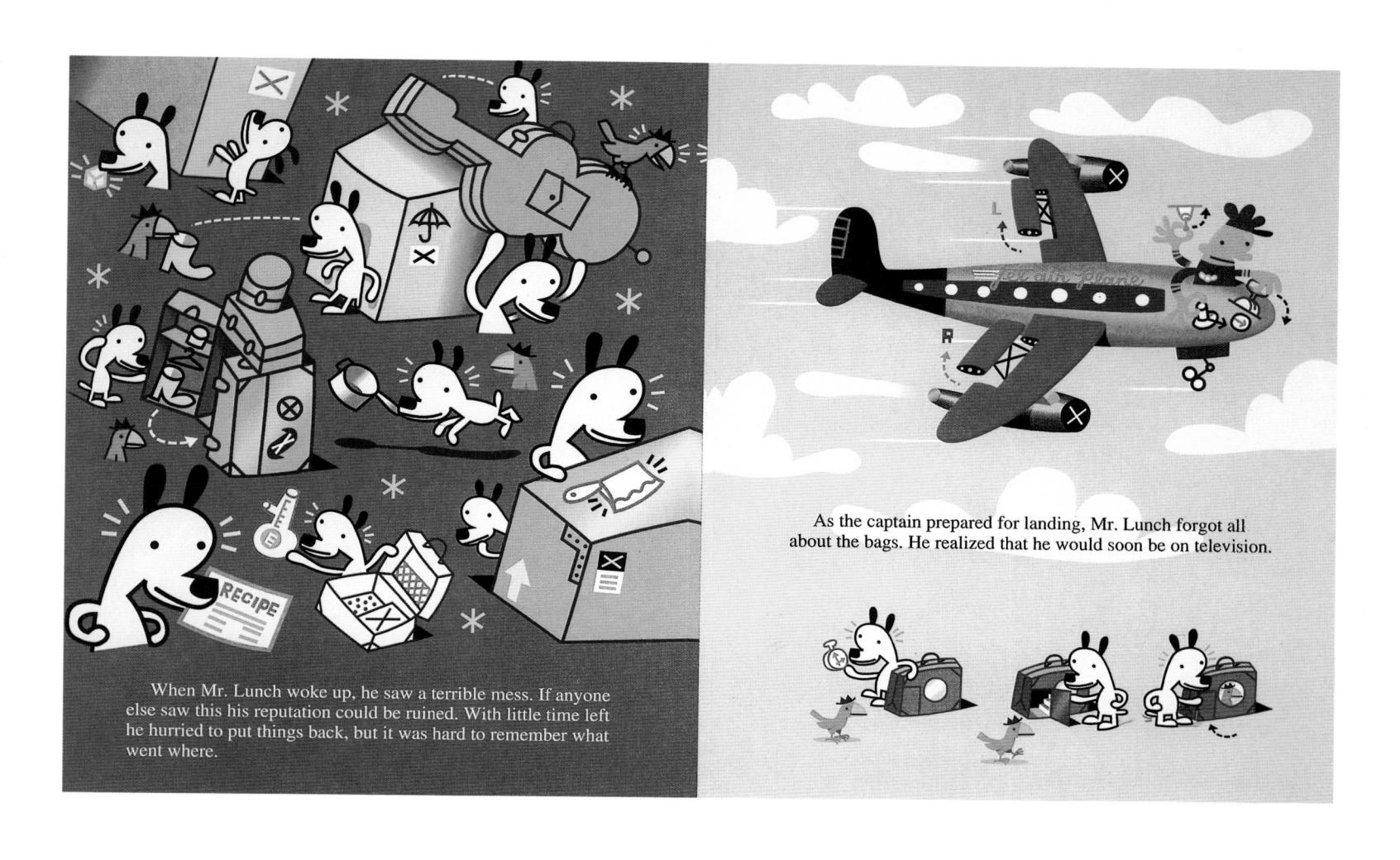

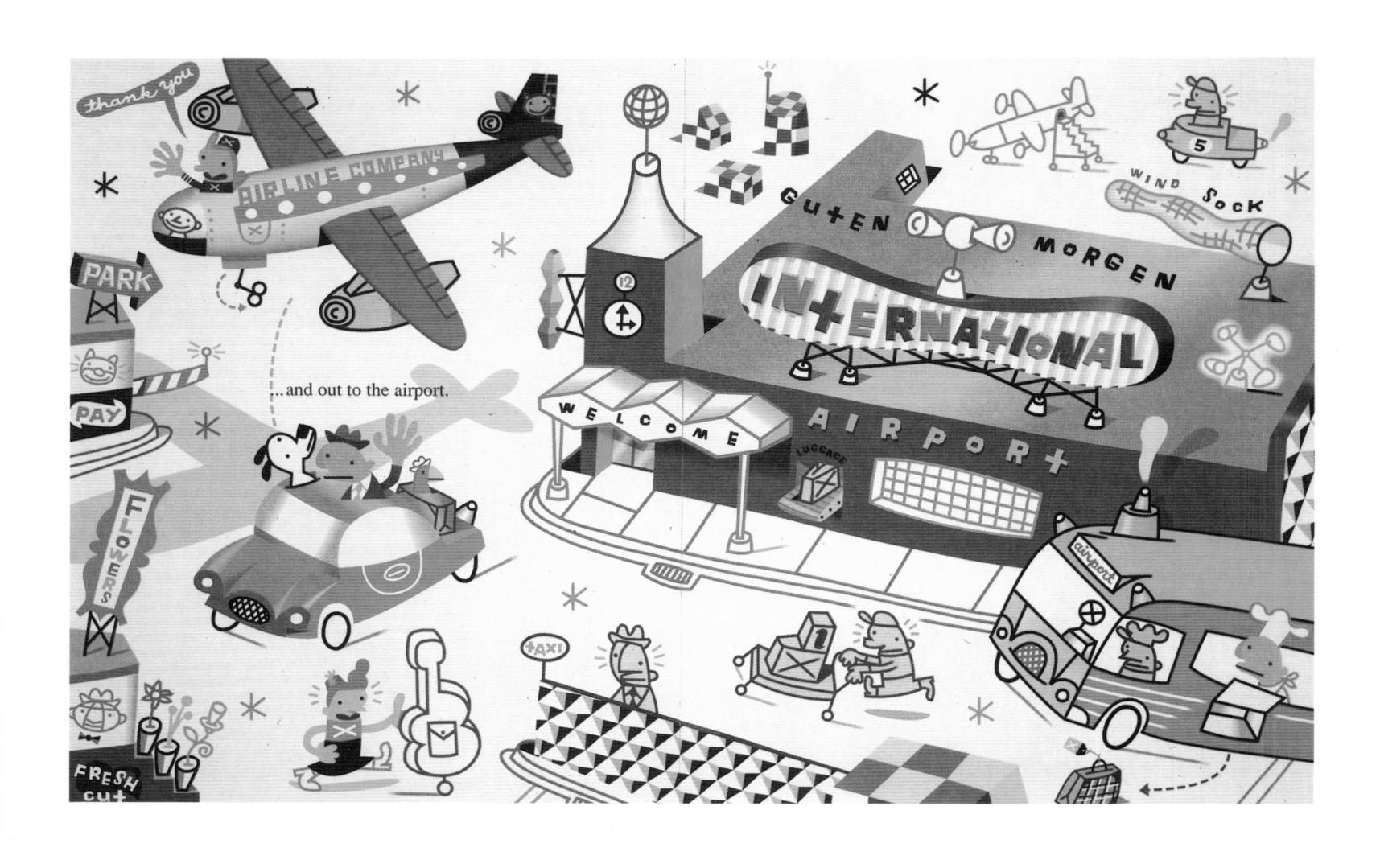

Richard McGuire

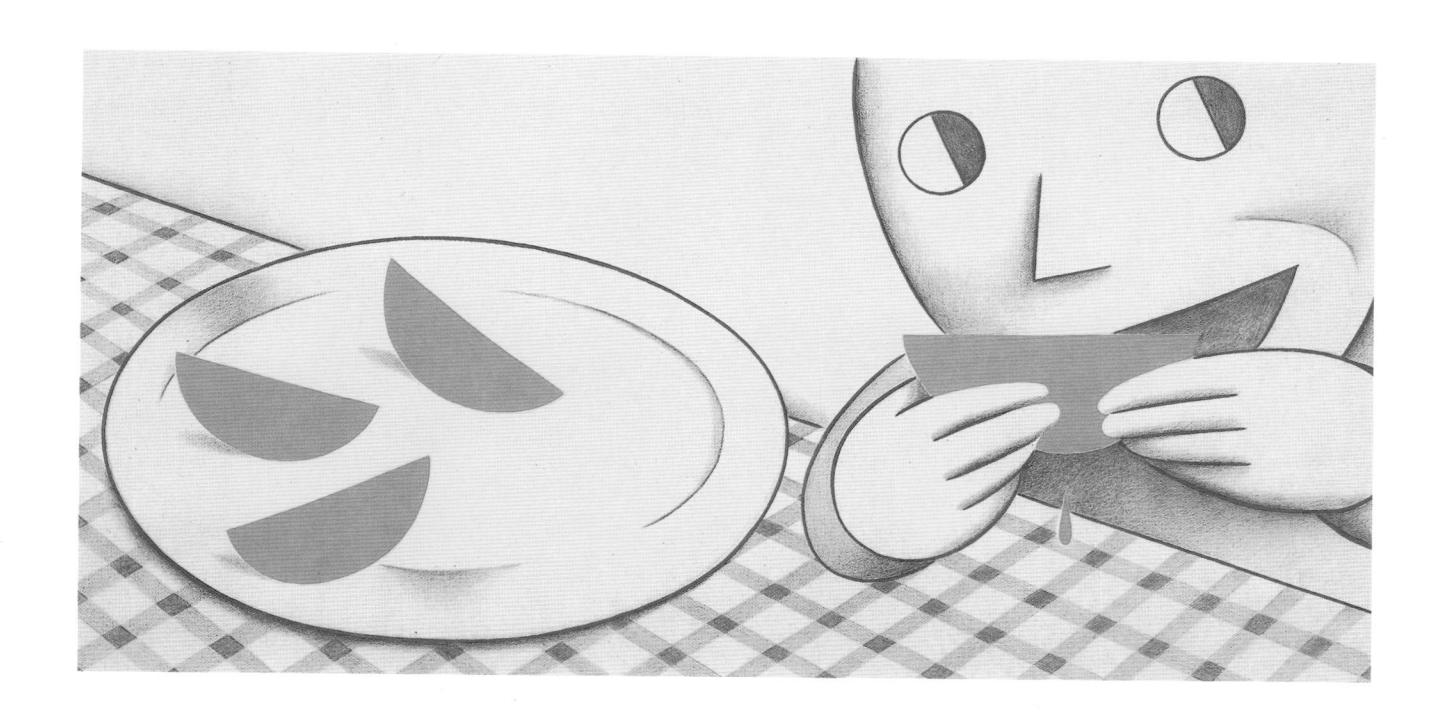

129

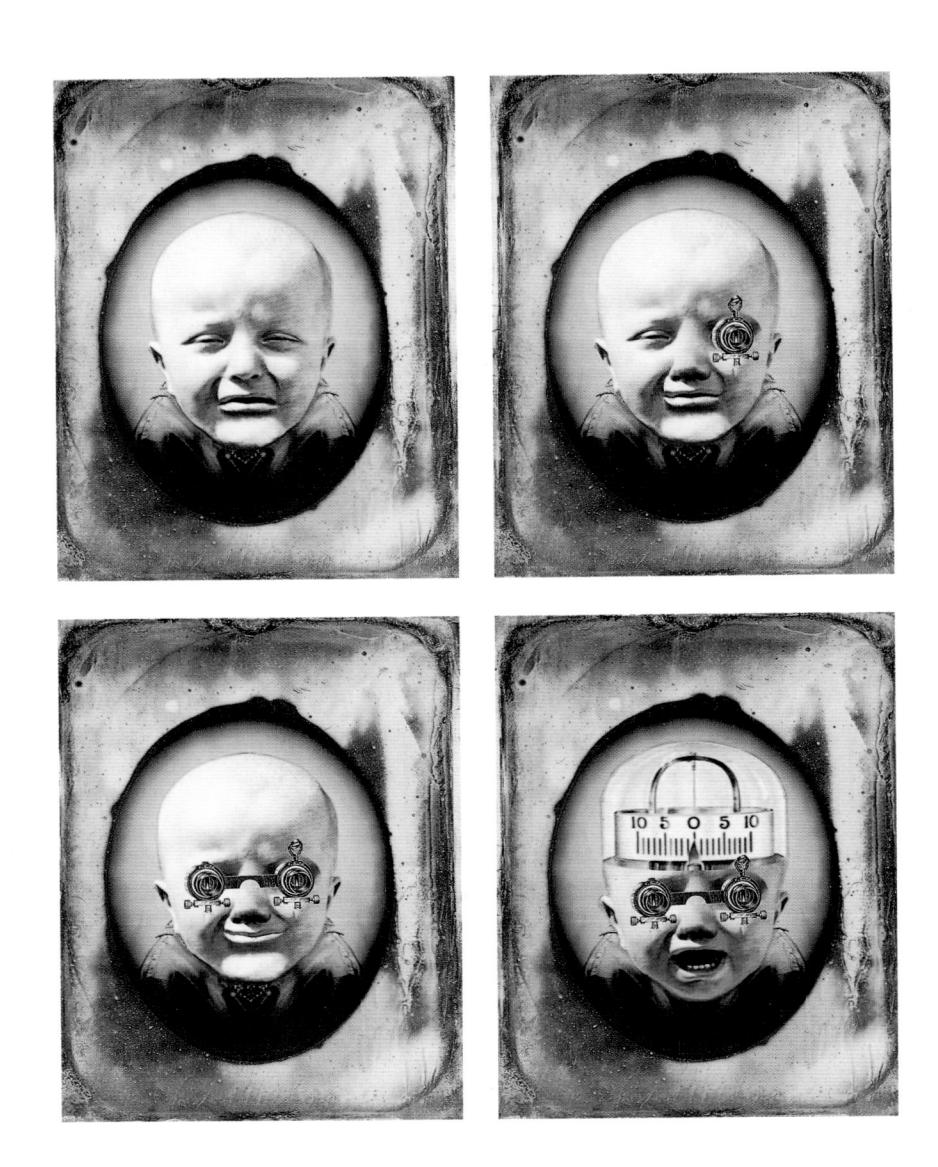

John Borruso

Ma**rk Ryd**en

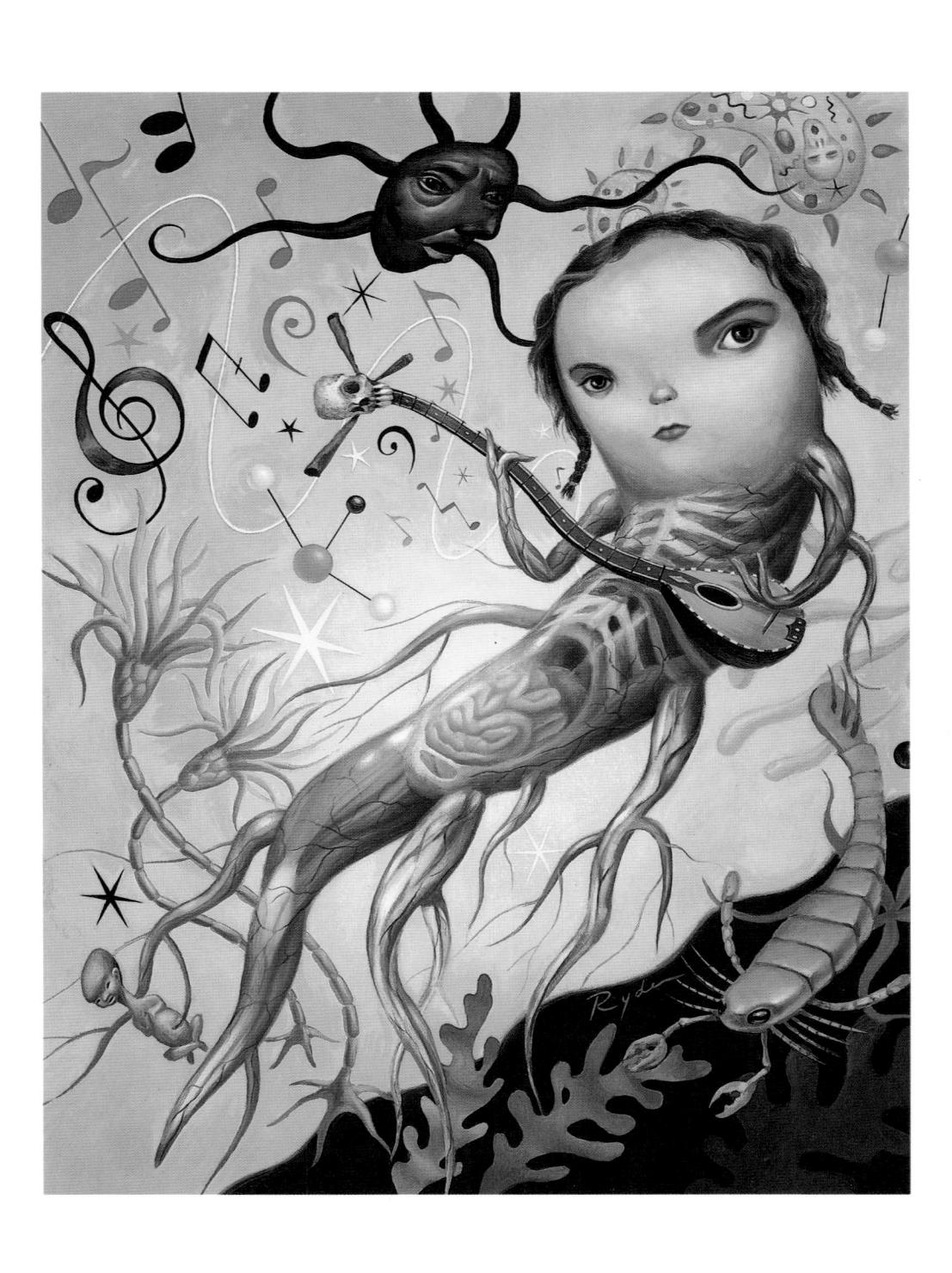

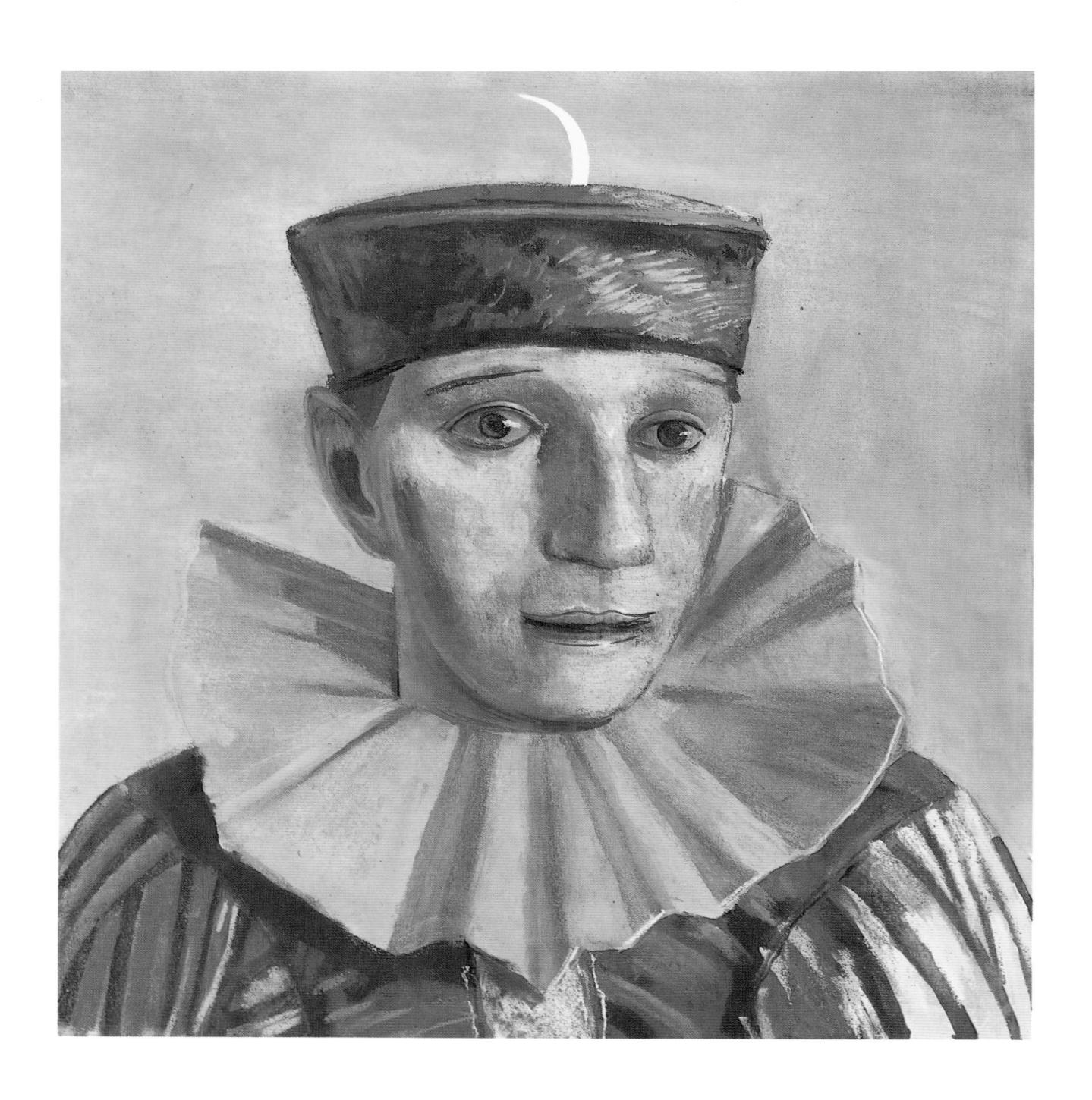

John Collier

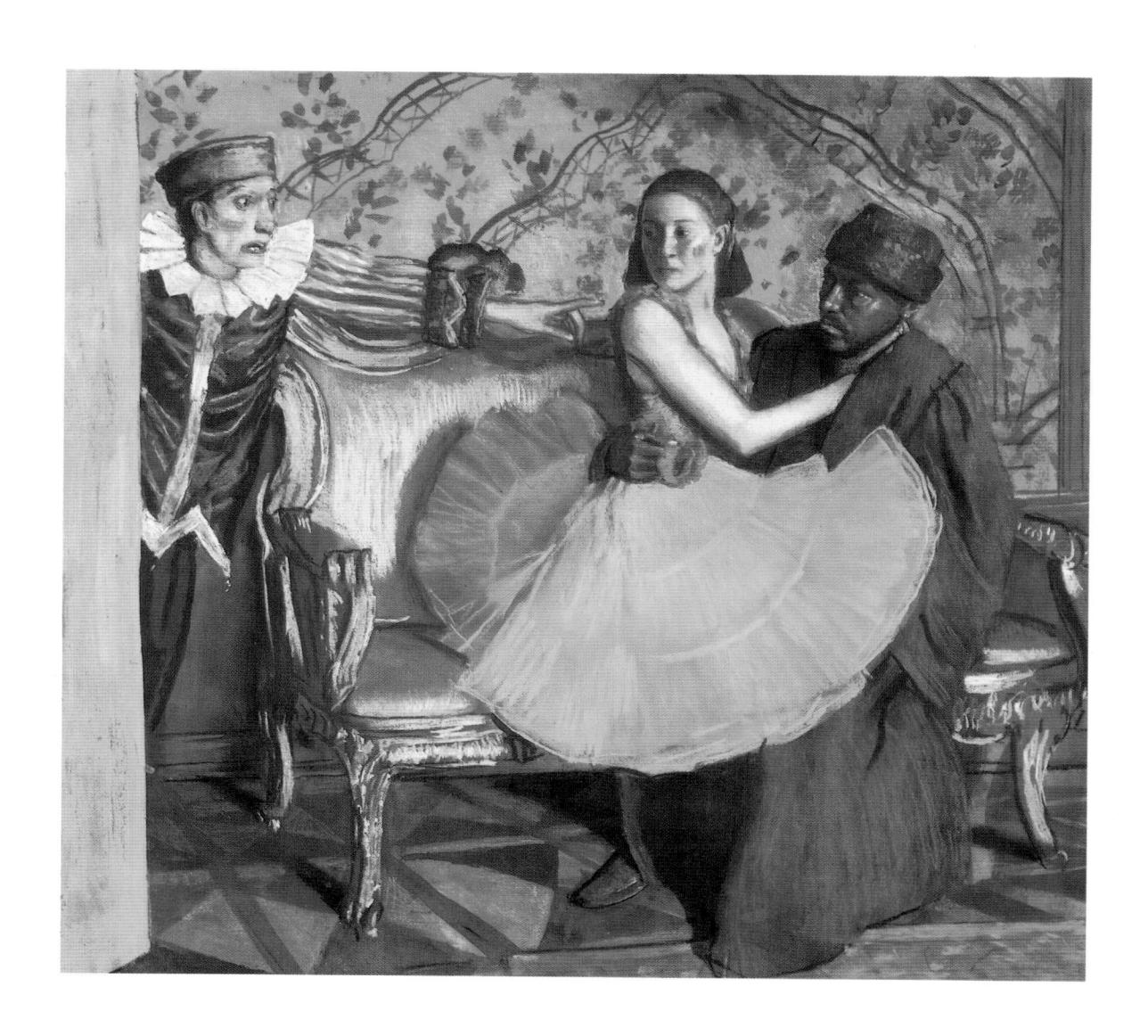

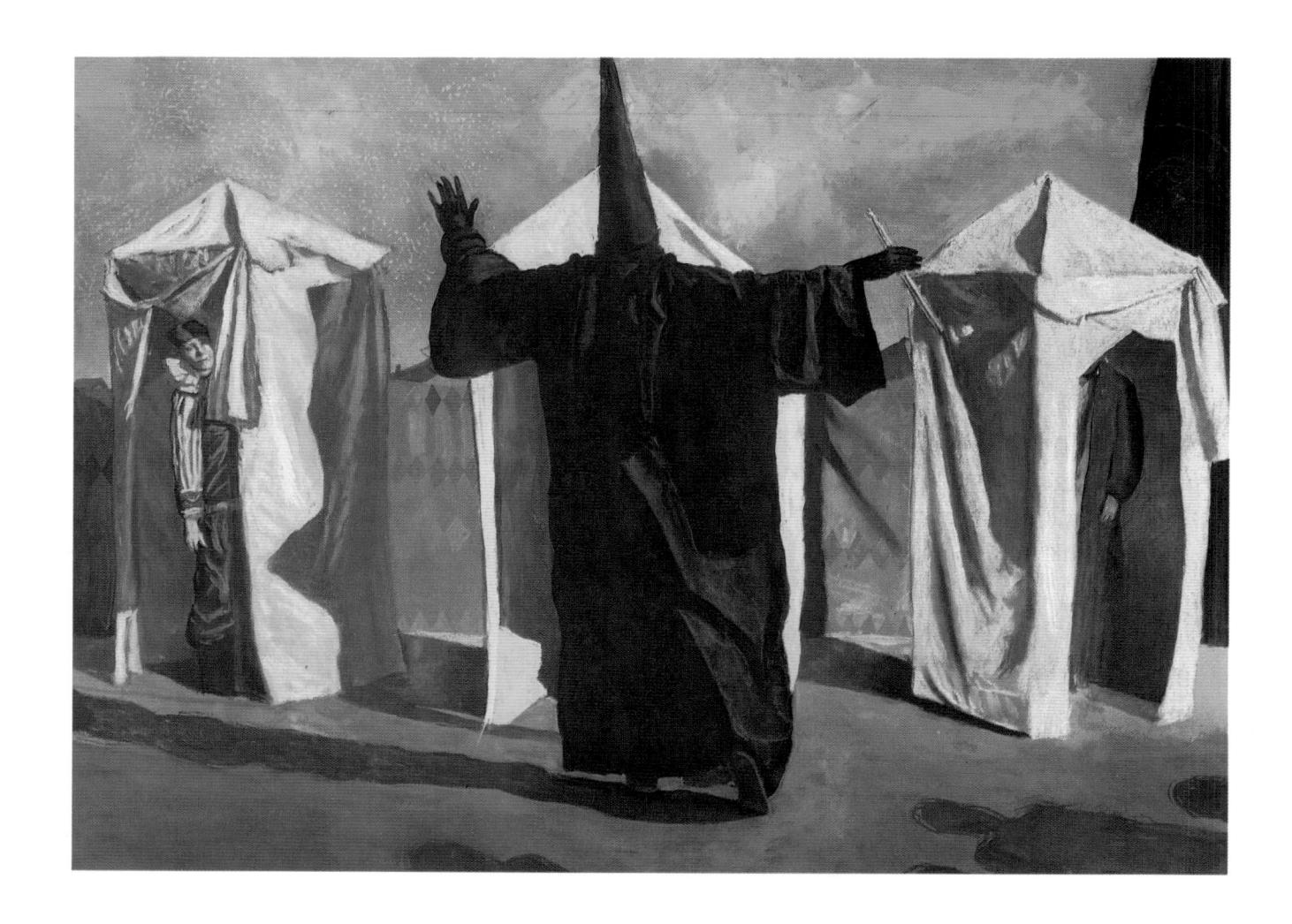

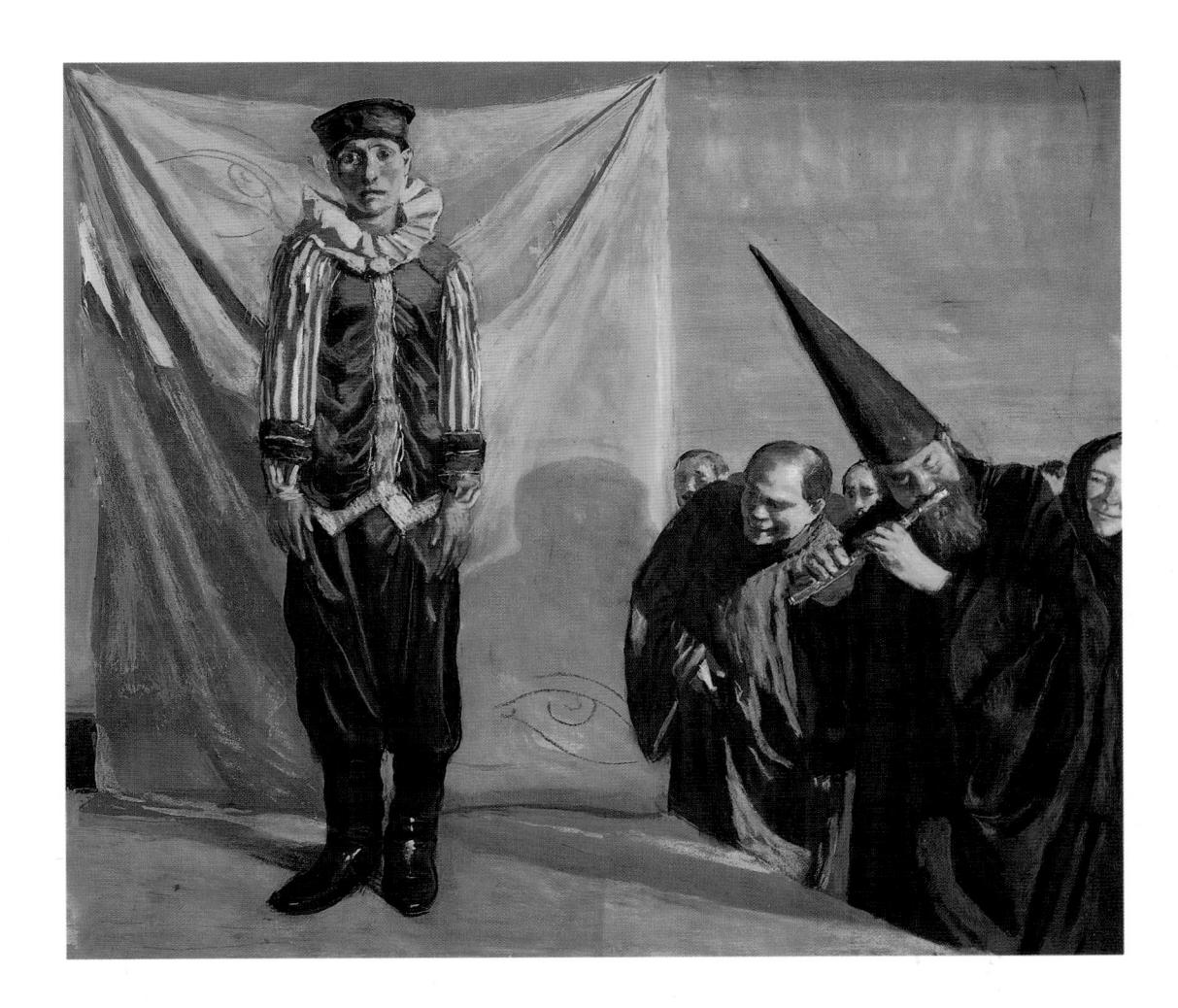

"Petrouchka and the Magician's Flute."

Lilla Rogers

Art Director) Tomoko Kochi Date) February 1993 Publisher) Fukutake Publishing Co., Ltd. Medium) Mixed media This series of illustrations accompanied the story "The Rainbow Magicians," written for a children's book.

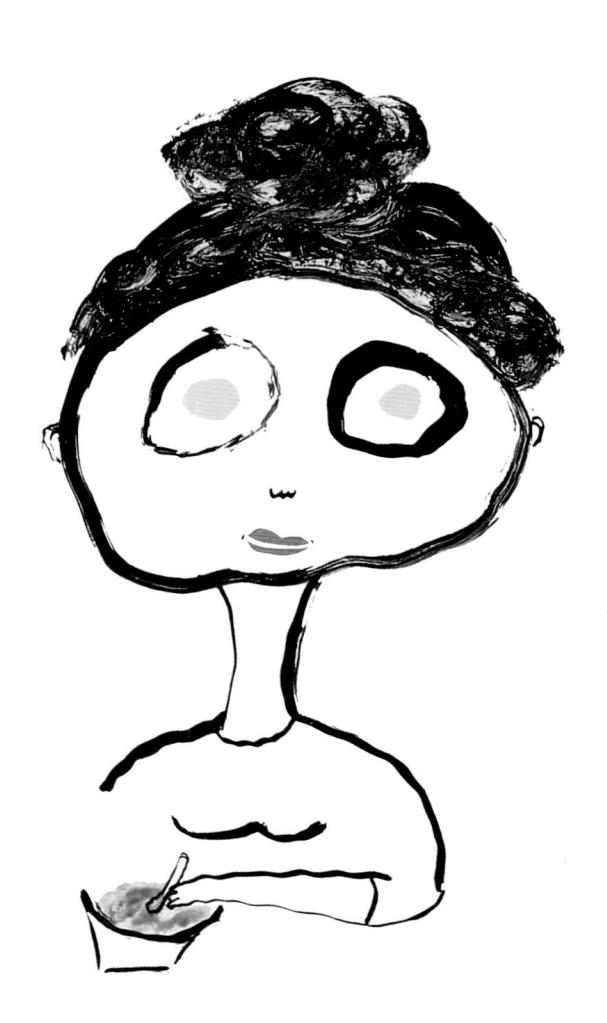

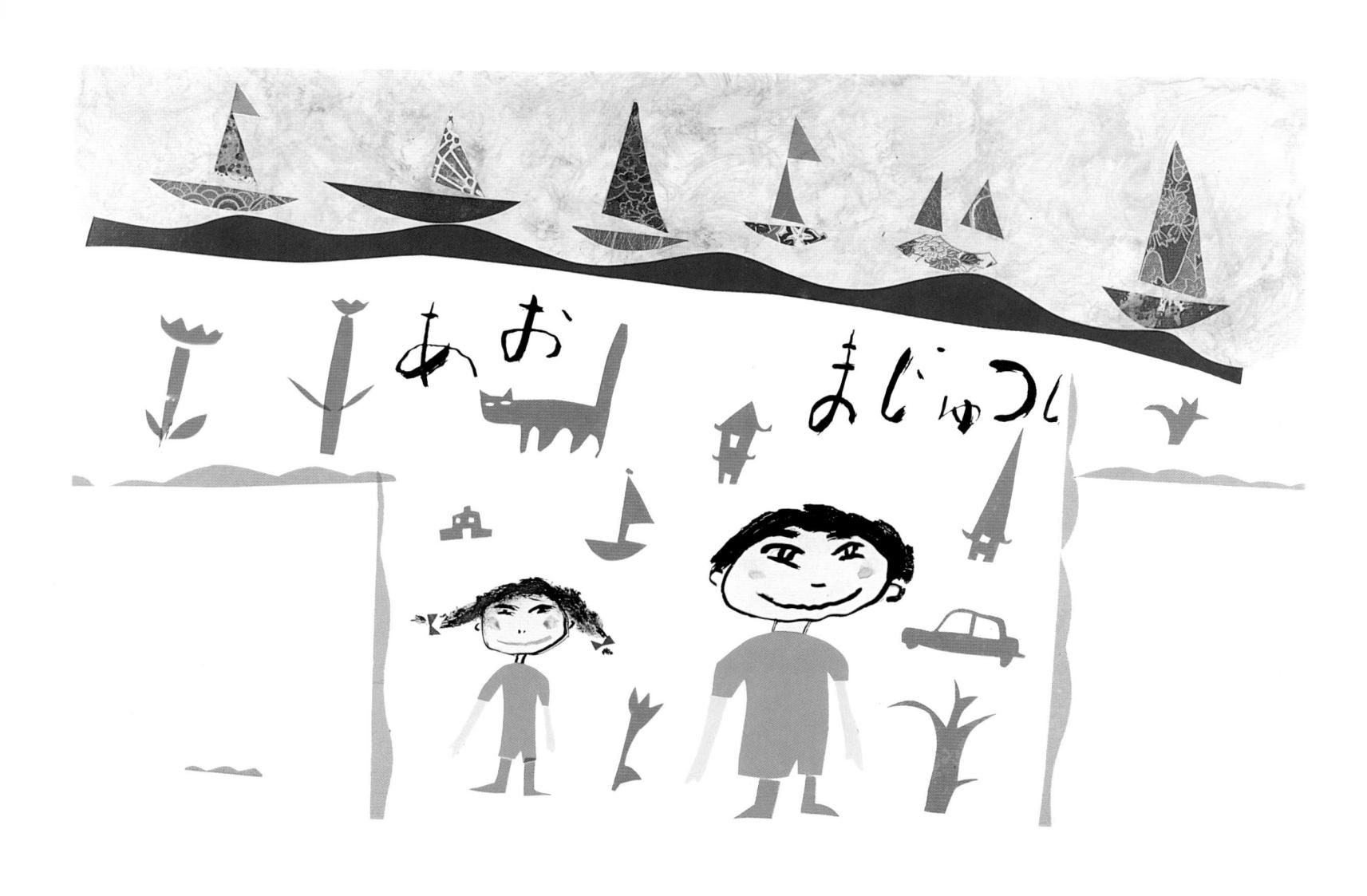

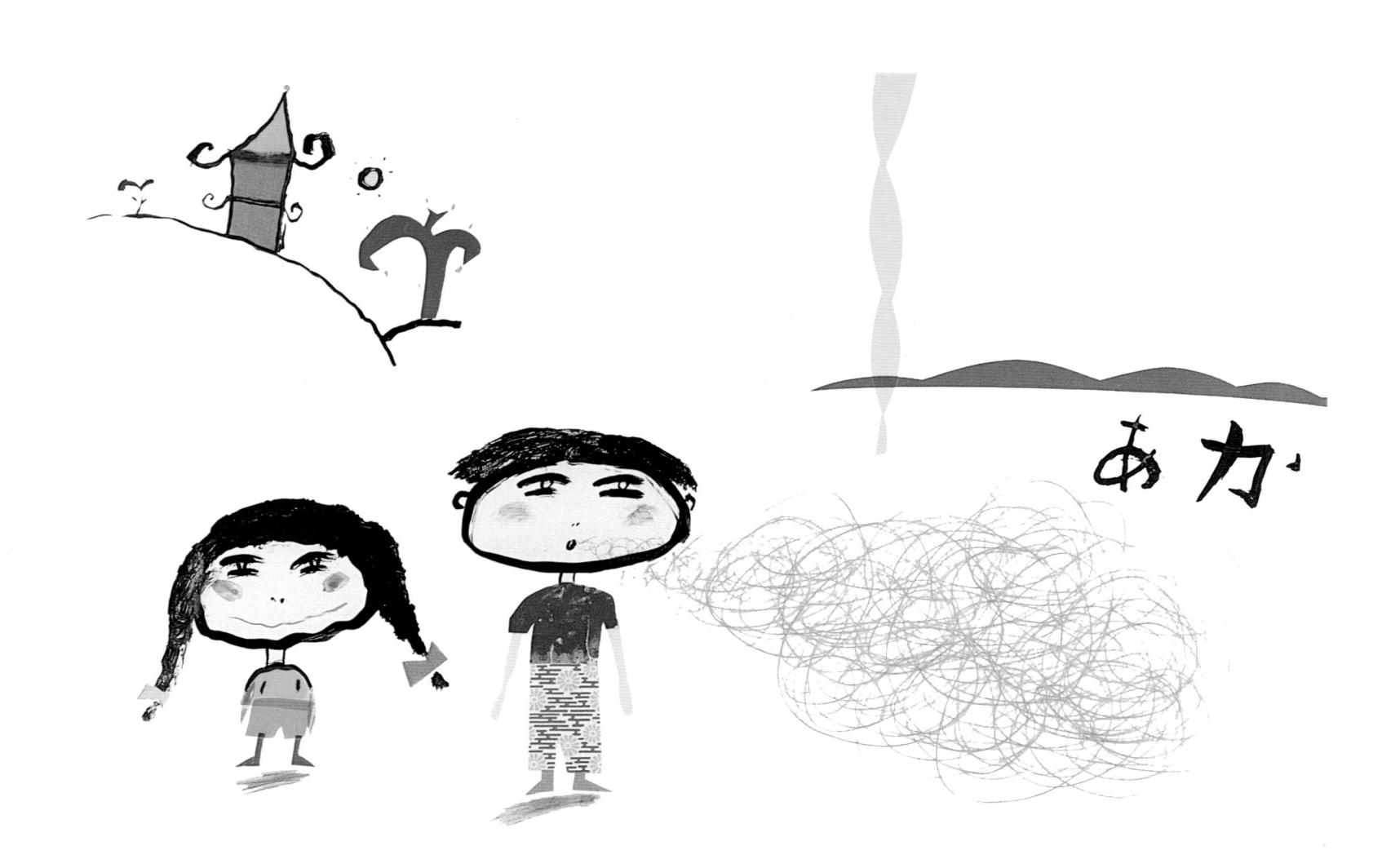

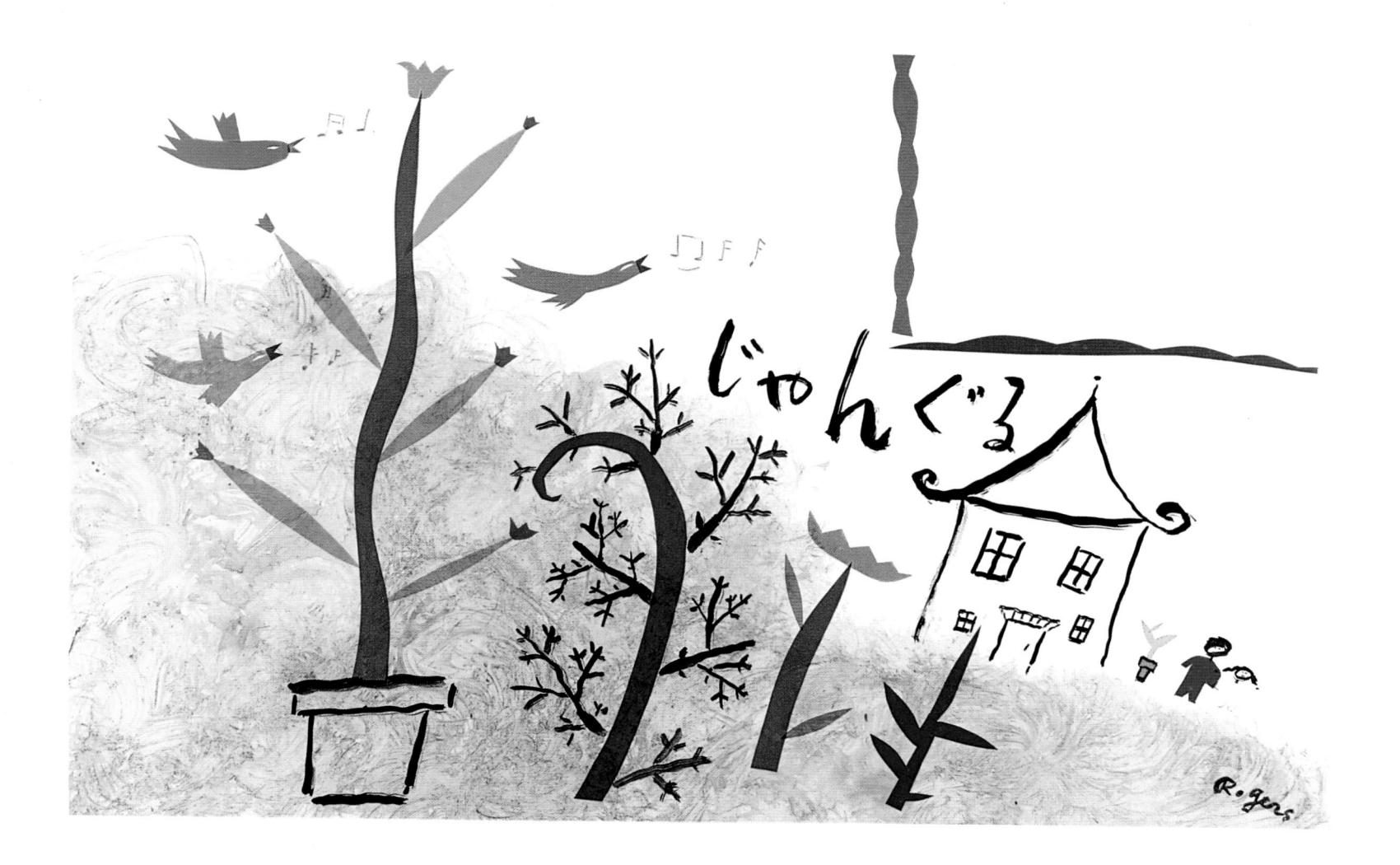

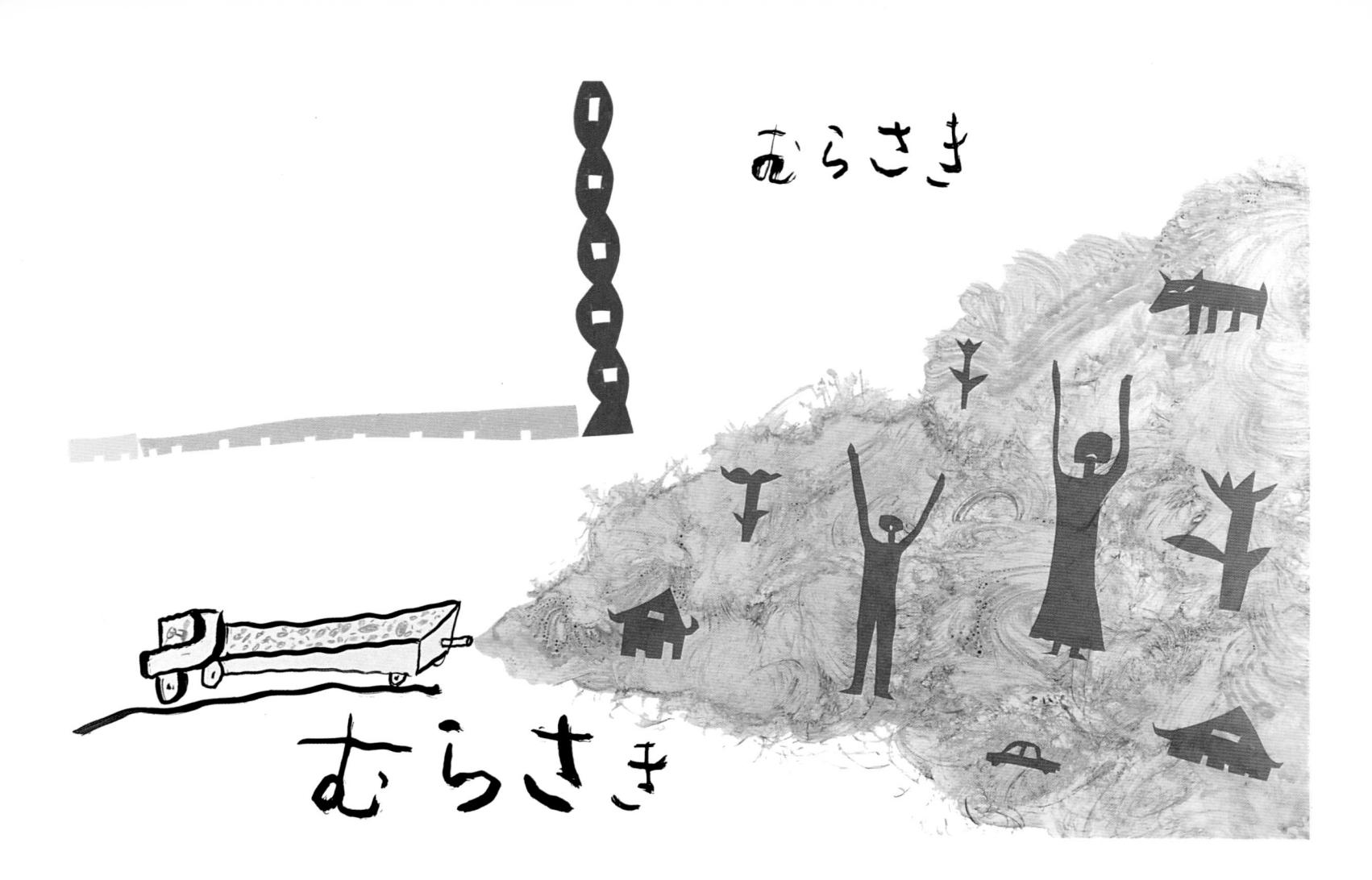

Peter Kuper

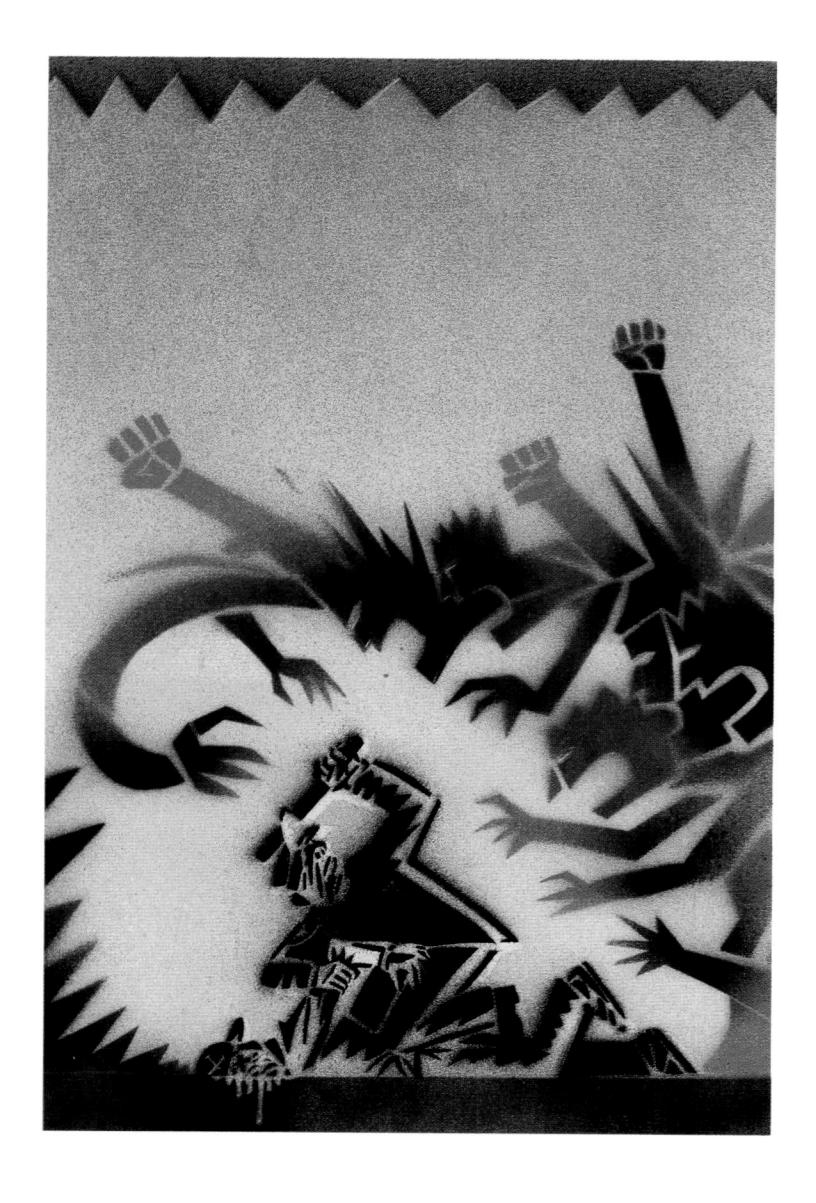

Vivienne Flesher

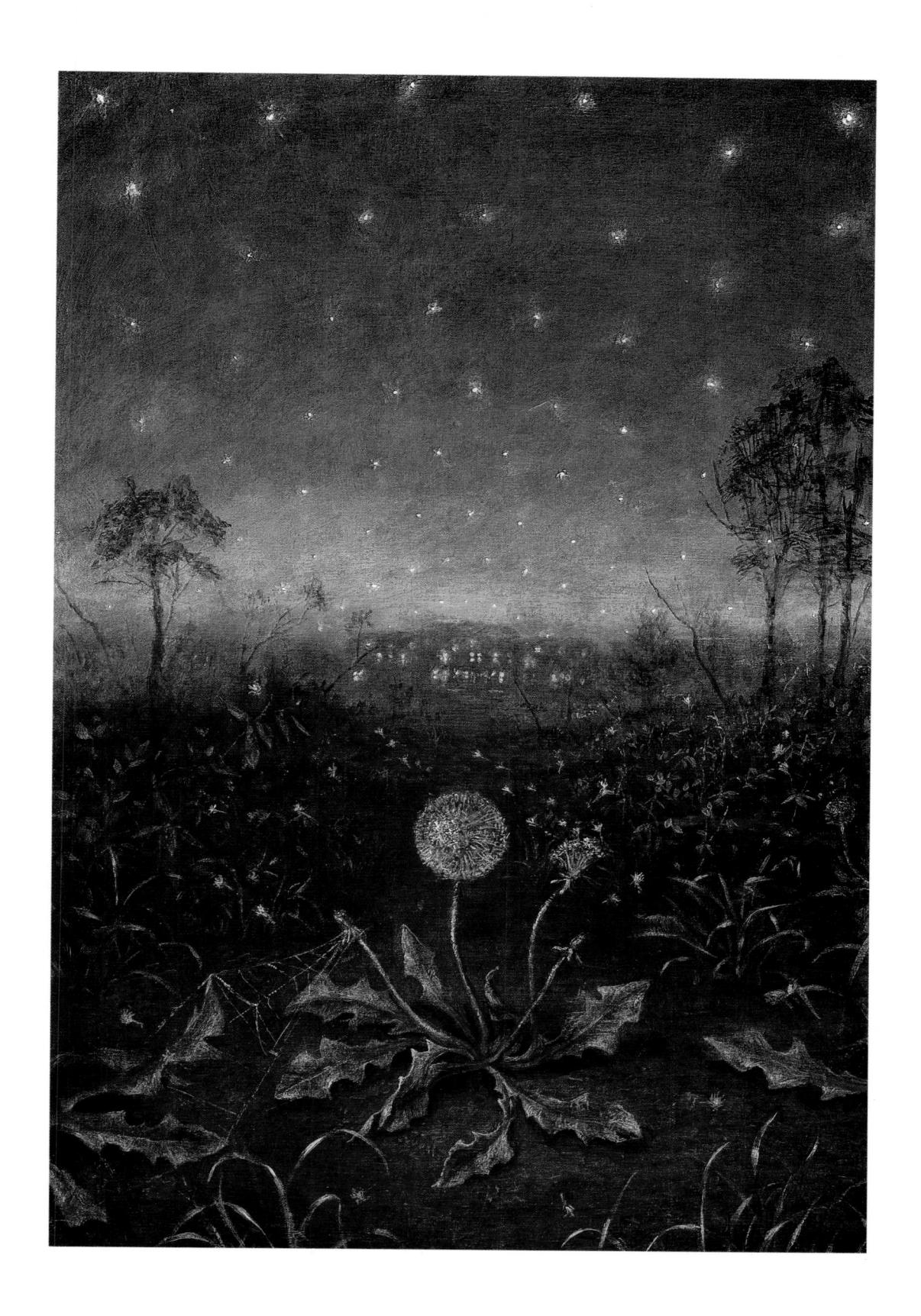

Thomas Woodruff

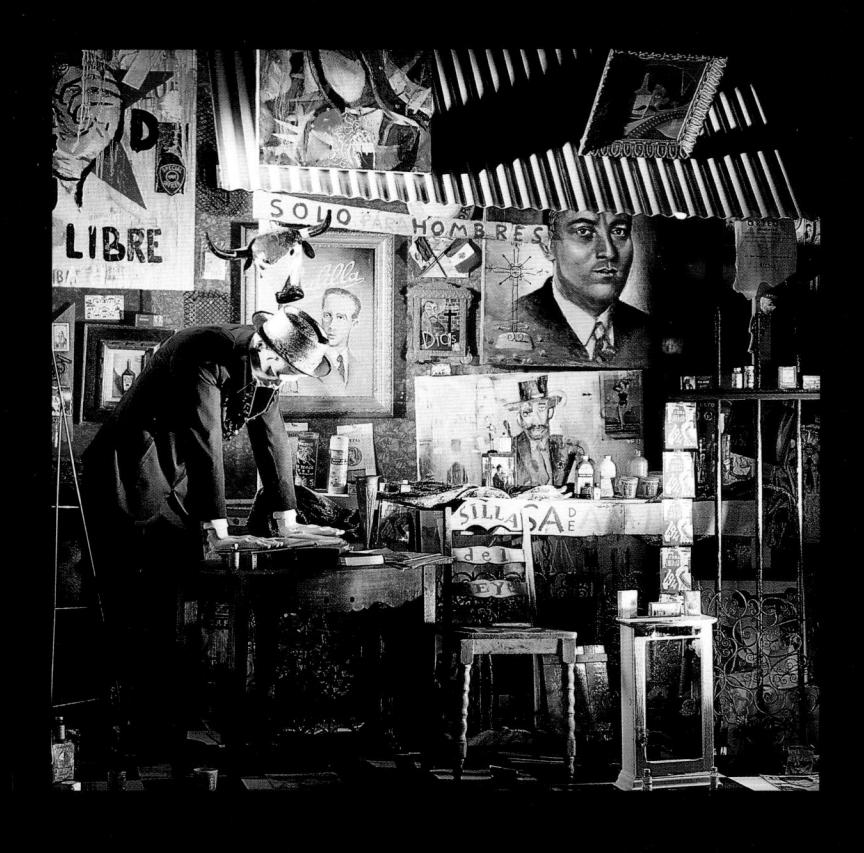

Josh Gosfield

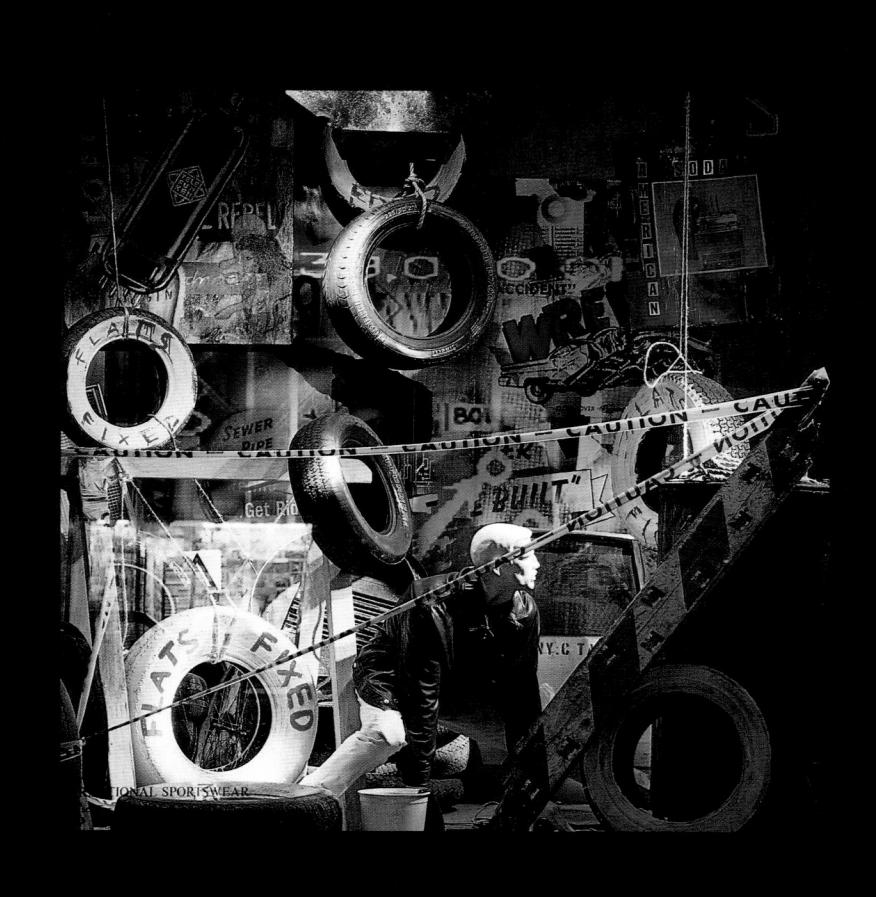

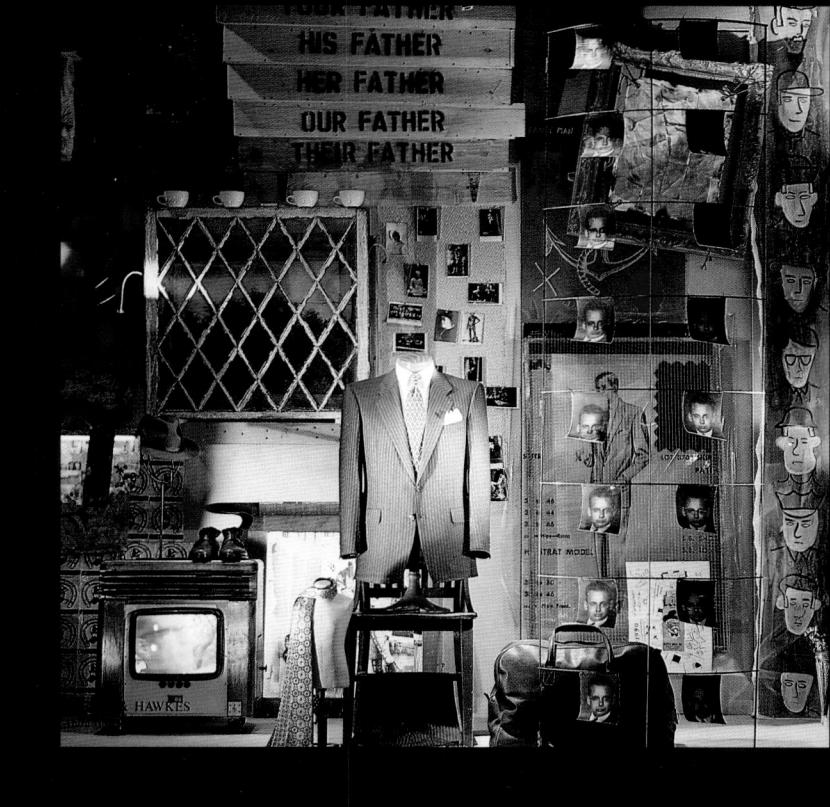

Art Directors) Simon Doonan, Tony Kushner and Josh Gosfield Client) Barneys New York Medium) Mixed media This collection of window displays was created for Barneys New York, in celebration of Fathers Day, 1992.

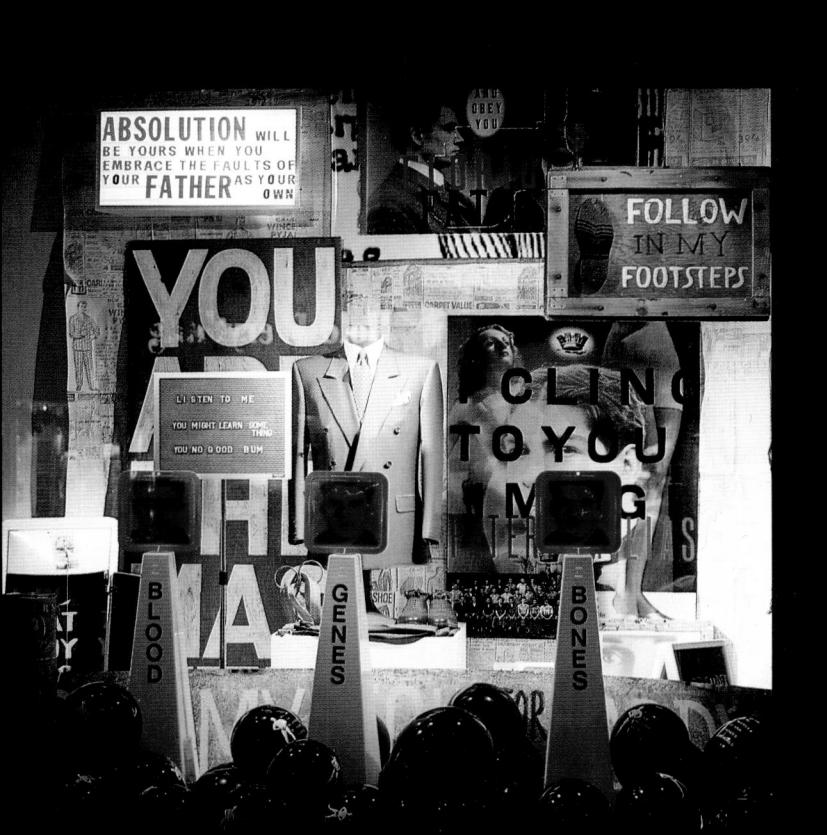

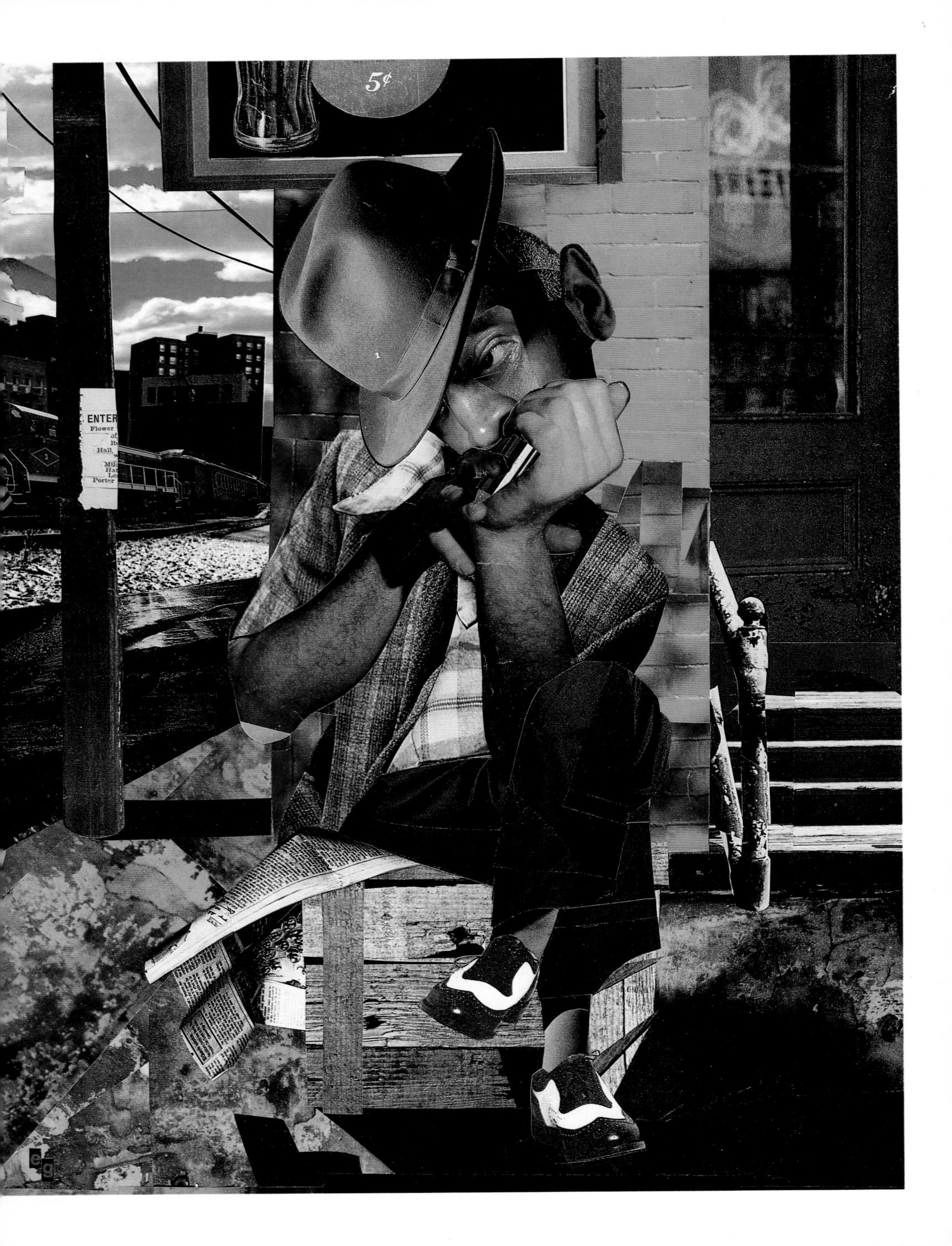

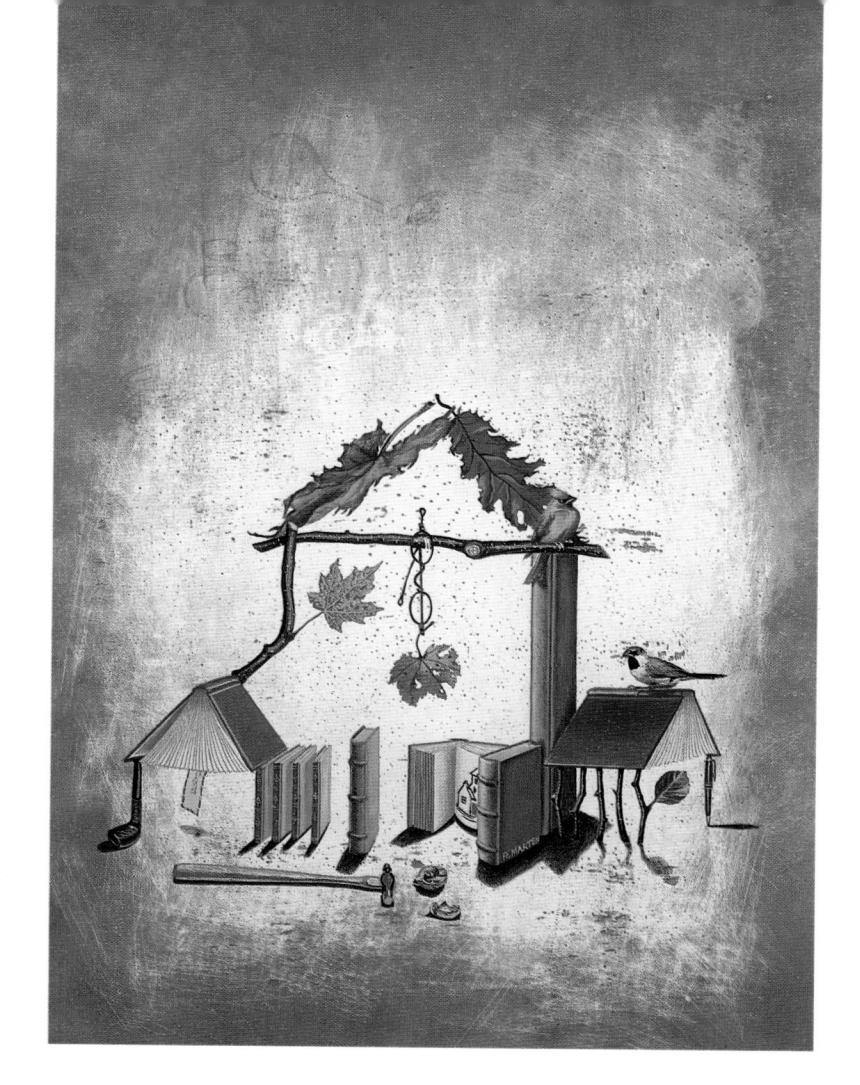

148/149

Ruth Marten

Art Director) Robin Schiff Publisher) Random House Medium) Egg tempera on wood This illustration appeared in the Random House Autumn Catalogue, 1992 (above).

00

Art Director) Melanie Nissen Publication) The Seventh Annual Soul Train Music Awards Date) March 9, 1993

Client) Atlantic Recording Corporation Medium) Collage This collage appeared in the award show's souvenir program book (left).

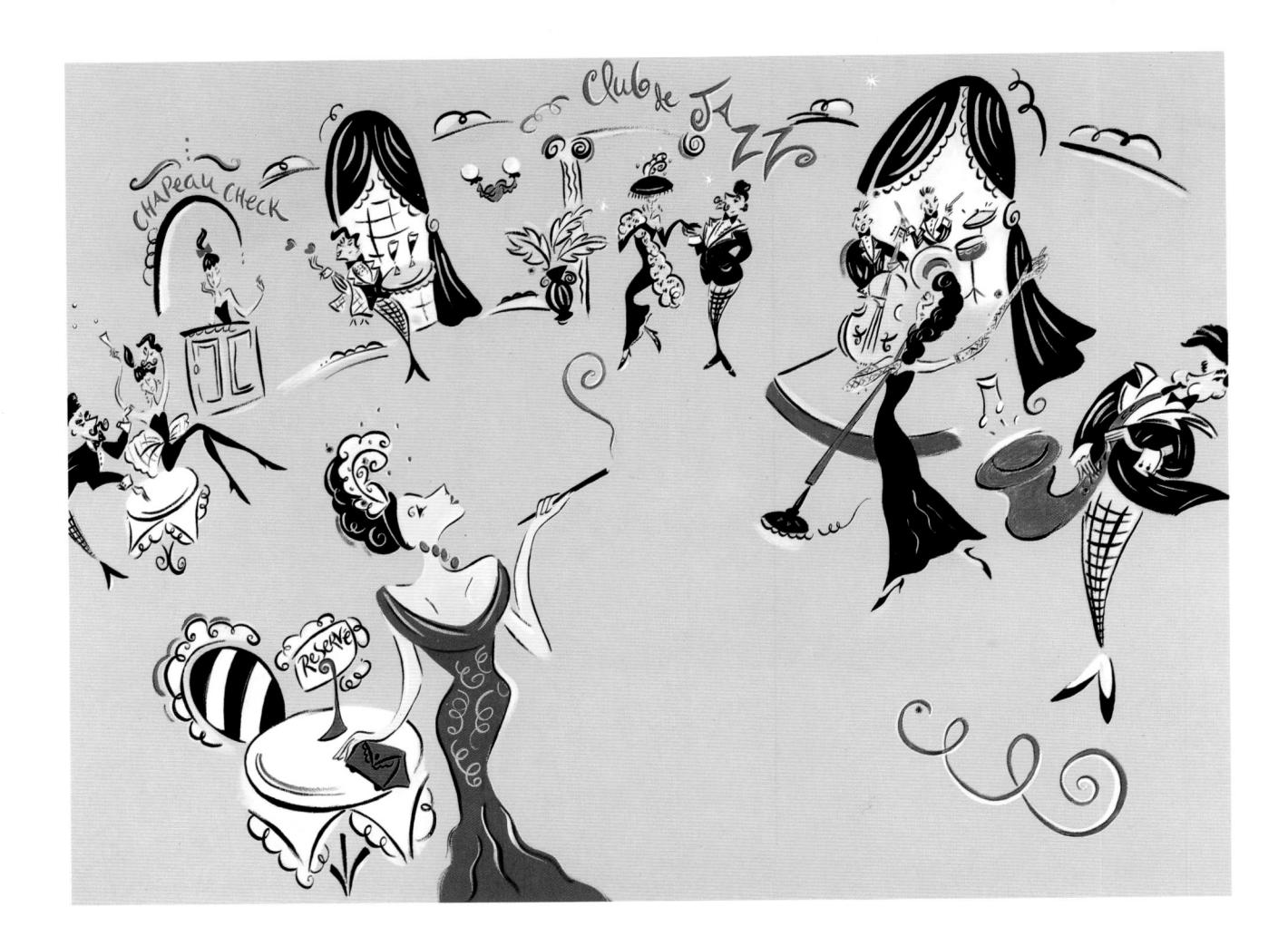

Chesley McLaren

Scott Menchin

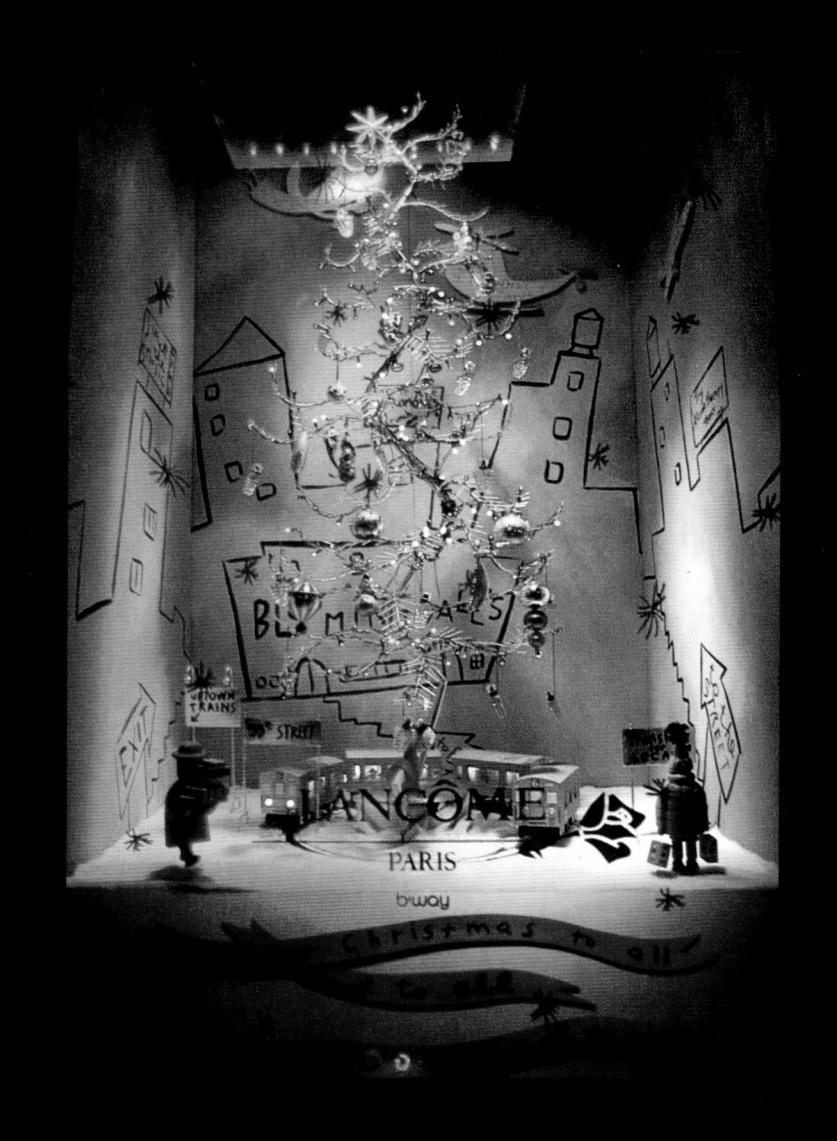

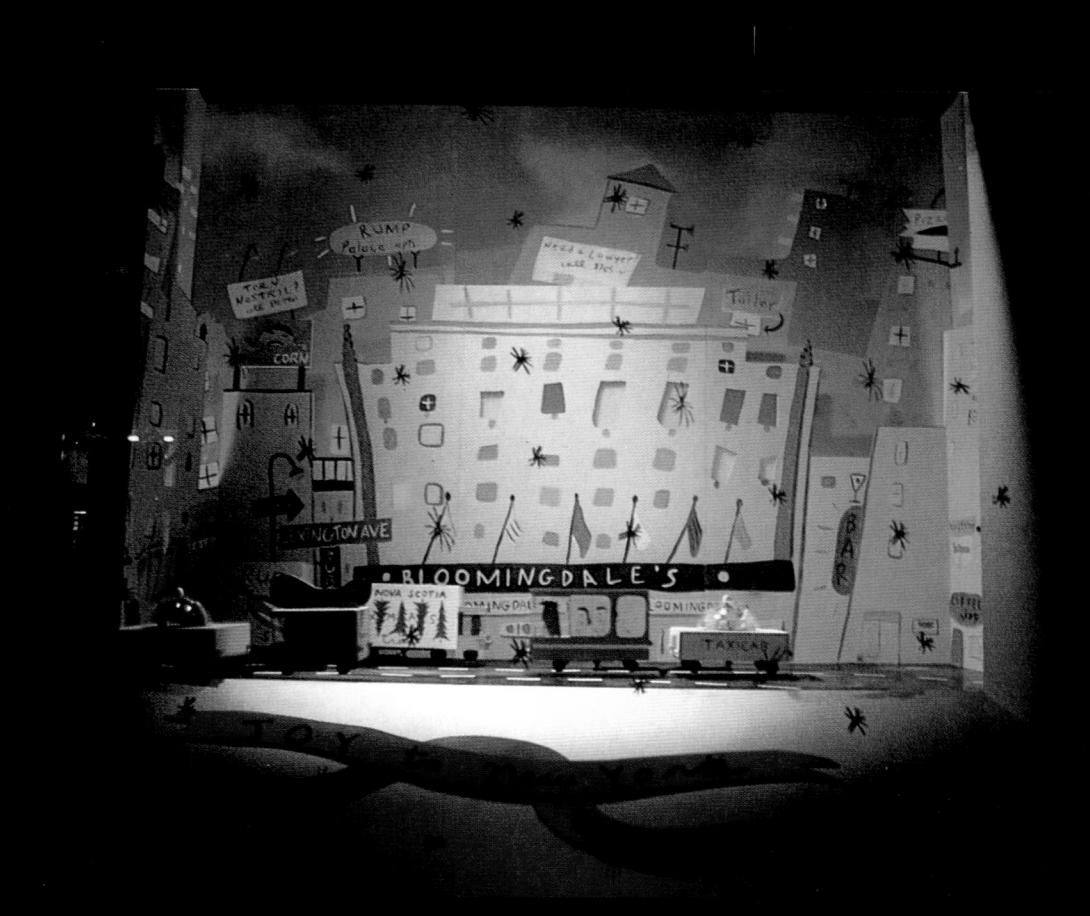

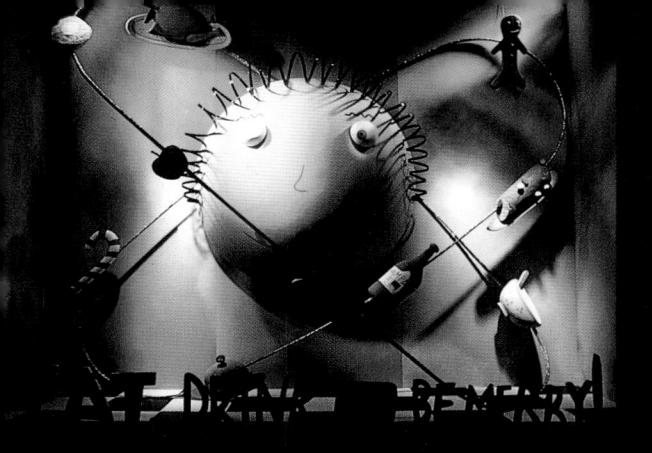

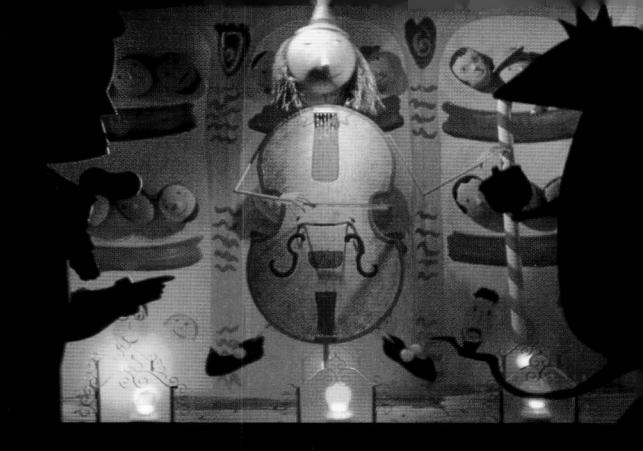

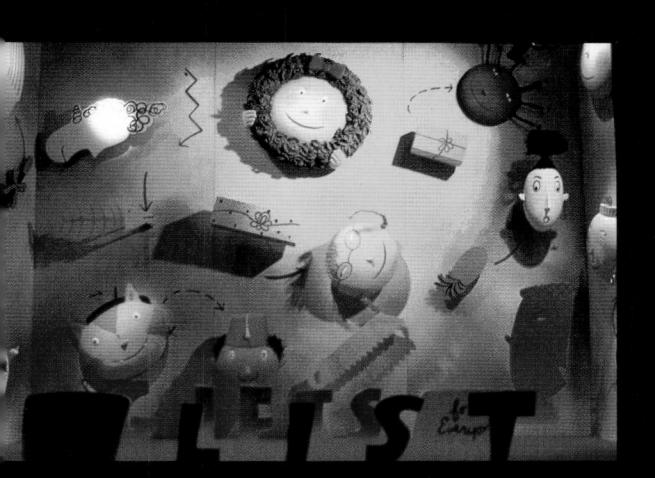

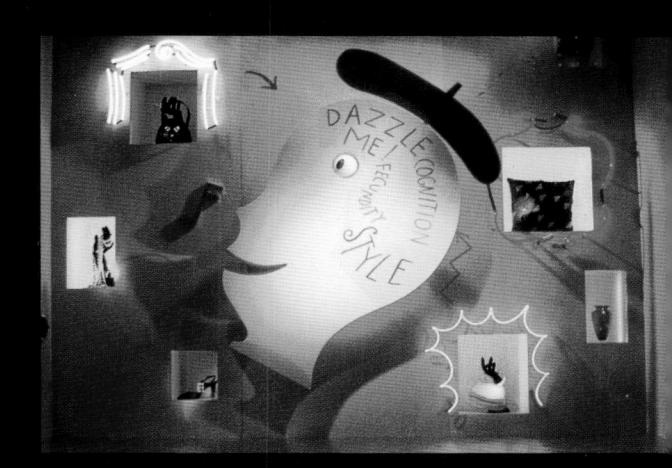

Jessie Hartland

Jill Buchanan

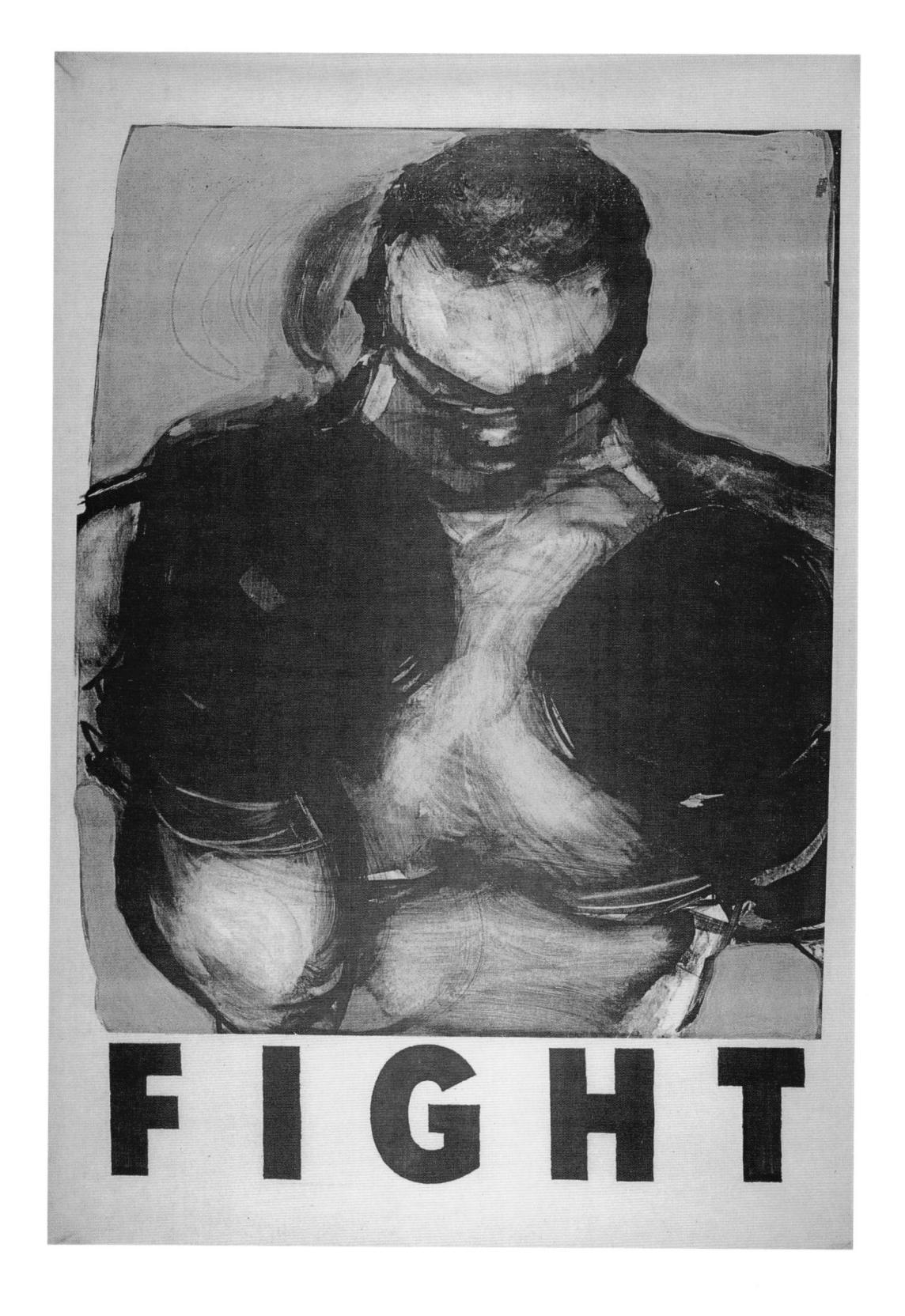

156

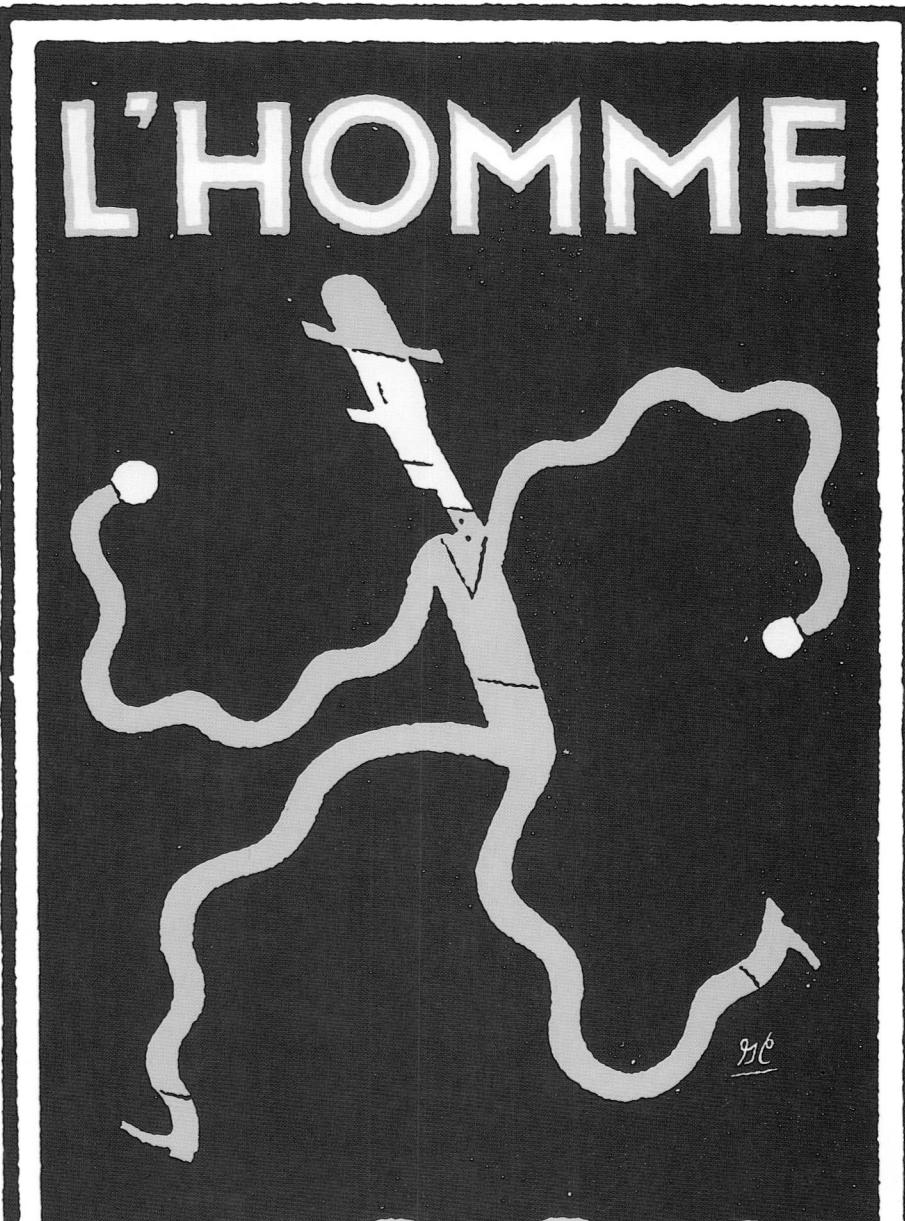

WIGGLY
MARQUE DÉPOSÉE

157

Greg Clarke

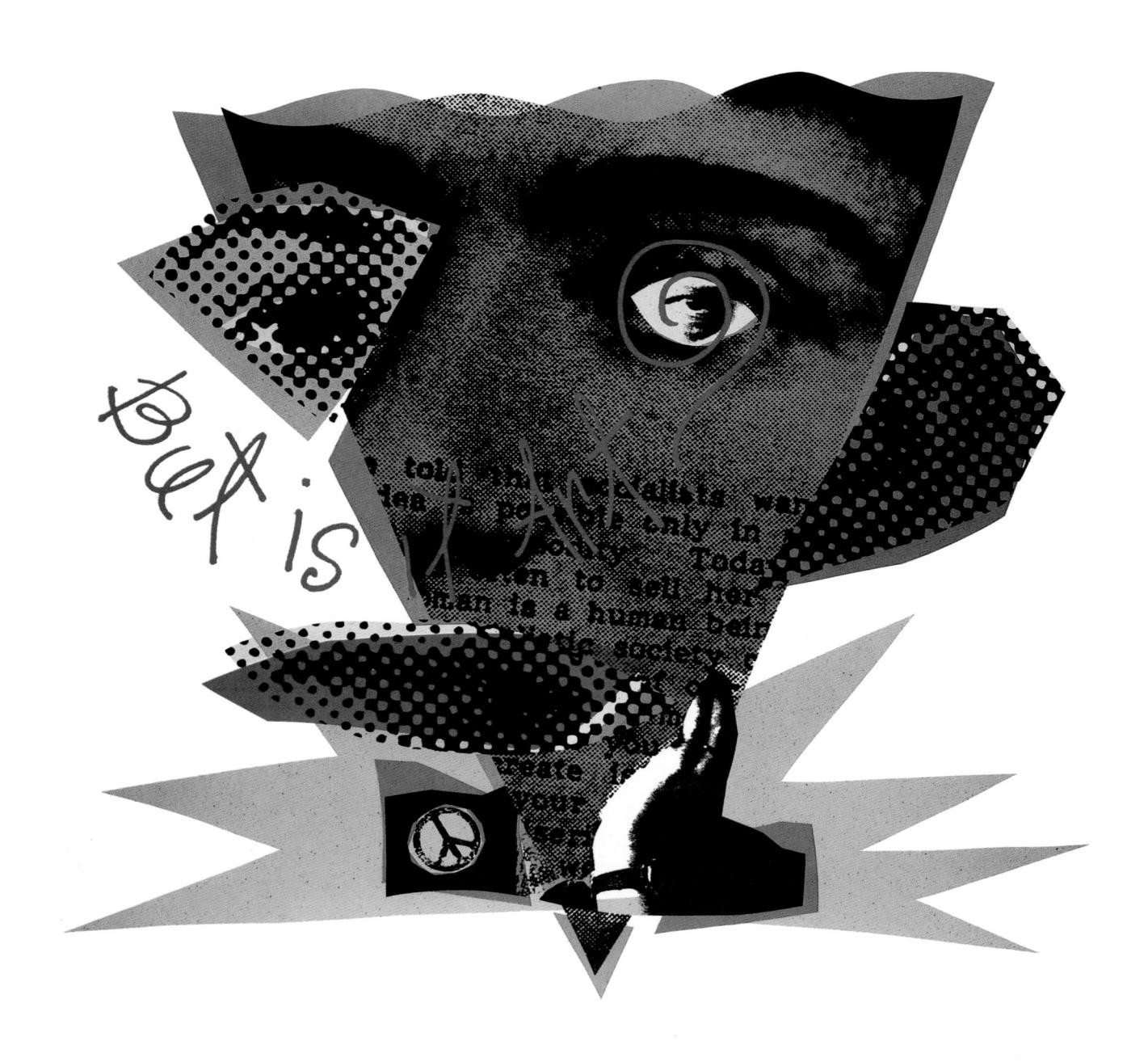

Art Garcia

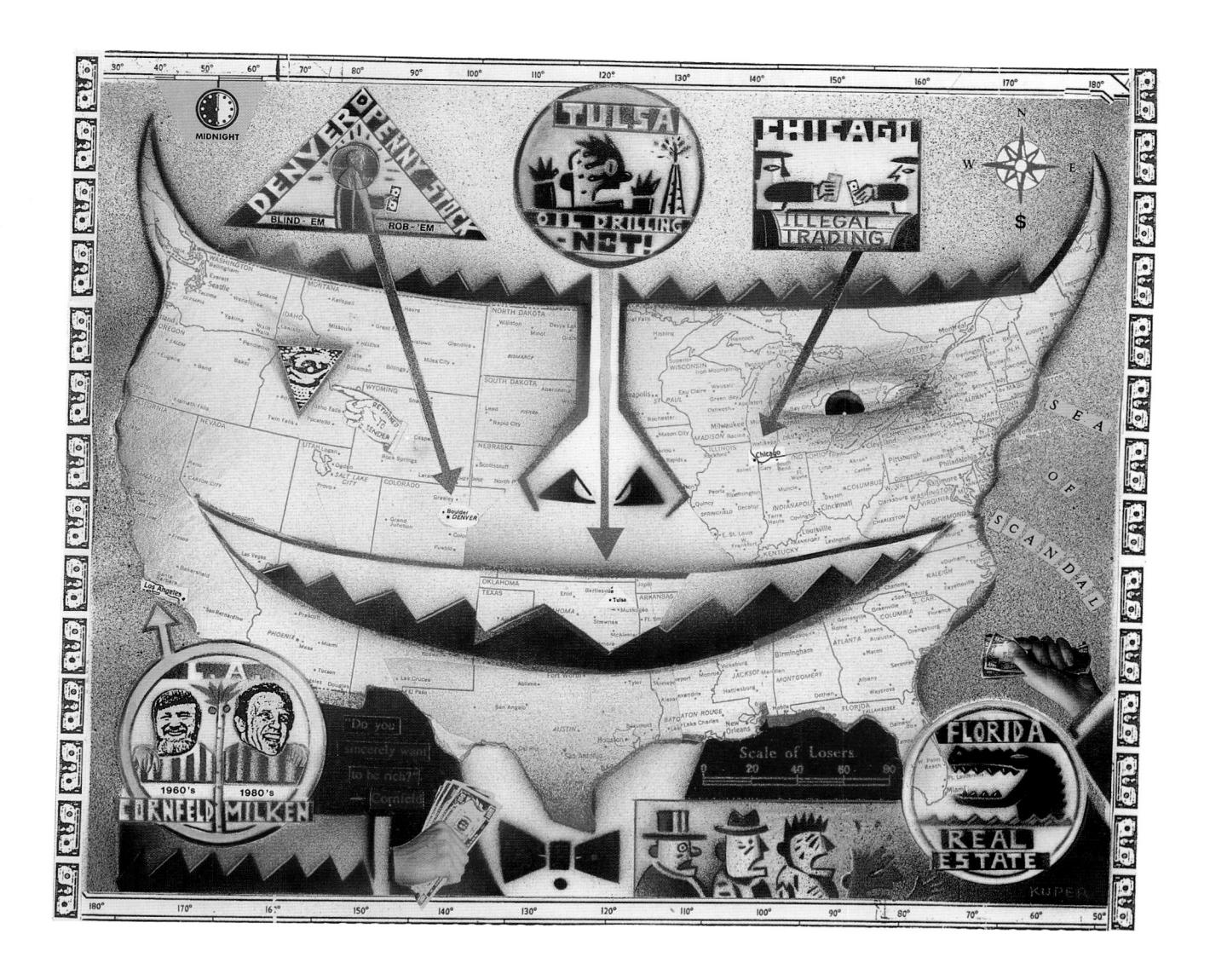

Peter Kuper

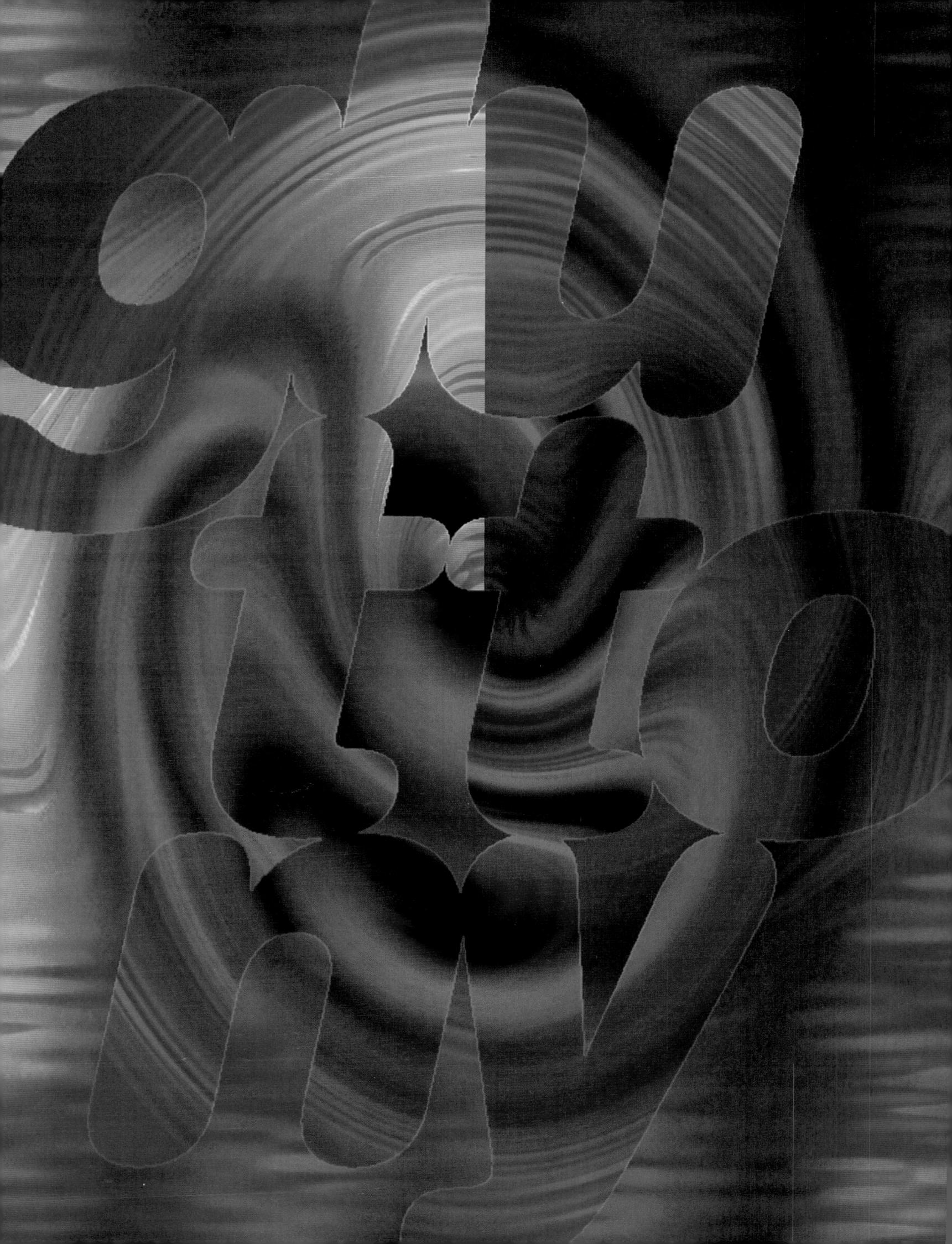

Lilla Rogers

Isabelle Dervaux

Kiy**oshi Kan**ai

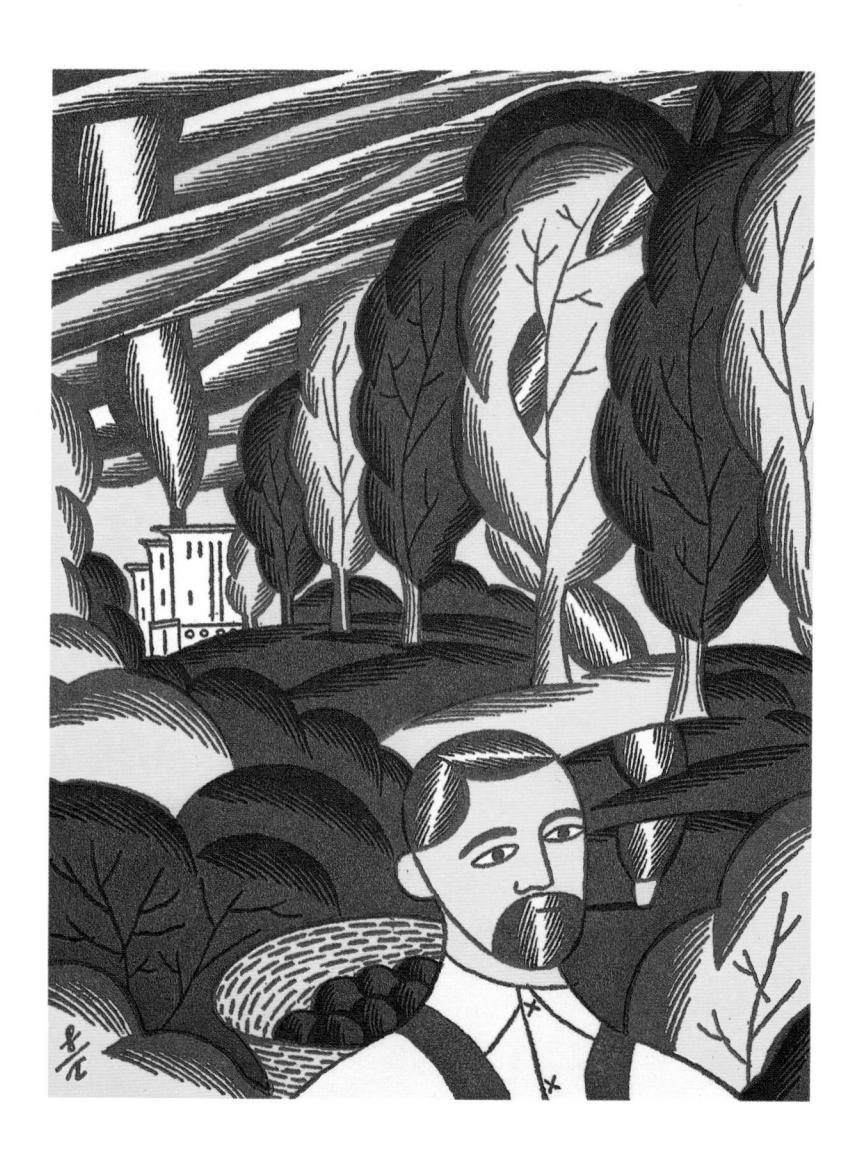

Brian Cronin

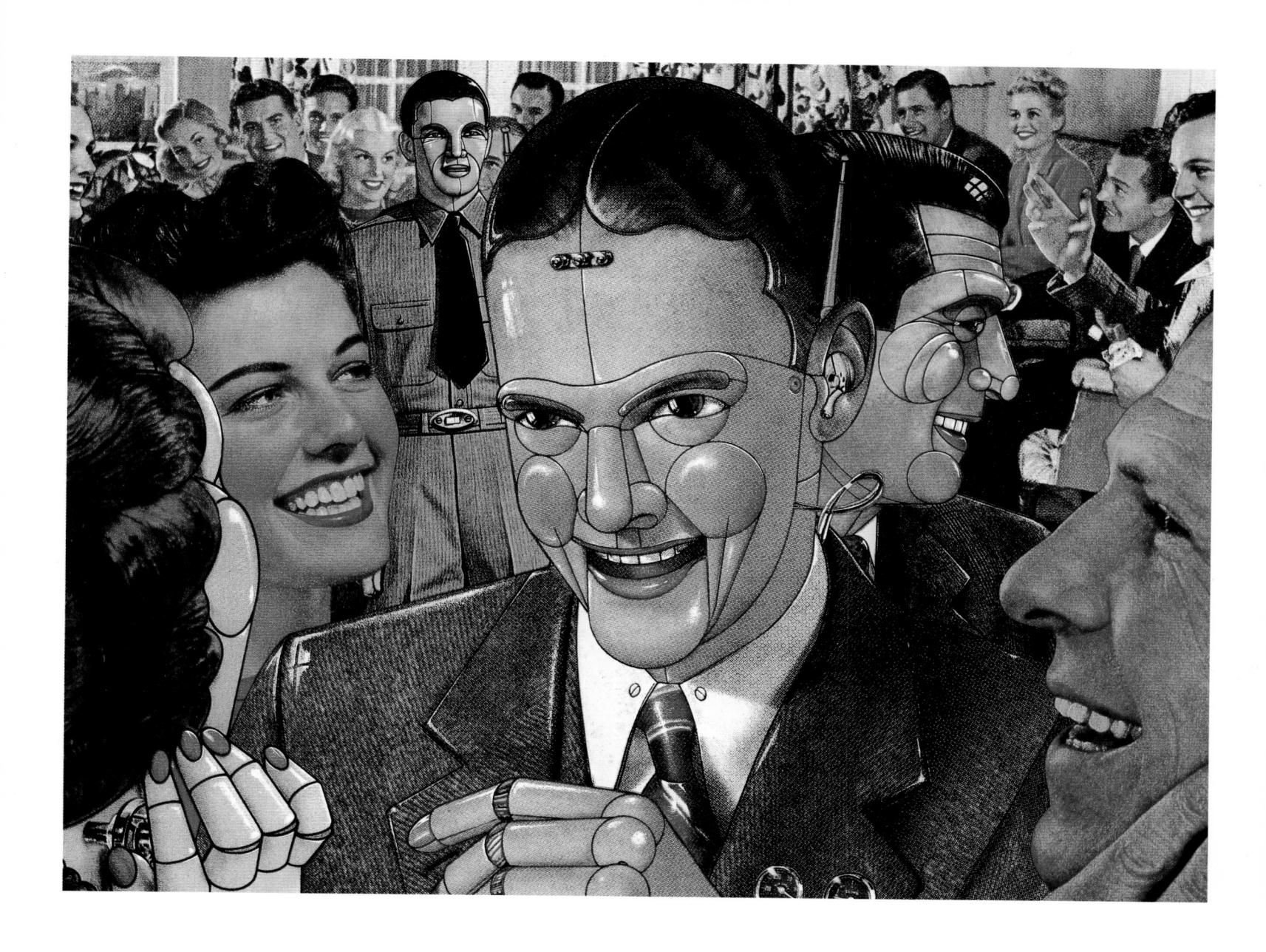

John Craig

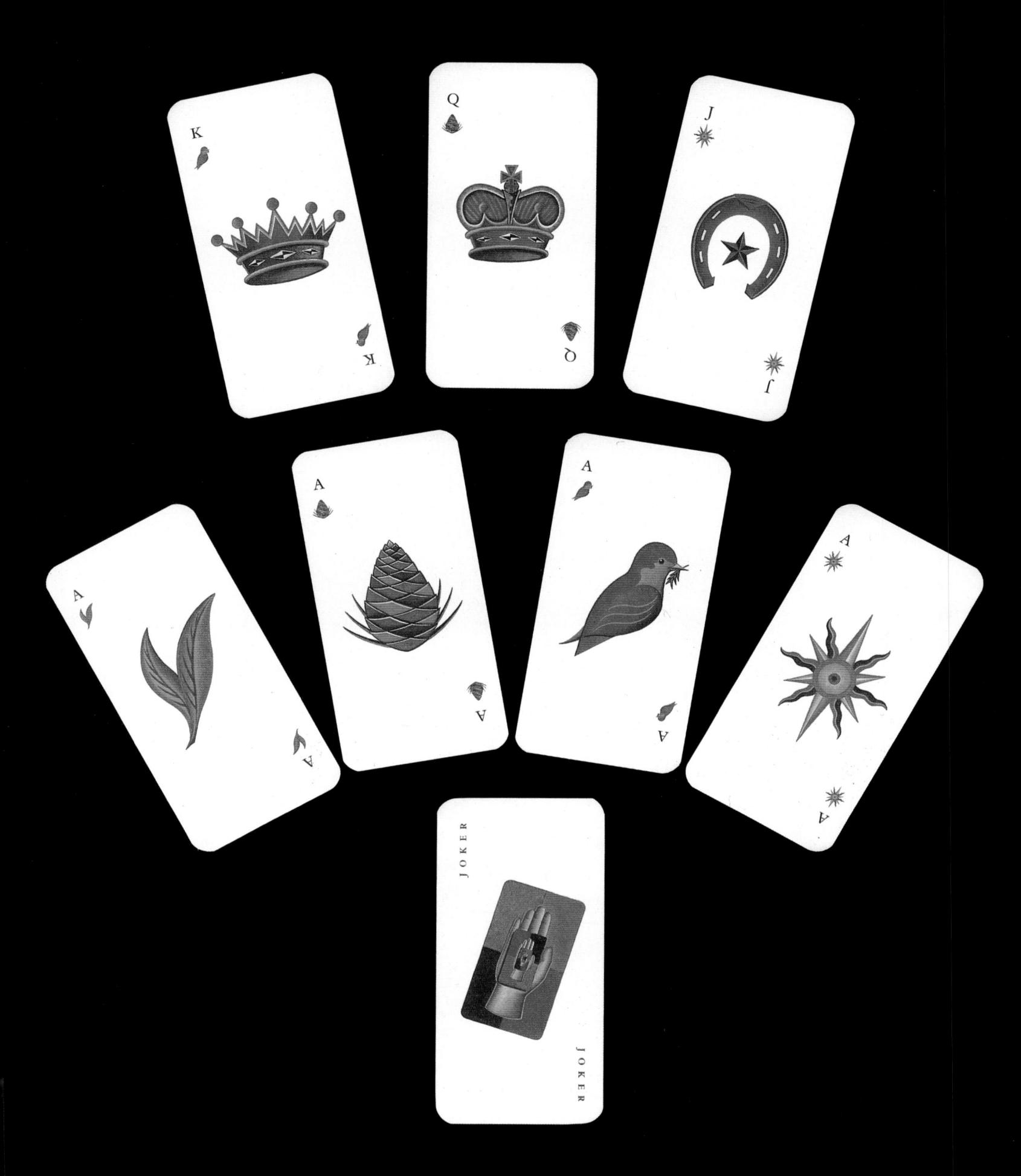

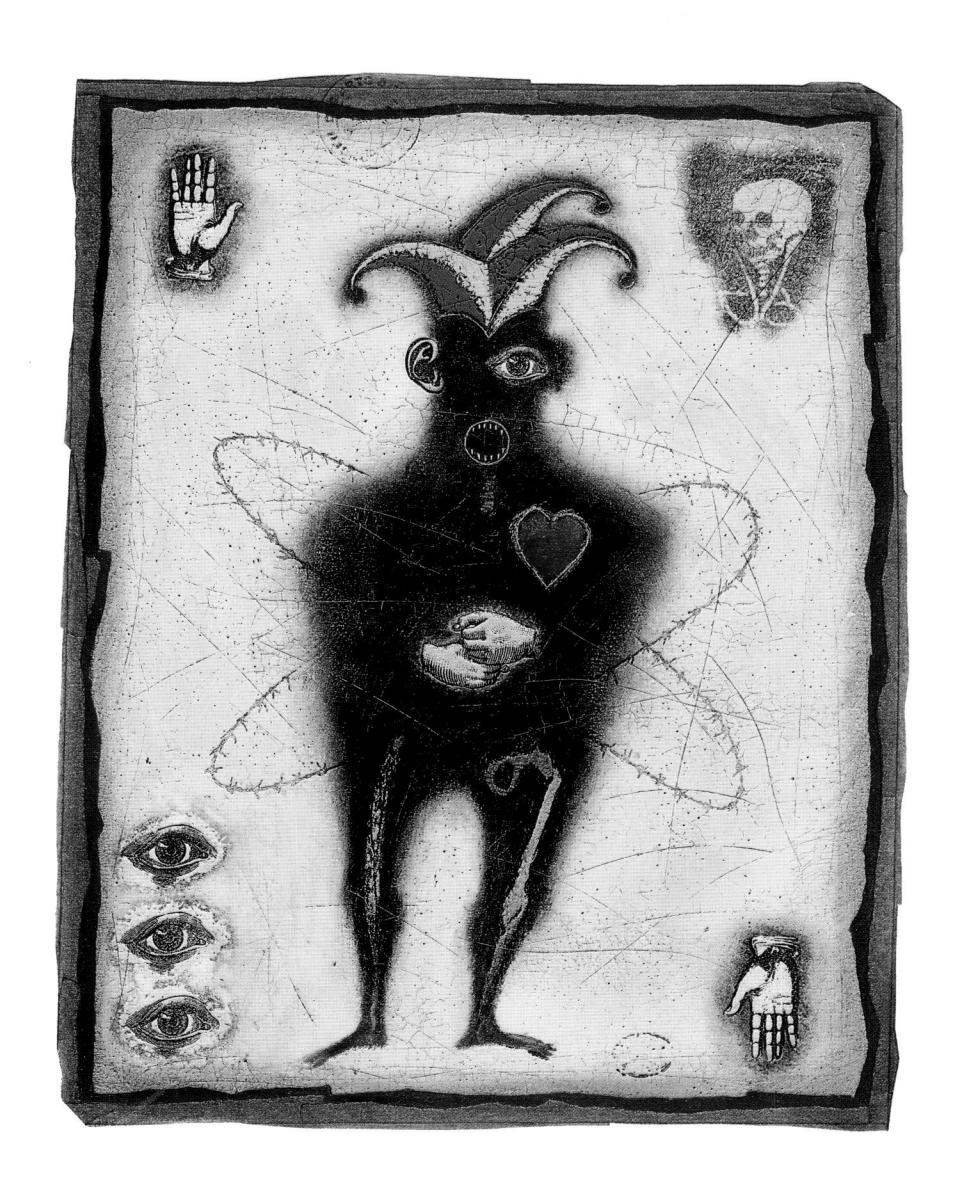

Pol Turgeon

Art Director) Lori Siebert Design Firm) Siebert Design Associates, Inc. Client) Beckett Paper
Agency) Northlick, Stolley, La Warre Writer) Bob Gard Date) Winter 1992 Medium) Photocopy, oil, ink, gouache, tape and varnish
This illustration, part of a promotional series exploring different emotions, represents the emotion hate (above).

00

Art Director) Sunil Bhandari Design Firm) Harris-Bhandari Writer) Helen Battersby Medium) Acrylic With each suit representing a different season, these playing cards were sent out as Christmas greetings (left).

Bill Mayer

Art Director) Jerry Sullivan Client) Graphic Ads Medium) Gouache and dyes
This ad, entitled "Graphic Ads is Having an Identity Crisis," ran originally in Ego Magazine (below).

00

Art Director) Kim Champagne Client) Warner Brothers Records Date) August 11, 1992 Medium) Multi-media three dimensional art
This illustration was created for the Elmore James "King of the Slide Guitar" CD package (right).

Josh Gosfield

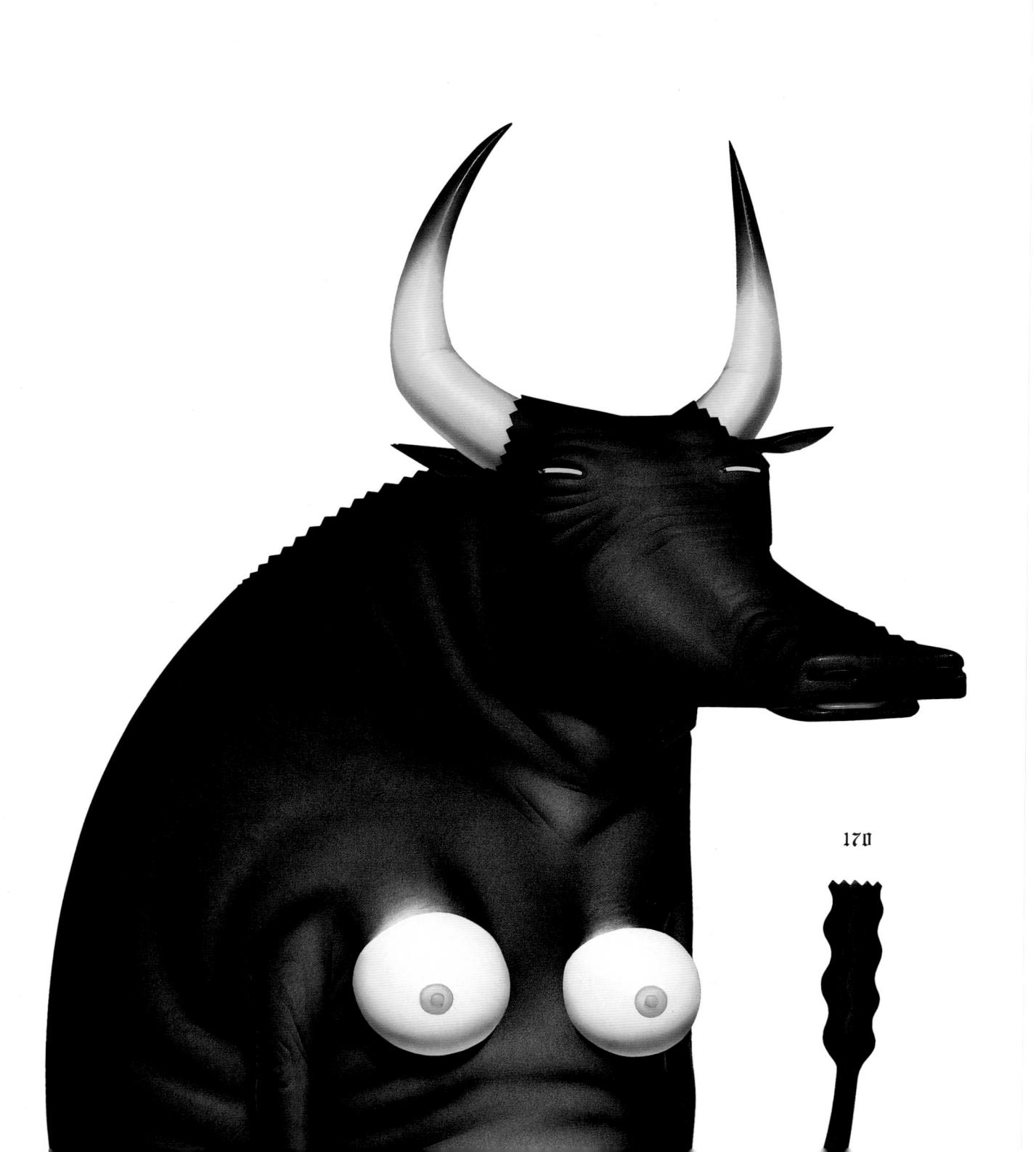

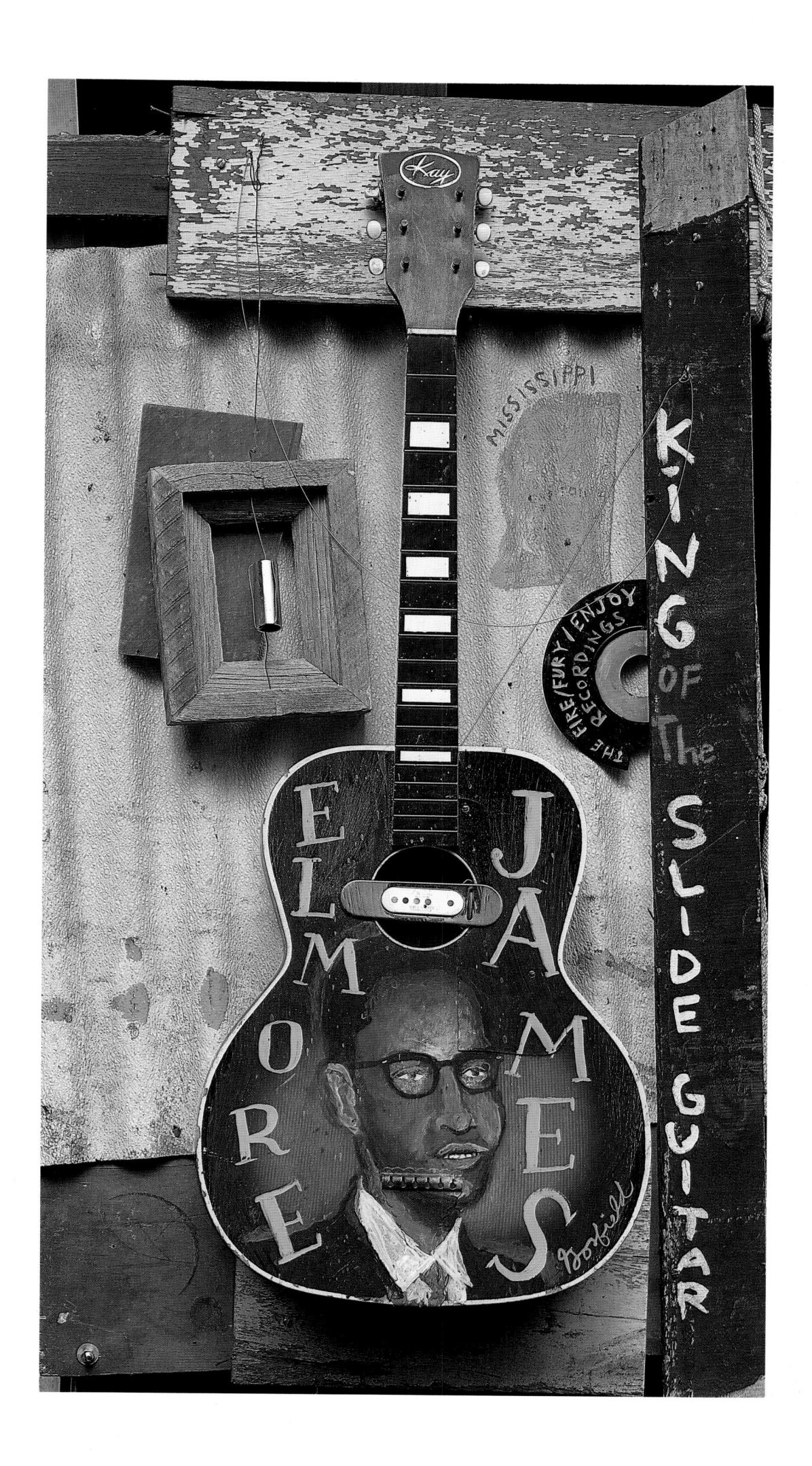

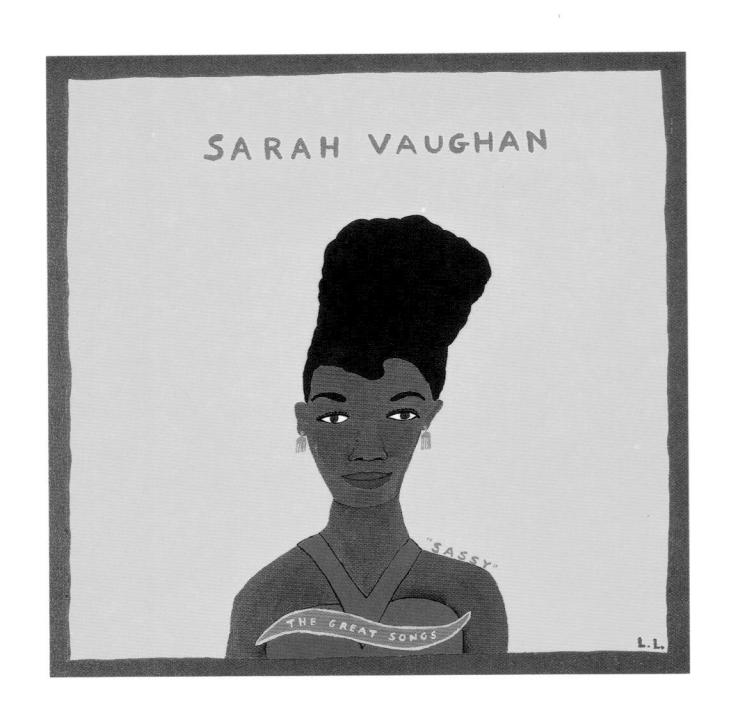

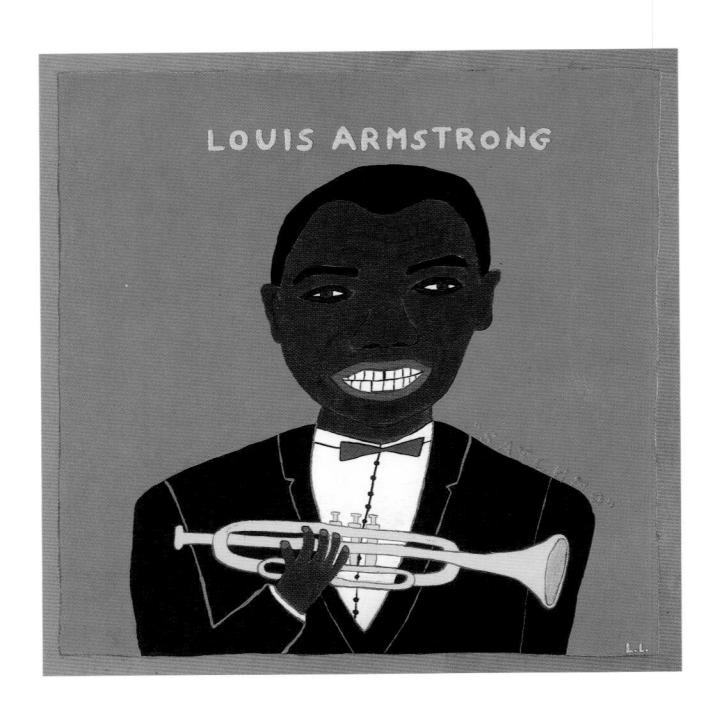

Laura Levine

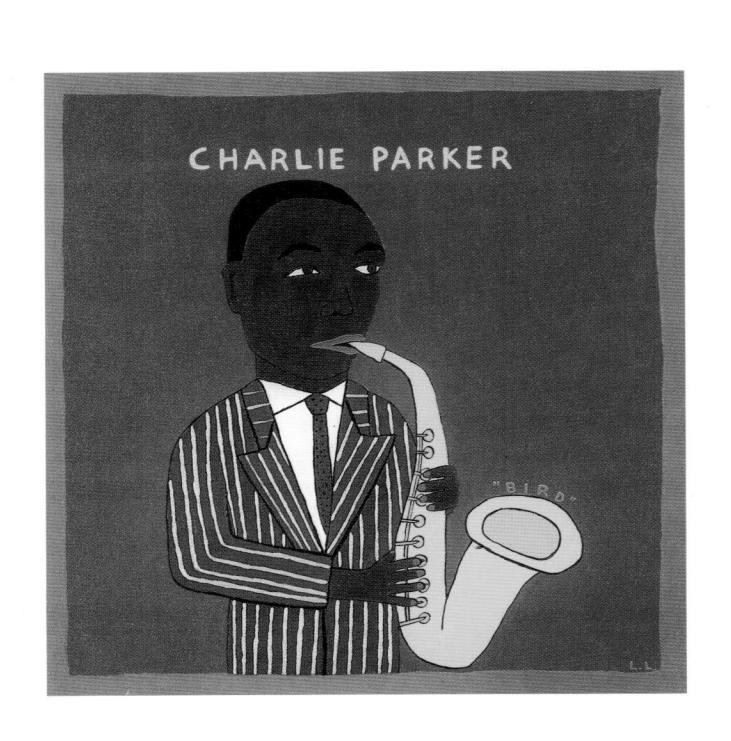

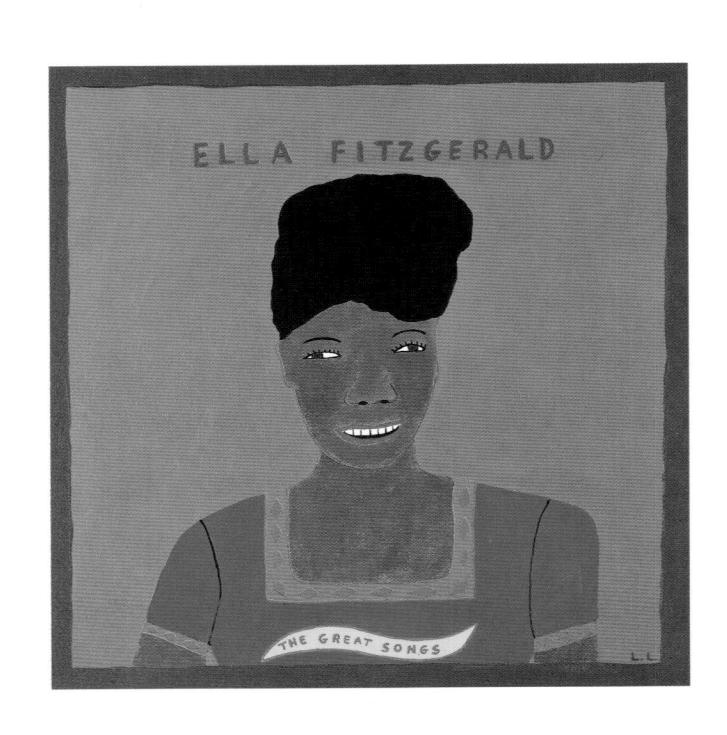

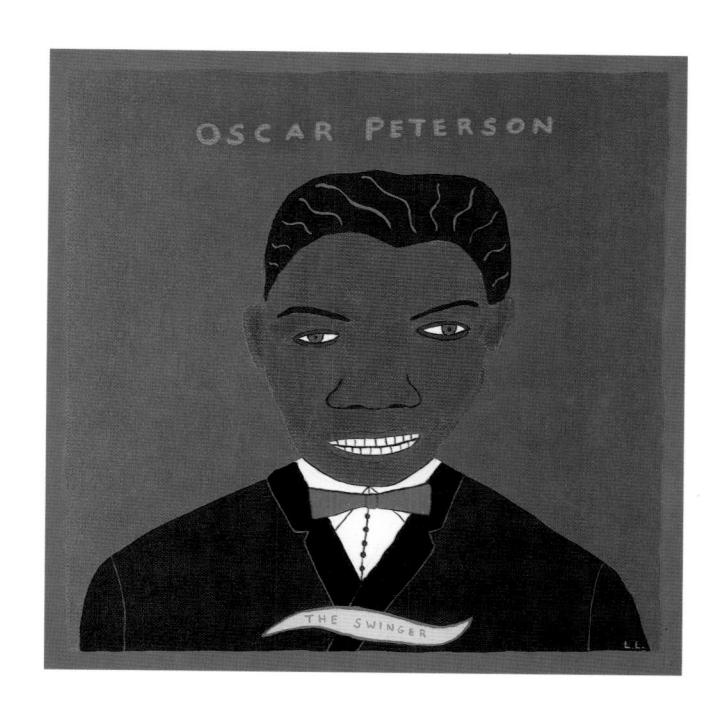

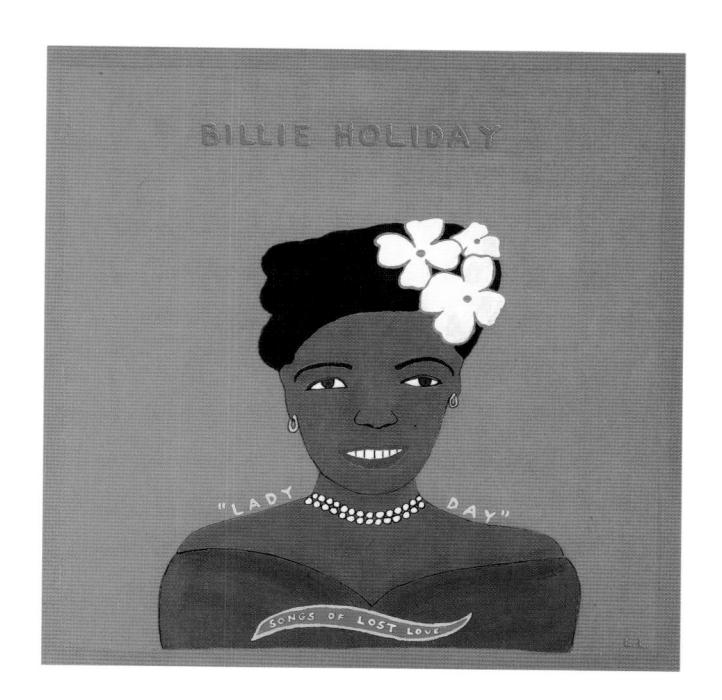

Art Director) Alli Truch Client) Verve/Polygram Records Medium) Acrylic on masonite These portraits appeared on the CD covers of the "Essential Series."

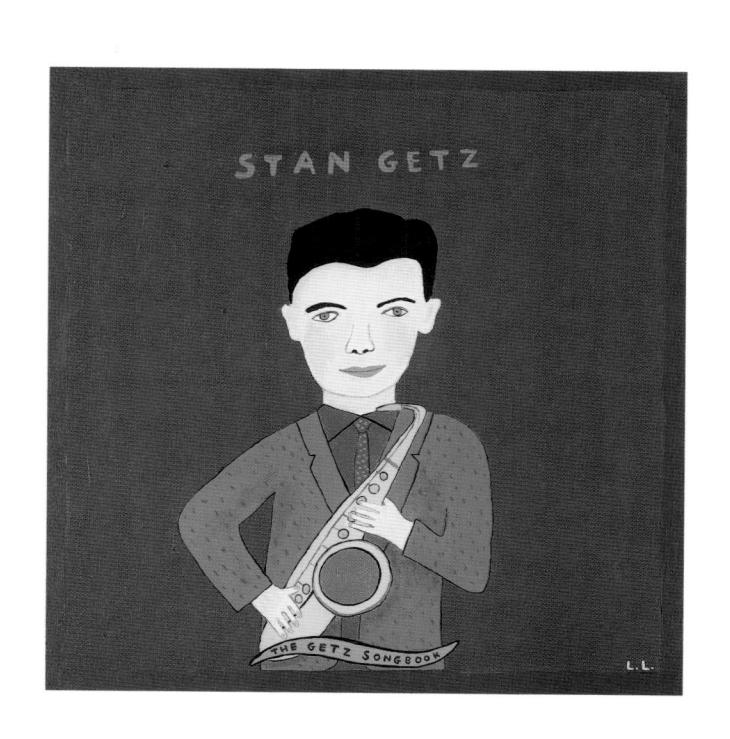

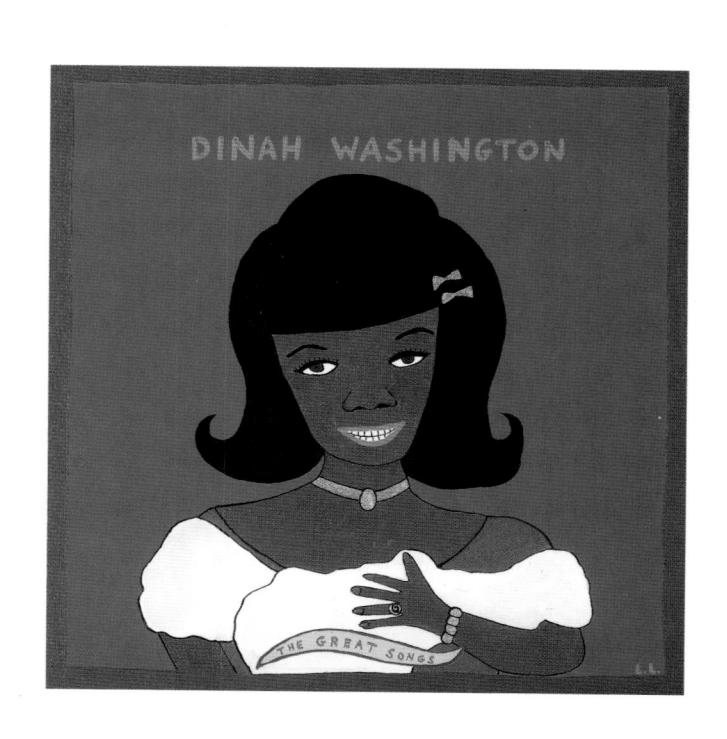

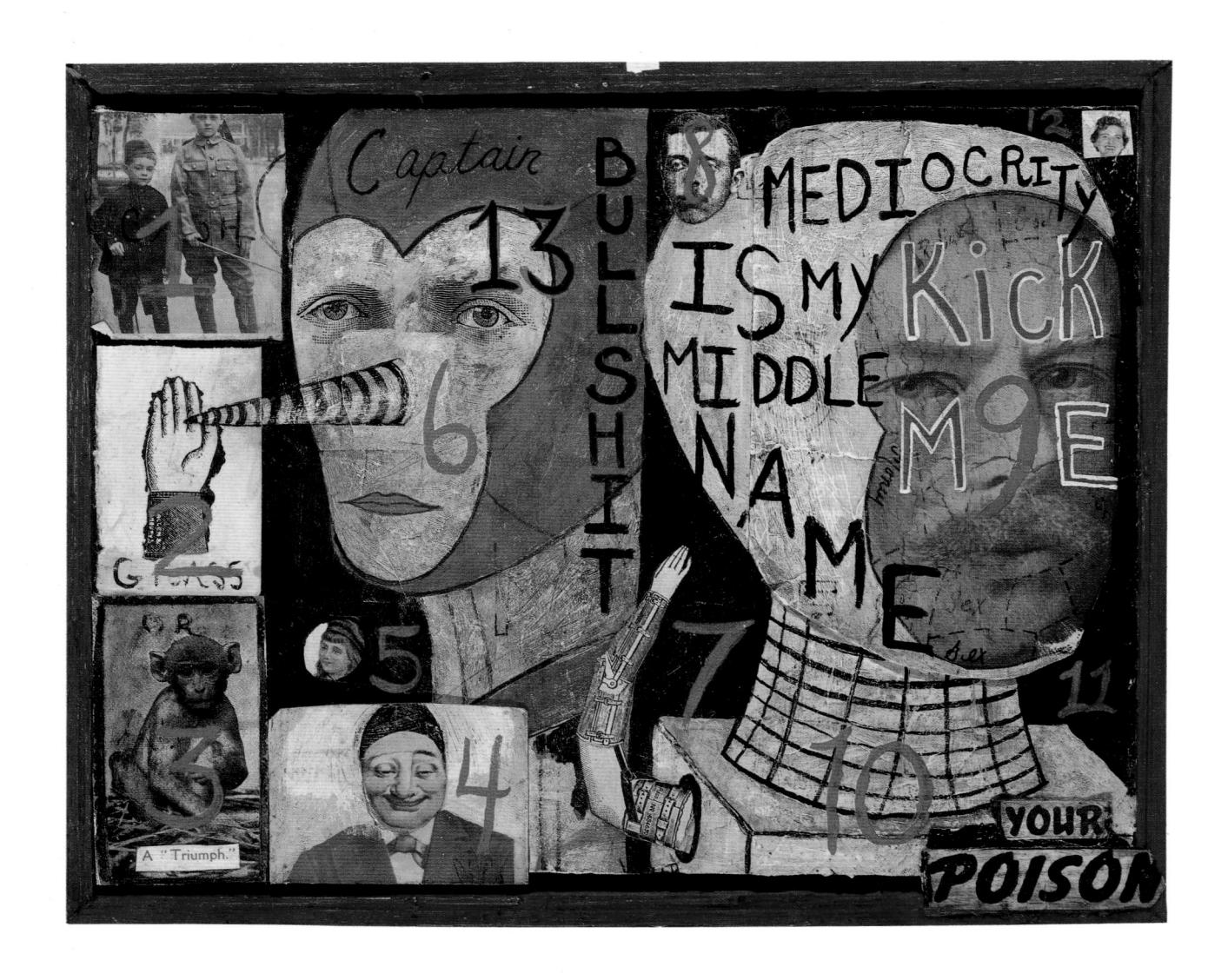

Christian Northeast

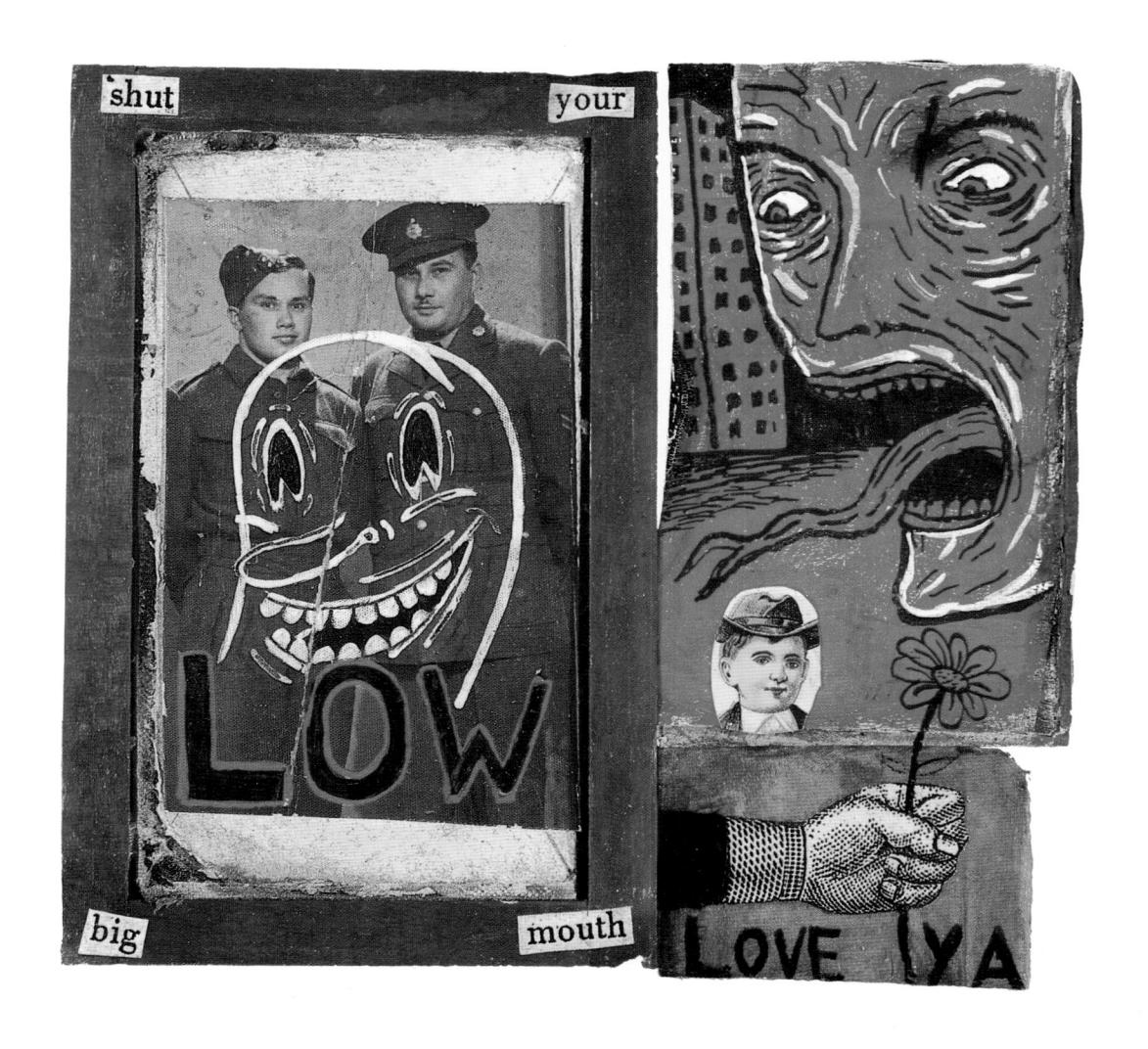

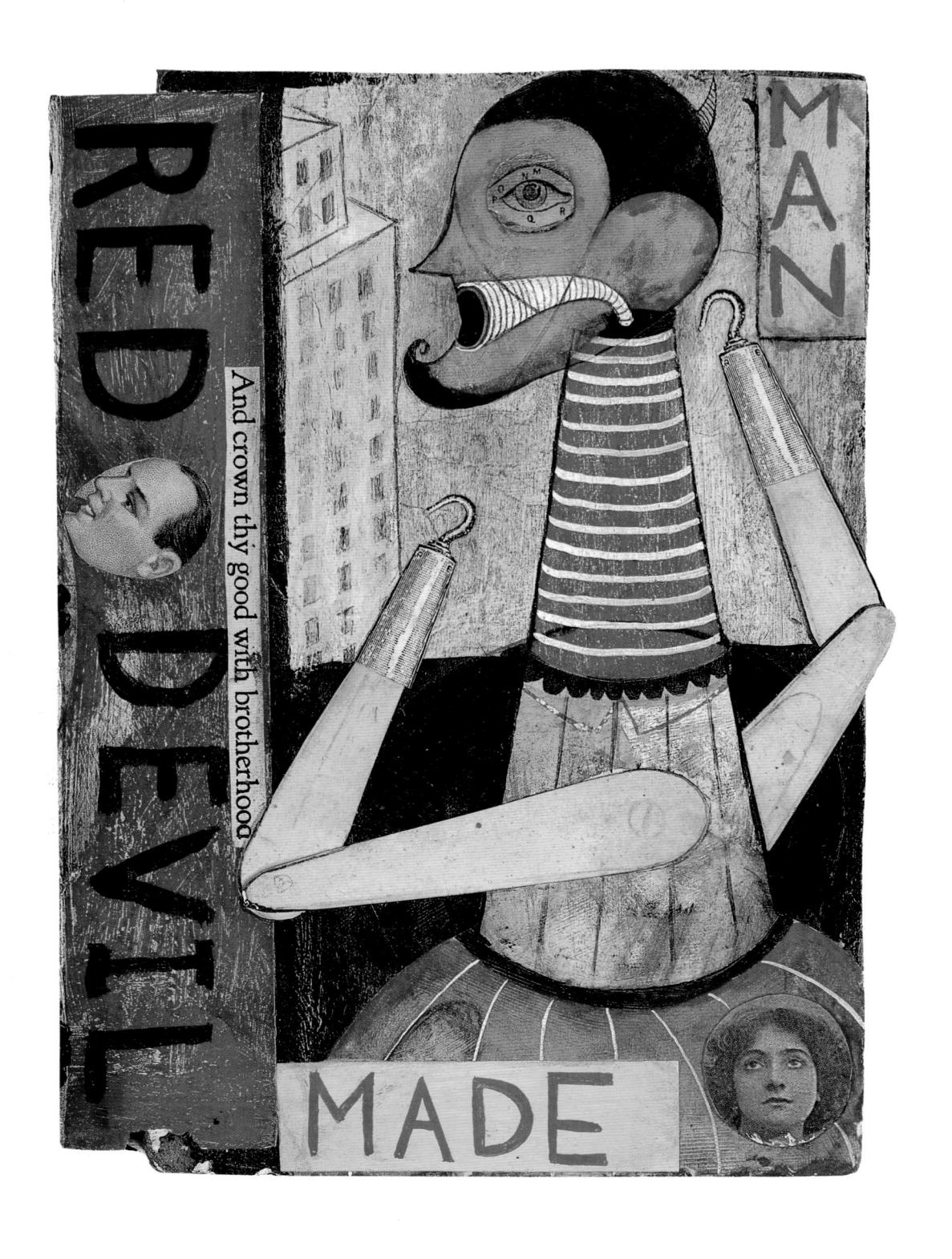
Gerald Bustamante

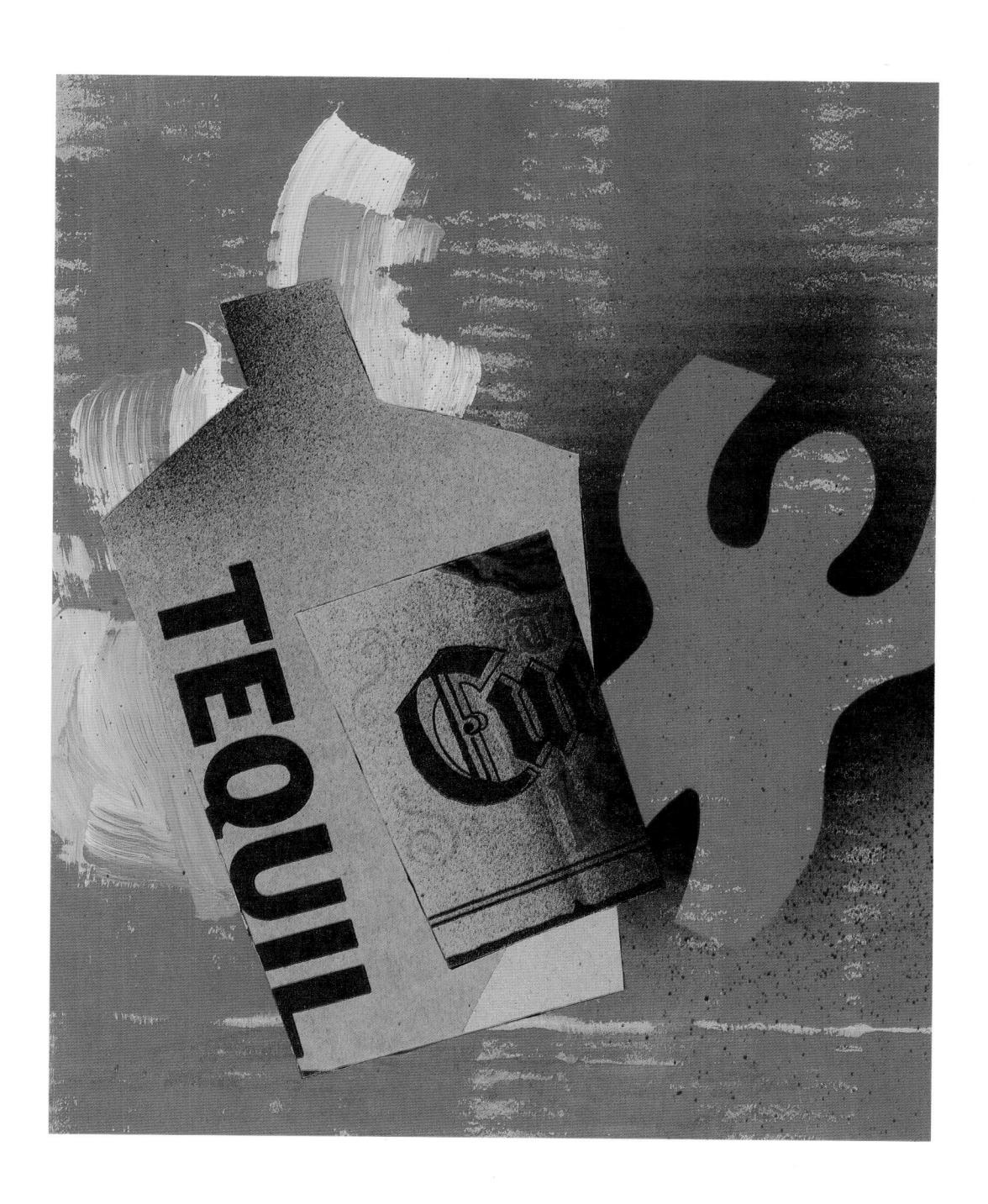

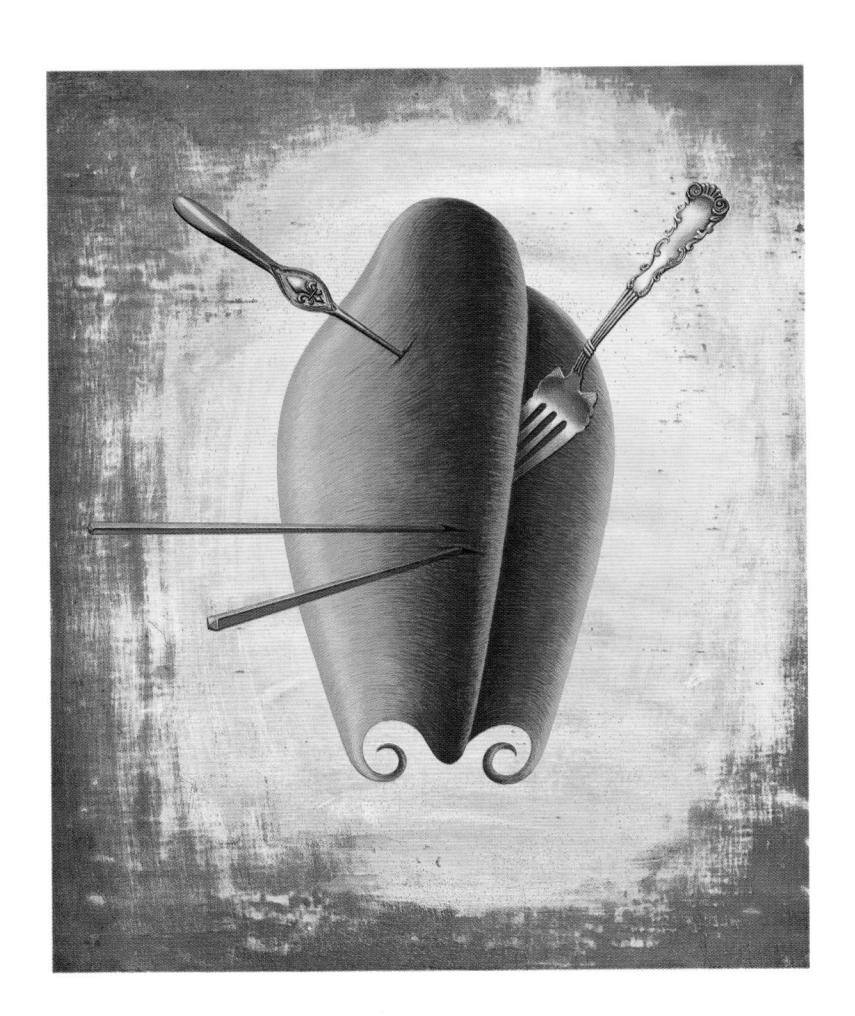

Ruth Marten

Medium) Egg tempera on wood "Havana Red" (above).

00

Medium) Egg tempera on wood "Portrait of Saul" (right).

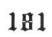

Lisa Manning

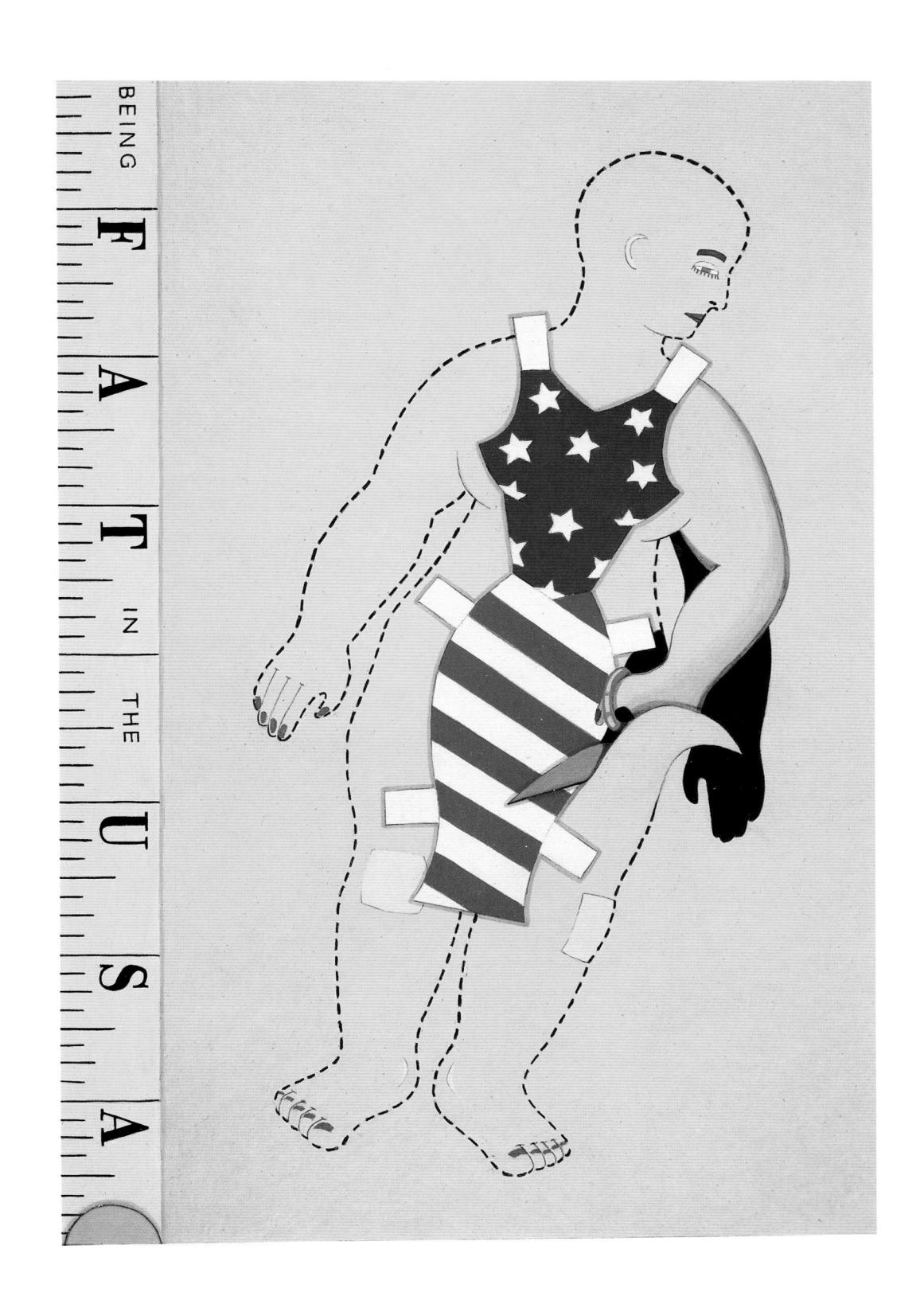

182

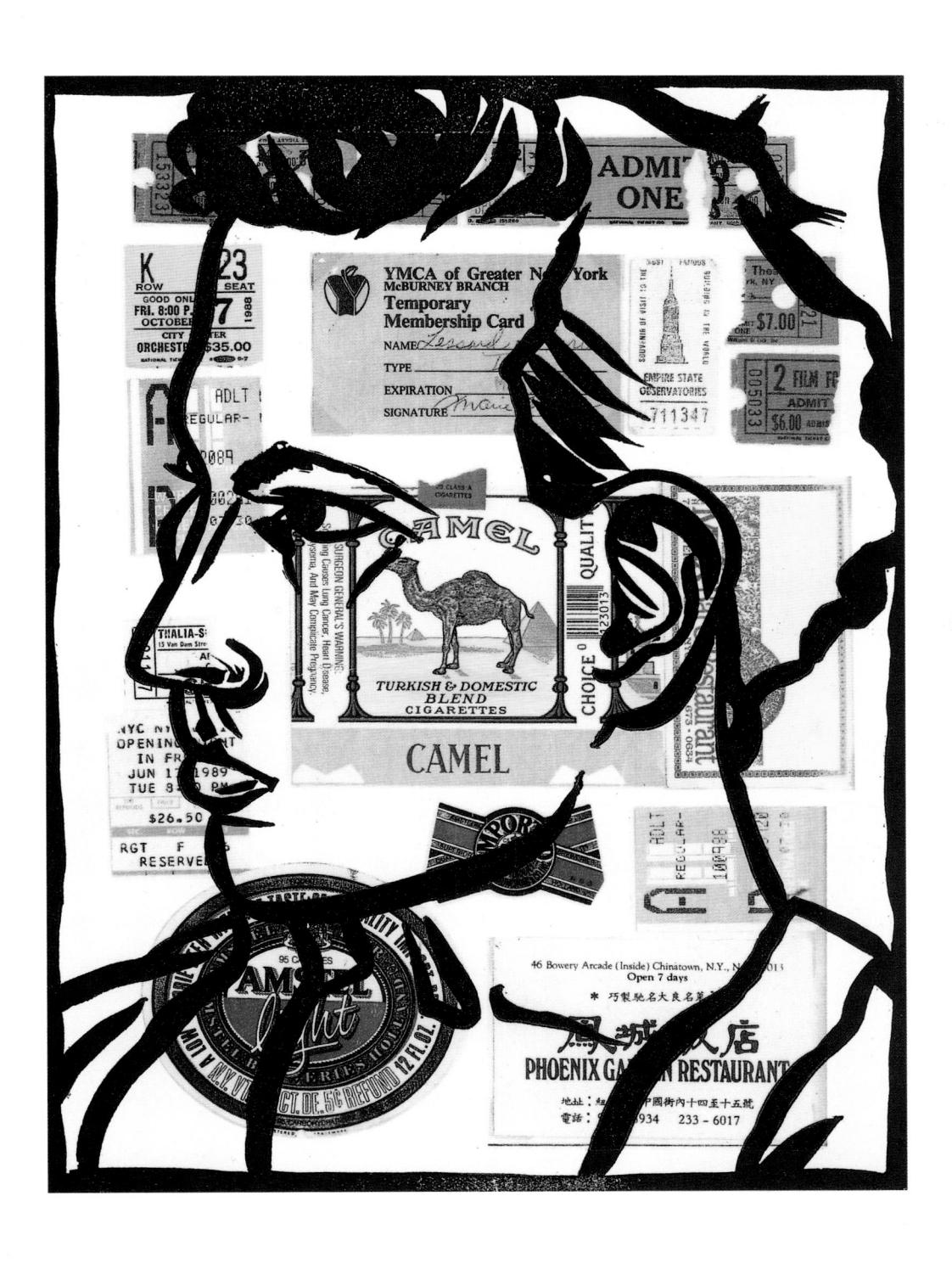

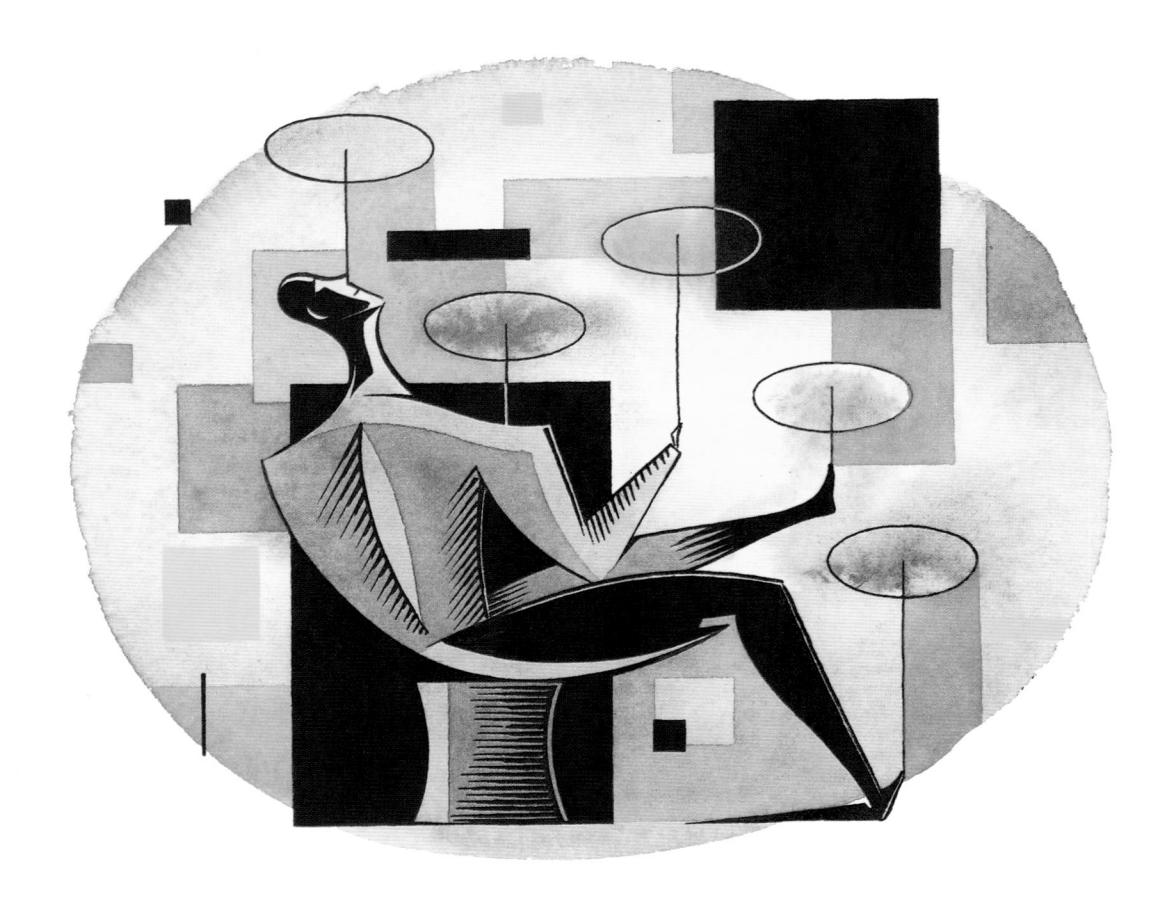

Tim Lewis

Medium) Water color over Xeroxed copy of drawing A personal piece entitled "Plate Spinner" (above).

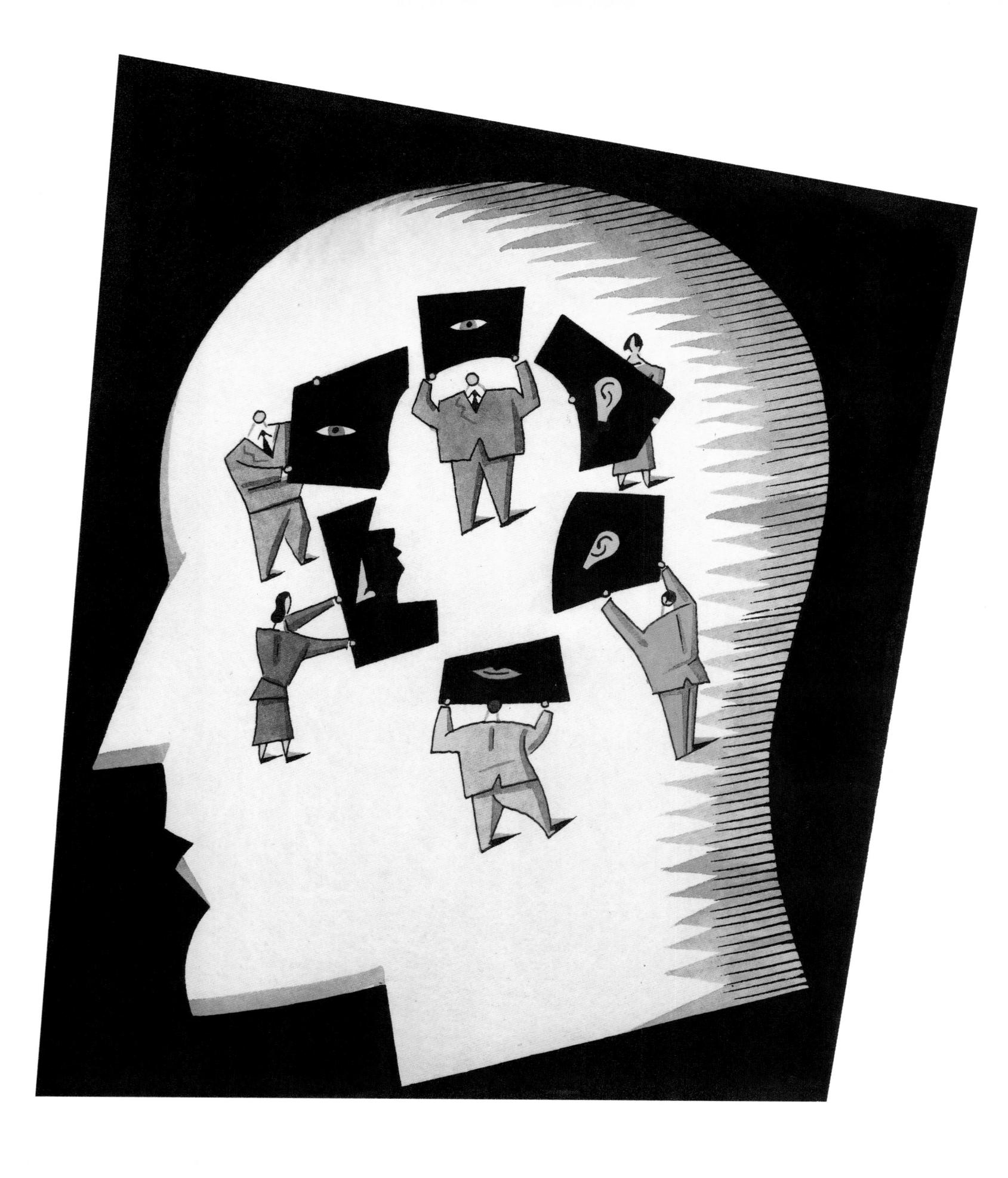

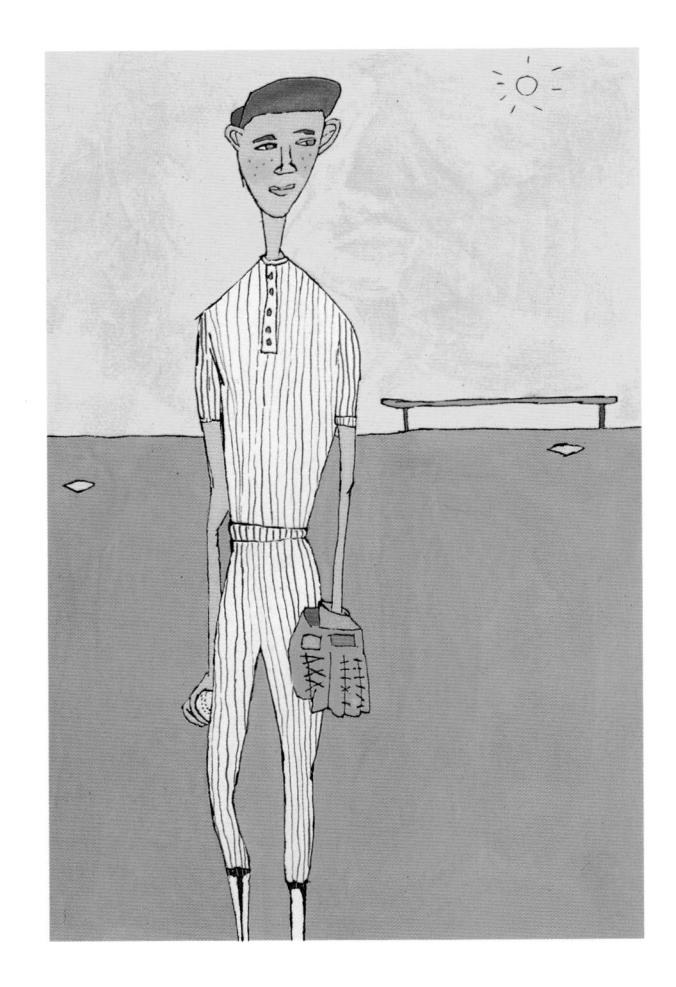

Beth O'Grady

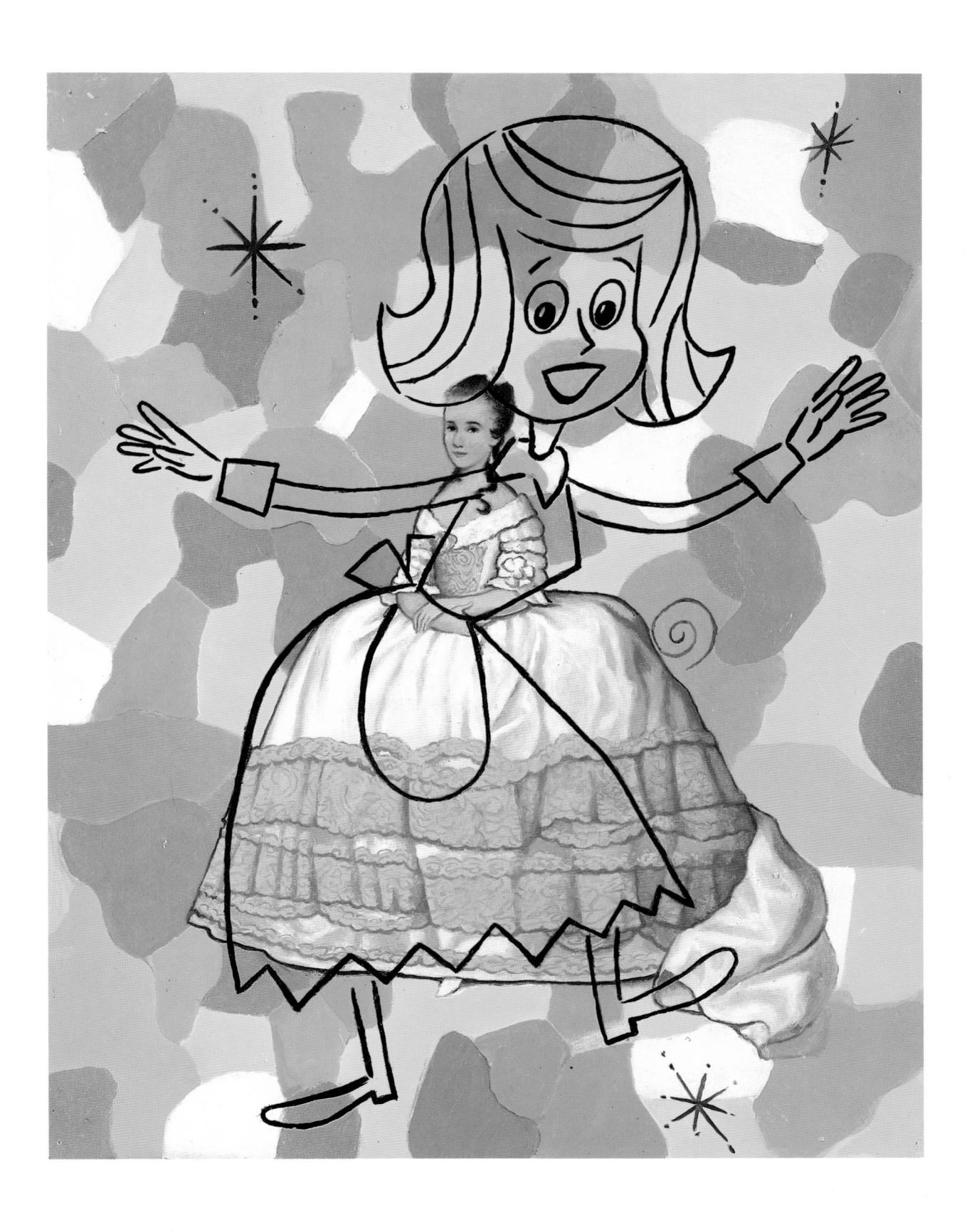

Irene Rofheart Pigott

Jessie Hartland

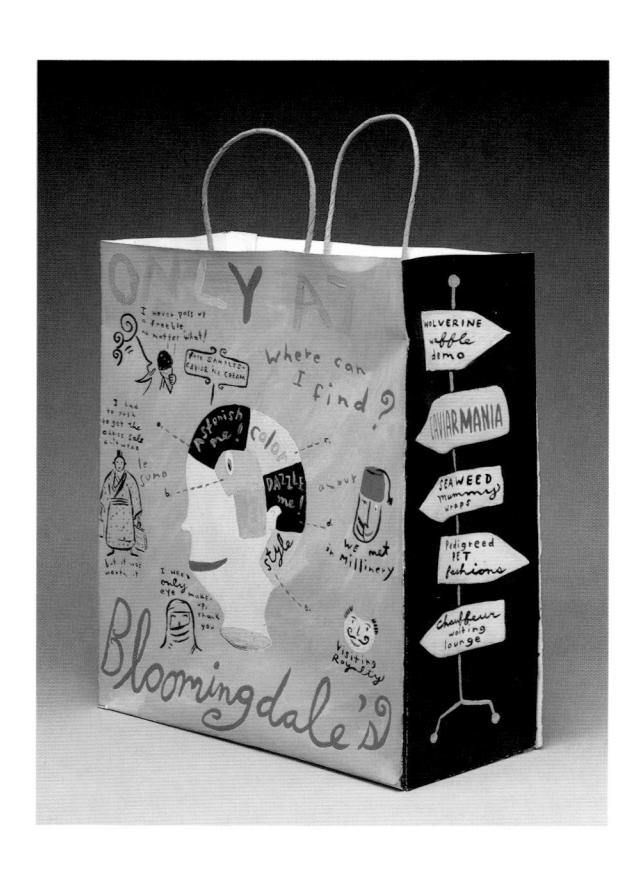

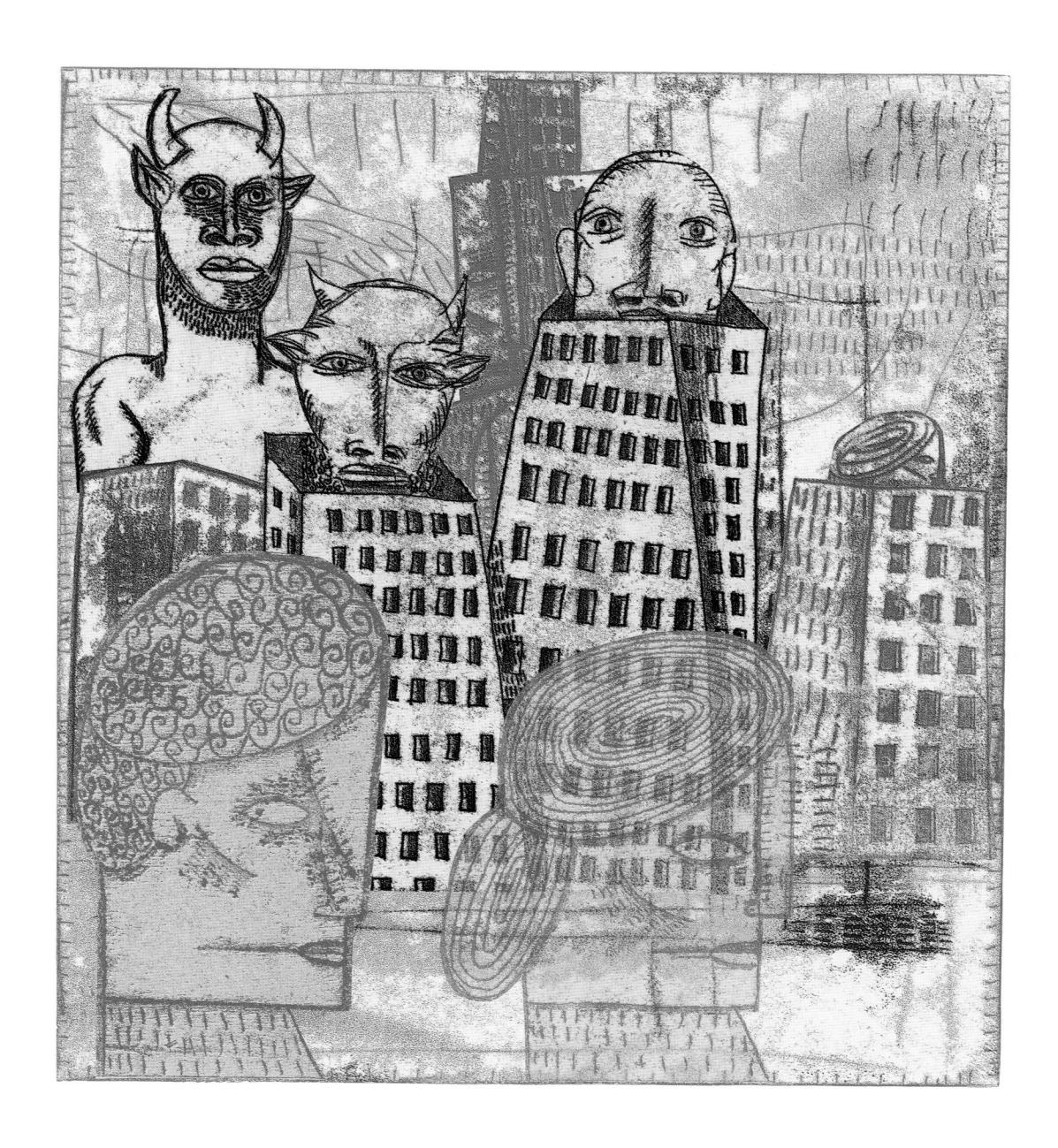

Richard Downs

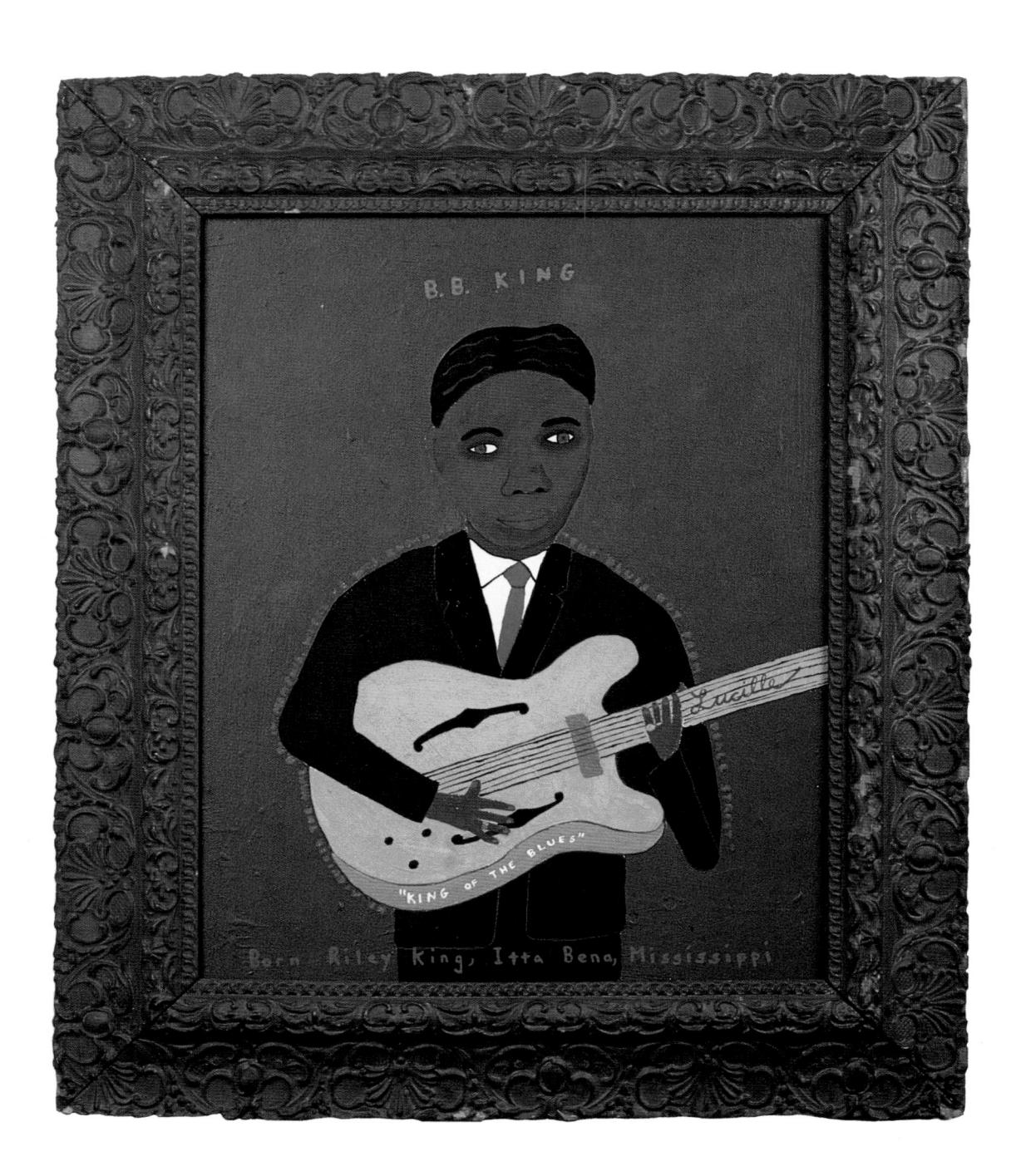

Laura Levine

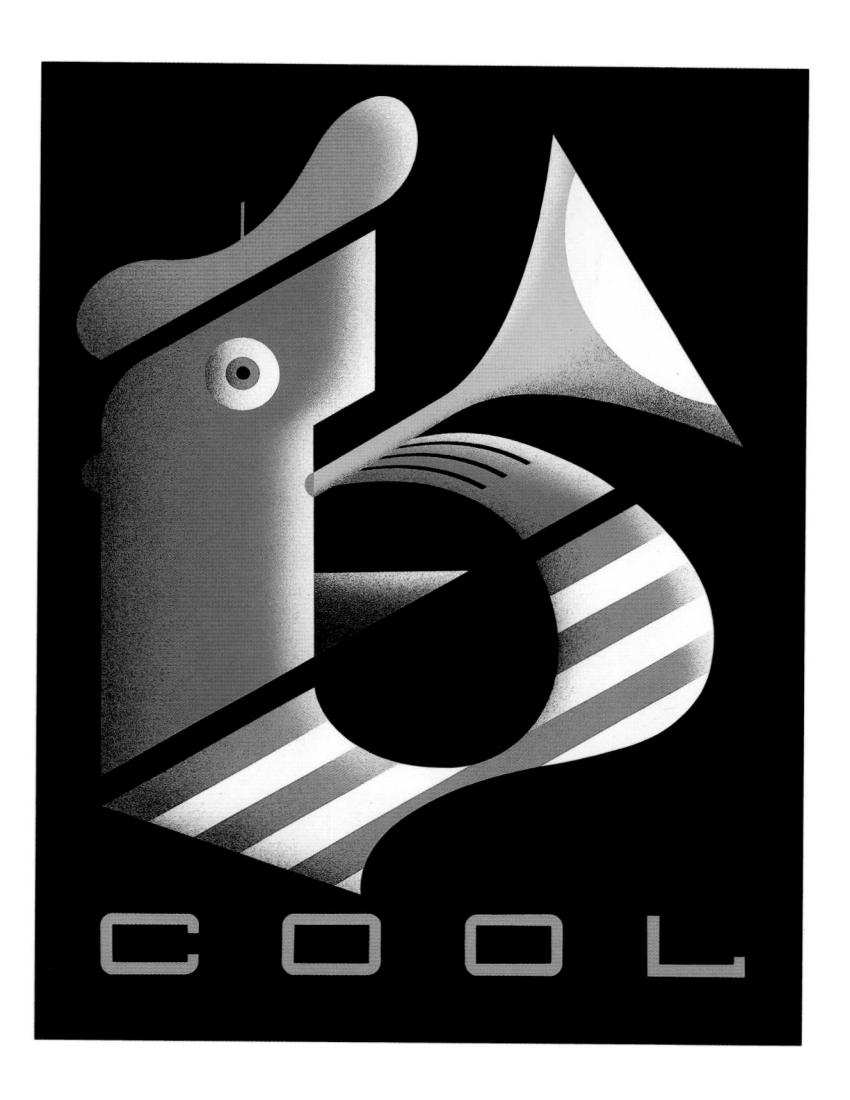

Terry Allen

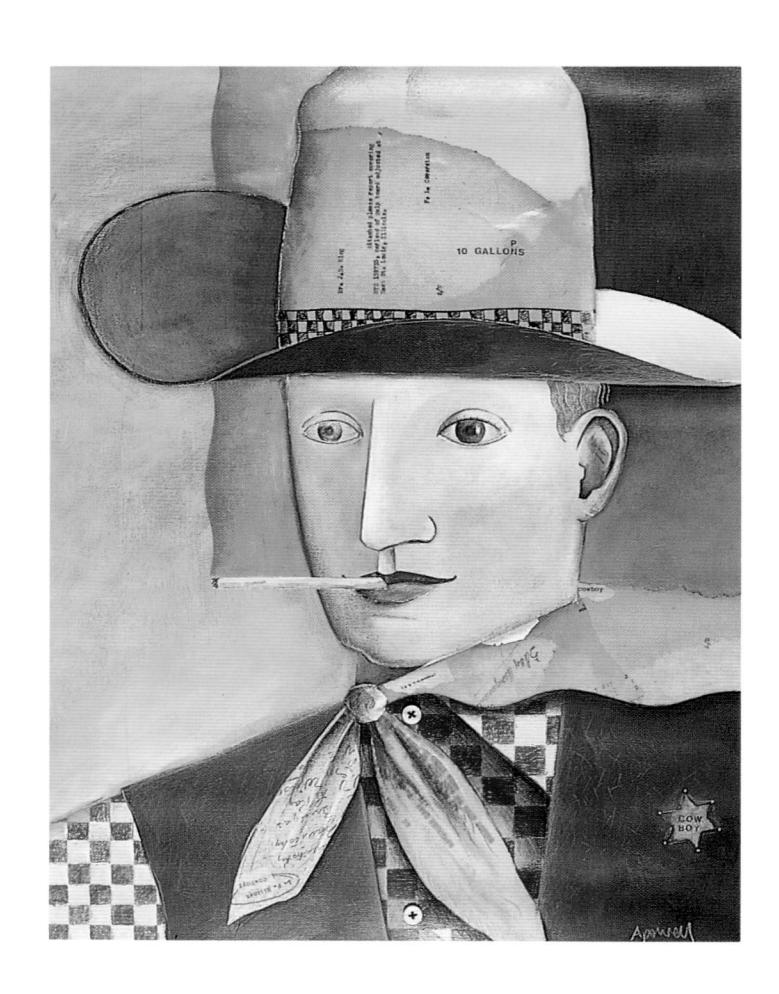

Calef Brown

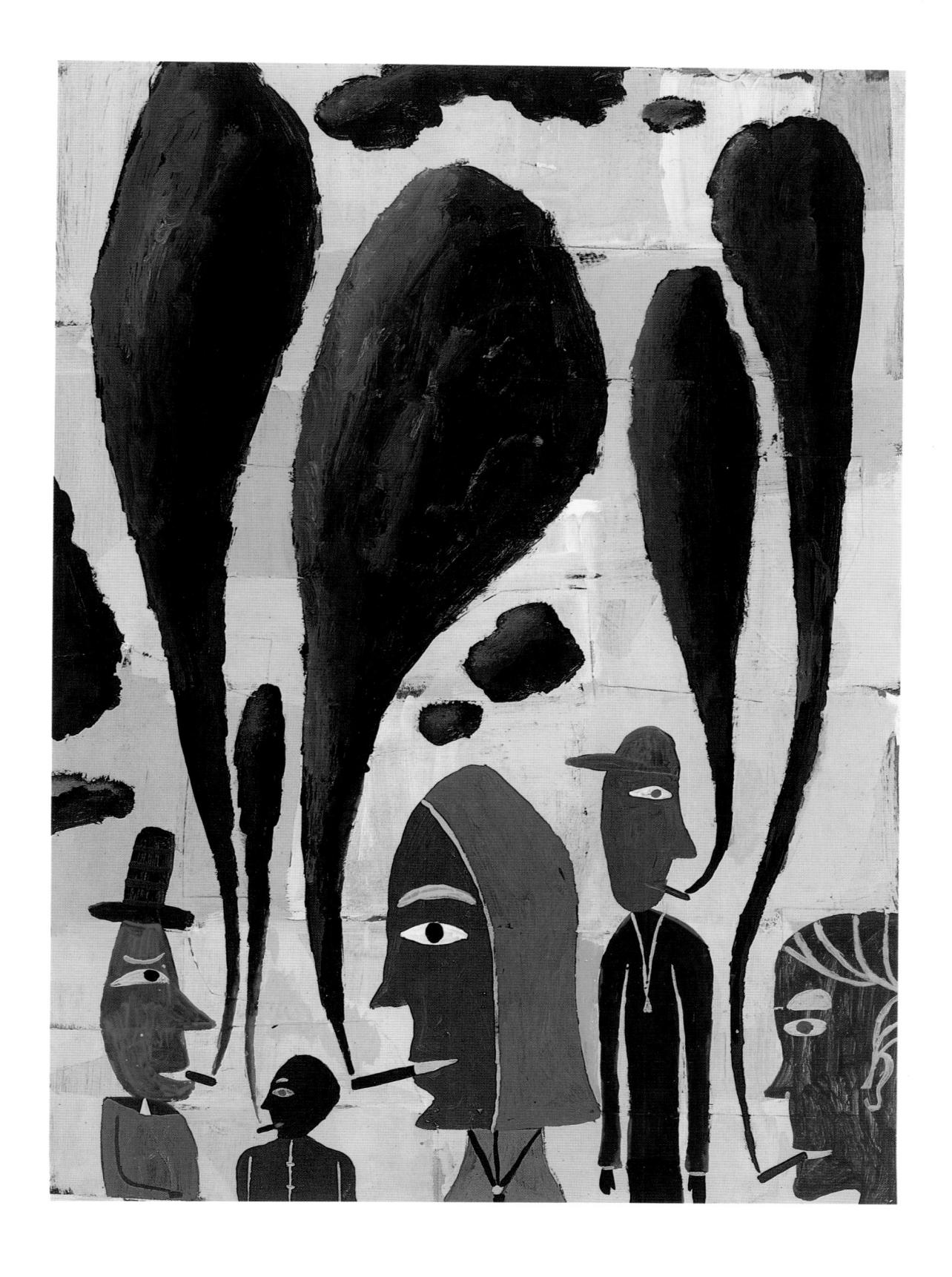

Calef Brown

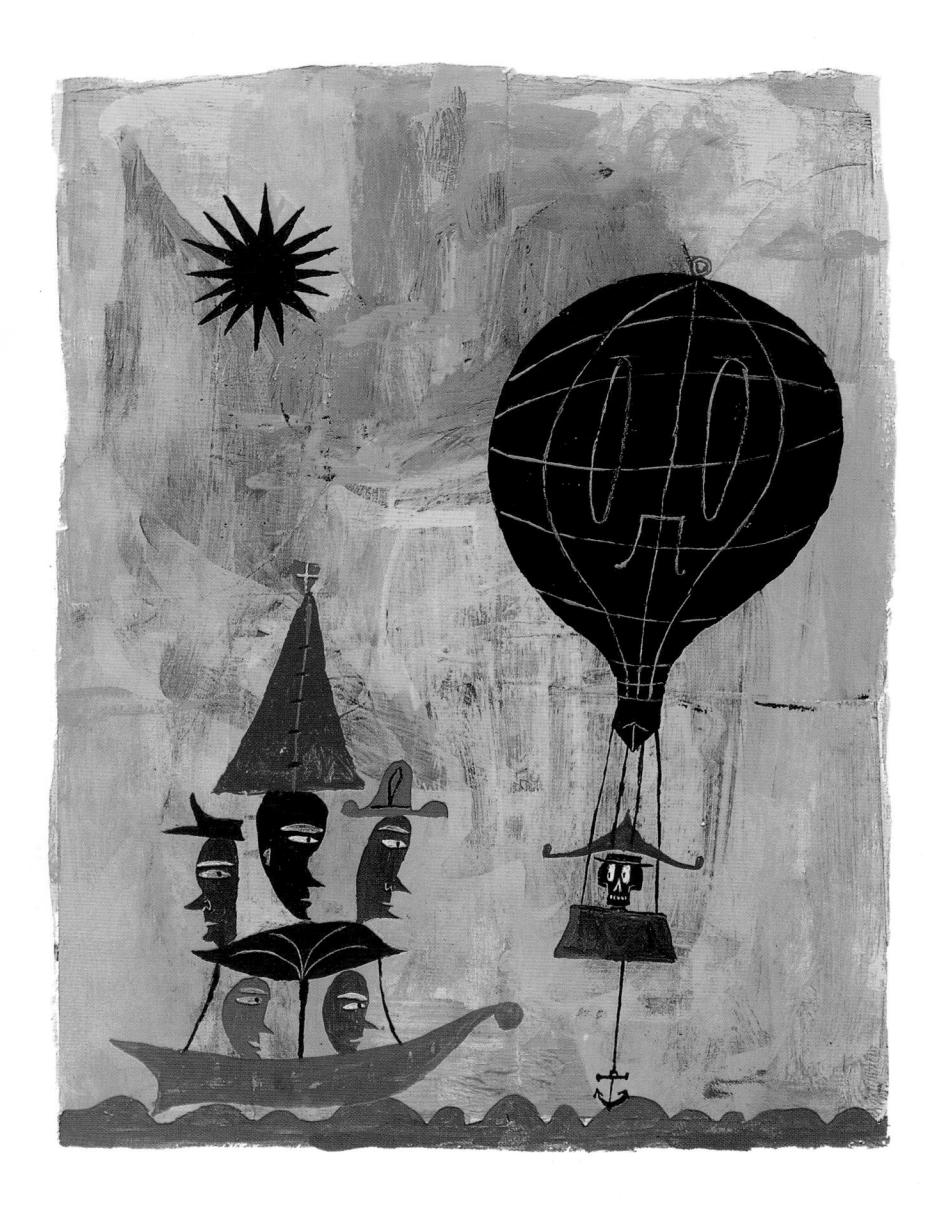

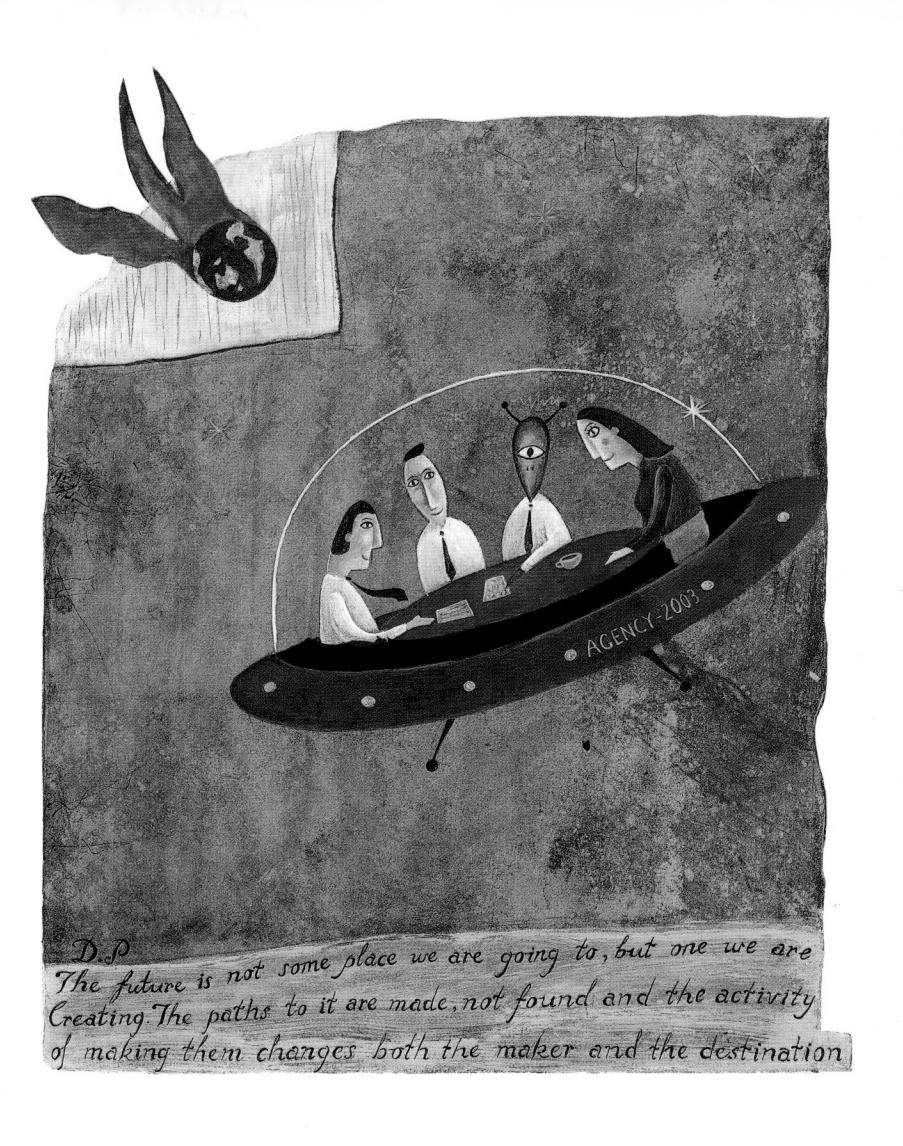

Darren Pryce

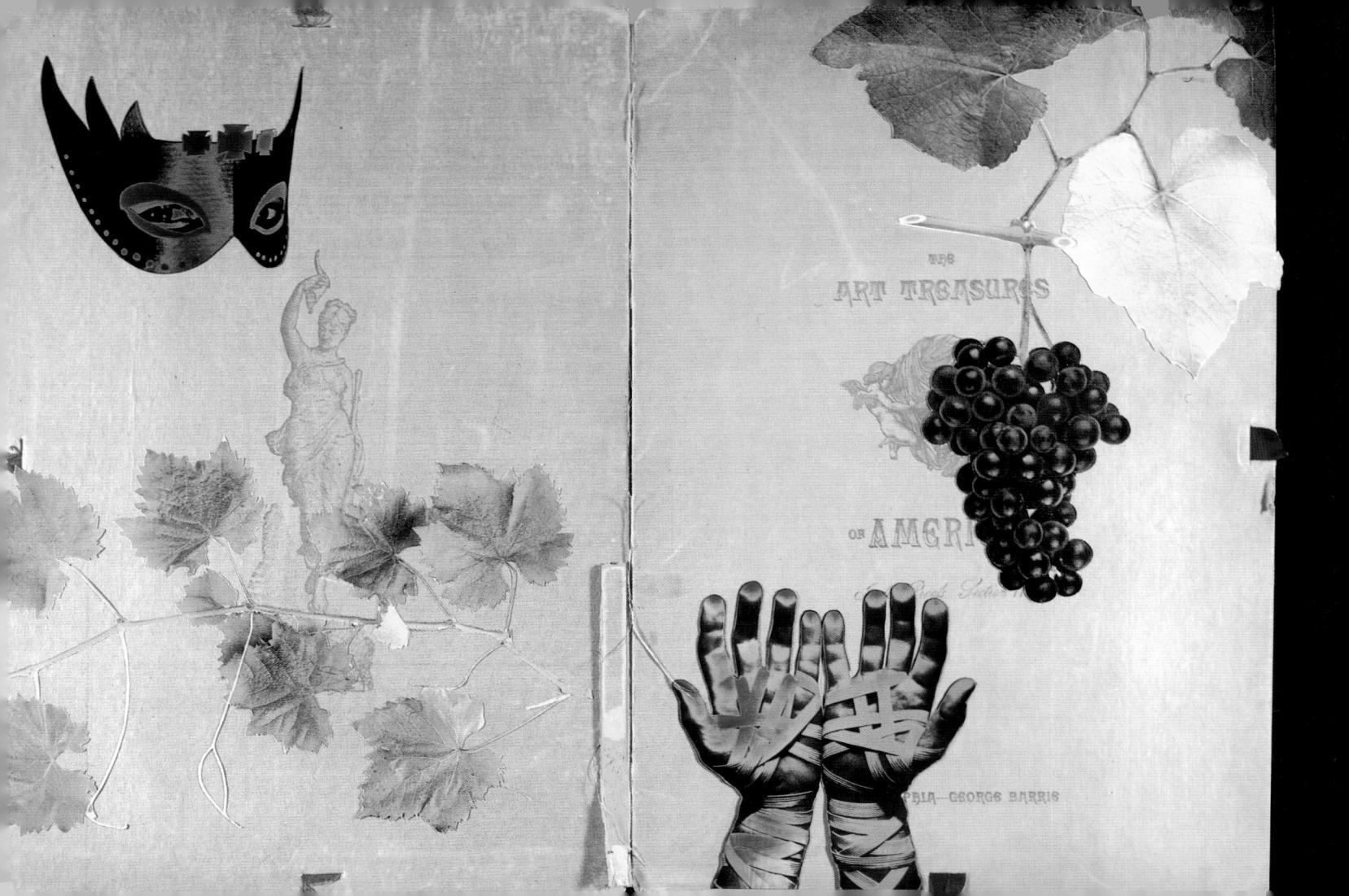

Greg Clarke

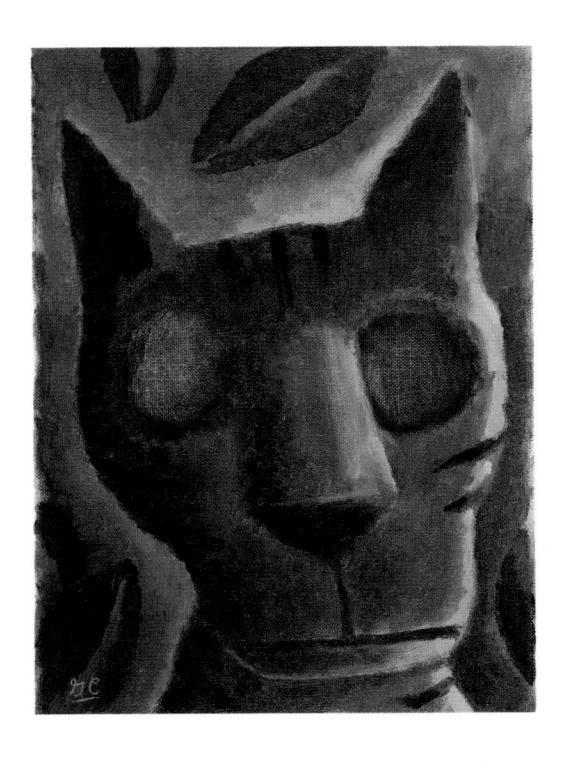

Art Director) Michael Walsh Medium) Ink and watercolor This commissioned but unpublished book jacket is in part a self-portrait. The Illustrator wore a rubber gorilla nose during the execution.

Alan E. Cober

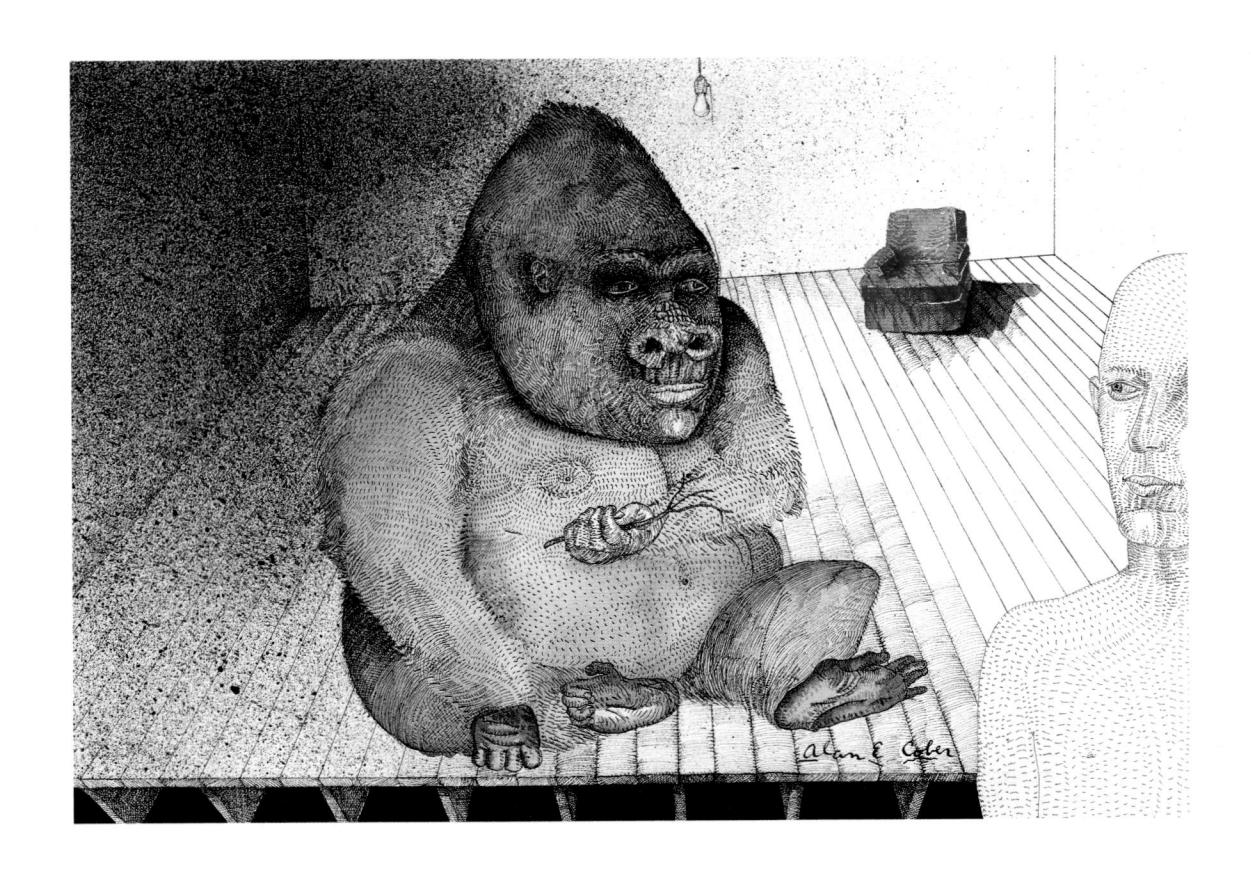

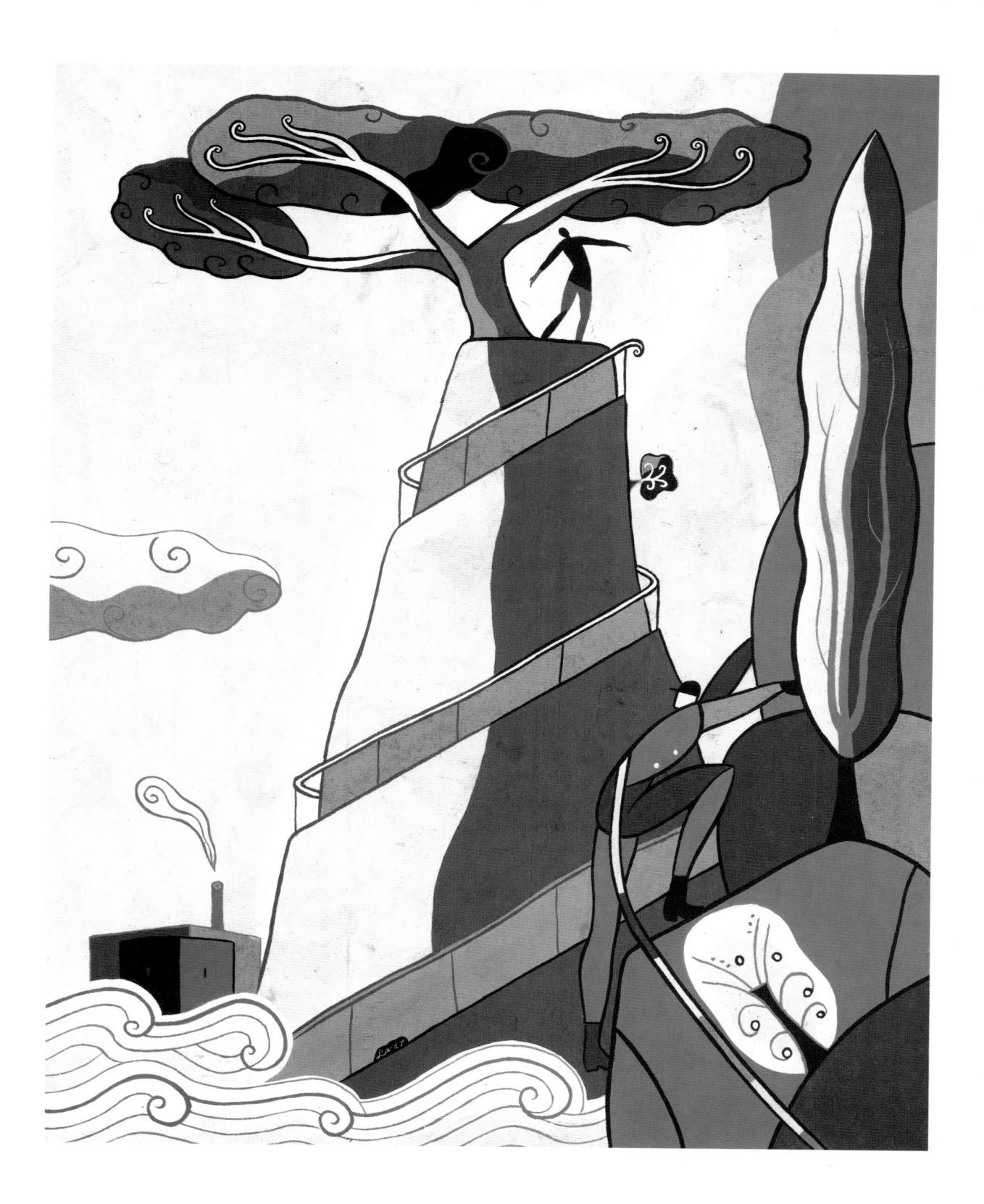

Philippe Lardy

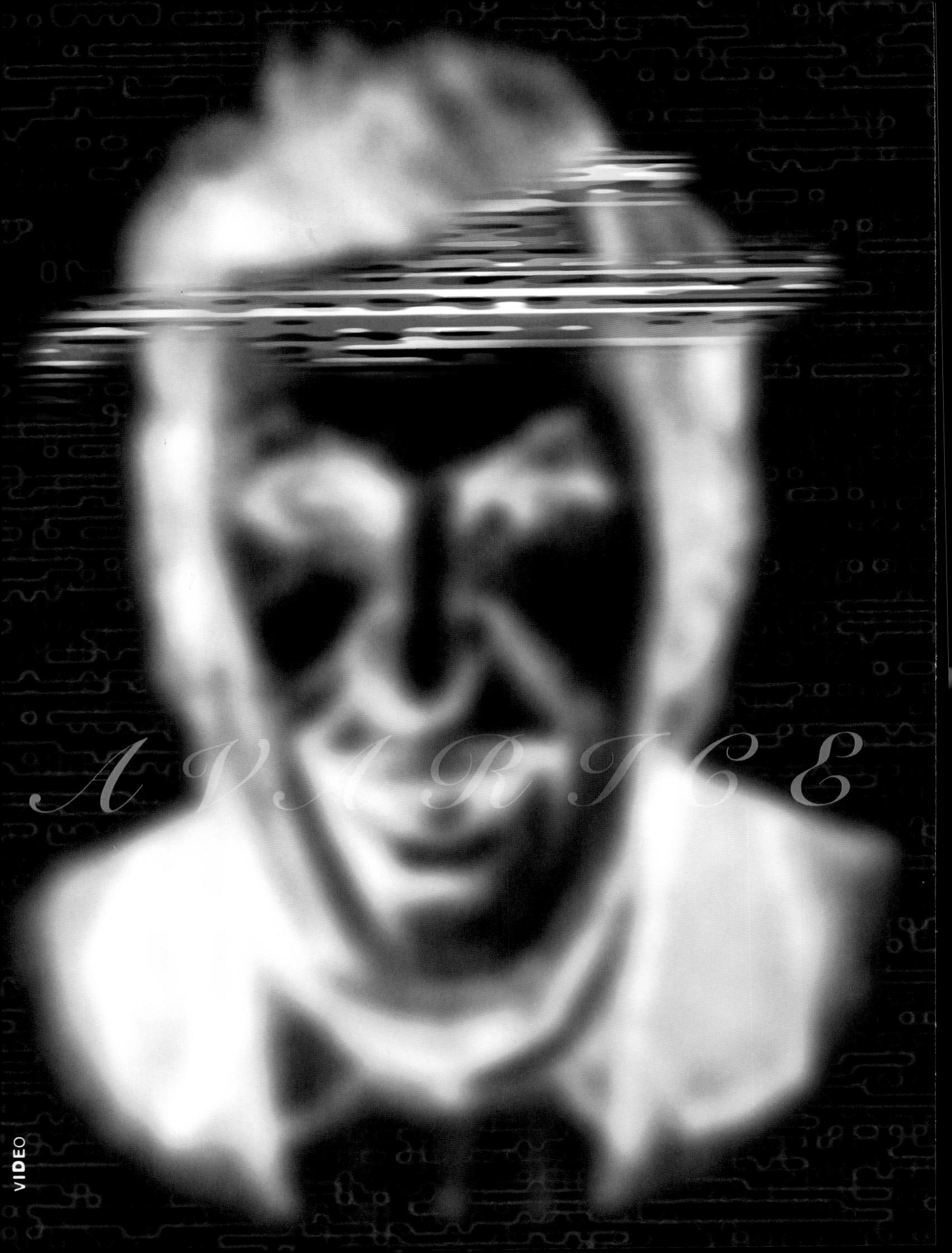

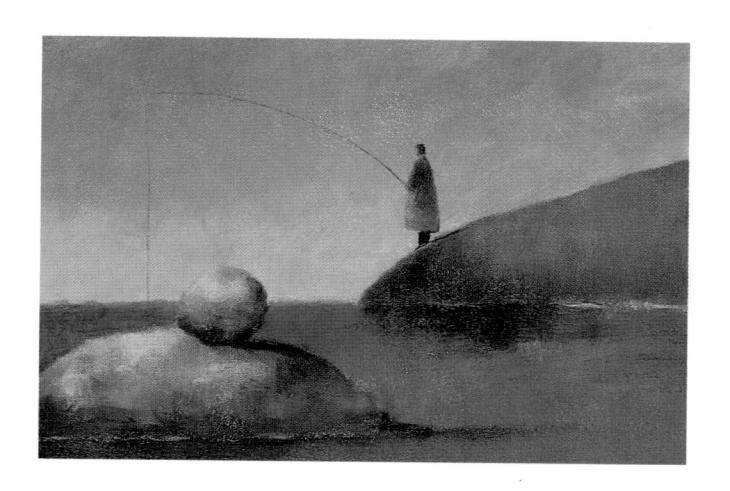

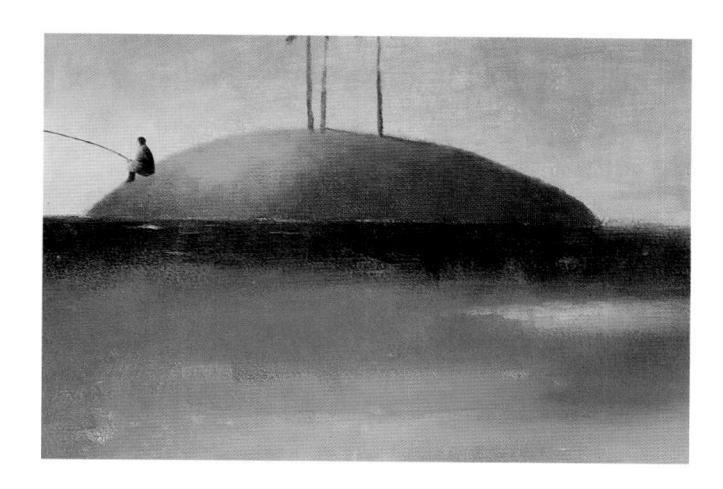

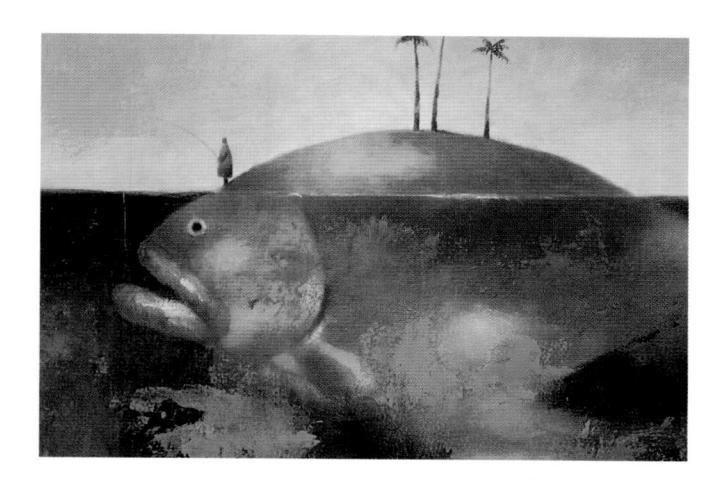

Brad Holland

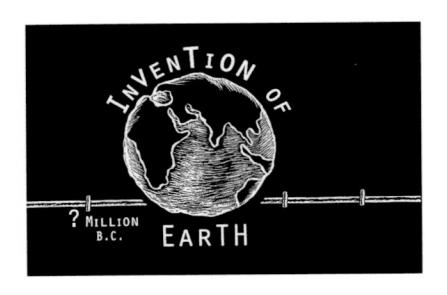

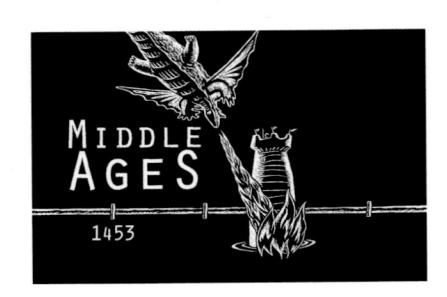

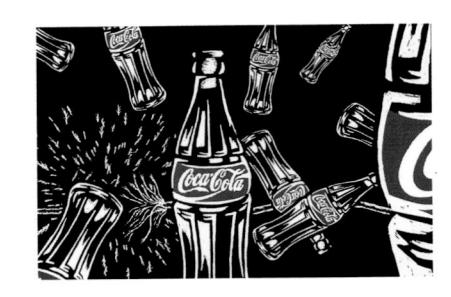

Geoffrey Grahn

Animators) Rob Palmer, Kate Flather and Geoffrey Grahn Art Director) Kate Flather Writer) Mark Fenske

Agency) Creative Artists Agency Production Company) The Bomb Factory Client) Coca-Cola Sound) Warren Dewey Medium) Scratchboard,

Macintosh computer with Adobe Photoshop and Macromind Director "Coca-Cola Time Line," a thirty-second

animated televison commercial, began airing nationally in February 1993 and internationally in March 1993.

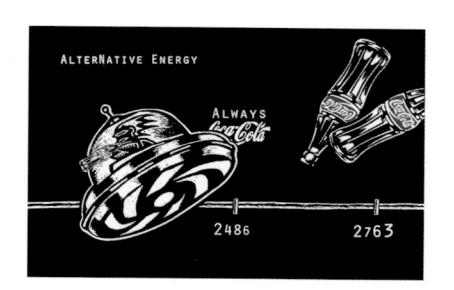

Mark Marek

Index

Terry Allen

164 Daniel Low Terrace Staten Island, NY 10301 £1/1£1

Michael Bartalos

4222 18th Street San Francisco, CA 94114 1IIf

Gary Baseman

443 12th Street #2D Brooklyn, NY 11215 37

Benoît

c/o Riley Illustration 155 West 15th Street #4C New York, NY 10011 73

Maris Bishofs

251-16 Northern Boulevard Little Neck, NY 11363 57

Patrick Blackwell

P.O. Box 324, Pond Road North Truro, MA 02652

Barry Blitt

34 Lincoln Avenue Greenwich, CT 06830 1fi/1fi2

John Borruso

1259 Guerrero Street San Francisco, CA 94110 1317

Steve Brodner

120 Cabrini Boulevard New York, NY 10033 4II-41

Calef Brown

15339 Camarillo Street Sherman Oaks, CA 91403 97/193/194

Jill Buchanan

168 Ludlow Street New York, NY 10002 156

Charles Burns

210 Brown Street Philadelphia, PA 19123 33-35

Gerald Bustamante

4528 North 44th Street San Diego, CA 92115 17¶

Stephen Byram

52 68th Street #1 Guttenberg, NJ 07093

Greg Clarke

844 Ninth Street #10 Santa Monica, CA 90403 157/197

Christian Clayton

10730 E. Bethany Drive, Suite 204 Aurora, CO 80014

Alan E. Cober

95 Croton Dam Road Ossining, NY 10562

Sue Coe

214 East 84th Street #3C New York, NY 10028 31/32

John Collier

c/o Richard Solomon 121 Madison Avenue #5F New York, NY 10016 132-135

John Craig

Tower Road Route 2, Box 2224 Soldiers Grove, WI 54655 157

Brian Cronin

"Montmolin" Royal Terrace Lane Dun Laoghaire, Co Dublin, Ireland 58/75/166

Georganne Deen

3834 Aloha Street Los Angeles, CA 90027 24

Isabelle Dervaux

c/o Riley Illustration 155 West 15th Street #4C New York, NY 10011 164

David Diaz

6708 Corintia Street Rancho La Costa, CA 92009 114-117

Eric Dinyer

5510 Holmes Kansas City, MO 64110 78

Sandra Dionisi

128 MacDonell Avenue Toronto, Ontario Canada M6R 2A5 \$\$\frac{48}{168}\$

Richard Downs

24294 Saradella Court Murrieta, CA 92562 #II/1##

Blair Drawson

14 Leuty Avenue Toronto, Ontario Canada M4E 2R3 2II/44

Henrik Drescher

c/o Reactor Art & Design 51 Camden Street Toronto, Ontario Canada M5V 1V2

Jeffrey Fisher

c/o Riley Illustration 155 West 15th Street #4C New York, NY 10011 51/87

Vivienne Flesher

194 3rd Avenue New York, NY 10003 142

Art Garcia

c/o Richelle Munn 2811 McKinney Avenue Suite 320, LB111 Dallas, TX 75204 158

Josh Gosfield

682 Broadway #4A New York, NY 10012 53/146-147/171

Geoffrey Grahn

9927 Braddock Drive Culver City, CA 90232 202-203

Steven Guarnaccia

430 West 14th Street #508 New York, NY 10014 117/1118

Amy Guip

352 Bowery #2 New York, NY 10012 \$7-\$\$/1\$\$

Edmund Guy

820 Hudson Street Hoboken, NJ 07030 27/148

Jessie Hartland

165 William Street New York, NY 10038 152-153/188

Sandra Hendler

1823 Spruce Street Philadelphia, PA 19103 23

Brad Holland

96 Greene Street New York, NY 10012 26/76/85/92/2011

Jason Holley

664 Monterey Rd. So. Pasadena, CA 91030

David Hughes

43 Station Road Marple Cheshire, England SV66AJ

Jordin Isip

44 4th Place #2 Brooklyn, NY 11231 45-48

Frances Jetter

390 West End Avenue New York, NY 10024 43/111

Joel Peter Johnson

P.O. Box 803 Ellicott Station Buffalo, NY 14205-0803 #4

Maira Kalman

59 West 12th Street New York, NY 10011 1 #1

Kiyoshi Kanai

115 East 30th Street New York, NY 10016 165

Brian Krueger

P.O. Box 6290 Cincinnati, OH 45206 fifi

Peter Kuper

250 West 99th Street #9C New York, NY 10025 141/159

Philippe Lardy

478 West Broadway #5A New York, NY 10012 1111/199

Marie Lessard

4641 Hutchison Montreal, Quebec Canada H2V 4A2 183

Laura Levine

444 Broome Street New York, NY 10013 172-173/1911

Tim Lewis

184 St. Johns Place Brooklyn, NY 11217-3402 184/185

Warren Linn

4915 Broadway #2A New York, NY 10034 28/96

Matt Mahurin

666 Greenwich Street #16 New York, NY 10014

Lisa Manning

12 Ledge Lane Gloucester, MA 01930 182

Mark Marek

199 Owatonna Street Haworth, NJ 07641 202-203

Ruth Marten

8 West 13th Street #7RW New York, NY 10011 149/180-181

Bill Mayer

240 Forkner Drive Decatur, GA 30030 1711

Richard McGuire

45 Carmine Street #3B New York, NY 10014 125-129

Chesley McLaren

228 West 82nd Street New York, NY 10024 1511

Scott Menchin

640 Broadway New York, NY 10012 1111/151

Christian Northeast

48 Abell Street #245 Toronto, Ontario Canada M6J 3H2 54-56/176-178

José Ortega

524 East 82nd Street New York, NY 10028 \$1/1111

Beth O'Grady

161 Fourth Street #3E Hoboken, NJ 07030 186

C.F. Payne

758 Springfield Pike Cincinnati, OH 45215 #4/##

Hanoch Piven

310 West 22nd Street #4A New York, NY 10011 52-55

David Plunkert

3647 Falls Road Baltimore, MD 21211 49-52/72/74

Andrew Powell

420 North 5th Street #706 Minneapolis, MN 55401 192

Darren Pryce

90 Clyde Street St. Kilda Victoria 3182 Australia 195

Robert Risko

155 West 15th Street #4B New York, NY 10011 39

Irene Rofheart Pigott

75 Prospect Park West #1A Brooklyn, NY 11215-3054 187

Lilla Rogers

6 Parker Road Arlington, MA 02178 136-140/162-163

Jonathon Rosen

408 Second Street #3 Brooklyn, NY 11215 #11-#1/1114-1115

Mark Ryden

221 West Maple Monrovia, CA 91016 131

Wiktor Sadowski

c/o Marlena Torzecka 211 East 89th Street, Suite A-1 New York, NY 10128 45

Rick Sealock

112 C 17th Avenue N.W. Calgary, Alberta Canada T2M 0M6

J. Otto Seibold

38 West 21st Street 11th Floor New York, NY 10010 122-125

Lane Smith

12 West 18th Street #6W New York, NY 10011 118-121

Owen Smith

4370 Faulkner Drive Fremont, CA 94536

Edward Sorel

156 Franklin Street New York, NY 10013 22

Ralph Steadman

c/o Andrea Harding 146 East 19th Street New York, NY 10003 42

Gary Tanhauser

3018 Orange Avenue Santa Ana, CA 92707 7II-71

Malcolm Tarlofsky

P.O. Box 786 Glen Ellen, CA 95442 77

Pol Turgeon

5187 Jeanne-Mance #3 Montreal, Quebec Canada H2V 4K2

Maurice Vellekoop

c/o Reactor Art & Design 51 Camden Street Toronto, Ontario Canada M5V 1V2

Stefano Vitale

478 Bergen Street #4 Brooklyn, NY 11217

Alexandra Weems

58 East 80th Street #2B New York, NY 10021 17/18

Philippe Weisbecker

c/o Riley Illustration 155 West 15th Street #4C New York, NY 10011 1113

Mick Wiggins

1103 Amador Avenue Berkeley, CA 94707 fill

Thomas Woodruff

29 Cornelia Street #17 New York, NY 10014 143

Janet Woolley

c/o Alan Lynch 11 Kings Ridge Road Long Valley, NJ 07853 25/93

Art/Creative Directors and Designers

Anderson, Gail #3, #II Armario, David £1, 1114-1115 Baker, Richard 38, 109 Bartholomay, Lucy 75, 86 Berry, Pamela 19, 20, 41, 56 Betts, Elizabeth £4 Bhandari, Sunil 168 Birch, Linda 1116 Black, Roger 73 Blechman, R.O. 2112-2113 Carson, David 47, 67-69, 78, 89, 91 Caruso, Leigh 511-52 Champagne, Kim 171 Christie, Jim 188 Chu, Michele 57 Churchward, Charles 39 Colyer, Martin 58 Cook, Tim 98, 99 Curry, Chris 16-18, 34, 62 Dazzo, Susan Gockel 37 Diaz, Cecelia 114-118 Diaz, David 114-118 Dizney, Joseph 59 Doe, Kelly 38, 109 Doonan, Simon 14fi-147 Duckworth, Nancy 97 Elliot, Paul 142 Evans, Mark 49 Farley, Chris 162-163 Ferrand, Jaime 96 Ferrell, Joan 45 Fillebrown, Tom #3 Flather, Kate 202-203 Flinchum, Dwayne 23, 84 Frank, Laura N. 48, 54-55 Frey, Jane 25 Froelich, Janet 311 Garcia, Art 158 Garlan, Judy 24 Gilman, Jennifer 111 Gosfield, Josh 145-147 Grevstad, Alison 199 Grossman, Michael #4 Helfand, Jessica 1111 Himagawa, Hitoshi 154 Hinzman, Laurie 151 Hoffman, Cindy 1117 Hoffman, Joanne BII

Hoglund, Rudolph C. 25 Honeycutt, B.W. 91 Ilić, Mirko 28, 29 Innes, Claire ## Jay, Alex 132-135 Juliano, Jennifer 151 Kochi, Tomoko 13fi-14fl Koudys, Mark 1112 Kushner, Tony 145-147 Lambertus, James 1114 Latis, Silvia 108 Lauritano, Robin M. 152-153 Leach, Molly 118-121 Littrell, Kandy 31 Loewy, David 74 Lorenz, Lee 15 Maddocks, Victoria ## Marino, Guy 2111 McMurray, Kelly 159 Merkley, Parry 201 Mitchell, Pat 711 Mortensen, Gordon 157 Nagel, Bart 13II Nissen, Melanie 148 Palecek, Jane 44, 53, 71, 79 Perry, Darrin 21 Pope, Kerig 26 Powers, Lisa 43 Priest, Robert 35, 94, 95 Routhier, Chuck 77 Rubinstein, Rhonda #7 Russell, Gina 162-163 Ruys, Suzette 23, 84 Sanford, John 75 Schiff, Robin 149 Siebert, Lori 169 Skelton, Claude 72 Sloane, Chris 1113 Smith, Adam 411 Staebler, Tom 26 Stearns, Sarah 1111 Sullivan, Jerry 1711 Sullivan, Michaela 143 Sullivan, Ron 158 Suzuki, Tom 98, 99 Thompson, Kate 45, 111 Tremain, Kerry #5 Truch, Alli 172 Wadler, Scott 151 Walsh, Michael 198

Woodward, Fred 22, 27, 31, 32,

33, 35, 42, 63, 66, 80, 82, 92-93

Animators

De Seve, Mike 202-203

Flather, Kate 202-203

Grahn, Geoffrey 202-203

Palmer, Rob 202-203

Editors Auchincloss, Kenneth 43 Arthaud, Katherine 95 Beatty, Jack 24 Brown, Tina 16-18, 34, 62 Bucky, Gillian 132-135 Duffy, Jim 49 Emmrich, Stuart 59 Ewing-Pearse, Betty 1112 Foell, Earl W. 48, 54-55 Gadsby, Patricia 1114-1115 Gergen, David 57 Groth, Gary 141 Guccione, Bob 23, 84 Hayes, Regina 118-121 Hoffman, Paul 1114-1115 Hunt, Chris 21 Inman, William 1111 Israel, Bret 97 Jarrett, Marvin Scott 47, 67-69, 78, 89, 91 Jimenez, Sandy #1 Jones, Sabrina #1 Lazar, Florence 74 Mark, M. 46 McDonell, Terry 73, 87 McGeary, Johanna 25 Minetto, Renato 1118 Mu, Queen 13II O'Donnell, Bob 1116 Ravgiala, Gail 1117 Reeves, Howard 125-129 Rice, Jim 72 Rome, Avery 1111 Ruby, Daniel 77 Rucker, Rudy 1311 Schrier, Eric 44, 53, 71, 79 Shipley, David 28, 29 Sylvain, Rick ## Thompson, Bob 38, 1119 Tobocman, Seth #1 Todd, Richard 143 Weidenbaum, Marc 83

Weinman, Steve 58

Wilburn, Deborah 45 Zellman, Ande 75, 86

Writers

Agnelli, Lauren 57 Alden, Grant & & Allen, Dave \$8-59 Anderson, Steve 57 Andreopoulos, Spyros £1 Atkinson, Mark A. 98 Battersby, Helen 168 Beck, Melinda ## Bergson, Eliot 77 Breen, Bill 711 Brisbin, Shelly ## Brzezinski, Zbigniew 48 Buford, Bill 311 Carlson, Peter 38 Clute, Kathleen 37 Cohen, Susan 1119 Coleman, Mark 27 Davis, Erik 46 Devitt, Jon 58 Diamant, Anita 75 Dolnick, Edward 53, 79 Dovidio, John 52 Fenske, Mark 202-203 Friedman, Steve 36 Galagan, Patricia A. 511/51 Gard, Bob 169 Gates Jr., Henry Louis 1111 Gibilisco, Stan 96 Gibney Jr., Frank 43 Gitter, Mike #3 Graves, Keith 58 Haley, Alex 25 Harrison, Jim 73 Heilbroner, Robert 72 Ho, Elizabeth 111 Isler, Scott BII Kaminer, Wendy 24 Kaplan, Michael 19 Keane, Fergal 58 Kohan, John 25 Laidlaw, Marc #4 Lowenstein, Jerold M. 1114-1115 Lyons, James 59 MacHale, D.J. 142 Markusen, Ann 28 Maas, Peter 87 McGill, Douglas C. 1111

McKillop, Peter 43 Moreau, Dan 1113 Mortimer, John 95 Oppenheimer, Larry 1116 Ortega, José #1 Patchett, Ann 143 Perkins, Mark 158 Powell, Bill 43 Reed, Kit 23 Ressner, Jeffrey 55 Rodriguez, Louis J. 1111 Rosack, T. 29 Scanlon, Charles 58 Schneider, Stephen H. 54-55 Schover, Leslie 99 Scieszka, Jon 118-121 Seibold, J. Otto 122-125 Sharp, David 44 Siegel, Paula 45 Siegel, Priscilla 158 Sirius, R.U. 131 Smith, Gary 21 Steinbaum, Ellen 1117 Stilgoe, John R. ## Stone, Bill 201 Strahinich, John 159 Strasser, Steven 43 Summers, Anthony 39 Thompson, Hunter S. 42 Travers, Peter 22, 32, 63 Tucker, Ken §4 Vidal, Gore \$4 Vienne, Veronique #5 Wach, Bonnie 71 Walsh, Vivian 122-125 Waugh, Eric 58 Wehrfritz, George 43 Werner, Vivian 132-135 Whitehead, Kevin 49 Wilkinson, Scott 1116 Winter, William E. ##

Wright, Lawrence #2

Publications

Abitare 108 American Health Magazine 37 The Atlantic Monthly 24 Bleeding Heart #2 141 Bloomberg Magazine 1111 The Boston Globe 1117 The Boston Globe Magazine 75.86 BBC Worldwide 58 City Paper 49 Details 90 Detroit Free Press ## Diabetes Forecast 98-99 Digital News 1112 Discover Magazine 1114-1115 East of the Sun, West of the Moon 142 Electronic Musician 1116 Entertainment Weekly \$4 Esquire #7 Esquire Sportsman 73 Garbage Magazine 711 GQ Magazine 36, 94, 95 Harnessing Information 157 Health 44, 53, 71, 79 Kiplinger's Personal Finance Magazine 1113 The Los Angeles Times Magazine 97 Macworld 39 Mirabella 411 Mondo 2000 13II Mother Jones 85 Mr. Lunch Takes a Plane Ride 122-125 The New York Times 28, 29 The New York Times Magazine 311 The New Yorker 16-18, 34, 62 Newsweek International 43 NeXTWORLD 77 Omni Magazine 23, 84 The Orange Book 126-129 The Patron Saint of Liars 143 Petrouchka-The Story of the Ballet 132-135 Philadelphia Inquirer Magazine 1111 Playboy 25

Pulse! #3

Random House Autumn Catalogue 149 Ray Gun 47, 67-69, 78, 89, 91 Recording Industry Sourcebook Rolling Stone 22, 27, 31-33, 35, 42, 63, 66, 80, 82, 92-93 Russia Special Issue of Time Magazine 25 The Seventh Annual Soul Train Music Awards Program 148 Smart Money 59 South Beach Magazine ## Sports Illustrated 21 Stanford Medicine £1 The Stinky Cheese Man and other Fairly Stupid Tales 118-121 Sweet Peas 114-118 TLC Monthly 75 Training and Development Magazine 511-52 US Magazine 19, 20, 41, 56 U.S. News and World Report 57 Vanity Fair 39 Varbusiness 74 The Village Voice 1111, 111 Voice Literary Supplement 45 Washington Monthly 72 The Washington Post Magazine 38, 109 Working Mother Magazine 45 World Monitor Magazine 48, 54-55 World War Three #1 Worth 159

Publishing Companies Abitare Segesta 188 Act III Publishing 1116 Affiliated Publications, Inc. 75, 86, 107 American Diabetes Association. Inc. 98, 99 American Society for Training and Development 511-52 The Atlantic Monthly Company 24 Brad Burkhart Publishing 131 Byron Preiss Visual Publications 132-135 Capital City Publications 72 Capital Publishing 159 The Christian Science Publishing Society 48, 54-55 CMP Publications 74 Condé Nast Publications, Inc. 16-18, 34, 36, 39, 62, 90, 94, 95 Digital Equipment of Canada, Ltd. 102 Discovery Communications 75 Disney Magazine Publishing, Inc. 104-105 Dovetale Publishers 711 Fantagraphics 141 Foundation for National Progress 85 Fukutake Publishing Co., Ltd. 136-140 General Media Publication Group 23 84 Harper Collins Publishers, Inc. 1311 Houghton Mifflin Company 143 The Hearst Corporation 73, 87

Hearst & Dow Jones 59

Hippocrates Partners

Icon Books 114-117

Integrated Media 77

Knight-Ridder ##, 1111

Lang Communications 45

Kiplinger Washington Editors 1113

44, 53, 71, 79

Macworld Communications, Inc. #11 Michael Bloomberg Publishing 1111 MTS Inc. 83 Murdoch Publications 41 New York Times Company 28, 29, 30 Playboy Enterprises, Inc. 26 Rabbit Ears 142 Random House 149 Ray Gun Publishing, Inc. 47, 67, 68-69, 78, 89, 91 Reader's Digest Publications, Inc. 37 Rizzoli International Publications, Inc. 126-129 Scranton Times 49 South Beach Magazine, Inc. ## Stanford University £1 Straight Arrow Publishers, Inc. 19, 20, 22, 27, 31-33, 35, 41, 42, 56, 63, 66, 80, 82, 92, 93 The Time Inc. Magazine Company 21, 25, 64 Times Mirror 97 Viking Books 118-125 VV Publishing Corporation 46, 110, 111 The Washington Post Company

Advertising Agencies

World Color Press 57

38, 43, 109

Close World Collection 154
Creative Artists Agency 202-203
Merkley Newman Harty 201
Northlick, Stolley, La Warre 159

Clients

Architects, Designers & Planners for Social Responsibility 155 Atlantic Recording Corporation 148 Bankers Trust Company 2011 Barneys New York 145-147 Beckett Paper 169 Bloomingdale's 152-153, 188 Coca-Cola 202-203 Comedy Central 151 Dallas Society of Visual Communications 158 Graphic Ads 1711 MBO/TVKO 156 Nordstrom 199 Prix Fixe Restaurant 1511 Stanford University 157 Sugar for Strawberry Fields and Bow Brand 164 Verve/Polygram Records 172 Warner Brothers Records 171

Design Firms

Chermayeff and Giesmar 162-163

Harris-Bhandari 168

Mortensen Design 167

Siebert Design Associates, Inc. 169

Studio J 132-135

Tom Suzuki Design, Inc. 98, 99

Production/Studios

The Bomb Factory 202-203
The Ink Tank 202-203

Sound

Warren Dewey 202-203